TurnerWhistlerMonet

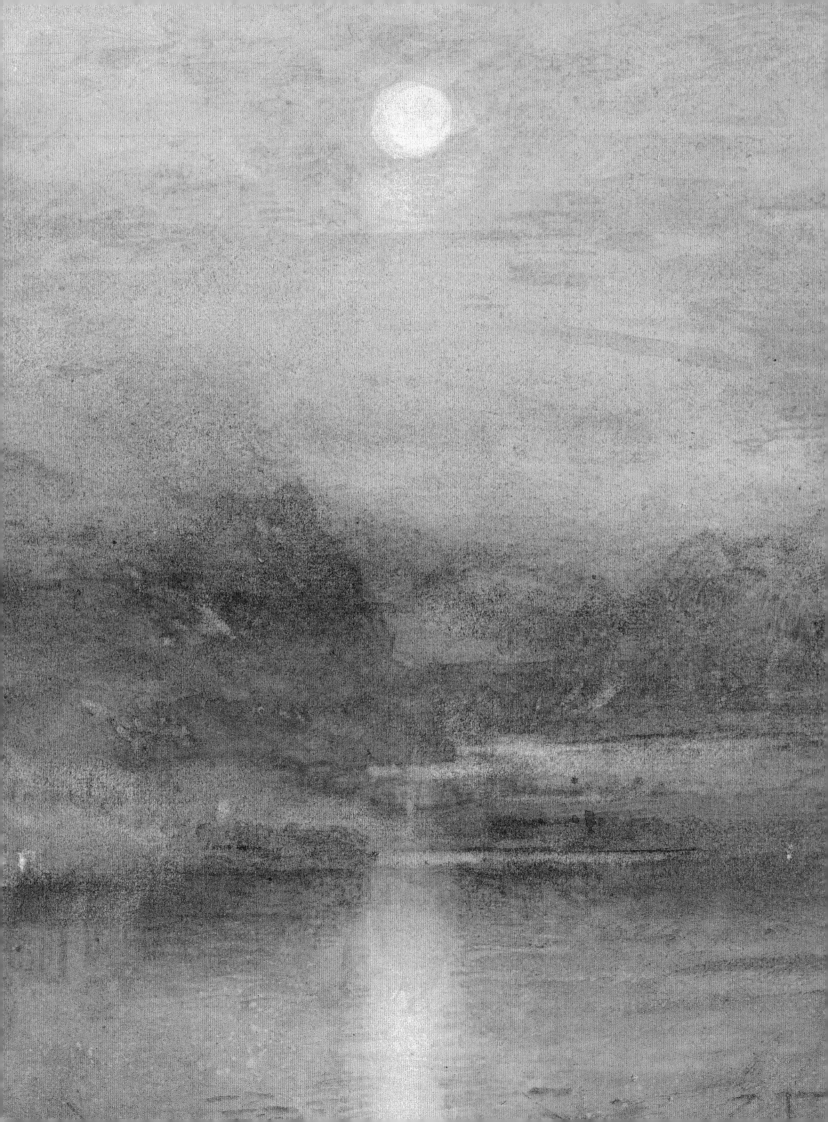

TurnerWhistlerMonet

Katharine Lochnan

WITH CONTRIBUTIONS BY

Luce Abélès, John House,
Sylvie Patin, Jonathan Ribner,
John Siewert, Sarah Taft,
and Ian Warrell

Tate Publishing
in association with the Art Gallery of Ontario

Published in 2004 in conjunction with the
exhibition *Turner Whistler Monet* conceived by
the Art Gallery of Ontario, Toronto, and organised
jointly by the Art Gallery of Ontario, Toronto,
the Réunion des musées nationaux and musée d'Orsay,
Paris, and Tate Britain, London

EXHIBITION ITINERARY

Art Gallery of Ontario, Toronto
12 JUNE–12 SEPTEMBER 2004

Galeries nationales du Grand Palais, Paris
12 OCTOBER 2004–17 JANUARY 2005

Tate Britain, London
10 FEBRUARY–15 MAY 2005

The exhibition at Tate Britain is sponsored by
Ernst & Young

EJ *ERNST & YOUNG*

Published by order of the Tate Trustees
by Tate Publishing, a division of Tate Enterprises Ltd,
Millbank, London SW1P 4RG
www.tate.org.uk/publishing

Preface and essay by Katharine Lochnan
© Katharine Lochnan 2004
Catalogue entries by Katharine Lochnan
© Tate Trustees 2004
Texts by John House, Jonathan Ribner, John Siewert,
Sarah Taft, Ian Warrell © Tate Trustees 2004
Texts by Luce Abélès and Sylvie Patin © Éditions
de la Réunion des musées nationaux 2004
49 rue Étienne-Marcel 75001 Paris:
translations from the French © Art Gallery of
Ontario 2004

British Library Cataloguing in Publication Data
A catalogue record for this book is available
from the British Library

ISBN 1 85437 500 8 (paperback)
ISBN 1 85437 532 6 (hardback)

Hardback edition distributed in the United States
and Canada by Harry N. Abrams, Inc., New York

Library of Congress Cataloguing in Publication Data
Library of Congress Control Number: 2003112067

Designed by Philip Lewis
Printed in Italy by Conti Tipocolor, Florence

FRONTISPIECE: J.M.W. Turner, *Moonlight on Lake
Lucerne, with the Rigi in the Distance c.1841* (detail, no.18)
PP.64–5: J.M.W. Turner, *Lake Lucerne: The Bay of Uri
from Brunnen c.1841–2* (detail, no.57)

Contents

Catalogue

WITH CONTRIBUTIONS BY
LUCE ABÉLÈS, JOHN HOUSE, KATHARINE LOCHNAN,
SYLVIE PATIN, JONATHAN RIBNER, JOHN SIEWERT,
SARAH TAFT, AND IAN WARRELL

Sponsor's Foreword

Ernst & Young is delighted to sponsor *Turner Whistler Monet* at Tate Britain and hope this catalogue provides you with an insight into the exhibition's examination of the relationship between Monet and Whistler, and their debt to Turner.

This is the eleventh exhibition that we have been associated with in the UK and our sixth with Tate. We are pleased to continue this relationship and are proud to be able to support Tate's commitment to the arts and the high quality exhibitions, such as this, that it presents.

Our sponsorship of *Turner Whistler Monet* is part of our continuing partnership with the arts in the UK, including galleries, museums and other community art initiatives. We recognise the need for long-term and sustained investment in the arts and are pleased that our support makes it possible for such world class exhibitions to be staged and for the public to have access to them.

NICK LAND
Chairman, Ernst & Young

Foreword

This exhibition explores an artistic dialogue across time and space inaugurated when the works of the great British painter James Mallord William Turner reached out to inspire the imaginative brilliance of James McNeill Whistler and Claude Monet. While Turner, Whistler and Monet have each been investigated in depth in recent monographic exhibitions, the connections between the artists have not been explored in a sustained way until now. Artists build on the works of their predecessors, and interact with their contemporaries. Their frame of reference is not confined to art, nor the perceived boundaries of national schools. By exploring artistic creativity in the context of nineteenth-century French and English art, we want to shed new light on the evolution of Realism into Impressionism and Symbolism.

From the start this project was conceived as an international undertaking. Whistler scholar Katharine Lochnan, Senior Curator and The R. Fraser Elliott Curator of Prints and Drawings at the Art Gallery of Ontario, first developed the idea over a period of years. When the Réunion des musées nationaux and musée d'Orsay, and Tate Britain joined the project in 1998, a Scientific Committee was assembled to develop the concept. Led by Dr Lochnan, its membership included Monet scholars Sylvie Patin, conservateur en chef at the musée d'Orsay, and John House, Walter H. Annenberg Professor at the Courtauld Institute, Turner scholar Ian Warrell, Curator, British Art, Tate Collections, and Alison Smith, Senior Curator, Tate Britain. They invited additional scholars to contribute to the catalogue: Luce Abélès, chargée de la littérature at the musée d'Orsay; Jonathan Ribner, Associate Professor, Art History Department, Boston University; John Siewert, Assistant Professor, Art History, The College of Wooster, Ohio, and Sarah Taft, Prints and Drawings Registrar, Tate Britain.

There are over one hundred works in this exhibition. The almost equal number of paintings on canvas and works on paper indicates the importance not only of the dialogue between artists, but between media during this period. We could not have proceeded without the generous support of institutional lenders. For the most part, they have not only allowed us to borrow extraordinary works, several of which are the most popular in their institutions, but to do so for all three venues. We are especially indebted for multiple loans of major works to the Art Institute of Chicago, the Boston Museum of Fine Arts, the National Gallery, Washington, the Philadelphia Museum of Art, and many others.

We also thank the private collectors who have lent to this exhibition, for whom the absence of these prized works from their walls represents a personal sacrifice.

We should like to offer our sincere thanks to Fidelity Investments who so generously supported the exhibition at the Art Gallery of Ontario. In Paris the exhibition at the Galeries nationales du Grand Palais was made possible by the generous support of ABN-AMRO and to them too we offer our great gratitude. Tate Britain is most grateful for the outstanding generosity of Ernst & Young who have sponsored the exhibition in London. The exhibitions at all three venues would not have been possible without the support of the Department of Canadian Heritage through the Canada Travelling Exhibitions Indemnification Program, the French Government Indemnity, and the British Government Indemnity Scheme.

MATTHEW TEITELBAUM
Director and CEO, Art Gallery of Ontario

SOPHIE AURAND
Administratice générale, Réunion des musées nationaux

SERGE LEMOINE
Président, musée d'Orsay

STEPHEN DEUCHAR
Director, Tate Britain

Acknowledgements

It was in August 1988 that the idea for this exhibition was born, and it was following the appointment of Matthew Teitelbaum as Chief Curator at the Art Gallery of Ontario in 1993 that plans began to move forward. The proposal was embraced in 1998 by Stephen Deuchar at Tate Britain, and Henri Loyrette and his successor, Serge Lemoine, at the musée d'Orsay, together with Irène Bizot and her successors, Philippe Durey and Sophie Aurand, at the Réunion des musées nationaux. It is thanks to our inter-institutional collaboration that the project has reached a happy conclusion.

This exhibition would have been impossible without the support of our lenders. We had to request the loan of works that are among the most popular in their respective institutions, many of which are light-sensitive, subject to legal or conservation restrictions, and seldom, if ever, lent. We cannot thank enough the directors and curators of institutions in Canada, France, Germany, Great Britain, Switzerland, and the United States (see List of Lenders on p.258) for their enthusiastic response, and willingness to support our ambitious requests.

An international team composed of John House, Sylvie Patin, Alison Smith, Ian Warrell, and myself, honed the concept, put together the exhibition list, and determined the contents of this catalogue as members of the Scientific Committee. We invited Luce Abélès, Jonathan Ribner, John Siewert, and Sarah Taft to join us, each of whom brought invaluable expertise to the project. John House played a catalytic role, bringing an academic perspective and great generosity of spirit to our investigation. It was John who was invited to vet the thesis at the outset, and who recommended that we develop the exhibition concept. I would personally like to thank him for his unflagging enthusiasm and guidance throughout, for editing my texts, and for doing his best to keep me from tripping on art-historical potholes. All the authors would like to acknowledge their primary debt of gratitude to the others, and thank them for sharing their information and

vetting their manuscripts. We would also like to acknowledge those Turner, Whistler, and Monet scholars in whose footsteps we are walking.

Many staff members of Tate Britain, the Réunion des musées nationaux and musée d'Orsay, and the Art Gallery of Ontario have played key roles in organising the exhibition. At Tate Britain, we would especially like to thank Alison Smith, and Katharine Stout, Assistant Curator. At the Réunion des musées nationaux, we would like to thank Luc Derepas, administrateur général adjoint chargé du développement culturel, Bénédicte Boissonnas, chef du département des expositions, Vincent David, chef de projets d'exposition, and Francine Robinson, coordinatrice d'expositions chargée du mouvement des oeuvres. At the Art Gallery of Ontario, we would like to acknowledge Jill Cuthbertson, Deputy Director, Exhibitions, Gwen Adams, Administrative Assistant to the Director of Exhibitions, Dale Mahar, Traffic Co-ordinator, Mara Meikle, Manager, Curatorial Administration, and Curtis Strilchuk, Exhibitions Registrar, who took on much of the organisation on behalf of the partnership. Thanks must also go to Lucie Chevalier, French Language Services Coordinator, for her contribution to the French edition, and to Keith Medley for the translation of the French text into English. I would especially like to thank Dennis Reid, Chief Curator, who provided me with guidance and wise council, Jessica Morden, Marvin Gelber Intern 2002–3, for her indispensable contributions on so many levels, and Brenda Rix, Assistant Curator of Prints and Drawings, who so capably relieved me of many duties enabling me to focus on this exhibition.

The authors would like to thank Celia Clear, Chief Executive of Tate Publishing, for the personal interest she has taken in the production of this handsome catalogue, Tim Holton, Production Manager, for the excellent reproductions, and Rebecca Fortey for the diligent picture research. Johanna Stephenson copy-edited the text with great care, and the elegant design is the work of Philip Lewis. We would especially like to thank Judith Severne, Project Editor, for her support and understanding, and for working long hours on this complex bilingual manuscript, paying scrupulous attention to detail. We would like to thank our colleagues who worked on the catalogue at the Réunion des musées nationaux, including Pierre Vallaud, directeur des éditions, Catherine Marquet, chef du département du Livre, and Sophie Laporte, responsable d'édition, for editing the French version.

There are far more individuals who have assisted in the realisation of this exhibition than we can possibly name here. We would like to thank all of you who have helped each of us in so many ways both professionally and personally. Jonathan Ribner would especially like to thank Susan Brady, Martin Fido, Alastair Grieve, and Camillo Tonini. Sylvie Patin would like to thank Dominique Lobstein. I would like to thank Sharona Adamowicz, Colin Bailey, Andrew and Cornelia Baines, Guido Bianchi, Marcel Brisebois, David Coker, Douglas Druick, Robin Hamlyn, Karen Kolbe, Jim and Fran McArthur, Margaret and Norman MacDonald, Enid Maclachlan, Louise Moore, Patrick Noon, Pierre Rosenberg, Robert Rosenblum, Jean Segurras, Lindsay Stainton, Claude Stren, Serge Thériault, Nigel Thorp, Matti Watton, Stephen Wildman, Andrew Wilton, Martin Wylde, Dennis Young, and Joyce Zemans.

My most loyal supporter has been my husband George Yost, who has kept alive my faith in the project during its uncertain beginnings and at moments of crisis along the way. He has endured my prolonged absences and evenings, weekends, and vacations invaded by this project. I know he would agree that, for both of us, it has been an exhilarating and rewarding journey.

KATHARINE LOCHNAN
Toronto

Preface

Katharine Lochnan

Monet's canvas *Impression, Sunrise* of 1872–3 (no.39), which gave rise to the term 'Impressionist', may be seen as the offspring of an atmospheric Turner sunset and a poetic Whistler Nocturne. Until now, assumptions about the relationship between the works of these three artists at this pivotal moment in history have been based largely on visual evidence. In the hope of penetrating this fascinating nexus and shedding new light on 'Impressionism', an international team of curators and academics has delved into archives, peered through magnifying glasses and diverged from better-travelled paths to look at contextual issues.

Artists cannot be understood in isolation or within the confines of a national school. This was especially the case during the second half of the nineteenth century, when the art community became increasingly international and artists interdependent. It is time to look at these three artists in an international framework, and consider the fertile exchange of ideas between Britain and France which contributed to 'Impressionism' and 'Symbolism'.

Although Whistler and Monet were admirers of Turner, and friends and collaborators for decades, the nature and significance of this artistic triangle remains to be explored. While not denying other influences, we have abstracted the skeins of this story from the much bigger narrative of late nineteenth-century art, and traced the evolution from a 'Realist' to an 'Impressionist' and then a 'Symbolist' mode of landscape: from a primary focus on material reality to a concern first with atmospheric effect, and then with the evocative mood of the landscape.

Our narrative begins with Turner's bequest to the nation designed, in part, to challenge the primacy of his great French forebear, Claude Lorrain, and claim supremacy in landscape for Britain.[1] Whistler set out to rival Turner, and Monet to rival both Turner and Whistler and reassert French supremacy. Their 'avant-garde gambits'[2] can be traced visually through shared themes and variations: inaugurated by Turner, changes were rung first by Whistler then by Monet. They constitute one of the most fertile artistic exchanges of the late nineteenth century, and provide a window through which to view the important relationship between British and French art.

Although Turner's early views of the Thames project an Arcadian vision, he witnessed the impact of the Industrial Revolution on the environment. By the time Whistler and Monet arrived on the scene, London was horribly polluted. For artists committed to working from nature and dedicated to the search for beauty in modern life, this posed an aesthetic dilemma. Shocking contemporary evidence forces us to conclude that after realist beginnings Whistler and Monet, like Turner before them, sought alternatives that emphasised the artist's power to transform his material. The ways in which they and their critics responded to modern reality suggest dramatically new readings for their works.

The watery landscapes in this exhibition, featuring the Thames, the Seine and the Venetian Lagoon, are among the most aesthetically pleasing in the history of art. They are rich in subtexts which enable us to consider them in different ways. The Thames and Seine have symbolic importance as national rivers and arteries of their bodies politic. The Venetian Lagoon, the mirror of the City of Art, was slowly sinking from view and can be read as a *vanitas* subject. However beautiful they appear on the surface, the water and air in these three venues gave rise, in varying degrees, to unpleasant odours, contagious and deadly diseases, and limited visibility. While acknowledging its negative impact on the environment, these three artists found inspiration in the modern industrial landscape.

Whistler is ripe for repositioning. Born in America, trained in France and resident in Britain, he is an artist who does not really fit into any single national school. One of the first international artists, his American identity enabled him to stand apart as well as participate actively in the English and French schools. Fluently bilingual, he played a catalytic role, carrying ideas back and forth between England and France, and effecting introductions on both sides of the Channel. Identified with the Impressionist movement, Whistler was criticised, like Turner and Monet, for 'lack of finish'. John Ruskin's infamous attack is reconsidered here in light of Whistler's artistic dialogue with Turner, and his promotion of French Impressionism in Britain in relation to the *Whistler v. Ruskin* court case. Although this committed member of the avant-garde fiercely maintained his independence, routinely denouncing all suggestions of influence, in the mid-1880s he reversed this trend and allied himself with Claude Monet.

So-called Impressionist 'lack of finish' resulted in part from the breaking down of the traditional hierarchy between works on paper and on canvas. The preliminary sketch all but disappeared, and painting assumed the role formerly played by preparatory drawings and oil sketches. The desire to capture transient effects

quickly, or to give painting the appearance of spontaneity, led to the hybridisation of drawing and painting techniques. Turner and Whistler imitated the translucency of watercolour,[3] and Monet the palette, chalky quality, and touch of pastel. Concepts developed on paper were transferred to canvas. Monet's series paintings are looked at here in the context of Turner's serial watercolours and Whistler's Venetian Nocturne etchings, in which the same motif was transformed under a range of atmospheric effects.

The relationship between art and poetry was important to all three artists in approaching the landscape. Turner, whose paintings embodied the concept *ut pictura poesis*, was seen to be influenced primarily by Lord Byron. As students in Paris, Whistler and Monet were inspired by the writings of Charles Baudelaire.

After moving to London Whistler collaborated with his friend and neighbour Algernon Charles Swinburne, an admirer and defender of Baudelaire. During the 1870s Swinburne collaborated with the French poet Stéphane Mallarmé, to whom Whistler was later introduced by Monet. Mallarmé translated Whistler's 'Ten O'Clock' lecture, becoming a friend in the process, and Monet, Whistler and Mallarmé formed a close personal and professional alliance.

Whistler and Monet sought and found beauty in contemporary landscape. Inspired by Turner, they created arguably the most poetic landscapes of the second half of the nineteenth century. Viewing nature through their unique temperaments, their artistic visions have never spoken more directly to audiences around the world than they do today.

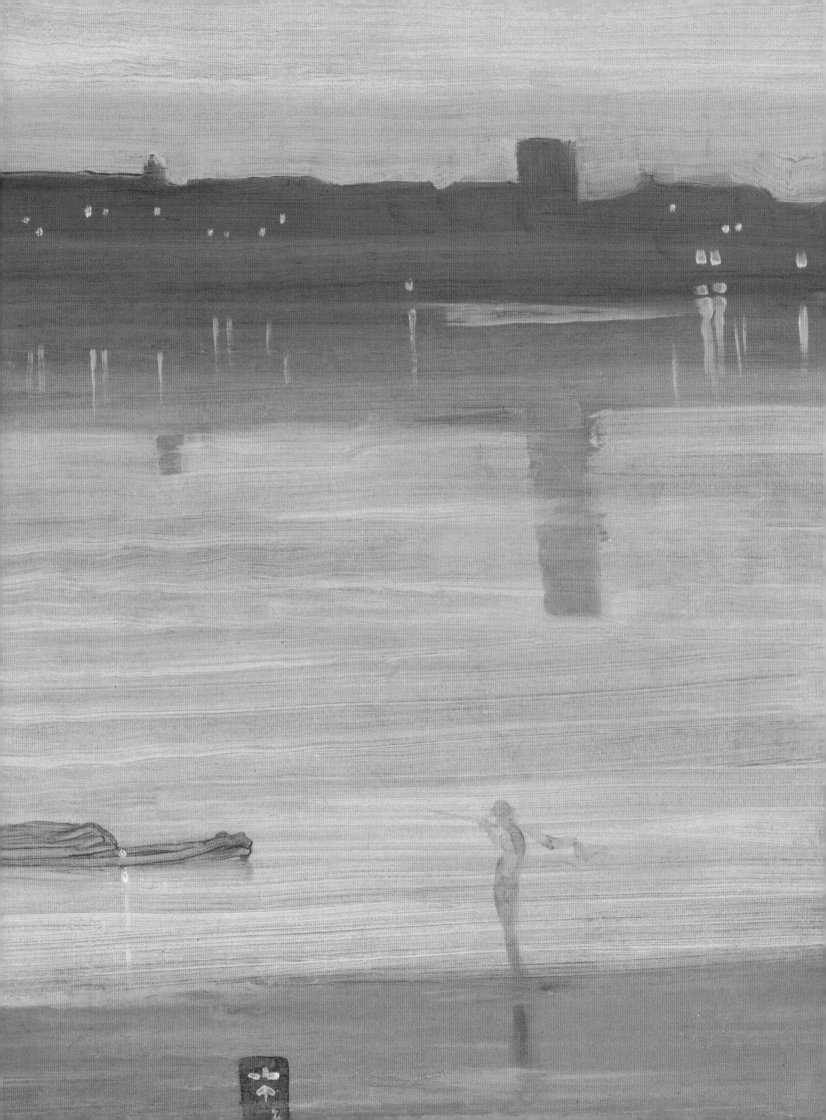

Turner, Whistler, Monet: an artistic dialogue

Katharine Lochnan

As music is the poetry of sound, so is painting the poetry of sight
(James McNeill Whistler, 'The Red Rag', 1878)[1]

In 1846 the leading artist of the British school, J.M.W. Turner, moved incognito to a house in Chelsea 'which commanded views of two of the finest reaches of the Thames in London' (fig.1).[2] His name was closely linked with the river that he observed at dawn, at dusk, and on moonlit nights from a rowing boat or rooftop balcony. On the day he died, 19 December 1851, Turner was found prostrate on the bedroom floor, trying to get to the window to look at the river. His doctor reported how just before 9 am, 'the sun broke through the cloudy curtain which so long had obscured its splendour, and filled the chamber of death with a glory of light'.[3] Turner 'died without a groan'.[4]

The 'cloudy curtain' was pollution. During Turner's lifetime London had become the largest industrial city in the world. The Thames, which inspired Arcadian views in his youth (see no.3), had become a giant sewer by the time of his death (see p.59). As the sky was obscured by smog much of the time, the sun made infrequent appearances. Rodner has noted that 'Shelley considered London's opaque greyness the very manifestation of hell in the guise of "a populous and smoky city"'.[5] Atmospheric pollution, however, brought with it sublime effects that excited Turner's imagination and contributed to spectacular sunsets.[6]

The response to environmental degradation brought about by the Industrial Revolution took different forms. Some decried the growing threat to the natural landscape and its picturesque quality by the spread of industry with its 'utilitarian structures'.[7] Others sought beauty in modernity. The Romantic poet Percy Bysshe Shelley believed that 'poetry turns all things to loveliness . . . it adds beauty to that which is most deformed [and] . . . lifts the veil from the hidden beauty of the world, and makes familiar objects be as if they were not familiar'.[8] Turner was dubbed 'the Shelley of English painting'.[9]

During the 1820s, Turner's work underwent a dramatic shift. While observing nature closely, and continuing to work from nature, he began to give greater rein to his imagination, focusing on fugitive aspects and creating extraordinary atmospheric effects. His contemporaries were dumbfounded and by the mid-1830s critics began to attack him, accusing him of insanity. In 1843 the young John Ruskin came to his defence in the first volume of *Modern Painters*, claiming that Turner was the greatest artist who had ever lived and setting him up against Claude Lorrain (see no.22). He promoted Turner's late style over his early one,

and his watercolours over his oil paintings. He especially admired the Venetian and Swiss watercolours, considering the latter to be 'the pinnacle of Turner's achievement'.[10]

That same year a nine-year-old American, James McNeill Whistler, passed through London with his mother and siblings en route to Russia where his father, Major George Washington Whistler, a civil engineer, was supervising the building of the railway, its bridges and aqueducts, from St Petersburg to Moscow. One of Whistler's most vivid memories of London was a row on the Thames 'by lamplight and starlight'.[11]

Following an outbreak of cholera in St Petersburg five years later, Whistler was sent to London to live with his half-sister Deborah and her husband, the socially prominent surgeon Francis Seymour Haden. This sojourn proved critical to the formation of the young artist. In January 1849 he wrote to his father to say that he wished to become a painter. Already concerned by what he perceived as lack of 'finish' in his son's drawings, Major Whistler warned him not to allow his taste in art to become 'too poetical', and recommended that he cultivate a taste for 'useful works' of art which would lead to a career in engineering or architecture.[12]

Seymour Haden was a talented amateur and a great admirer of Turner. Following the completion of his medical studies at the Sorbonne in Paris in 1844, he travelled to Italy and Switzerland. He visited some of the places depicted by Turner in his watercolours, including Lake Lucerne, Fluelen, Tell's Chapel and the Rigi.[13] His drawings executed on this trip, as well as his watercolours of the mid-1840s, owe a debt to Turner's early style.[14] Haden began to put together an important collection of prints and drawings after returning to Britain, and apparently acquired several Turner watercolours which have yet to be identified.[15] While it is not known whether Haden met Turner, his granddaughter believed they had painted together in Wales, though this is an unlikely scenario.[16]

Seymour Haden decided to school Whistler at home in the spring of 1849, and take his art education in hand. Whistler would have had access to Haden's extensive library and read in the first volume of *Modern Painters* (which Haden had in the 1848 edition) Ruskin's caution against imitation, which he deemed 'unworthy

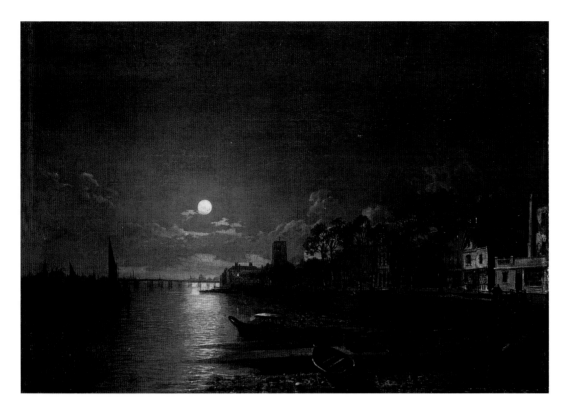

Fig.1 Henry Pether, **Cheyne Walk and Battersea Bridge by Moonlight** 1850
Oil on canvas 38 × 48 cm
The Royal Borough of Kensington and Chelsea

of the pursuit of the artist'. He would also have read Sir Joshua Reynolds's advice in his *Discourses* – a Christmas present from his father in 1848 – that aspiring artists should enter into 'a kind of competition by painting a similar subject and making a companion to a picture that was considered a model.'[17] Whistler was taken to museums and art exhibitions, and introduced to the works of Turner. He would have seen four Turner oil paintings when he was taken to the Vernon Gallery (see p.68, below),[18] including *The Golden Bough* 1834 (no.14) and two Venetian canvases – *The Dogano, San Giorgio, Citella, from the Steps of the Europa* (no.99), and *Bridge of Sighs, Ducal Palace and Custom-House, Venice: Canaletti Painting* (Tate, London; B&J 349) – which, in 1847, were the first Turners to enter the national collection.[19]

Whistler attended Charles Robert Leslie's lecture series at the Royal Academy, where he received an introduction to the British School and its art theory. He would have been particularly interested in the discussion about 'finish'. Ruskin expressed the opinion in *Modern Painters* that 'the less sufficient the means appear to the end, the greater will be the sensation of power'.[20] Leslie built on this, maintaining that it was the artist who was the judge of when a painting was finished: 'all pictures are finished if the intention of the master be fully conveyed . . . under the guidance of an exquisite taste.'[21] He also introduced Whistler to the issues surrounding the relationship of art and literature, calling poetry and painting 'sister arts', and saying that 'the ideal

is the poetic element by which . . . high art is distinguished from low or ordinary art'.[22] These opinions of Leslie's were later to become Whistler's maxims.[23]

After Major Whistler died in the cholera epidemic of 1849, his wife took the children back to America. Aware that Leslie had taught at West Point Military Academy, Whistler also wanted to go there. Leslie's successor, Robert Weir, probably drew Whistler's attention to the paintings of the Hudson River School inspired in part by Turner.[24] At that time Turner's images were known in North America only through reproductive prints: there was just one of his oil paintings in America, *Staffa: Fingall's Cave* of 1832 (Yale Center for British Art, New Haven; B&J 347), purchased in 1845 by Colonel James Lenox of New York on Leslie's advice. Whistler was no doubt treated to the story Leslie often told of how Lenox initially found the painting 'indistinct'. When he heard this, Turner was said to have replied: 'you should tell him that indistinctness is my *forte*' (although he actually said 'fault').[25] In 1851 the great artist fell ill and died while Whistler was still at West Point.

Haden encouraged Mrs Whistler to support her son's artistic ambitions. When she visited London in 1852 he took her to the Gallery for Amateurs and pointed out the Turner watercolours. She wrote to Whistler saying, 'I have a love for your favorite art.'[26] On New Year's Eve she wrote:

As Sis wished . . . to go to the water colour Gallery of Amateurs [–] she not having seen the four studies purchased for her home – we enjoyed the 2nd visit even more than our first, and Seyr pointed out one of Turners which would have been a feast for Jemie [James], such an exquisite specimen of that genius. You know the aged Artist has been taken from time to eternity since you were here, & it will interest you as one of his admirers to hear that he left to the National Gallery his masterpiece 'The Building of Carthage' upon Condition of its being placed between the Claudes of the same subject – the eccentric old Artist of England knew the merit of his productions & never yielded the palm to anyone. When Seyr recounted to us his peculiarities, I hope to store up some amusing anecdotes for next summer's furlough.[27]

Mrs Whistler could have seen the Turners juxtaposed with the Claudes. According to the terms of Turner's contested will (see pp.67–8, below), the two paintings *Dido Building Carthage* 1815 (fig.15 on p.34) and *Sun Rising through Vapour* (no.2) had to be installed before the first anniversary of Turner's death, on 19 December 1852. While the condition of the latter was very good, many of the paintings in Turner's Queen Anne Street Gallery were in very poor condition, and *Dido Building Carthage* was in the worst condition of all: 'after 30 years in Mr. Turner's wretched gallery, where the weather and everything bad attacked it . . . the dirt hung over it like dirt from the smoke of a chimney'. The staff of the National Gallery were 'obliged to have the picture taken down to the pavement in front of the door, before we could have it put into the wagon, and it looked almost as if a chimney had been swept upon the pavement'.[28] Upon arrival at the Gallery 'there were absolutely large pieces of the colour flaking off' and 'it was necessary to make the pieces of colour to adhere again, and to do a great deal to the picture to put it at all in a solid condition' before it could be placed on the wall.[29] As the two paintings were picked up in early December and placed on view on 8 and 9 December 1852, only ten days before the deadline, the restoration must have taken place within a week.

Like all paintings at the National Gallery, *Dido Building Carthage* was regularly wiped with a silk handkerchief to counteract 'the constant deposit from atmospheric and other sources leading to a dull appearance.'[30] A few months after its installation it was declared to be in 'a very hazardous state; a great deal of it was rising from the cloth'. In April 1853 a Select Committee was appointed to investigate the conservation of paintings in the national collection. There was a public perception that the paintings had begun to look 'yellower and nastier than they ought to do', and there were suspicions about 'over-cleaning'. H.A.J. Munro of Novar (Turner's executor), who investigated these complaints, reported to the Committee that *Dido Building Carthage* was 'excessively cracked' and had been cleaned with soap and water without first being relined. He confirmed that the 'evils attributed to the locality of the National Gallery are partly those arising from its situation, and partly from the great concourse of people who come there with dusty feet'.[31]

In February 1853 Haden took Mrs Whistler to visit Charles Stokes, who had one of the most comprehensive collections of Turner's work in private hands. She described the visit in a letter to a friend thus: 'one evening accompanied Debo and her husband to an old bachelor friend who invited us for the extraordinary treat of Turner's paintings, that I might enjoy the retrospect with my cadet. Oh how I wished for him, he never can except at Mr. Stokes see such a collection, from the artist's first effort at 16 years to his meridian.'[32] Whistler was not able to share this experience as Mr Stokes died later that year and his group of Turner's watercolours was then gradually dispersed.

Whistler was dismissed from West Point in June 1854. He spent the next year learning as much as he could about printmaking techniques, while continuing to make drawings and watercolours. In July 1855 he made a watercolour after a chromolithograph of a Turner oil painting (nos.24, 25). As soon as he turned twenty-one and came into a small inheritance from his father, he set sail from America never to return.

Whistler stayed with the Hadens in London for three weeks in October 1855 before continuing on to Paris to study art. Although he lived and studied in Paris until 1859, and gravitated from Gleyre's Academy into the Realist circle of Gustave Courbet, he made frequent trips to London to keep an eye on the British art world. He undoubtedly went to see the Turners juxtaposed with the Claudes at the National Gallery for the first time.

Following Turner's death in 1851, Ruskin had laid claim to the

artist's posthumous reputation, declaring: 'my great mission is to interpret him.'[33] Through his writings Ruskin 'defined for a generation the aims of landscape painting in relation to the qualities he discerned in the artist's works, inextricably binding them together'.[34] In 1857 he published an unauthorised catalogue, which sold extremely well, of the paintings placed on view by the National Gallery at Marlborough House. As an aid to understanding Turner's development Ruskin divided the artist's work into three phases. These were: firstly, 'imitating successively the works of the various masters who excelled in the qualities he desired to attain himself' (1800–20); secondly, giving up imitation and producing 'beautiful compositions or ideals, instead of transcripts of natural fact' (1820–35); and thirdly, drawing on 'the simple impressions . . . received from Nature, associating them with . . . deepest feelings' (1835–45).[35] Whistler appears to have adopted Ruskin's system.

Ruskin preferred Turner's watercolours to his oil paintings because they were 'simple records of his first impressions and first purposes'.[36] In February 1857 the National Gallery installed 102 finished watercolours on screens in the gallery at Marlborough House, which drew a large audience (see p.68, below). Ruskin offered to have one hundred watercolours framed at his own expense and made available in cabinets in the basement of the National Gallery, where students could see and copy them on application. After a very public campaign, begun in 1856, he was finally awarded responsibility for the display and interpretation of the Turner Bequest, and taken up on his offer in 1857 (see p.69, below). As Ian Warrell has noted, for 'the public who for many years had heard so much and seen so little of the collection, the eventual display of Turner's sketches must have come as a revelation'.[37] By March 1859 plans were under way for the expansion of the National Gallery, and a vastly larger space was designed to house Turner's drawings.[38]

Turner's reputation began to spread across the Channel. In 1857 he was represented in the 'blockbuster' Manchester *Art Treasures* exhibition by twenty-four oil paintings and eighty-three watercolours.[39] In his French review, G.F. Waagen drew attention to British distinction in landscape and said that 'one could get to know the British landscapists' there. He drew special attention to 'marine painting', which 'is represented by several beautiful works by Turner' (no.4), and noted that Turner was represented here by both his 'beautiful paintings as well as his flights of fancy'.[40] In September Whistler made a special trip across the Channel to see the exhibition; it is very likely that he also passed through London and visited the exhibition at Marlborough House (see p.69, below).

Following the completion of his studies at Gleyre's Academy, Whistler joined forces with fellow realists Henri Fantin-Latour and Alphonse Legros. Looking to Charles Baudelaire and Gustave Courbet for guidance,[41] they formed a 'Société des Trois', defining themselves as independent artists with plans to inaugurate 'the painting of the future'[42] and advance each other's careers.[43] After Whistler moved to London in May 1859 he invited Fantin-Latour to visit and stay with the Hadens. On 11 July, no doubt encouraged by Whistler and Haden, Fantin-Latour went to the South Kensington Museum and wrote to a friend later that day, singling out the work of Turner and saying, 'I will see even more tomorrow.' The next day he went to Ruskin's exhibition at Marlborough House (see p.69)[44] and continued his letter, saying that Turner

> gave at the time of his death, paintings, thousands of drawings, sketches etc. He is, I believe, the most remarkable artist (English). In his marine landscapes, and effects of light, he is truly remarkable. Gudin, Roqueplan, Isabey, and many other romantics come out of this: I would even say that it seems to me that Romanticism must have come from England.[45]

Whistler was searching for a realist subject he could call his own. In his Salon review of 1859 Baudelaire urged artists to consider 'the landscape of great cities'.[46] Taking this advice to heart, Whistler began to depict London along the Thames, which was horribly polluted in the summer of 1859 (see p.59, below). He incorporated motifs suggested by Baudelaire, among them 'obelisks of industry, spewing forth their conglomerations of smoke against the firmament' (no.33).[47] When the first of Whistler's Thames etchings (nos.28–30) were shown in Paris in 1862, Baudelaire praised them for portraying 'the profound and intricate poetry of a vast capital'.[48] Whistler complained to Fantin-Latour that 'Baudelaire says many poetic things about the Thames, and nothing about the etchings themselves!'

Poetry, however, was to assume increasing importance for Whistler in the summer of 1862, when he befriended the Pre-Raphaelite poet and artist Dante Gabriel Rossetti, for whom the

relationship between art and poetry was central. Rossetti introduced Whistler to his circle of friends, which included the painter Edward Burne-Jones. He shared Tudor House on the Chelsea embankment with the poet Algernon Charles Swinburne, whose favourable review of the scandalous 1861 edition of Baudelaire's *Les Fleurs du mal* secured the poet's gratitude.

In September 1862 the young Stéphane Mallarmé published an article in *L'Artiste* describing his elitist views about art, which were closely modelled on those of Baudelaire.[49] Whistler appears to have read *L'Artiste*, which did so much to promote original printmaking, and may have seen this article.[50] Although Mallarmé lived in England in 1862–3, and was married in London, there is no evidence that he came in contact with the Tudor House group. Nonetheless, they shared many ideas, and their involvement with introspection, mystery and the slow revelation of meaning helped Whistler to move away from a realist mode to a type of painting that placed primary emphasis on aesthetic qualities.

In the spring of 1863 Whistler moved to a house at 7 Lindsay Row, close to Tudor House and the house where Turner had lived. Although his windows overlooked the same stretch of river as Turner's, the bucolic view of the Battersea riverside had changed dramatically since Turner's death (fig.3). Whistler looked out on an unbroken row of industrial buildings that produced large amounts of steam mixed with coal smoke (see p.60, below), and the odours of malt, phosphorous, vinegar, gas, coal, and coke.[51] He began painting the views from his window in a realist mode by the grey light of day (nos.32, 33). As he made the gradual transition from realism to aestheticism, he began to seek beauty in modern life, and to depict these views shrouded in mist or cloaked in darkness (nos.33, 46).

During the 1850s, when the Pre-Raphaelites were under attack for their British brand of realism, Ruskin came to their defence, seeing them as Turner's successors. By the early 1860s he was the leading authority on art in the English-speaking world, and could make or break an artist's reputation. From time to time he visited Tudor House (fig.4).[52] Since Whistler had moved to London in part for financial reasons, to have Ruskin's support would have constituted a tremendous advantage. Perhaps in anticipation of meeting Ruskin, Whistler began to formulate colour harmonies and work on atmospheric views of the Thames. He wrote to Fantin-Latour in early 1864 saying that he was working on 'two

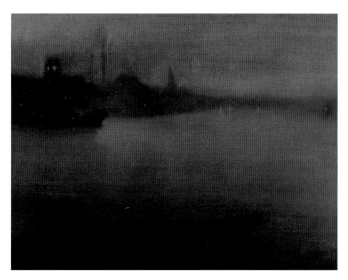

Fig.2 James McNeill Whistler, **Nocturne in Blue and Silver** 1872–8 (no.48)

Fig.3 Old Battersea Bridge photographed by Henry W. Taunt (undated). Oxford Central Library

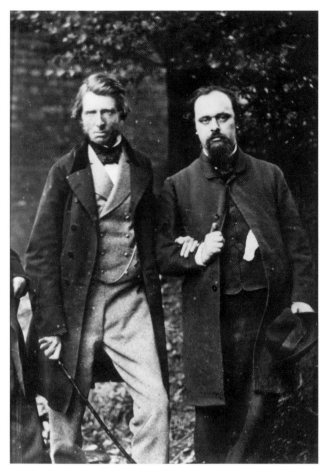

Fig.4 **John Ruskin and Dante Gabriel Rossetti in Cheyne Walk Garden** 1863
Photograph by W. & D. Downey
The Mass Gallery London

little pictures of the Thames: an old bridge and a foggy effect'. He was not entirely happy with them, saying: 'I thought them good when I finished them, but now I don't like them as much.'[53]

Seymour Haden seized every opportunity to extol Turner's virtues and show Whistler's friends his copy of the mezzotints of the *Liber Studiorum*;[54] his own work increasingly reflected his enthusiasm for Turner (see nos.5–7). After purchasing Alphonse Legros's painting *The Angelus* (formerly private collection; whereabouts unknown), Haden desecrated it by making his own additions. Whistler described his brother-in-law's 'crime' in a letter to Fantin-Latour in January 1864: 'Imagine the anguish of Legros at the moment of discovery! Searching in the tones of a sunset, in the style of Turner by the way, the calm grey stones of his beloved church!!!' Whistler and Legros spirited the painting away to Whistler's house, removed the sunset, replaced it on the wall and waited until Haden finally noticed. 'Oh! You have removed all that!', he said. 'Alright! Do it better [the next time].'[55]

On 11 August 1865 Swinburne wrote to invite Ruskin to visit Whistler's studio. He enclosed a copy of his poem 'Before the Mirror' as Ruskin requested, which he had written to accompany

Whistler's painting *Symphony in White, No.2: The Little White Girl* (1864, Tate, London; YMSM 52). Swinburne asserted that 'whatever merit my song may have, it is not so complete in beauty, in tenderness and significance, in exquisite execution and delicate strength as Whistler's picture'. He said that he was taking Burne-Jones to Whistler's studio on Sunday and invited Ruskin to accompany them, saying:

> Whistler (as any artist worthy of his rank must be) is of course desirous to meet you, and to let you see his immediate work. As (I think) he has never met you, you will see that his desire to have it out with you face to face must spring simply from knowledge and appreciation of your own works. If this meeting cannot be managed, I must look forward to the chance of entrapping you into my chambers on my return to London. If I could get Whistler, [Burne-]Jones, and Howell to meet you, I think we might so far cozen the Supreme Powers as for once to realise a few not unpleasant moments.[56]

It would seem that there was already disagreement between Whistler and Ruskin, which may explain why Ruskin did not take Swinburne up on the invitation, and the proposed visit never took place. This must have been a major blow to the young artist.

Whistler became increasingly frustrated and began to fall out with friends over points of principle. In 1866 he knocked Legros down in the course of an argument, bringing to an abrupt end the original Société des Trois. He proposed a new friend, Albert Moore, as a replacement for Legros in an attempt to effect a synthesis of French and British ideas.[57] Burne-Jones took Legros's side and waited for an opportunity to get back at Whistler.[58]

Personality clashes, disagreements about lifestyle and professional rivalry in the field of etching led to the estrangement of Whistler and Haden.[59] Their growing animosity came to a head on 23 April 1867 when Whistler pushed Haden through the plate-glass window of a Paris restaurant. Their relationship ended on the spot, polarising friends and family.[60] Both Legros and Burne-Jones took Haden's side.

At moments of crisis Whistler's opinions became iconoclastic. On 29 May 1867 William Michael Rossetti recorded a conversation where there was 'much discussion about Turner – Whistler being against him as not meeting either the simple natural or the decorative requirements of landscape-art which he regards as

the only alternative' (see p.147, n.7, below).[61] Whistler wrote to Fantin-Latour denouncing Courbet's influence and the concept of just opening one's eyes and painting whatever one found in front of one, maintaining that there were 'more beautiful things to do'.[62] Despite his problems, Whistler did spare a thought for 'poor Baudelaire', who fell ill and died in August 1867.[63]

After Whistler's paintings were confused with those of Moore,[64] he decided to return to his Thames subject and approach it from his new aesthetic perspective. The poetic element began to assume increasing importance in his work at this time. In 1868 his mother, who had lived with him for four years, wrote to a friend to say that 'artists have inspirations as poets'.[65] Indeed, when he began to paint the Thames cloaked in mist and darkness Whistler appears to have had Baudelaire's 'Tableaux Parisiens' (1859) in mind, especially 'Le Crépuscule du Soir',[66] and Swinburne's 'Nocturne',[67] as he was later to paraphrase passages from both poems in his 'Ten O'Clock' lecture.[68] While Baudelaire portrayed the timeless beauty of dawn and dusk largely as a backdrop to modern urban life, Swinburne saw transitional times of day in more universal terms as metaphors for forgetfulness, life and death, the passage of time and the destiny of the soul. These allusions are inherent in Whistler's Nocturnes.

Whistler literally picked up where Turner had left off. Mr Greaves, the Chelsea boatman who died in 1871, entertained Whistler with stories about rowing Turner on the Thames (fig.5). Whistler hired his sons Walter and Henry to row him on the river at dawn and dusk so that he could memorise the landscape and put it on canvas back in the studio as Turner had done. Like Turner, he initially called these paintings 'moonlights' (no.1). Their subjects recall Turner's Venetian watercolours (figs.8, 9), and their mysterious blue-green palette Turner's Swiss watercolours (figs.6, 7). The thinness of Whistler's glazes replicates the translucency of watercolour washes that Turner used to capture transitory effects of light and atmosphere and to suggest reflections. Whistler applied paint so thinly that it ran off the canvas, and used the end of his brush to scrape out details.[69] Framed under glass like watercolours, they resemble views seen through a window, and invite contemplation.

It is tempting to read spiritual subtexts into these enigmatic paintings.[70] Whistler's mother saw God reflected in the creation: for her the night sky, dawn and dusk inspired meditation.[71]

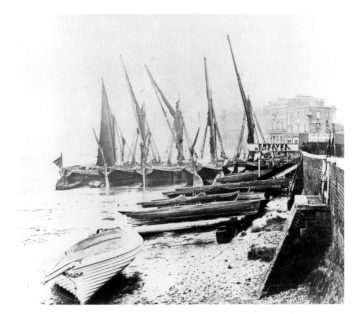

Fig.5 The Greaves boat business, photographed in 1872: the boats in the foreground are probably of the kind used to row Turner and Whistler
Photograph by J. Hedderly
The Royal Borough of Kensington and Chelsea

Whistler had memorised biblical passages as a child, regularly accompanied his mother to Chelsea Old Church, and later considered converting to Catholicism. In 1872 his mother described his beliefs as follows: 'his is natural religion; he thinks of God as the diffusive source of all he enjoys, in the glories of the firmament, in the loveliness of flowers, in the noble studies of the human form. The Creator of all!!!'[72] Given the discourse on the state of the environment (see pp.51–63, below), his beautiful depictions of the industrial landscape cloaked in mist or darkness may be read as hymns or requiems to nature.

Whistler probably crossed paths with Claude Monet for the first time sometime during 1865–7. Six years his junior, Monet followed in Whistler's footsteps through Gleyre's Academy into the Courbet circle. They had several friends in common, including Courbet, Manet and Fantin-Latour. In 1867 Fantin-Latour wrote to his British patrons, Mr and Mrs Edwin Edwards, to whom Whistler had introduced him, of his admiration for Monet. In spring 1870 Fantin-Latour included Monet in his group portrait *A Studio in the Batignolles* (Musée d'Orsay, Paris). In July 1870, following the outbreak of the Franco-Prussian war, Fantin-Latour wrote to the Edwards saying that he might be forced to seek refuge in England.[73] As it turned out it was Monet who did so, arriving in London that autumn. It is likely that he visited Whistler in Chelsea or saw him at the Edwardses' home at Sunbury-on-Thames.[74] This had been a popular destination for Whistler's friends and other visiting French artists through the 1860s, and the Edwardses would have been eager to hear news of Fantin-Latour and meet Monet.[75] About six weeks after Monet left England in May 1871, Fantin-Latour wrote to Edwards

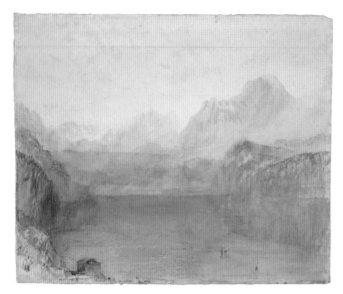

Fig.6 J.M.W. Turner, **Lake Lucerne: the Bay of Uri from Brunnen; Sample Study** c.1841–2 (no.57)

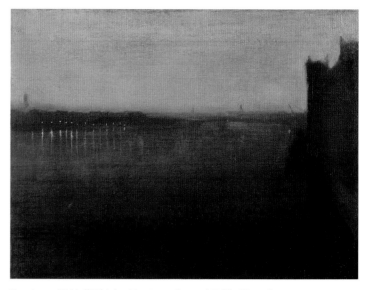

Fig.7 James McNeill Whistler, **Nocturne: Grey and Gold – Westminster Bridge** 1871–2 (no.45)

describing *A Studio in the Batignolles*[76] saying that it included a portrait of 'Monet, the painter, whom you know personally'.[77] The Edwardses agreed to buy the painting sight unseen.

Monet probably visited Whistler's studio in 1870–1 where he could have seen the first Nocturnes. They may also have looked at Whistler's Japanese prints together, for they were both enthusiastic *japonistes*. Whistler had discovered the 'decorative requirement' he found wanting in Turner in the art of Japan, and was busily applying the lessons learned to art and interior decoration. It does not appear to be a mere coincidence that Monet and Whistler used similar *japoniste* motifs in their views of the Thames and the Seine during the 1870s (nos.40, 46). Moreover, Monet appears to have adopted some of Whistler's revolutionary ideas about interior decoration, arranging asymmetrical 'flights' of Japanese fans across a monochromatic wall in his house at Argenteuil in the early 1870s, and emulating Whistler's decorative schemes in his later interior at Giverny.[78]

This visit to London provided Monet with his first opportunity to see the works of Turner (see p.38, below), which may help to explain the three foggy views he painted of the Thames (see nos.36, 37). They suggest, however, an even greater interest in and familiarity with Whistler's Thames paintings and etchings. Following his return to France in 1871 Monet moved to Argenteuil, where the Seine, the bridge with its wooden scaffolding, and the factory chimneys, recalled Whistler's Chelsea. Whistler's silhouette of industrial Battersea, sometimes framed by the arch of wooden bridges (no.31 and fig.45), finds an echo in Monet's views at Argenteuil (no.38).

At Argenteuil, as in Chelsea, the air and water quality continued to deteriorate as industrial development intensified.[79] Toxic and corrosive smoke issued from factory chimneys, and a high volume of sewage was pumped into the river a short distance upstream. By 1874 it was the cause of mounting concern; by 1878 the mayor deemed the pollution of the river 'complete'.[80] It is impossible to know whether environmental degradation had anything to do with Monet's move from Argenteuil to Vétheuil in 1878, after a brief period in Paris.[81] However, T.J. Clark has pointed out that Monet appears to have deliberately 'read out' the industrial elements of the Argenteuil landscape (no.40 and fig.47).[82]

Monet seems to have had both Turner's sunrises and sunsets and Whistler's Nocturnes in mind when he painted his view of the Seine at Le Havre, *Impression, Sunrise*, dated 1872–3 (no.39), which may explain the fact that one critic mistook it for a view of the Thames (see p.41). Dubbed 'impressionist' for its seeming 'lack of finish' when shown in the first exhibition organised by the Société anonyme des artistes peintres, sculpteurs, graveurs, etc. in 1874, this painting gave its name to the movement. Like Turner before them, Monet and Whistler were dogged by accusations of 'lack of finish' throughout the 1870s.

Whistler was identified on both sides of the Channel with the French school. From 1871 to 1873 he exhibited with the Society of French Artists at Durand-Ruel's London gallery, along with Manet, Monet, Degas, Pissarro and Renoir. In 1873, probably referring to Whistler's *Symphony in Grey: Early Morning, Thames* (1871, Freer Gallery of Art, Washington; YMSM 98), shown at the fifth (winter) exhibition of the Society of French Artists in 1872,[83] Ruskin declared that he had never seen 'anything so impudent on the walls of any exhibition, in any country, as last year in London.

It was a daub professing to be a "harmony in pink and white" (or some such nonsense); absolute rubbish, which had taken about a quarter of an hour to scrawl or daub – it had no pretence to be called painting. The price asked was two hundred and fifty guineas'.[84] In 1873 Whistler was invited by Degas to exhibit in the first Impressionist exhibition; however, like Manet he preferred to remain independent and focus on one-man shows. By 1878 Whistler was seen in Britain as carrying 'to the extreme the principles of the French impressionists'.[85]

In 1864 Rossetti had introduced Whistler to Frederick R. Leyland, the Liverpool shipping magnate and Pre-Raphaelite patron. Whistler became increasingly intimate with the family, and was soon competing with Rossetti and Burne-Jones for commissions. A self-made man whose greatest ambition was to learn to play the piano, Leyland decided to install a music room in his London house. When Burne-Jones and Rossetti heard this they began painting works with musical themes in the hope that Leyland would buy them.[86] It is more than likely that Whistler entertained the same ambition.

Whistler was raised in a musical family, and was used to listening to music played in the home. His knowledge of piano repertoire and musical theory was considerable.[87] When, in 1872, Leyland suggested that he employ the term 'nocturnes' in place of 'moonlights' as titles for his works, Whistler wholeheartedly embraced the suggestion saying 'it does so poetically say all I want to say and no more than I wish'.[88] By adopting musical titles for his works he was also able to effect the desired synthesis of art, poetry, and music. Although Leyland admired Whistler's Nocturnes, and said that a 'beautiful moonlit night' at Speke had reminded the family of *Nocturne: Blue and Gold – Old Battersea Bridge* 1872–7 (no.47), he did not purchase them. Whistler gave one to Leyland's wife, Frances, with whom he was becoming increasingly intimate; she treasured it for the rest of her life.

The relationship with Leyland was soon to take an abrupt downturn. In 1876, while Leyland was in Liverpool, Whistler began transforming his new dining-room at 49 Princes Gate in London into the nocturnal 'Peacock Room', dramatically exceeding the terms of his commission. In the spring of 1877 Whistler held open house without Leyland's permission and was overheard calling Leyland a 'parvenu'. Worse still, Whistler was by this time carrying on an affair with Leyland's wife in London, and gossip began to

circulate that she was planning to elope with him. Despite his own philandering, Leyland was outraged at this discovery. He not only refused to pay Whistler's bill, he also forbade his wife to see Whistler, and sent the artist a letter threatening to 'publicly horsewhip' him if he was ever found in her company again.[89]

This drama coincided with the opening of the new Grosvenor Gallery in London on 1 May 1877, which was the talk of the town.[90] Ruskin did not attend the opening, as he was travelling in Italy. Suffering from depression,[91] he looked forward to seeing, upon his return, a group of Turner watercolours purchased on his behalf. He hoped that they would reignite his old enthusiasm for Turner and inspire both a biography and a lecture series on the artist at Oxford.[92] However, the watercolours proved a disappointment, and he was plunged once again into a 'melancholy' state. It fell to Edward and Georgiana Burne-Jones, who were like children to him,[93] to cheer him up over dinner on 19 June. Ruskin must have been eager to hear the latest news of the London art world, and no doubt the Burne-Joneses gave him their impressions of the Grosvenor Gallery exhibition and recounted the colourful tale of the Peacock Room. Given Burne-Jones's longstanding friendship with Leyland and his desire to settle his old score with Whistler, it can be safely assumed that Whistler's exhibits and activities would have been portrayed in a most unsympathetic light.

After visiting the Grosvenor Gallery on 23 June, Ruskin dined once again with the Burne-Joneses. They would have discussed Burne-Jones's *Seven Days of Creation*, which Ruskin greatly admired, and Whistler's Nocturnes, which he abhorred. Four days later, on 27 June, Ruskin's counterpart, Sidney Colvin, Slade Professor of Fine Art at Cambridge, published his review of the exhibition. Colvin acknowledged the beauty of Whistler's work and its truth to nature, commenting on 'the silvery mystery of the night, the subtly varied monotony of the great glimmering river surface, the soft profundity of the sky, and the indefinable atmosphere above the houses, half duskiness, half glare, which is the effluence of the city's life'.[94] Although Whistler saw the nocturnal industrial landscape and its 'effluence'[95] as a thing of beauty, Ruskin did not. He believed not only that 'the pollution which hung over London' had 'blotted out traditional English sunsets', but also that 'physical gloom "mirrors the moral gloom" of society'.[96] Having turned a blind eye to Turner's industrial subjects, Ruskin was now confronted with Whistler's.

The self-appointed judge of those who copied or worked in the manner of Turner, Ruskin was in the habit of writing to artists to tell them what he thought. In 1874 he had written to congratulate Seymour Haden on his outstanding ability to interpret the artist in etching.[97] When Berthe Morisot visited London in 1875 she wrote, after visiting the National Gallery, 'I saw many Turners (Whistler, whom we liked so much, imitates him a great deal)'.[98] When Ruskin looked at Whistler's Nocturnes he would immediately have made the connection with Turner. He must have been outraged to see Whistler appropriating Turner's subject matter and employing Turnerian effects to beautify the industrial landscape across the Thames from the house where Turner spent his last years. He would have seen what Colvin called 'effluence' as symptomatic not only of a 'fallen world', but of Whistler's moral degeneracy. This would have been underscored by Whistler's depiction of that notorious venue of nocturnal assignations, Cremorne Gardens, in *Nocturne in Black and Gold: The Falling Rocket* 1875 (no.50). Ruskin would have realised its debt to Turner's late Venetian watercolours and to his fiery nocturnal masterpiece *The Burning of the Houses of Lords and Commons* (no.78). He found Whistler's work intolerable.

Ruskin's review which appeared in *Fors Clavigera* on 2 July 1877 echoed his 1872 criticism of Whistler. Clearly intending to compare them, he called Burne-Jones's works 'immortal', and condemned Whistler's in the same passage. Of Whistler he wrote: 'I have seen and heard much of Cockney impudence before now; but never expected to hear a coxcomb ask two hundred guineas for flinging a pot of paint in the public's face.'[99] As if privy to Whistler's insults to Leyland, he attacked Whistler's social status by calling him a 'Cockney', and his dandy affectations by calling him a 'coxcomb'. Both words incorporate lewd references to the male sexual organ, an etymology not lost on Ruskin.[100] While the image of flinging a pot of paint echoed the criticisms allegedly hurled at Turner, of painting with 'soapsuds and whitewash',[101] or throwing handfuls of 'white, and blue, and red at the canvas, letting what chanced to stick, stick',[102] in this context it appears to be loaded with sexual innuendo. Whistler's reputation was placed in jeopardy and his market undermined. He decided to sue Ruskin for libel.

Whistler relished the prospect of confronting Ruskin in court, but he was not to have this satisfaction. Ruskin's doctors declared

him unfit to appear, and Burne-Jones volunteered to appear in his place. This provided Burne-Jones with a perfect opportunity to settle his score with Whistler while, at the same time, promoting his own ideas about art. In the months leading up to the trial Burne-Jones curried favour with Leyland, and was overheard making 'dismissive remarks' about Whistler at a dinner party in the Peacock Room.[103]

Despite his struggle with mental illness, Ruskin managed to organise two exhibitions for the Fine Art Society which opened in March 1878. One contained over a hundred of his Turner watercolours, accompanied by 'Turner Notes', in which he lamented that, among other modern subjects, 'the Manufactory must, in days to come, be the object[s] of [England's] artists' worship'.[104] He staked his claim to being Turner's true artistic heir in a companion exhibition of his own watercolours accompanied by 'a little autobiography' of 'His own Handiwork Illustrative of Turner'.[105]

Whistler's witnesses, Albert Moore and Algernon Graves, told his lawyer, Anderson Rose, that the defence should focus on the relationship of Whistler's Nocturnes to the late works of Turner,[106] a strategy that must have received Whistler's approval.[107] Moore was a credible source of information. He had been party to Whistler's search for a new subject, frequently accompanied Whistler on his night-time boat trips, and witnessed the gestation of the Nocturnes. Although Graves told Whistler's biographers, the Pennells, following the artist's death, that 'Whistler always reviled Turner',[108] this remark must be interpreted in light of Whistler's fights with Haden and Ruskin, his vehement rejection of any suggestion of 'influence', and his desire to rewrite his own history.

Moore pointed out in his interview with Rose that Ruskin believed in the superiority of Turner's late over his early works, and that Turner had been accused of painting with 'soapsuds and whitewash'.[109] Based on the input of Whistler, Moore, and Graves, Rose built his case. The closing argument drafted by Rose for Serjeant Parry, who appeared for the plaintiff in court, began as follows:

> It has been attempted to hold up Mr. Whistler's pictures as absurdities, and to fasten on him the contemptuous epithet of 'eccentric'. Now it is well known that the idol of Mr. Ruskin's worship is Turner, many of whose pictures are

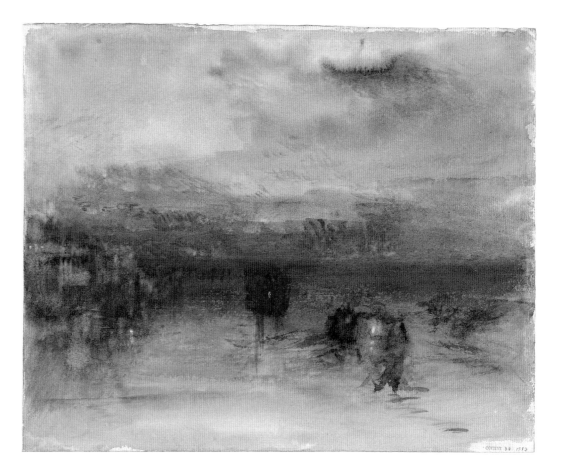

Fig.8 J.M.W. Turner, **Venice: Moonlight on the Lagoon** 1840 (no.16)

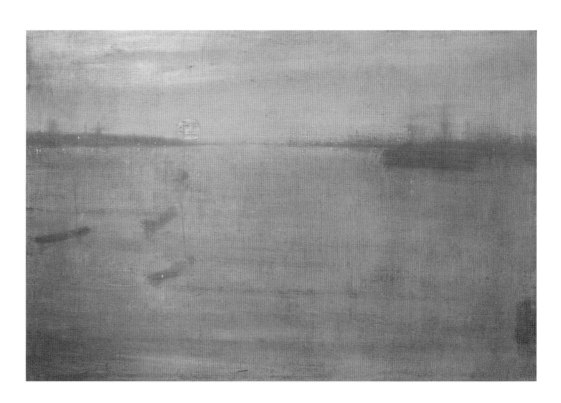

Fig.9 James McNeill Whistler, **Nocturne: Blue and Gold, Southampton Water** 1872 (no.44)

25

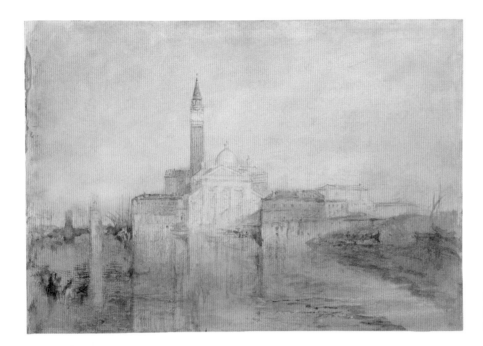

Fig.10 J.M.W. Turner, **Venice; San Giorgio Maggiore, possibly from the Hotel Europa** 1840 (no.101)

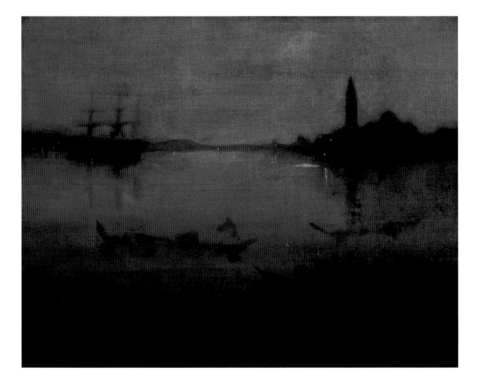

Fig.11 James McNeill Whistler, **Nocturne in Blue and Silver: The Lagoon, Venice** 1879–80 (no.105)

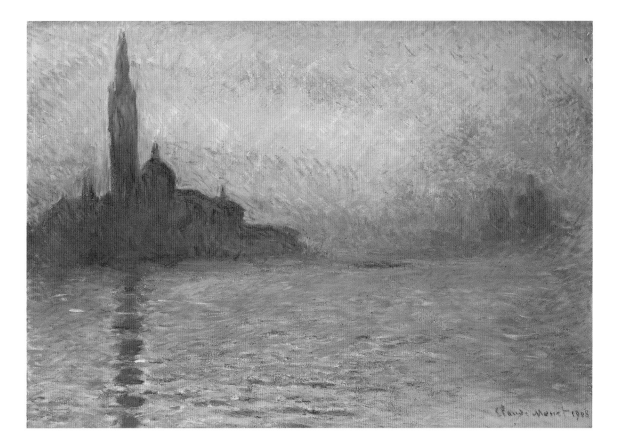

Fig.12 Claude Monet, **San Giorgio Maggiore at Dusk** 1908 (no.106)

almost incomprehensible to the general public, and who is looked upon by the artist and critics of the Continent, as more than eccentric, almost as insane. Nevertheless Turner is undoubtedly a great artist, only he does not please those who are not familiar with his manner of painting, and to many people who cannot appreciate his technical merits, some of his pictures appear nothing more than a meaningless confusion of colour. Mr. Ruskin has presented to the Fitzwilliam Museum at Cambridge, 20 of Turner's watercolours which he looks upon as priceless treasures. Many of these were puzzles in which no subject can be distinguished. Yet to many art lovers these sketches afford the greatest delight.[110]

Ruskin's witnesses, Edward Burne-Jones and Francis Frith, avoided all reference to Turner, which they undoubtedly realised would weaken Ruskin's case. Burne-Jones, who believed that French Impressionism, left unchecked, would undermine the British School, focused on the issue of 'finish'. Maintaining that the Nocturnes were 'incomplete', he said that 'the danger of the plaintiff's want of finish is that men who come afterward will perform mere mechanical work without the excellencies of colour and unrivalled power of representing atmosphere which are displayed by the plaintiff, and so the art of the country will sink down to mere mechanical whitewashing'.[111] While

Burne-Jones only made this veiled reference to Turner, Frith fell headlong into the Turner trap that had been set for him. When asked if he knew that Turner's *Snow Storm – Steam-Boat off a Harbour's Mouth* 1842 (Tate, London; B&J 398) had been 'described as a mass of soapsuds and whitewash', he said that he did not. When asked, 'would you call it a mass of soapsuds and white-wash?' he said: 'I think I very likely should. When I say that Turner should be the idol of painters, I refer to his earlier works and not to the period when he was half crazy and produced works about as insane as the people who admire them.'[112] Everyone in the court room was astonished. Parry was thrown off course and did not have a chance to deliver his argument.[113]

This unleashed a debate on the subject of finish. When asked by Rose if he was familiar with Ruskin's statement in *Modern Painters* that 'The imperative demand for finish is ruinous . . . because it refuses better things than finish', Burne-Jones denied all knowledge of it.[114] Moore set this into a larger context by pointing out that the 'chief difference between the English and Continental nations is the degree of finish'. After listening to both sides, the judge concluded that Ruskin's criticism of Whistler was 'almost exclusively in the nature of a personal attack . . . calculated to injure the artist . . . for the purpose of holding him up to ridicule and contempt'. He also made a point of saying that '"cockney" means something dirty and disagreeable'. Although

Whistler was awarded only a farthing in damages, he won the right for artists to determine when their work was finished. This landmark case was eagerly followed by the press in Britain, Europe and America, spreading Whistler's name around the globe.

The professional and emotional fallout from the case overshadowed Whistler and Ruskin for the rest of their lives. Whistler's Nocturnes, brought into court upside-down (see also no.21), and lampooned by the press as 'coal-holes', were unsaleable, and his 'series' came to an abrupt end. Burne-Jones succeeded in supplanting Whistler in Leyland's stable. After losing the case for Ruskin, he dreamt of 'fighting a duel' with Whistler 'on the sands of Calais' to ensure that Impressionism stayed on the other side of the Channel.[115] Just as Turner's death inspired Ruskin's mission, Ruskin's loss inspired Whistler's mission: he would become the leading protagonist for French Impressionism in Britain, and do everything possible to ensure that British artists and the British public were exposed to it.

The Fine Art Society rushed to the aid of both plaintiff and defendant, raising money to cover Ruskin's legal costs, and helping Whistler financially by commissioning him to go to Venice to make a series of etchings. This gave Whistler an opportunity to challenge Turner and Ruskin in another venue. Their names were synonymous with Venice: Turner's through his paintings and watercolours, and Ruskin through his writings.[116] In 1851 Ruskin had published the first part of his widely read classic, *The Stones of Venice,* alerting the world to the fact that Venice was being swallowed up by the sea.

In Venice Whistler made his own variations on Turnerian themes. His painted and etched Nocturnes of San Giorgio Maggiore recall Turner's watercolours of the church 'floating' on the Lagoon (nos.100–1). They also recall Ruskin's eloquent description of Venice: 'a ghost upon the sands of the sea, so weak – so quiet – so bereft of all but her loveliness, that we might well doubt, as we watched her faint reflections in the mirage of the lagoon, which was the city, and which the Shadow'.[117] By transposing the Nocturne concept to copper, and hybridising the watercolour and etching technique, Whistler created two etchings, *Nocturne: Palaces* and *Nocturne* (nos.84–6, 102–4), in which he transformed the time of day and atmospheric effects by wiping different amounts of ink over the surface of the copper plate. These innovative prints may have been inspired by Turner's

serial watercolours, such as the views of Lake Brunnen (nos.54–9), in which the artist depicted the same subject at different times of day and under different atmospheric conditions. Whistler's etchings recall Turner's pencil sketches (nos.96, 97), and his pastels Turner's watercolours (nos.16, 95). In addition to making his own variations on Turnerian themes, Whistler inaugurated themes of his own, among them the frontal close-ups of palace facades (no.87) on which Monet would later make variations (see p.206, below).

Whistler's Venice etchings and pastels were hung in the galleries at the Fine Art Society where Ruskin's 1878 exhibitions had hung, a delicious irony. Although the pastels proved popular, the response to the etchings was mixed. Whistler had minimised the amount of detail on his copper plates, and they were attacked for 'lack of finish', one critic writing, 'it is this deliberate incompleteness, this purposed vagueness and want of finish that persistently puzzle and irritate us'.[118] Moreover, he had once again sought beauty in a modern urban subject. To another critic his prints revealed the state of pollution in Venice which accelerated with the *Risorgimento* (see p.62, below)[119]: 'It does not represent any Venice we much care to remember: for who wants to remember the degradation of what has been noble, and the foulness of what has been fair?'[120]

The Impressionists followed Whistler's battles with concern and sympathy from the other side of the Channel. In 1882 Pissarro wrote to his son Lucien criticising Ruskin for denigrating Whistler, which he called 'serious, very serious, for this American artist is a great artist, and the only one that America can truly glorify with this title'.[121] He advised Lucien to study Whistler's Venice etchings: 'the suppleness you find in them, the pithiness and delicacy which charm you derive from the inking which is done by Whistler himself.'[122]

Their concern may have been fuelled by a certain amount of self-interest: the Impressionists were keen to break into the lucrative London art market. In 1882 they pleaded unsuccessfully for a show at the Grosvenor Gallery. No doubt hoping to strengthen their chances, they openly acknowledged their debt to Turner (see pp.42, 44, below). The English were quick to take them up on this: when Monet showed at Dowdeswell's in London in 1883 Frederick Wedmore pointed out, for the benefit of British audiences, that 'Turner anticipated Monet' (see no.22).[123]

In the wake of the court case, young artists flocked to Whistler from different parts of the world, wanting to become his pupils and followers. They were conscripted into his 'holy war' against the 'enemy'. To their chagrin, increasing amounts of Whistler's time and energy were devoted to writing mock-heroic diatribes designed to embarrass Ruskin and garner as much publicity as possible.[124] Whistler began to play a leadership role in art societies, beginning with the New English Art Club, using his position to promote a knowledge and understanding of French Impressionism. The young members 'devoted themselves to the discovery of the "painter's poetry"' in the life about them,[125] and demonstrated their enthusiasm for Monet by 'making innumerable studies of rapid effects'.[126] Whistler dispatched his most talented pupil, Walter Sickert, to Paris in 1883 to study under Degas and to meet Monet and the other Impressionists.

As Impressionism increased in popularity, Whistler must have taken enormous pleasure in the discomfort of Ruskin and Burne-Jones. By 1884 Ruskin feared that the British schools were in danger of losing their national character in their attempts to respond to foreign schools.[127] Georgiana Burne-Jones reported that her husband was initially 'incredulous' that the concept of lack of finish could be taken seriously by anyone, and that as 'what is called the "Impressionist" school gained ground it was one of the most disheartening thoughts of his life'.[128]

In 1885 Whistler decided that it was time to make a personal statement about his work. He did so in the form of the 'Ten O'Clock' lecture, a work of 'performance art' in its own right. An apologia for aestheticism in general, and the Nocturnes in particular, it was shot through with references to those whose writings had been central to his development, including Shelley, Leslie, Ruskin, Swinburne and Baudelaire. The most memorable passage paraphrased a verse of Baudelaire's 'Le Crépuscule du Soir',[129] which the poet reworked in prose in 'The Painter of Modern Life'. Published in 1863, this essay was a central text for the Impressionists:[130]

And when the evening mist clothes the riverside with poetry, as with a veil, and the poor buildings lose themselves in the dim sky, and the tall chimneys become campanili,[131] and the warehouses are palaces in the night, and the whole city hangs in the heavens, and fairy-land is before us – then the wayfarer

hastens home; the working man and the cultured one, the wise man and the one of pleasure, cease to understand, as they have ceased to see, and Nature, who for once, has sung in tune, sings her exquisite song to the artist alone, her son and her master – her son in that he loves her, her master in that he knows her.[132]

In the 'Ten O'Clock' lecture Whistler stated his belief that the vision and role of the artist was 'to seek and find the beautiful in all conditions and in all times'.[133] He employed a musical metaphor by way of explanation:

nature contains the elements, in colour and form, of all pictures, as the keyboard contains the notes of all music. But the artist is born to pick, and choose, and group with science, these elements, that the result may be beautiful – as the musician gathers his notes and forms his chords, until he bring forth from chaos glorious harmony.[134]

Hitherto fiercely independent, Whistler now set out to link his name publicly with that of Monet. The tone of their correspondence indicates a warm and deepening friendship. In March 1887 Monet, who was on the jury of the International Society, proposed that Whistler be invited to submit fifty oils, watercolours and pastels to the Exposition Internationale Annuelle de Peinture et Sculpture (Annual International Exhibition of Painting and Sculpture). The proposal received unanimous support. Monet subsequently wrote to Duret to say, 'The announcement which I made about the acceptance of Whistler has had the best reception. Everyone is delighted.'[135] The exhibition took place in May–June at the Georges Petit Gallery in Paris.

In 1886 Whistler had been offered the presidency of the Society of British Artists in the hope that he could rejuvenate the moribund organisation. Under his leadership it quickly began to rival the Grosvenor Gallery. The 1887 Spring Exhibition, which included a number of British 'Impressionists', received excellent reviews. Monet came to London to see the exhibition and stayed with Whistler for about twelve days. The success of this visit can be gauged from Monet's letter to Théodore Duret, in which he said that he was 'very impressed by London and also by Whistler, who is a great artist', adding, 'he could not have been more charming to me'.[136] Whistler invited Monet to exhibit at the

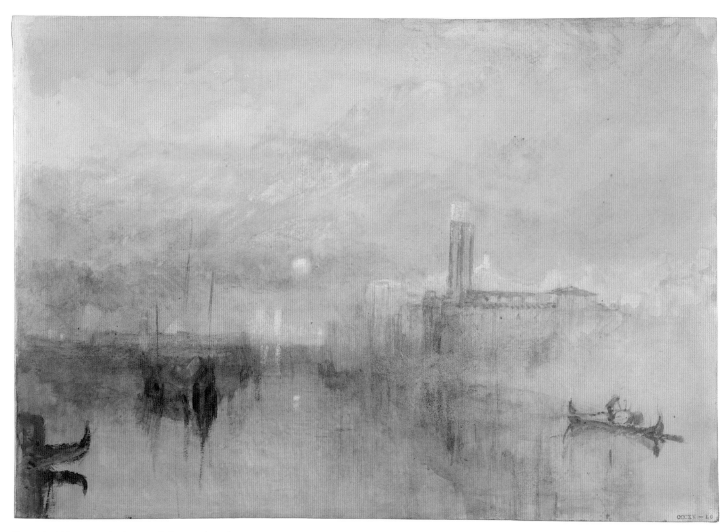

Fig.13 J.M.W. Turner, **Venice by Moonlight** 1840 (no.17)

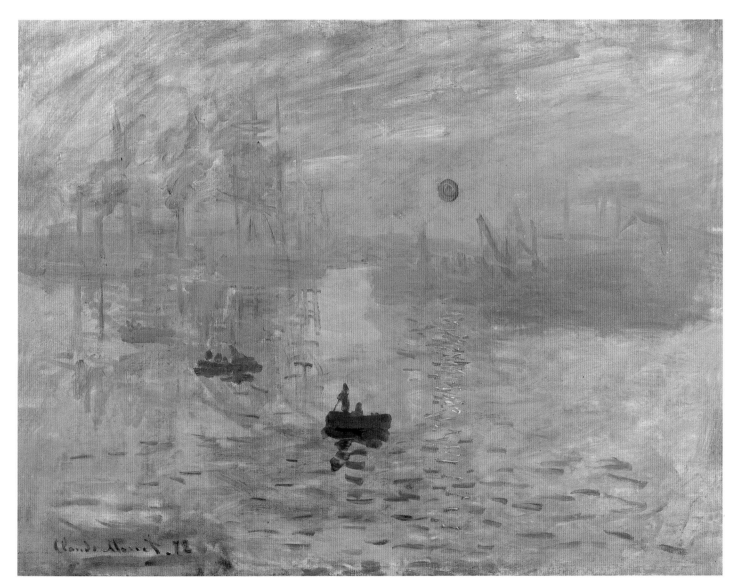

Fig.14 Claude Monet, **Impression, Sunrise** 1872–3 (no.39)

Winter Exhibition expressing, at the same time, interest in exhibiting with him the following year in Paris.[137] Monet replied that he would be very happy to exhibit in London, especially in Whistler's company, but was concerned about the possible consequences: 'do I have the right to show with you since your society only includes British artists, and are you not afraid that by showing me you will cause problems for yourself ?'[138] He wrote to Duret saying that he hoped that the committee would 'not be too frightened by my painting. As for me, I anxiously await their response'.[139] Monet added that he was looking forward to coming to London to see the exhibition, and to planning their joint exhibition in Paris which he predicted would be 'superbe'.[140] He arrived in London around 20 or 25 November.

The exhibition raised Monet's visibility in London and played an important role in his subsequent international recognition. He was hailed by the *Magazine of Art* as 'the acknowledged chief' of the French Impressionist school: 'for strength and brilliancy of general tone, and for mere decorative effect, [his paintings] have few, if any, rivals.'[141] The space assigned to Monet's paintings, and the glowing reviews that they received, no doubt raised the hackles of the Society's members. Although Monet exhibited under the title of 'Honorary Member', Whistler intended to put him forward for membership.[142] There were, however, serious objections to the admission of a French artist, and Whistler's unsuccessful attempt contributed to his expulsion from the presidency. A contemporary jingle, 'The Sufferings of Suffolk Street', tells the tale:

> But no sooner was he seated in the Presidential chair
> Than he changed our exultation into wailings of despair
> For he broke up our traditions and went in for foreign schools
> Turning out the work we're noted for, and making us
> look fools.[143]

During Monet's November visit, Whistler and Monet planned an exhibition to take place at Paul Durand-Ruel's in Paris in 1888. When Monet cancelled after a falling-out with the dealer, he wrote to apologise to Whistler, saying that he would like to exhibit with him in London the following season. They continued to look for opportunities to get together in Paris or London. On one occasion, after their efforts had been frustrated, Monet wrote, 'that's too bad because you know what pleasure it gives me to see you'.[144]

Realising that Stéphane Mallarmé would recognise the kinship of Whistler's ideas to his own, Monet brought them together over lunch in 1888 (see p.163, below). The meeting proved a great success, and Mallarmé offered to translate Whistler's 'Ten O'Clock' lecture into French. They became close friends while working on the project. Mallarmé wrote to Whistler saying, 'I sympathise completely with your vision of Art', and would be 'very happy to put my name below yours'.[145] Mallarmé's French translation contributed to the spread of Whistler's ideas and gave birth to a liaison between Whistler, Monet, and Mallarmé. They shared ideas, promoted each other's interests on opposite sides of the Channel and celebrated each other's successes. Monet and Mallarmé assisted Whistler in securing the recognition in France which had eluded him in England, and congratulated him when he was awarded the Légion d'honneur in 1889. Monet wrote: 'Bravo, you have finally received a well-deserved award. I congratulate you sincerely and with all my heart';[146] Mallarmé urged him to move to Paris.[147]

In November 1891 Mallarmé and Duret persuaded the French state to purchase Whistler's *Arrangement in Grey and Black: Portrait of the Painter's Mother* of 1871 for the Musée du Luxembourg (Musée d'Orsay; YMSM 101), and in January 1892 Whistler was promoted to Officer of the Légion d'honneur. Monet made a quick trip to London in December 1891 to see his paintings on display in the New English Art Club and to celebrate Whistler's double victory at the newly opened Chelsea Arts Club. Whistler put him up at the Club and introduced Monet to young Chelsea artists, who expressed a great deal of interest in his work.[148]

Recognition in France facilitated recognition in Britain. The Goupil Gallery held a Whistler retrospective in London in 1892 entitled *Nocturnes, Marines, and Chevalet Pieces*: it was a huge critical success. The following year the British press noted that Impressionist ideas had arrived in Britain, and 'permeated, where they did not overwhelm, the painting of the younger generation'.[149] Whistler could now consider his mission accomplished. At the urging of Mallarmé, he decided to move to Paris with his wife Beatrice (whom he had married in 1888, by which time she was calling herself Beatrix), to a house on the Left Bank not far from the Louvre. He wrote to a friend: 'I have really earned my Paris! I mean that if I had come away before absolutely completing my long fight of many weary years over there, I should not

feel that I had a right to the peace and recognition that awaited me here.'[150]

In 1889 Monet's work had begun to undergo a fundamental change: he began to paint in series, making variations on a single theme, seeking to capture the moment by painting the same subject under different atmospheric and lighting conditions. This practice was anticipated in Turner's serial watercolours (nos.54–9) and Whistler's Venice Nocturne etchings (nos.84–6, 102–4). While French critics quite rightly pointed out that Monet's series *Mornings on the Seine* (nos.60–2) owes a debt to Claude and Corot, they restricted their frame of reference to the French tradition.[151] It also appears to 'reference' Whistler's Thames Nocturnes and their antecedents, Turner's Swiss watercolours. Just as Turner had set out to rival Claude, Monet set out to rival both Turner and Claude. In this series he sought to supersede Claude and Corot in France and Turner and Whistler in England.

Monet's series reflects his kinship with Mallarmé's ideas. Like Whistler, Monet only acknowledged painting effects. However, these paintings are visual analogues to Mallarmé's layered metaphors. The interest in reflections inaugurated by Turner and taken up by Whistler draws attention to the nature of the real and the imaginary. The landscape subject is encoded with associations: the river with life, the Seine with France, and Giverny with Utopia.

After a happy domestic interlude in Paris, Beatrice fell ill with cancer. In January 1896 Whistler brought her back to London for medical attention. They moved into a sixth-floor corner room in the prestigious Savoy Hotel on the Victoria Embankment overlooking the Thames (see p.179, below). Here he made a series of lithographs of views from the window: Waterloo Bridge, Charing Cross Bridge, the Houses of Parliament, and the industrial South Bank (nos.64–9). Like Mallarmé's poems, they are more suggestive than descriptive and have the quality of things remembered rather than things seen.[152]

Beatrice died on 10 May. On 18 May Monet wrote to say, 'may the tribute of an old friend be at least a feeble source of consolation for you . . . you know beyond the admiration I bear for you, how much I love you'. It was signed 'with all my heart, Monet'.[153] Devastated, Whistler began to divide his time between London and Paris. He threw himself back into his old battles, and attacked Ruskin indirectly through Turner. When, on a visit to the National

Gallery, one of Whistler's pupils thought that 'Turner's work must be touching him', Whistler flatly denied it, saying: 'It is too prismatic. There is no reserve. Moreover, it is not the work of the man who knows his trade. Turner was struggling with the wrong medium. He ought not to have painted. He should have written.'[154]

Ruskin had written of Turner's *Decline of the Carthaginian Empire* (1817, Tate, London: B&J 135) (his pendant to *Dido Building Carthage*, fig.15): 'this picture was painted as the sequel to that in Trafalgar-square which is far the finer of the two.'[155] Whistler, however, delighted in pointing out the *inferiority* of Turner's *Dido*, 'so amazingly demonstrated in Trafalgar Square where Turner had invited the comparison disastrous to him'.[156] In their *Journal,* the Pennells reconstructed Whistler's remarks on a visit to the National Gallery in 1896, made as he stood before Turner's *Dido* and Claude's *Seaport with the Embarkation of the Queen of Sheba* (fig.16):

> Turner painted the sun, a great big circle, low down right in the middle of the picture, and if it was there he could not have seen anything else or even have looked at it. And yet the picture was filled with detail from end to end instead of light, all for the benefit of the Islanders [the British]; in fact, you could not have seen anything at all, the sun would have blinded you. Claude, knowing this, veiled his sun in the same place with a thin cloud which enabled you to see the sunset without being blinded. And yet neither Turner nor Ruskin had the sense to see that the earlier artist solved the problem where they only made a mess, the one in his painting, the other in his writing.[157]

In their *Life,* the Pennells embroidered this passage:

> Well, you know, you only have to look. Claude is the artist who knows there is no painting the sun itself, and so he choses the moment after the sun has set, or has hid behind a cloud, and its light fills the sky, the light he suggests as no other painter ever could. But Turner must paint nothing less than the sun – and he sticks on a blob of paint – let us be thankful that it isn't a red wafer as in some of his other pictures – and there isn't any illusion whatever, and the Englishman lifts up his head in ecstatic conceit with the English painter, who alone has dared to do what no artist would ever be fool enough to attempt.[158]

Fig.15 J.M.W. Turner, **Dido Building Carthage; or, the Rise of the Carthaginian Empire** 1815
Oil on canvas 155.6 × 321.8 cm
B&J 131
National Gallery, London

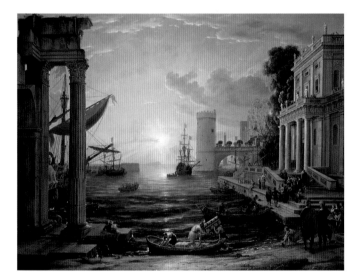

Fig.16 Claude Lorrain,
Seaport with the Embarkation of the Queen of Sheba 1648
Oil on canvas 148 × 194 cm
National Gallery, London

This is, in fact, the *only* one of Turner's paintings that Whistler is ever known to have criticised, and he was not alone. When it was first shown at the Royal Academy in 1815, it was felt that the yellow in the sky was too predominant, and Turner repainted it.[159] In 1853 H.A.J. Munro told the Select Committee that 'the sky does not look to me as I generally see the skies of Turner in his other pictures'.[160] Before the canvas was relined and varnished in 1860 much of the sky had cracked, lifted, flaked, or been rubbed away.[161] Little of the upper paint layers appear to have survived, and the sky that Whistler criticised was certainly not the sky that Turner modified.[162] Significantly, Whistler is not known to have commented on *Sun Rising through Vapour* (no.2), which was in its

original condition, and hung in the same room with the Claudes. Given both its subject and its concern with atmospheric effects, this painting must have greatly interested him.

In 1898 Whistler became President of the International Society of Sculptors, Painters, and Gravers. He declared that the New English Art Club 'was only a raft'; the International, by comparison, was 'a fighting ship of which he as captain had taken command'.[163] In this position he was responsible for organising exhibitions of the finest international art. The first included works by the Impressionists, among them those of Monet.

Monet knew and admired Whistler's Nocturnes for 'their uncanny power to evoke the mystery of early evening light on

the Thames'.[164] It is possible that he learnt of Whistler's decision to abandon the subject when the latter passed through Paris en route to Venice in 1879, for it was in 1880 that Monet first stated his desire to return to London to paint the Thames.[165] It was not, however, until 1899 that he realised his ambition (see p.179). Monet's Thames series can best be understood within an international reading of 'Impressionism', and his ongoing dialogue with the works of Turner and Whistler. In them, Monet 'references' the two artists whose names had become, successively, synonymous with the Thames. He looked at the works of Turner with renewed interest on his visits,[166] and no doubt saw Whistler on his second campaign. Robin Spencer has discovered 'some evidence to suggest that Whistler may have been involved in Monet's project by keeping him informed of changes in the weather'.[167]

In 1899 Monet, like Whistler, took a sixth-floor room in the Savoy Hotel overlooking the river, returning to the hotel in the winters of 1900 and 1901. He painted many variations on the themes of Charing Cross Bridge, Waterloo Bridge and the Houses of Parliament at different times of day and under different atmospheric and lighting conditions. By that time air pollution had reached unprecedented levels and was capable of creating nocturnal effects at midday (see nos.73, 77). Despite its deleterious effect on his lungs, Monet loved the toxic London smog with its extraordinary visual effects. He found it impossible to capture more than fleeting atmospheric effects on the spot and decided to finish his London paintings at Giverny, working from memory as Turner and Whistler had done (see no.20). He was still finishing them when Whistler died on 17 July 1903, in the studio of the house he rented at 74 Cheyne Walk, not far from the house where Turner had died. Monet's London series can be seen on one level as a tribute to their personal friendship and artistic liaison. Although Monet was not able to arrange a showing in London, the paintings were exhibited in Paris to great acclaim the following year.

Monet went to Venice for the first time in the autumn of 1908 (see p.203). Afraid of disappointment, he had put off the trip until he thought he was going blind and would soon have to stop work. Once again he worked in series, some based on themes originated by Turner and taken up by Whistler, such as San Giorgio Maggiore 'floating' on the Lagoon (no.106), and others introduced by Whistler, such as frontal close-up views of palazzo facades (nos.88–90). Monet's Venetian 'impressions' may reflect the physiological idiosyncrasies of the artist's failing sight: the forms are simplified and run together, increasing their visual impact. These beautiful and poetic works are portals through which the viewer can enter a world of memories, reveries and dreams. Fearing that they might constitute the final chapter in his artistic evolution, Monet sounded in them the last notes of the artistic dialogue with Turner and Whistler that had been central to his artistic development.

Monet and his wife Alice frequently went on evening gondola rides to watch the 'splendid sunsets' which were said to be 'unique in the world'.[168] In 1900 the poet Gabriele D'Annunzio had described one: 'the heavens were illuminated by a red glare as of a conflagration. An almost terrible joy seemed spreading over the Sea-City . . . the signal of the conflagration in which the beauty of Venice was finally to stand resplendent.'[169] These sunsets inspired first Turner, then Whistler, and finally Monet. In Venice Monet must have felt their presence in spirit: one senses that in his spectacular San Giorgio Maggiore at Dusk he was bidding them both farewell (figs.10–12).

Tinted steam: Turner and Impressionism [1]

John House

Neither Monet nor Whistler could ignore Turner. For painters in the later nineteenth century he stood as a prime example of artistic independence, and his later paintings offered a challenge to which they had to respond. Yet both artists had reasons for wanting to resist Turner's influence – or at least for declaring their own independence from him. For Whistler, these reasons were in part personal. Turner was a prime focus for the admiration of his brother-in-law Seymour Haden, with whom Whistler spectacularly quarrelled in 1867, and, of course, for Ruskin, Whistler's opponent in the celebrated libel case of 1878 (see pp.24–8, above). For Monet, the issue may have been more one of artistic nationalism. As the Impressionists established their reputations in the 1890s they sought to define the artistic lineage to which they belonged, and an insistence on their essential Frenchness became an important issue. They also, certainly, had artistic reasons for their reservations about Turner; in significant ways, as we shall see, Turner's example led in very different directions from their own aims, especially in the early years of Impressionism. Yet Turner's reputation and his art, as they came to know it, were inescapable points of reference for them as they explored the possibilities of a form of landscape painting defined primarily in terms of colour. At the same time, an extended artistic dialogue developed between Monet and Whistler that was in significant ways inflected by their interest in Turner.

For the artists of Monet's and Whistler's generation who rejected the precepts and authority of the Academy, it was a fundamental tenet that each artist should explore his or her own personal vision and develop an individual, personal manner of painting – a recognisable 'signature style'. Within this framework, the notion of artistic influence was problematic, since it might suggest some lack of individuality or a sacrifice of the artist's personal identity in the face of a more powerful predecessor or mentor. Here, the example of Turner was significant. It was widely recognised by French writers that, in his earlier work, he had explicitly used as his starting point landscapes by seventeenth-century masters – notably, of course, Claude Lorrain. Yet it was through his studies of past art that he had developed the very distinctive personal manner of his later career. [2] However, for Whistler's and Monet's generation, such relationships with the work of other artists were more problematic. In 1867, Whistler wrote to Henri Fantin-Latour repudiating the influence

of his former mentor, Courbet, and indeed denying that any such influence had taken place. [3] In 1868 Monet wrote from the coastal village of Etretat to Frédéric Bazille: 'One is too preoccupied by what one sees and hears in Paris, however strong one is, and what I shall paint here will at least have the merit of not resembling anyone else, or at least I think so, because it will simply be the expression of what I myself have personally experienced.' [4]

In this context, influence became a matter of anxiety. A past exemplar was something to match oneself against and something with which to compete, as Turner did in insisting on juxtaposing his works with Claude's in the National Gallery; but it was also something to use as a point of reference in order to establish one's own otherness, one's distinct individuality. As Harold Bloom phrased it in *The Anxiety of Influence: A Theory of Poetry*, 'Poetic history, in this book's argument, is held to be indistinguishable from poetic influence, since strong poets make that history by misreading one another, so as to clear imaginative space for themselves.' [5] To use Griselda Pollock's formulation, making 'reference' to a mentor within this pattern of thinking was a matter of 'difference', not 'deference'. [6] Viewed from this perspective, after Monet had first encountered his work Turner was one of his reference points for the rest of his career. But Turner's presence in his work cannot be gauged simply by visual similarities: his paintings offered a challenge to which Monet had to make his own distinctive replies.

Monet and Camille Pissarro first saw Turner's art in London in 1870–1, while they were taking refuge there from the Franco-Prussian War. Before then they would have known him only at second-hand; none of his works was exhibited in Paris before 1874. [7] We do not know what texts, if any, they may have read that discussed Turner; but we can assume that the outlines of his reputation would have been known to them before they arrived in London. A view of Turner that was widespread in France was voiced by another French visitor to London in 1871, Hippolyte Taine:

his painting degenerated into lunacy. [His late works] compose an extraordinary jumble, a sort of churned foam, a wonderful litter in which shapes of every kind are buried. Place a man in a fog, in the midst of a storm, the sun in his eyes, and his head swimming, and depict, if you can, his impressions on canvas;

these are the gloomy visions, the vagueness, the delirium of an imagination that becomes deranged through overstraining.[8]

Likewise in *Manette Salomon*, the art-world novel by the Goncourt brothers published in 1867, the growing obsession of the painter Coriolis with his attempts to paint effects of light is compared with Turner:

> he was to some extent descended from the hallucination of the great Turner, who, at the end of his life, wounded by the shadow of other pictures, dissatisfied by the way in which light had been painted before him, dissatisfied even by the daylight of his own time, tried to elevate himself, in a painting, through the dream-world of its colours, to a virginal and primordial day, to the *Light before the Deluge*.[9]

More positive French commentaries on Turner from these years also insisted that the keynote of Turner's art was his aim to paint light itself.[10] The intensity of his colour was of course noted, as was his suppression of shadows and his avoidance of traditional dark foregrounds.[11] Yet there was some disagreement about the relationship between his paintings and their natural subjects. His interest in atmospheric effects and mists was often related to London's climate,[12] and the heightened colour of his later work to his travels in Italy.[13] Yet it was recognised that his art could not readily be classified in 'naturalist' or 'realist' terms, and in this context the contrast was frequently drawn with Constable. Constable, it was widely agreed, had been a formative influence on French landscape painting, through the display of his paintings in Paris, notably the *Hay Wain* (National Gallery, London) at the 1824 Salon, and it was Constable who had led painters to seek the ensemble of a natural scene by focusing on atmospheric effects, while suggesting details by fresh and lively brushwork.[14] By the 1860s the lessons of his work had been thoroughly assimilated into the practices of French landscapists. By contrast, Turner's art seemed more foreign to French concerns. French viewers, in the view of a hostile critic, faced with 'the metaphysical nature, the mystery, the magnificence of Turner', which the English so admired, absolutely rejected 'what was in flagrant discord with nature'.[15] However, his supporters in France could admire the fusion of 'dazzling reality' and 'passionate imagination' in his art;[16] Turner was exploring 'the infinite in nature', evidence of

a 'poetic pantheism'.[17] He sought everywhere 'fantastic, grandiose, heroic, splendid subjects, in which the sky, the sea and the earth could in some sense be created afresh by his genius. Nature as it is appeared drab to him, and ordinary sunlight rather pale. His painting is a fairyland whose elements are exalted to their utmost power.'[18]

In 1869–70, in the two years before they travelled to London and had the chance to see Turner's art for themselves, both Monet and Pissarro had developed a refined and flexible shorthand for the representation of the colours and textures of the natural world. Their brushwork had become smaller and more variegated, their colour more nuanced, as they sought an art that would convey their own sensory experiences (*sensations*) in front of the natural scene, working on a relatively small scale that allowed them to execute much of their canvases in the open air, in front of the scene itself. Indirectly, they were the latest inheritors of Constable's legacy. Both of them had also treated a very wide range of seasonal effects (see no.35), and Monet had painted his first sunset scenes, emphasising contrasts between the richly coloured sky and the dark terrain silhouetted in front of it.[19]

On their arrival in London in 1870, Monet and Pissarro would have found the National Gallery newly extended and reinstalled, finally able to use the full suite of rooms behind the Trafalgar Square facade, since the east wing had recently been vacated after the Royal Academy of Arts moved into its new premises in Burlington House in 1869. In this new installation Turner occupied pride of place, with the first two rooms in the west (left) wing devoted entirely to the paintings from the Turner Bequest, and, in the fourth room in the east wing, the two canvases that Turner insisted should be hung with the work of Claude (see no.2) displayed in the room devoted to the French school.[20] In the basement they would also have been able to view a very wide selection of Turner's watercolours and drawings, if they applied to view them as students; we know that Pissarro, at least, took advantage of this opportunity, since in 1883, before he had made a return visit to London, he urged his son Lucien to look closely at Turner's watercolours.[21] Further watercolours by Turner would, it seems, have been on display at the South Kensington Museum (now the Victoria and Albert Museum): in 1872, a French visitor described how this mass of sketches revealed 'the most secret and profound' aspects of Turner's genius, including summary sketches

of the same type as no.15.[22] The oil paintings on view in the National Gallery included a small group of canvases listed as 'unfinished', including *Chichester Canal* (no.10), with its dramatic sunset effect.[23] However, Monet would never have seen the large number of still more sketchy, lightly worked unfinished oil paintings in the Turner Bequest; they were only catalogued and put on display in 1906, after his final visit to London.

But how did Monet and Pissarro view Turner's work in 1870–1, and what impact if any did it have on their work? We can well imagine that they saw *War. The Exile and the Rock Limpet* (no.21) as more than just another Turnerian sunset. Both men were committed republicans, and the image of the first Napoleon in exile after his fall from power would have struck a particular chord in the light of recent events, so soon after the fall of Napoleon III and his imprisonment by the victorious Prussians.

However, the question of Turner's influence on their work is more complex, and any answers are clouded by later comments and reminiscences from the artists themselves; these are a necessary part of our story. The key evidence lies in the pictures themselves. With Pissarro, the answer is fairly clear. The paintings from his London stay and those that he executed in 1871–2, on his return to France, continue to explore just the same technical devices and the same types of subject matter as his pre-London canvases of 1869–70. There is a slight loosening of his brushwork as he gained greater fluency in the sort of representational short-hand that he had adopted around 1869, but there is no sign of fresh approaches that can be attributed to the impact of Turner. However, there is one canvas for which Turner is clearly relevant: *Lordship Lane Station* (fig.17), showing a steam train passing through a suburban railway station in south London, viewed from above, from a bridge across the tracks.[24] Inevitably this painting sets up a dialogue with *Rain, Steam and Speed* (fig.18) and actively invites comparison with it; but Pissarro's approach to the railway could not be more unlike Turner's. In place of Turner's elemental forces and expansive space and the generalised treatment of the land-scape, Pissarro's canvas is determinedly specific and low key, the grey weather complementing the incoherent clusters of subur-ban housing that punctuate the countryside in this very mundane site. This is, in a sense, art as art criticism, highlighting Turner's pretensions while at the same time proffering a very differ-ent alternative model of 'modern' landscape painting.

Fig.17 Camille Pissaro, **Lordship Lane Station** 1871
Oil on canvas 44.5 × 72.5 cm
Courtauld Institute Gallery, London

Fig.18 J.M.W. Turner, **Rain, Steam and Speed: The Great Western Railway** 1844
Oil on canvas 90.8 × 121.9 cm, B&J 409
National Gallery, London

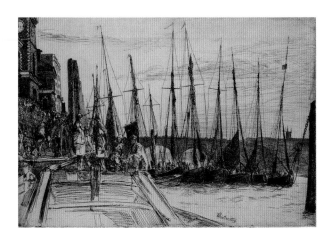

Fig.19 James McNeill Whistler, **The Pool** 1859 (no.29)

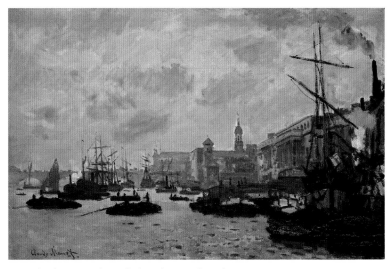

Fig.20 Claude Monet, **The Pool of London** 1871 (no.37)

Monet's case is more complex. As with Pissarro, we can trace a path through certain paintings, from 1869 to 1872, showing an increasingly refined and flexible representational shorthand; but other works do not fit into this pattern. His three river scenes painted in London (see nos.36, 37) all share a delicate atmospheric harmony unlike any of his previous works; yet their treatment is quite unlike Turner, with their relatively thinly painted, smooth surfaces, punctuated by crisp accents that serve to define the distinctive forms in the foregrounds of the pictures. In *The Thames below Westminster* (no.36) especially, the thin veils of colour are more comparable to Whistler's contemporary work – to his first Nocturnes (for example nos.43, 46). We still cannot prove that Monet and Whistler knew each other at this date, though it seems very likely that they had met in Paris in the mid-1860s, or at least made contact while Monet was in London.[25] The evidence of these pictures strongly suggests that it was contact with Whistler's pictures, none of which was exhibited publicly during Monet's stay in London, that helped Monet to see the potential of broadly swept, fluid paint layers as a means of conveying atmospheric effects. Equally, the subject of his two canvases of the Pool of London (see no.37) invites comparison with Whistler's 'Thames Set' of etchings, and especially with *Billingsgate* (no.30).[26]

Over the next three years, after his return to France, Monet continued to treat such effects in ways that clearly evoke comparison with Whistler, most notably in *Impression, Sunrise* of 1872–3 (no.39), the canvas whose title led to the naming of the 'Impressionists' when it was included in their first group exhibition in 1874. The broadly brushed, liquid swathes of paint that convey the sky and water, and the shadowy silhouettes of the ships and cranes in the background, show clear similarities with the treatment of Nocturnes such as nos.43 and 46. Moreover, the

closely related *Sunrise (Marine)* (fig.21), with its more subdued light effect, is still closer to Whistler's canvases; at around the same time, Monet executed one of the very few night scenes of his career, another view of the port of Le Havre (private collection; W 264). In January 1873 Whistler exhibited some of his early Nocturnes, together with *The Balcony* (fig.50; see p.141), in the dealer Durand-Ruel's gallery in rue Laffitte in Paris, in an exhibition that Monet presumably saw.[27] A reviewer described his views of the Thames during a fog or at nightfall as 'strictly monochrome, either greenish-blue or pale yellow'.[28] It is interesting to surmise how Whistler's paintings would have looked if he had accepted Degas's invitation to show his work in the 1874 group exhibition;[29] instead, he exhibited them in a solo show in London that summer.[30]

But it would be mistaken to rule Turner out of consideration at this point. Monet's Thames scenes include nuances of atmospheric colour that are unlike Whistler's Nocturnes: in *Impression, Sunrise* he chose a subject, of sunrise seen over water, that invited direct comparison with *Sun Rising through Vapour* of 1807 (no.2), one of the two canvases that Turner's will had demanded be hung alongside Claude at the National Gallery, and a painting that French commentators regarded as a key work from the earlier, more 'naturalistic' phase of Turner's career.[31] Again, though, as with Pissarro's *Lordship Lane Station*, we can view *Impression, Sunrise* as a critical commentary on Turner as well as a tribute. In contrast to the large scale and elaboration of Turner's canvas, evidently executed in the studio, Monet confronted the challenge of painting momentary effects of light and weather head-on, by seeking to execute his *Impression* as rapidly as possible, and as far as possible while the effect itself lasted.[32] In these terms it bears closer comparison with the rapid notations of effects of sunlight over water in some of Turner's

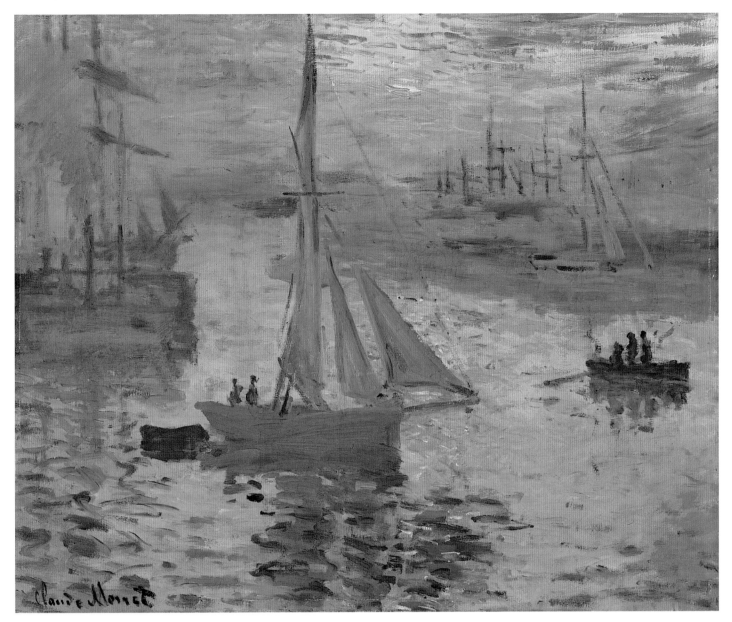

Fig.21 Claude Monet, **Sunrise (Marine)** 1872
Oil on canvas 49 × 60 cm, W 262
J. Paul Getty Museum, Los Angeles

watercolours, such as no.15; as we shall see, Monet later voiced his admiration for Turner's work in watercolour. In this context, it is interesting that the critic Ernest Chesneau, one of the leading French writers about Turner, mistakenly described *Impression, Sunrise* as 'sunrise on the Thames' in his review of the 1874 exhibition – presumably a response to affinities that he sensed with Turner.[33] Turner's art also appeared on the walls of this exhibition in another guise: Félix Bracquemond exhibited an etched copy of *Rain, Steam and Speed* with the title *The Locomotive, After Turner (Unfinished Plate)* (fig.22). On occasion, too, reviewers of the Impressionists' exhibitions made casual comparisons between their art and Turner.[34]

We can trace developments in Monet's art through the 1870s and early 1880s – his abandonment of explicitly contemporary subjects after 1878, and changing rhythms and patterns in his brushwork. But throughout these years his work was characterised by its diversity, as he sought to capture in paint the widest range of natural effects. However, there are certain paintings that suggest that Turner's art remained one of Monet's points of reference in these years, notably a number of sunset scenes over the river Seine, painted at Argenteuil in the mid-1870s and at Vétheuil around 1880. The dazzling effect of *Sunset on the Seine* of 1874 (no.40) echoes Turner; yet in *The Seine at Argenteuil* (fig.47 on p.134), painted at the same time and showing virtually the same

scene, the soft, hazy light effect is treated with a fluency and delicacy that are clearly reminiscent of Whistler. In these two canvases Turner and Whistler appear as a complementary pair.[35]

One of these sunset canvases, *Sunset on the Seine, Winter Effect* (fig.24), played a particularly significant role in Monet's art in these years. Far larger than the bulk of his work, it was painted expressly for exhibition at the Paris Salon in 1880 and was executed in the studio from smaller outdoor studies. However, before submitting it to the Salon jury Monet decided that it was 'too much to my own taste for me to submit it, and it would be refused'.[36] Its subject is clearly reminiscent of the notorious *Impression, Sunrise*, a likely explanation for the opposition that Monet expected it to meet from the Salon jury. However, in its conception, its more elaborate setting and its scale it is more comparable to canvases like Turner's *Sun Rising through Vapour* (fig.23): Monet, like Turner, was seeking to transform a fleeting effect of light into an ambitious and substantial work of art – to go beyond the *impression*.

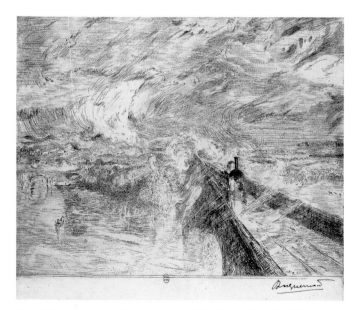

Fig.22 Félix Bracquemond, **The Locomotive, After Turner (Unfinished Plate)**
c.1874
Etching 20.2 × 26.3 cm
Cabinet des estampes, Bibliothèque Nationale de France, Paris

Turner – or rather the Turner myth – also offered Monet a precedent for the hardships to which he submitted himself in painting out of doors. Especially in the 1880s, he pursued subjects that represented the forces of nature at their most extreme – stormy seas and fierce winds, as well as dazzling sunlight. He may well have known the story of Turner being lashed to the mast of a ship in order to study the effects of a storm for the canvas that he exhibited in 1842 with the title *Snow Storm – Steam-Boat off a Harbour's Mouth Making Signals in Shallow Water, and Going by the Lead. The Author Was in This Storm on the Night the Ariel Left Harwich*; he would have seen the picture itself in the Turner Bequest (Tate, London; B&J 398),[37] and it was this canvas that became a focus of discussion in the Whistler–Ruskin trial of 1878.[38] However, whether true or not, this narrative of *plein-airist* heroics had its roots in France, in the very similar story told of the French eighteenth-century marine painter Claude-Joseph Vernet.[39] Monet, in turn, proudly spoke of the physical dangers that he had encountered as he painted the wind and the waves.[40]

Yet at the same time he retained his memories of London, and intended, over a number of years, to return there to paint. He first voiced this wish in 1880;[41] in 1887, when he was planning his visit to London for the opening of the Royal Society of British Artists show in which he exhibited at Whistler's invitation, he was more specific, saying that he wanted to 'try to paint some fog effects on the Thames'.[42] He was only able to realise this project in 1899–1901.

We cannot tell how far Turner was in Monet's mind when making these plans, alongside his other memories of London. However, in the early 1880s he and his Impressionist colleagues invoked Turner as a precedent for their own art in an ambitious attempt to set up an exhibition of their work in London. Monet was one of the signatories of a letter to Sir Coutts Lindsay, Director of the Grosvenor Gallery in London, probably written in 1882, in which nine painters – effectively the core members of the Impressionist group – asked Lindsay to mount an exhibition of their work:

A group of French painters, united by the same aesthetic tendencies, struggling for ten years against convention and routine to bring back art to the scrupulously exact observation of nature, applying themselves with passion to the rendering

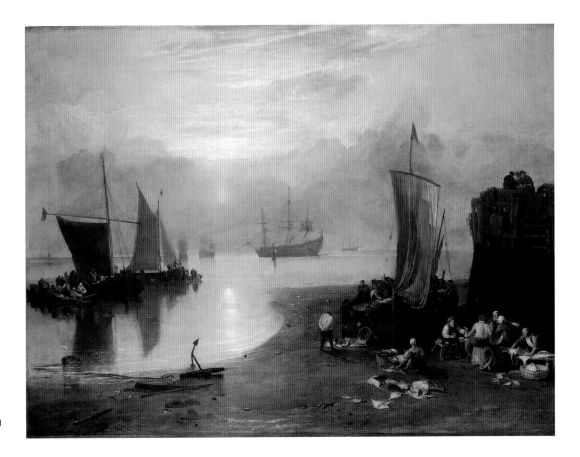

Fig.23 J.M.W. Turner, **Sun Rising through Vapour: Fishermen Cleaning and Selling Fish** exh.1807 (no.2)

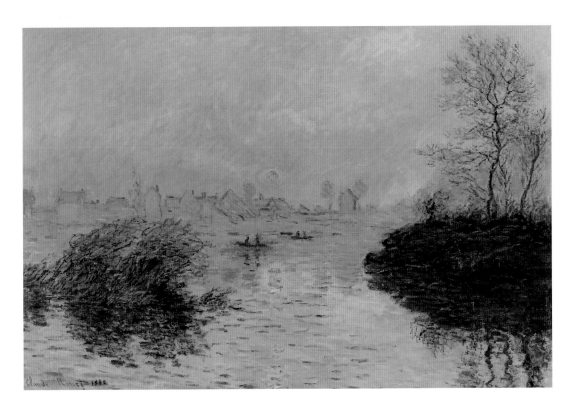

Fig.24 Claude Monet, **Sunset on the Seine, Winter Effect** 1880 (no.41)

Fig.25 J.M.W. Turner,
Frosty Morning exh. 1813
Oil on canvas
113.7 × 174.6 cm, B&J 127
Tate, London

of reality of form in movement, as well as to the so fugitive
phenomenons of light, cannot forget that it has been preceded
in this path by a great master of the English school, the
illustrious Turner.[43]

This emphasis on Turner as a pioneer of 'exact observation' is
perhaps surprising, although it was in line with the standard view
of his art propagated in England at the time, notably by Ruskin.
By contrast, however, the French critic Chesneau, in his survey of
English painting published in the same year, insisted that in his
later work 'Turner did not look at nature enough', and that he
'did not paint the sun that he had before his eyes, but the sun of
which he dreamed'.[44] As we shall see, Monet shared this view.

Monet's few personal comments about Turner that have
been recorded were equivocal. Shortly after his death, Raymond
Koechlin insisted that Turner had not played a significant role
in Monet's evolution: 'in his private conversations he did not
conceal the fact that Turner's work was antipathetic to him
because of the exuberant romanticism of his fantasy.'[45] Marthe
de Fels insisted that 'all his life Monet repeated that Turner
was a bad painter'.[46] George Moore also recorded disparaging
comments about Turner, but remembered Monet saying about
Frosty Morning (fig.25) that 'Turner had painted that morning
with his eyes open'.[47] In 1918 the dealer René Gimpel recorded
a comment of Monet's in his diary: 'At one point, I greatly liked
Turner, but today I like him much less – he did not draw enough

with colour and he used too much of it. I have studied him
closely.'[48]

But when was Monet's admiration for Turner at its height?
In 1870–1, or on his return visits to London from 1887 onwards?
Two clues suggest that it was on these later visits that he came to
appreciate Turner more fully. In 1888 an English journalist who
had interviewed Monet recorded: 'Every now and then [Monet]
runs over to London, where at the National Gallery he ponders
over the later works of Turner, for whom he has an enthusiastic
admiration as a master from whom he has learnt much in struggle
after qualities of colour.'[49] In September 1892 the American
painter Theodore Robinson recorded in his diary: '[Monet] spoke
of Turner with admiration – the railway one – and many of the
w.c. studies from nature.'[50] And in autumn 1905 the English critic
Frank Rutter visited Monet at Giverny, shortly after the exhibition
of the London series, and remembered him saying 'that it was
Turner's later pictures, not his earlier, that were the special
objects of his admiration'.[51]

Pissarro, too, at the end of his life commented retrospectively
about Turner's impact on himself and Monet. In 1902 he wrote
about their stay in London in 1870–1 to the English painter
Wynford Dewhurst, who was preparing an article on the Impres-
sionists: 'The watercolours and paintings of Turner, the Constables
and the Cromes, certainly had an influence on us. We admired
Gainsborough, Lawrence, Reynolds, etc., but we were more
struck by the landscapists, who were closer to our own researches

into the open air, light and fugitive effects.'[52] Dewhurst's resulting article presented Impressionism as a movement with its roots in English painting, which elicited an indignant response from Pissarro: he insisted in a letter to Dewhurst, that 'the base of our art is evidently of French tradition'.[53] He elaborated on his view of Turner in a letter to his son, Lucien:

> he says that before going to London we had no idea of light, although we have studies which prove the opposite, he suppresses the influence of Claude Lorrain, Corot and the whole 18th century, but what he doesn't realise is that Turner and Constable, though helping us, confirmed to us that they had not understood the *analysis of shadows* which in Turner is always a stereotype effect, a void. As for the division of tones, Turner confirmed its value as a procedure, but not in terms of accuracy or nature; besides, the 18th century was our tradition. It strikes me that Turner too looked at Claude Lorrain, and it seems to me that there is a picture, *Sunset*, hung side by side with a Claude?[54]

However, like Monet, Pissarro was paying particular attention to Turner in the years around 1890. As we have seen, in 1883 he was encouraging Lucien to study Turner closely, and when in 1888 he himself was exploring ways of freeing his art from the precision of the Neo-Impressionist *petit point*, he wrote that he was going to the Louvre to study certain works that were relevant to his concerns, adding: 'Isn't it idiotic not to have any Turner [in the Louvre]?'[55] After a return visit to London in 1890 – his first since 1870–1 – he was quoted by an interviewer as saying: 'It seems to me that we are all descended from the Englishman Turner. He was perhaps the first painter who knew how to make colours blaze out with their natural brilliance.'[56] Around the same time he wrote to a journalist seeking to clarify the Impressionists' position in the history of nineteenth-century art: 'Our path begins with the great English painter Turner, Delacroix, Corot, Courbet, Daumier, Jongkind, Manet, Degas, Monet, Renoir, Cézanne, Guillaumin, Sisley, Seurat! That is our lineage.'[57]

In these years, too, a few works by Turner were put on exhibition in Paris. Most interestingly for us, in 1887 a very lightly worked oil painting, one of the oils that is generally considered unfinished, was displayed in a charity exhibition at the Ecole des Beaux-Arts; this was described by a number of critics, including

Joris-Karl Huysmans, and can very probably be identified as *Junction of the Severn and the Wye* (no.22, now in the Louvre). The Turners in the collection of Camille Groult were accessible to select visitors by 1890, and in 1894 a dozen paintings attributed to Turner were displayed at the Sedelmeyer Gallery in Paris, in order to publicise Sedelmeyer's unsuccessful attempts to sell *Ancient Italy: Ovid Banished from Rome* (private collection; B&J 375) to the Louvre.[58] Pissarro commented on this show, and was unenthusiastic about *Ancient Italy*, but praised two canvases, possibly including no.22, that had been loaned by Groult.[59]

It was in the early 1890s that writers on art began regularly to invoke Turner's name in discussing the genesis of Impressionism. The critic Gustave Geffroy, a close friend of Monet, noted in 1891 that Monet and Pissarro had returned from their trip to London 'with the dazzling experience of the great Turner in their eyes',[60] and in 1892 Georges Lecomte, in the first book to be published on Impressionism, noted that Monet and Pissarro had 'found the definitive confirmation of their researches' in Turner's art when they saw it on their first visit to London.[61] Geffroy elaborated on the impact of Turner in his book on Impressionism published in 1894. After an eloquent description of Turner's art ('an eruption of lava, an incandescent flow'), he noted that Monet and Pissarro had found, on seeing his work in 1870–1, 'the joy of perceiving that what they were seeking had already haunted another spirit'.[62]

A recurrent feature of these accounts is their preoccupation with artistic lineages. Pissarro's 1892 list placed Turner at the head, but he was followed exclusively by French artists; his objection to Dewhurst's account was that he had tried to co-opt Impressionism for an anglocentric version of the history of nineteenth-century art, neglecting what they owed to French art of the seventeenth and eighteenth centuries. Geffroy's 1894 account turned the argument around by insisting on French roots for Turner's art: 'What Turner was seeking was anticipated in the *Embarkation for Cythera* by Watteau as well as in the burnished and gilded canvases of Claude Lorrain.'[63] National cultural identity was clearly one facet of the 'anxiety of influence'.

Geffroy's and Lecomte's accounts focus on Monet's and Pissarro's first encounter with Turner in 1870–1, but it is no coincidence that they appeared at the same time as Monet's and Pissarro's own positive comments about Turner. For the years around 1890 marked a significant shift in the practice of both

painters, in a direction that gave Turner's art a fresh relevance for them. Around 1870, as we have seen, they were preoccupied by notating the diverse textures and colours in the natural scene; indeed, even in 1894 Geffroy still insisted that their concern with direct observation was quite different from Turner's more formulaic attitude to coloration.[64] However, by the late 1880s both Monet and Pissarro had become far more concerned with the overall coherence of their canvases, in terms of both colour and touch. Pissarro in 1890 phrased this in terms of his developing understanding of the concept of 'unity',[65] and in 1892 he spoke of his wish to express 'the true poem of the countryside'.[66] The starting point of a picture was still the artists' direct experiences, but they were deeply concerned with the qualities of the finished picture in a new way – not just as a record of their personal *sensations*, but also as a set of carefully orchestrated pictorial relationships on the surface of the canvas. This conveyed the unity that they sought in the natural scene, but transformed this into a mesh of coloured touches that had its own coherence. In broad terms, there are clear parallels here with Whistler's aims, as expressed in his 'Ten O'Clock' lecture, translated into French by Stéphane Mallarmé (see p.163, below, and no.53), though his paint-handling was a far cry from Monet's and Pissarro's poly-chrome mosaic. By 1890, too, Monet was extensively reworking most of his canvases in his studio before declaring them finished, and for a few years around this date Pissarro was executing his more ambitious oils entirely in the studio.[67]

It was in this context that they paid renewed attention to Turner, not as a close observer of the specifics of natural forms and lighting, but as the creator of lavish colour harmonies that expressed the effects of light in more generalised terms. We can gain some idea of what they were looking for in Turner's work by returning to the comments that they made about him in the late 1880s. The 1888 interview that mentioned how much Monet had learned from Turner 'in struggle after qualities of colour' went on to describe Monet's own colour practice:

One of his great points is to use the same colours on every part of the canvas. Thus the sky would be slashed with strokes of blue, lake, green and yellow, with a preponderance of blue; a green field would be worked with the same colours with a preponderance of green, while a piece of rock would be treated in the same way, with a preponderance of red. By working in this way . . . the subtle harmony of nature . . . is successfully obtained without the loss of colour.[68]

Pissarro's letter of 1888, lamenting the lack of works by Turner in the Louvre, describes his search for a way of combining the pure colour of the Neo-Impressionists with the 'freshness of *sensation*' of the Impressionists in a technique that abandoned the tightness of the *petit point*. It seems likely that he was alerted to Turner's work in this context, not by memories of his own experiences of his work in 1870–1, but by a passage in one of the key texts for the Neo-Impressionists, Ogden Rood's *Modern Chromatics*, in which Rood advocated study of Turner's work as an example of 'gradations' of colour, 'the tints melting into each other', and explicitly contrasted this with a technique in which distinct touches of different colours were placed side by side and blended in the viewer's eye.[69]

In Monet's work, these increasingly rich and complex coloured surfaces began to emerge in the paintings from his travels of the 1880s, notably to the Mediterranean coast. However, his art took a further crucial turn in 1890–1, when he began to work more systematically in series of canvases of identical or closely related subjects, and to exhibit these groups of paintings together, telling a journalist that they 'only acquire their full value by the comparison and the succession of the whole series'.[70] Central to his concerns in the series was the constantly changing light, the coloured *enveloppe* that transformed the appearance of the objects in the scene. The surfaces of these serial paintings, from the *Grain Stacks* exhibited in 1891 and the *Poplars*, shown in 1892 onwards, display a new degree of elaboration in colour and texture, the result of extensive reworking in which Monet treated the whole series as an aesthetic entity transcending the individual paintings that made it up.[71]

It was at this moment that Monet declared his interest in Turner's art (see p.42, above); *The Poplars*, too, is a response in broader terms to what Monet was now finding to admire in Turner's work, in the conception of the whole picture in terms of a complex harmony of lavish colour, and in the richness of the painterly technique.

Turner's work seems relevant to Monet's series in two ways. First, the surfaces of Turner's later paintings displayed a rich

weave of high-key colours, and offered a practical demonstration of the potential of colour to evoke the dazzling effects of sunlight. Some of the sunset effects in the *Grain Stacks* series are comparable to Turner's *War. The Exile and the Rock Limpet* (no.21), while the luminosity and bold colour-contrasts, of oranges and pinks against blues, in *The Poplars: White and Yellow Effect* (1891; Philadelphia Museum of Art, W 1298) recall the coloration of canvases such as *The Golden Bough* (no.14). In more general terms, the lessons of Turner's rich coloration can be seen even in canvases whose colour harmonies seem very different from his. Indeed, the *Morning on the Seine* series (nos.60–2), dominated by harmonies of greens, blues and mauves and much more restrained in colour than the *Grain Stacks,* may readily be compared with the colour effects that Turner achieved in some of his watercolours, such as the sequence of Brunnen views (nos.54–9).

Turner's watercolours may, moreover, have provided Monet with a precedent for working in series. Turner himself never actually exhibited his work in series, and it is very possible that the displays of his watercolours that Monet would have been able to see in the National Gallery did not present them in a way that highlighted groups of studies of a single subject in different light conditions; it is, perhaps, the subsequent interests of historians that have allowed us to focus on such groupings in Turner's work (see nos.54–9). Even without any such display of closely related subjects, though, Turner's watercolours would have shown Monet how a material subject could be transformed by richly coloured atmospheric effects.

As we have seen, Monet had long planned to return to London to paint, drawn by the challenge of painting the changing light conditions in its foggy atmosphere. The series of Thames views that he began in 1899 (nos.70–81) are in a sense a direct response to Turner. Geffroy in his 1894 book had evoked Turner's Thames scenes in terms that anticipate Monet's remarkably closely: 'In the fog that weighs down so heavily on the flow of the Thames, Turner had seen rainbow-colours, sudden flaming bursts of sunlight, he had wanted to express these cascades of precious stones in the atmosphere, and sometimes he succeeded in giving the sensation of the spectacle of enchantment that played in the air.'[72] Detail for detail, of course, Monet's canvases do not resemble Turner's; he remained more closely tied to the specifics of the scene in front of him, both to its spatial layout and to the play of light. However, his high viewpoint, especially in the views from the Savoy Hotel (nos.70–7) offers a wide, almost panoramic view of the city that has few precedents in his own previous work and is reminiscent in general terms of the expansive space in many of Turner's landscapes. Moreover, Monet's *Houses of Parliament* series (nos.79–81), viewed from St Thomas's Hospital, invites comparison with one of Turner's most celebrated subjects, *The Burning of the Houses of Lords and Commons* (no.78), though we cannot be sure that Monet would have been aware of this.[73] Beyond this, there are clear echoes of Turner in the richness of his colour schemes, as he sought to convey the fleeting effects of sunlight through fog. Reviewing the exhibition of Monet's London series in 1904, Gustave Kahn imagined hanging some of them alongside Turner's work, just as Turner hung alongside Claude in the National Gallery, as a juxtaposition of 'two dates in the history of a particular visual sensibility'.[74]

Yet Whistler, too, was a key presence in Monet's views from the Savoy, but in a very different way from Turner. Whistler's lithographs made in the Savoy (nos.64–8) treat virtually the identical scenes to Monet's canvases, but on a very small scale (figs.26–7): the forms dissolve into mists in the distance and into the uninked paper at the margins, making the images seem like rapid, self-effacing glimpses, quite unlike the confidence and boldness with which Monet treated these vistas. The print that shows Whistler's dying wife at the window (no.63), in particular, is a reminder that this view could be seen in very private and intimate terms.

Monet's close friend Geffroy, who watched him at work on the Thames series in 1900, acknowledged that the pictures could be compared with Turner, but insisted: 'The light in Monet's canvases is more unified, the colour more consistently luminous; they do not have the burned, fired, enamelled appearance of the great English landscapist, the admirable precursor of modern landscape painting.' Geffroy felt that the closer analogy for Monet's Thames pictures was with Whistler's closely integrated harmonies, despite the difference between their favoured colour schemes.[75]

After his spells in London in 1899–1901, Monet only travelled away from Giverny in order to paint on one final occasion – to Venice in 1908. Here he was, of course, following in the footsteps of both Turner and Whistler; but in a sense he was also following the path of Turner's career, as it had been described by Ernest Chesneau:

Fig.26 James McNeill Whistler,
Evening, Little Waterloo Bridge
1896 (no.66)

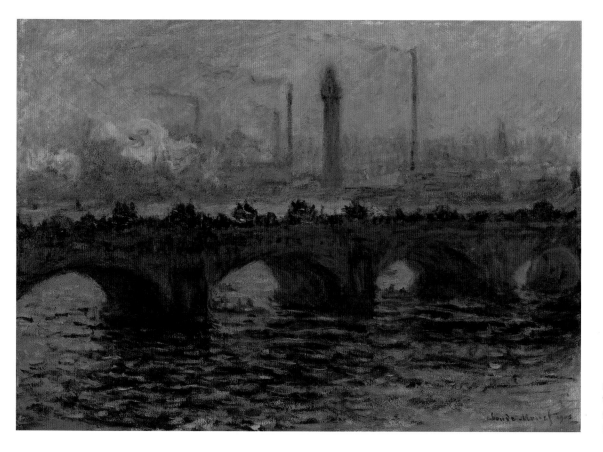

Fig.27 Claude Monet,
**Waterloo Bridge: Effect of
Sunlight in the Fog** 1903
(no.77)

Turner reproduced the most remarkable phenomena of the atmosphere in the lands of fog. But, in the long run, this fog depressed him and made him nostalgic for dazzling light. The stormy skies over northern mountains and seas, the serene grey weather, no longer satisfied him, and it was to the lands of sunlight that he went to achieve the fullest realisation of his dreams of light.[76]

Monet's Venice pictures, like his London series, were an attempt to sum up the essential character of a great city by presenting some of its most distinctive views 'enveloped' by the most characteristic atmospheric effects of the place. The 'southern' Venice series complement the 'northern' London ones, and together they echo Turner's determination, throughout his maturity, to show himself the master of both the traditional modes of landscape, the Dutch and the Italianate, the northern and the southern. But, as with the London series, Monet's Venice canvases also pay tribute to Whistler. If the views of the Lagoon, and especially of San Giorgio in the sunset (no.106), are among the most Turnerian canvases of his whole career, the palace facades (nos.88–90), viewed frontally and cut off at the top by the picture frame, are an overt tribute to Whistler's Venice etchings of facades and courtyards (nos.84–7), a quiet and intimate counterpoint to the brilliant spectacle of the Lagoon.

Unable to return to Venice, Monet often declared himself dissatisfied with his Venice paintings, only completed for exhibition in 1912, over three years after his visit. In his last years his art was entirely devoted to painting his gardens at Giverny, and especially to the monumental Water-Lily Decorations. It is in the light of the remarkable coherence of structure of the Decorations and the economy of their colour schemes that we can perhaps understand the comment that he made to René Gimpel in 1918, that Turner 'did not draw enough with colour and used too much of it'.[77]

Monet's career in a sense ran parallel to Turner's, with a gradual move from a form of naturalism based on close observation towards to a broader view of nature and a richer and more complex use of colour. Yet even when his pictorial concerns came closest to Turner's, as he evolved the lavish colour schemes of his series, from the *Grain Stacks* and *Poplars* to the London and Venice series, his vision remained consistently grounded in direct observation. The 'exuberant romanticism' of Turner's 'fantasy' always represented a radically different approach from his own to the meaning and purpose of landscape painting.

However, Turner's art offered the Impressionists, and Monet in particular, a continuing challenge. His paraded independence from academic methods, his reputation as the painter of light, and his use of colour, all these factors made him a figure with whom Monet had to reckon. From his first paintings of London in 1870 to the Venice series of 1908–12, Turner's presence recurs in his art as a powerful ancestor – more perhaps a brilliant but eccentric uncle than a father figure – in relation to whom, and against whom, Monet felt the need to define himself. Within the culture of individuality and originality that has dominated the art world for the past two centuries, this is the most significant form of 'influence': a complex blend of emulation and competition, in which reference to the model is defined not by imitation but by difference. Monet's engagement with Turner can stand as a prime example of this pattern.

The poetics of pollution

Jonathan Ribner

I adore London . . . But what I love more than anything is the fog.
(Claude Monet to art dealer René Gimpel)[1]

Long before Monet checked into the Savoy Hotel in 1899 to paint the fog-bound Thames Britons had grown to detest the coal smoke that fed London's air. In the late thirteenth century, Edward I ineffectually prohibited coal burning. By the seventeenth century, with the substitution of soft, sulphur-rich coal for a depleted wood supply, the situation had deteriorated. In a plea submitted to Charles II, *Fumifugium: or the Inconvenience of the Aer and Smoake of London Dissipated* (1661), the polymath diarist John Evelyn denounced the

> Hellish and dismall Cloud of SEA-COALE . . . which is not onely perpetually imminent over her [London's] head . . . but so universally mixed with the other wholesome and excellent *Aer*, that her *Inhabitants* breathe nothing but an impure and thick Mist, accompanied with a fuliginous and filthy vapour, which renders them obnoxious to a thousand inconveniences, corrupting the *Lungs*, and disordering the entire habit of their Bodies; so that *Catharrs, Phthisicks, Coughs* and *Consumptions*, rage more in this one City, than in the whole Earth besides.[2]

Growing with London's population, the presence of its coal smoke was known far beyond the city's limits. In the eighteenth century, London began to be called the 'big smoke' or, simply, 'the smoke'.[3] The Reverend Gilbert White, in *The Natural History and Antiquities of Selborne* (1788), thus characterised a 'MIST, CALLED LONDON SMOKE', which periodically wafted from the capital to his beloved Hampshire town: 'It has a strong smell, and is supposed to occasion blights.'[4] 'The Smoke of London, first viewed from a distance, affords a sight which strikes a foreigner with astonishment,' wrote W. Frend, an insurance actuary, in 1819.[5]

Astonishing atmospheric effects were the speciality of Turner, who, long before Monet or Whistler, viewed smoke and fog with a creative eye. In the 1830s and 1840s Turner repeatedly represented black coal fumes blending with moist air, *Rain, Steam and Speed: The Great Western Railway* 1844 (fig.18 on p.39) being a well-known example. As William S. Rodner has pointed out, Turner stood apart from his contemporaries in his willingness to candidly record urban smoke.[6] He did so as early as 1809 in *London from Greenwich Park* (no.3), returning to the capital's fumes in a work apparently unknown to nineteenth-century viewers, *The Thames above Waterloo Bridge* c.1830–5 (fig.28; the work was first publicly

displayed in 1906). Like the smoking locomotive of *Rain, Steam and Speed*, this industrial cityscape embodies Turner's taste for compelling historical and topographical evocation – in this case, of the powerful and active British capital in the nineteenth century.

Absent from Turner's depictions of coal smoke is the outrage that runs from John Evelyn's complaint, through William Blake's lamentation over England's 'dark satanic mills', and on to the wrenching descriptions of his polluted nation by John Ruskin, whose cult of Turner did not warm to the master's renderings of coal smoke and iron. Nor was London's coal smoke appreciated by Michael Angelo Taylor, MP for Durham City. In 1819 Taylor complained to his colleagues in Westminster Palace that 'the volumes of smoke which issue from the furnaces on every side of the river Thames opposite my own house actually blacken every flower I have in my own garden in Whitehall'.[7] The resulting legislation for smoke abatement in steam engines and furnaces (enacted 28 May 1821) began a history of nineteenth-century reform that saw the Smoke Nuisance Abatement Act of 1853, smoke clauses in the Sanitary Acts of 1858 and 1866, and further regulation in the Public Health Act of 1875.[8] Yet these measures neither touched domestic smoke nor provided for an official air monitoring authority. With its insatiable appetite for coal, London only grew smokier.

The smoke fed fogs of extraordinary density, which, to make matters worse, began to gradually increase in frequency around 1750. On 25 February 1832, Dorothea, Princess Lieven (wife of the Russian ambassador to London) wrote to Lady Cowper: 'The Duke of Devonshire's ball was held in the clouds: so thick was the fog in the drawing-room that you could not recognize people at the other end of the room. In the streets there was chaos, torches, shouting and carriages colliding.'[9] And this was prior to the 1840s, when the thick, yellow 'pea-soupers' first appeared.[10] Following a peak in the 1890s, London fog began to subside around the time of the 1904 exhibition of Monet's London paintings.[11] Such improvement – long before the Clean Air Act of 1956 prohibited the emission of dark smoke – indicates that climate, and other factors beside coal fire exhaust, contributed to the London fog.[12] At the same time, coal smoke brought pollution and pigmentation to the fog, and nineteenth-century Britons had no doubt that smoke was the cause of what Charles Dickens, in

Fig.28 J.M.W. Turner, **The Thames above Waterloo Bridge** c.1830–5
Oil on canvas 90.5 × 121 cm
B&J 523
Tate, London

Bleak House, termed 'London Particular'. That London Particular was dangerous as well as disruptive became increasingly clear as the mortality rate jumped when visibility was lost. A dense fog could kill five hundred to seven hundred people in a week in London; in the great fog of 1886, fatalities equalled those of the worst cholera years.[13] Humans were not solely at risk: a terrible fog in December 1873 suffocated cattle on show at Islington.[14]

Concern about the situation was a very public affair prior to the painting campaigns which thrice brought Monet to London between 1899 and 1901. F.A. Rollo Russell (Lord John Russell's son), a leading advocate of smoke abatement reform, aroused public opinion with *London Fogs* (1880). In November 1881, a year after the first meeting of the Fog and Smoke Committee under the auspices of the National Health and Kyrle Societies, an exhibition of smoke-abating fuels, stoves, and fireplace grates opened in South Kensington, with a second venue in Manchester. In response to the obscurity enveloping London on 9–13 January 1888, *Punch* showed King Fog overwhelming the sun (fig.29). Three demons issue from a smoking chimney to pipe out the industrial ingredients of 'fog poison' while, in the lower left, 'Science powerless' cowers in defeat.[15]

By the end of the nineteenth century approximately 18 million tons of coal were burned annually in London. According to Louis C. Parkes, a health official for Chelsea, over two hundred tons of fine soot were going into London atmosphere daily in 1892.[16] London's mixture of smoke and fog, christened 'smog' in 1905,[17] provided visual effects sufficiently extraordinary to induce Monet to cross the English Channel: 'I adore London . . . But what I love more than anything is the fog', he told the dealer René Gimpel.[18]

Having sought shelter in London from the Franco-Prussian War, Monet had long been aware of the capacity of the thick Thames atmosphere to foster tonal unity. *The Thames below Westminster* (no.36), a product of his visit to London of 1870–1, employs limited visibility to update, according to the visible facts of nineteenth-century urban life, the silvery, misted shorelands of the late Corot and the luminous harbours of Claude Lorrain. Monet's paintings of 1899–1901 exploit yet more forcefully the visual evidence of London's environmental degradation. In *Waterloo Bridge* (no.76), for example, the smoke-impregnated fog provides a cohesive ambience that subsumes a series of striking contrasts. The squat horizontality and regular bays of the bridge are set off against the ghostly shore, with its irregular array of tall smokestacks. The warmth of the fog-choked sky is cut by the active chimneys, which display London's relentless industrial productivity. Such effects – or those which inspired the extraordinary chromatics of the *Houses of Parliament* (nos.79–81) – require smog.

The unhealthiness of the foggy London air does not to seem to have concerned Monet, in spite of the pleurisy he contracted during his visit of 1901. He complained about the fog solely when it was impenetrable or absent. His letters home mark anxious occasions on which the fog – so pleasing when translucent – rolled in with such density that the artist had to endure idleness.[19] In a letter to his wife, Alice – from whom Monet endured painful separation in order to paint in London – the artist reported: 'when I got up I was terrified to see that there was no fog, not even the shadow of a fog. I was devastated and already imagined that all my canvases would be ruined, but little by little the fires were lit, and the smoke and fog returned.'[20] This tenacious affection for the fog flew in the face of French as well as British opinion: the standard French view of London's climate was in place long before the artist's birth. A comic stage production of 1787, *L'Anglais à Paris*, opens with the Englishman, Lord Porter, declaring, on arrival, that the good Parisian air has lifted his health and spirits, and that he is glad to be away from his homeland: 'I don't like the fogs.'[21] Nor had French disapproval of London fog diminished by the time that Monet exhibited his London canvases. In 1906, the actress Blanche Denège complained that, when going out for an evening of theatre, 'One must cover all the delicate parts of one's *toilette* with a cloak or else they will be ruined.' More serious was the fog's noxious aspect: 'When breathing in, one coughs as if one had inhaled sulphur from a match.' Having had the temerity to enter a thick fog to view the novel and very entertaining spectacle of people groping their way through the street, Denège confessed: 'I paid for my curiosity and temerity by being bed-ridden for about ten days.'[22] In an enthusiastic review of Monet's London paintings, Arsène Alexandre gave the artist credit for having worked in so unhealthy an environment. 'The splendidly coloured fogs hovering above the Thames almost destroyed his health', the critic wrote with exaggeration. 'For a great part of the time he spent in London, Monet seemed to be close to death.'[23]

Just as, in 1870, Monet preferred refuge in London to the prospect of fighting for France, so too did his affection for London fog contrast with the patriotic vitriol with which some nineteenth-century middlebrow French writers treated the topic. Horror-stricken by the very effects sought out by Monet in the London winter, Hector France looked towards the sun in this 'monstrous city', and observed: 'Throwing a pale light, a stain of yellowish oil smears the fog (heavy with the soot of eight hundred thousand chimneys and the exhalations of three million chests) with a reddish tint.'[24] Chilled by the fall of night at midday, the anglophobic writer invoked the suicides that would inevitably follow.[25] With similar venom, Fernand de Jupilles described the fog of 'Brouillardopolis': 'Not only is the obscurity of a London fog a hindrance, the senses of taste and smell are adversely affected by the bizarre mix of coal smoke and the odours of sludge and rotten eggs. Every object feels greasy and viscous to the touch.'[26] The author warned of the criminal activity that thrived in this 'pickpocket paradise'[27]: 'The fog that covers the capital of Albion with a thick and nauseating veil also encourages physical assaults of all kinds'.[28]

Fig.29 **In the Days of King Fog**, wood engraving, *Punch*, 21 January 1888

The fog as malevolent cloak was not solely a French theme. In the lower-right corner of *London Sketches: A November Fog* published in the *Graphic* in 1872 (fig.30), a young ne'er-do-well hungrily palms a woman's purse. Surrounded by shouting link boys – whose torches lead blinkered horses to impending collision – the preoccupied victim presses a kerchief beneath her useless spectacles .[29] A grimmer linkage of evil with London's poor air is represented by John Tenniel's caricature, *The Nemesis of Neglect* (fig.31), a commentary on the horrific murders committed by Jack the Ripper in the late summer and autumn of 1888 in the East End. A knife-bearing spectre of Crime – attributed by the earnest draughtsman to the neglect in which London's poor fester – looms before a wretched, refuse-strewn street, enshrouded in dark haze. 'There floats a phantom on the slum's foul air', reads the caption.[30] The low-lying East End was particularly susceptible to fogginess, and fog became part of the popular mythology surrounding Jack the Ripper, notwithstanding the fact that his crimes were not committed on foggy nights.[31]

Fig.31 **The Nemesis of Neglect**, wood engraving, *Punch*, 29 September 1888

Fig.30 **London Sketches: A November Fog**, engraving, *Graphic*, 9 November 1872

Exaggeration also fogged the Parisian notion of Victorian London, viewed from the hexagon as a place of perpetual darkness.[32] According to one British analyst of Gallic opinion, Bayle St John, 'it is an article of French meteorological faith that England is always covered by one dense mist; or that, at any rate, the sky is invariably cloudy.' Thus London is conceived of by the French as 'a kind of smoky Venice': 'We loom upon them, as it were, through a fog.'[33] This national stereotype was brought to bear in the hazing of the English artist Albert Ludovici, Sr, when he joined Alexandre Cabanal's class at the Ecole des Beaux-Arts in the late 1860s: 'If it happened to be a fine day, they [his classmates] would call out to me, "Look, newcomer, at this beautiful sun, you have never seen anything like it in your land of fog".'[34] According to Max O'Rell – a nineteenth-century French commentator on things English – on the rare occasions when the sun is seen in London, it is photographed: 'In order not to forget it.'[35]

Monet's conception of London conformed to this *idée réçue*. Without the fog, London was 'insufficiently London-like'

– as Monet characterised some of his false starts from his sojourn of 1900.[36] As we have seen, Monet discovered, to his dismay, that clear skies were a distinct possibility in London, even in winter. The energy with which he sought and captured the salient particularities of a stereo-typical motif – London deep in fog – points to his background as a caricaturist.

Monet provides but one example of how word of such extreme atmospheric conditions provoked curiosity as well as distaste. London's fog had a tourist allure for French travellers who, like the repentant Blanche Denège, wished to witness the famous 'pea soup' first-hand. Considering the fog as England's national attraction, with a draw comparable to an eruption of Vesuvius, one author maintained that: 'Among the French there are some who have gone out of their way to witness this phenomenon. They have remained in London until November in the hope of viewing *the darkness*.'[37] In the 1890s a splendid view of the Thames in fog was advertised as one of the advantages of the Savoy Hotel.[38] Thus, like his previous work on the Normandy coast, Monet's London series targeted an established tourist attraction.[39] Both locations share with Belle Isle and the Creuse River valley (two other sites painted by Monet) a forbidding aspect that only enhanced their appeal as settings for uncommon chromatic effects.

That London offered visitors awesome, even terrifying, sights was set forth in what I call the 'London Sublime' – an overheated representational mode of the 1870s and 1880s,[40] in which London's smoke, noise and dehumanising congestion are presented with a frightful amplitude that brings to mind the biblical disasters of John Martin, which had enjoyed a Parisian vogue under Louis-Philippe.[41] Such is Gustave Doré's image of Ludgate Hill (fig.32), with its overwhelming, agitated crush, from *London: A Pilgrimage* (1872).[42] Doré's plates apparently inspired another example of the London Sublime, the 'picture of a land of mist and mud' imagined by Des Esseintes as he anticipated a voyage to the British capital in Huysmans's novel, *A Rebours* (1884). This was 'London as an immense, sprawling, rain-drenched metropolis, stinking of soot and hot iron, and wrapped in a perpetual mantle of smoke and fog' with ceaseless activity:

> in warehouses and on wharves washed by the dark, slimy waters of an imaginary Thames, in the midst of a forest of masts, a tangle of beams and girders piercing the pale, lowering

Fig.32 Gustave Doré, **Ludgate Hill**, engraving from Jerrold Blanchard and Gustave Doré, *London, A Pilgrimage* (1872)

Fig.33 Gustave Doré, **Houses of Parliament by Night**, engraving from Jerrold Blanchard and Gustave Doré, *London, A Pilgrimage* (1872)

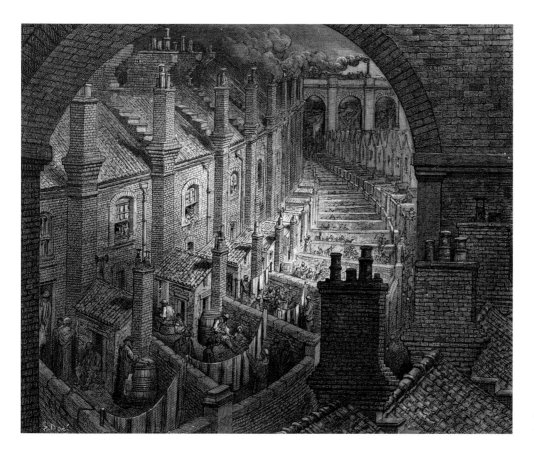

Fig.34 Gustave Doré, **Over London by Rail**, engraving from Jerrold Blanchard and Gustave Doré, *London, A Pilgrimage* (1872)

clouds. Up above, trains raced by at full speed, and down in the underground sewers, others rumbled along, occasionally emitting ghastly screams or vomiting floods of smoke through the gaping mouths of airshafts.[43]

Such overheated description is alien to Monet's art.[44] At the same time, the London Sublime fed his audience's curiosity about London, whose unparalleled commercial might – spectacularly manifest in the dense river and bridge traffic – excited the admiration of French visitors.[45]

The resounding critical and commercial success of the 1904 exhibition of Monet's London paintings squares with the timeliness of their subject matter. For centuries the French had been drawn to England, and the number of French visitors to London increased dramatically during the second half of the nineteenth century.[46] Two contemporary travelogues, which offer striking affinities to the London series, suggest that Monet spoke to a sensibility shared with some of his compatriots. It is telling that each writer viewed his experience in light of the art of Turner, whose example was inspirational to Monet's work in London

(see pp.37–42, above). In *Passé le détroit* (1895) Gabriel Mourey wrote of how the Thames and its ever-changing atmosphere brought to mind the English Romantic painter: 'Fog, smoke and speed [*sic*]: Turner's masterpiece appears before my eyes.' The description that follows foretells the effects that Monet would work so hard to capture beside the Thames:

> Minutes ago, the sun, a melting creamy disc, seeped out in yellowish streaks, scattering reflections like dirty snow . . . And then it disappeared once again, and everything became drab and dismal . . . Once again the sun blazes forth, piercing the fog. The water acts as a mirror, its large sheets of liquid lead streaked with gold. A fairyland rises from the waves, everything turns to colour and sings in an apotheosis of light.'[47]

Two years before the exhibition at Durand-Ruel's another visitor, Emile Pierret, recalled his startling conversion while viewing the Thames: 'And Turner, whom I found excessive in Paris, I found true to nature on Westminster Bridge.'[48] While he wrote with Turner in mind, Pierret's description shows an appreciation of the effects that Monet captured in his paintings of the river and its polluted atmosphere. The author marvelled at the way in which the setting London sun cast its final ray:

> This ray did not illuminate a particular point in the landscape as we are accustomed to seeing it do in our country, but spread out in endless layers, emerging from a cloud only to be swallowed up by the fog. A London fog is very different from the others: the transparent smoke is soft and floating, while at the same time thick and luminous.[49]

To these unfamiliar testimonies can be added the famous example of the artist's friend, Stéphane Mallarmé (see pp.167–8, below). As John House has indicated, Mallarmé's aesthetic

Fig.35 **Sancta Nicotina Consolatrix: The Poor Man's Friend**, wood engraving, *Punch*, 30 January 1869

THE "SILENT HIGHWAY"-MAN.
"Your MONEY or your LIFE!"

Fig.36 **The 'Silent Highway'-Man. 'Your Money or your Life!'**
wood engraving, *Punch*, 10 July 1858

OUR NASAL BENEFACTORS.

Is it true, we wonder—it should be, if it isn't—that with the view of ascertaining the exact state of the Thames, the Government have sent out a Smelling Expedition, for which service none but the sharpest-nosed M.P.s were allowed to volunteer? As we are always anxious to avoid misstatement, we should be glad, if we are wrong, to be officially corrected; but we have heard that, with the knowledge of the perils of the trip, it was agreed, that only the unmarried members should be suffered to embark on it. Lest widowhood result, none but single men were accepted for the

Fig.37 **Our Nasal Benefactors**
wood engraving, *Punch*, 10 July 1858

goals are akin to Monet's pursuit of what the artist referred to as the *enveloppe* – the palpable atmosphere through which a motif could be imbued with a tonal unity at once mysteriously elusive and sharply evocative of a particular and transient visual experience.[50] Among the thickly atmospheric paintings of Monet's late career the London series stands out as particularly close to Mallarmé, given the poet's affection for London fog. A *lycée* English teacher, Mallarmé sojourned in London as a student (1862–3). Foreshadowing Monet's opinion, he wrote to his friend Henri Cazalis at the outset of his visit, 'I hate London when there is no fog: in the fog it is an incomparable city.'[51]

It is telling that in the same letter, Mallarmé professed his total devotion to art: 'there is nothing as true, as immutable, as great, or as sacred as Art.'[52] Like Monet, Mallarmé harboured a devotion to art so uncompromising that his delight in the fog was undiminished by the pollution it carried. And he was well aware of the ill effects of London air, having been stricken with a cough upon arrival. 'In my room,' he complained to Cazalis, 'the coal asphyxiated me, and if I were to open the window, the dirty November fog would fill my lungs.'[53]

In 1864, Mallarmé nostalgically recalled the smoky air of London, and its appealingly elegiac associations, in his prose poem 'Le Pipe':

Yesterday I found my pipe as I was dreaming of a long evening of work, of fine winter work . . . Barely had I drawn a first puff than I forgot about the great books to be written; instead, amazed and strangely moved, I inhaled last winter which began to come back . . . and suddenly the whole of London, London as I had experienced it on my own for a year, reappeared. First of all those dear fogs which muffle up our brains and have over there a special smell when they seep under the window.[54]

Like Monet's relentless efforts to capture the fog's ever-changing nuances, Mallarmé's fond association of tobacco smoke with the air of London has a distinctly French air of aesthetic detachment. This Gallic flavour is brought salience when contrasted with a *Punch* caricature, 'Sancta Nicotina Consolatix: The Poor Man's Friend' (fig.35).[55] Tobacco smoke – enjoyed in foggy London by Mallarmé and Monet – is here distributed as a balm to a stunted

urban multitude amid the darkness issuing from countless chimneys, a landscape as inhospitable as those later imagined by Doré and Huysmans. Such moral earnestness was characteristic of the Victorian response to issues of public health and pollution; and the anti-Catholic resonance of 'Sancta Nicotina Consolatix' serves as a reminder of the uncompromising Protestantism that shaped the British view of degradation of the environment.

An extreme example is provided by Ruskin's 'Storm Cloud of the Nineteenth Century' (1884). Deeply troubled by the 'plague-winds' blowing into the lake country, Ruskin distinguished these 'plague-winds' from fog – the former blanching the sun, while the latter reddened it. Ruskin maintained that whereas the 'plague-wind' was thoroughly polluted, London fog was not intrinsically foul. Defilement of the fog was the wicked work of men: 'in a London fog the air itself is pure, though you choose to mix up dirt with it, and choke yourself with your own nastiness.' Adopting a prophetic posture, Ruskin associated the phenomenon with the blasphemy, iniquity, and injustice of his nation: 'Of states in such moral gloom every seer of old predicted the physical gloom.'[56]

This passage seems less eccentric when placed within the British tradition from which it sprang: the moralising discourse of Victorian sanitary reform. At the raging centre of this movement was the Thames, which served London both as water supply and sewer.[57] While Parisians relied, into the early twentieth century, on regular servicing by cesspool cleaners, London privies had been permitted since 1815 to connect to sewer lines bound for the Thames; such connections became obligatory in 1848. The volume of effluent was increased by water-propelled toilets, invented in the eighteenth century and increasingly common in the Victorian age. Until the construction of the London sewer system (begun in 1859, opened in 1865, fully completed in 1875), under the direction of Sir Joseph Bazalgette – which shifted the problem downstream, to the outfalls at Crossness and at Barking Creek – Thames pollution was a pressing issue for the capital.[58] By 1857 the Thames was receiving some two hundred and fifty tons of fecal matter daily. To this was added the refuse of soap manufacturers, tanners and other riverside industries. Unlike the lazy Seine, which flows steadily through Paris unaffected by tide, the Thames runs through London as a tidal river. In the nineteenth century sewage returned to London on the flow, while the ebb revealed

stinking mudflats, probed by ragged children ('mudlarks') for coal and wood spilled by passing boats, and raked by shore workers (also known as 'shore men' or 'toshers') seeking marine hardware.

Thames pollution became critical during the hot summer of 1858, ignominiously remembered as the 'Great Stink'.[59] Jokes about the condition of the Thames filled *Punch* that fetid summer. Typical was the report that a Mr Cooke had been commissioned by the government for a view of the Thames, *A Sniff of the Slimy*, to serve as pendant to a work titled *A Sniff of the Briny*.[60] Professing concern for the painter having to perform 'so perilous a service,' the humorist described the artist's preparation: 'a pailful [*sic*] of Thames water is every morning placed within nose-shot of his studio, and he is thus becoming gradually accustomed to the smell of it.' The foreground (or 'fore-filth') will feature 'the small steamboat which was chartered by the Government upon a nosing expedition, and sent out with the view of ascertaining if the Thames were in reality as black as the *Times* has lately painted it'.[61] It was to honour the 'nasal gallantry' of those who undertook such an expedition that *Punch* proposed the creation of an 'Order of Nasal Valour' (fig.37).

This humour drew nervous laughter. Mid-century medical wisdom held that disease was caused by miasma, foul-smelling vapours born of decomposition. Illness was viewed as a rot of the body that could be picked up from putrid air. According to this 'zymotic' paradigm of infection – lent prestige by the German chemist Justus von Liebig and generally embraced until Louis Pasteur's ideas prevailed in the 1880s – the odour that made life in London so unpleasant was fraught with pestilence. With an unsmiling sobriety reserved for topics of particular national concern, 'The "Silent Highway"-Man' featured in *Punch* in 1858 (fig.36) gave skeletal form to the fears that had taken hold of a city thrice visited by cholera between 1831 and 1854. As a precaution, the windows of the new Houses of Parliament were draped with canvas soaked in chloride of lime.

In accord with the moral perspective of Victorian Britain, filth was associated with bodily sin. Disease, according to a sermon preached by Charles Kingsley in 1849, came as punishment for 'our sins of filth and laziness . . . foul air, foul food, foul drains, foul bedrooms. Where they are, there is Cholera.'[62] While the faith of this cleric and author was uncommonly strong, the association of filth and disease with moral corruption was – as

Susan Williams has demonstrated – a Victorian commonplace.[63]

Two years after the Great Stink, Whistler began work on a painting conceived as an amoral echo of the Victorian association of physical and moral pollution. *Wapping* 1860–4 (no.26) represents the seamiest section of the commercial Thames, whose turbid waters provide the setting for what was originally conceived as a burlesque encounter between a sailor and a prostitute.[64] It is a remarkable indication of Whistler's taste for low life that he chose to paint and etch around Wapping at this time. During the summer following the artist's move to London from Paris in May 1859, the river flowing past this seedy stretch of shoreline reeked nearly as much as it had during the Great Stink of 1858. Nor was Whistler prepared for this by his recent stay in Paris. Nineteenth-century visitors to Paris complained of the city's foul odours, but Seine pollution did not become a public issue until the beginning of the Third Republic, when industrial effluent and stench carried by the new sewer system began to cause general alarm. Prior to the completion of Baron Haussmann's collector sewers in 1868, the river ran though the capital as an open sewer: but this natural sewer, like those built by Haussmann, largely carried surface drainage and street sweepings.[65] While the Seine stank, both before and after the new sewers were built, Parisians never knew the level of olfactory horror visited upon London during the Great Stink. In addition to the calamitous practice of channelling cesspool effluent directly into the Thames, one must consider the population of the British capital. Some ten times larger in area than its more densely populated French rival, nineteenth-century London far surpassed Paris in its rate of population growth.[66]

In the Nocturnes of the 1870s, Whistler left behind the turbid waters of *Wapping* by daylight to explore the subtle pleasures of sunless, foggy views of the Thames. From 7 Lindsay Row, the artist's address since March 1863 – a short distance from Rossetti's, just west of the end of Old Battersea Bridge and close to the house in which Turner died – Whistler lived in view of the industrial riverfront featured in the Nocturnes. Whistler's house faced a manufacturing ensemble dominated by the Morgan Crucible Company (see no.33). Mindful of this unlovely setting, we can appreciate at once the continuity between the Nocturnes and *Wapping,* and the artist's ingenuity in crafting such loveliness. The Nocturnes imbue features of the smoggy Thames twilight that

contemporaries considered unsightly or unseemly – whether the ungraceful silhouette of Battersea Bridge or the lights of lustful Cremorne Gardens – with the delicacy of Japanese woodblock prints. The fascination with the evening fog's capacity for metamorphosis, articulated in Whistler's famous evocation in the 'Ten O'Clock' lecture of chimneys changed into campanili, unexpectedly recalls a contemporary strain of middlebrow humour. A *Punch* caricature showing the transformation by fog of two ordinary men into ominous spectres suggests that reference to the fog's surprising alchemy was common Victorian currency (fig.38). Like Monet and Mallarmé, Whistler's appreciation of the effects of London fog was undiminished by its notorious threat to health. A reminder of this was provided by Whistler's coughing mother, whose move into her son's Thames-side residence brought her chronic respiratory infection.

Whistler's attachment to his 'lovely London fogs' was such that he waxed nostalgic for them in Venice.[67] Recollections of the fog-bound Thames haunt the Nocturnes that he painted in that city of light and colour. The link between Whistler's work in the two cities is not solely a question of an ongoing preoccupation with tonal values. There were aspects of Venice that resonated with his Thames experience. Both locations spoke to his curiosity regarding waterside landscapes in transition and decay. At the same time that the distinguished Venetian past appealed to Whistler's reverence for traditions of artistic excellence – as in his attraction to Japanese prints, the painting of Velásquez and the draughtsmanship of Ingres – the dilapidation of Venice, like the grit of Wapping, removed the Italian city from the blighting influence of the conventions and sentimentality of the art of his time.[68]

There is another way in which the Venice of 1879–80 would have struck a familiar urban chord: it smelled. I am not thinking of the canal stench frequently complained about by British visitors at mid-century – around the same time that European doctors were prescribing the therapeutic Venetian winter air for consumption and other respiratory ills.[69] Such complaints arose in the warmth of the late summer and early autumn. Whistler's visit saw the coldest weather in some thirty years, and his letters home, full of griping about being frozen, say nothing about canal odour. There was another aroma that any late-nineteenth-century visitor to Venice could not help but experience in any season:

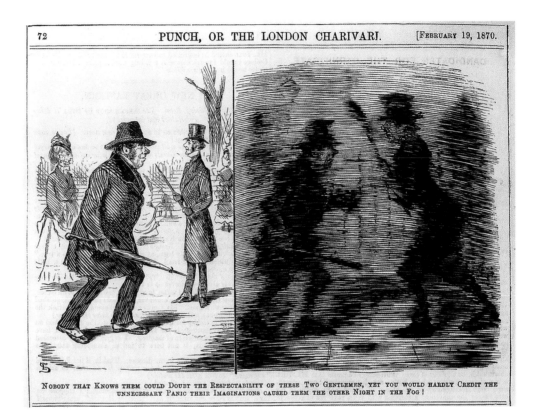

72 PUNCH, OR THE LONDON CHARIVARI. [FEBRUARY 19, 1870.

NOBODY THAT KNOWS THEM COULD DOUBT THE RESPECTABILITY OF THESE TWO GENTLEMEN, YET YOU WOULD HARDLY CREDIT THE UNNECESSARY PANIC THEIR IMAGINATIONS CAUSED THEM THE OTHER NIGHT IN THE FOG !

Fig.38 **Nobody that Knows them Would Doubt the Respectability of these Two Gentlemen, yet you Would Hardly Credit the Unnecessary Panic their Imaginations Caused them the Other Night in the Fog!**
wood engraving, *Punch*, 19 February 1870

sulphurous coal smoke. And this was so familiar to Whistler that it hardly merited comment.

As Alastair Grieve has indicated, the Venice of Whistler's time was significantly impacted by pollution.[70] Indeed, during the nineteenth century Venice was a major European industrial centre.[71] While central Venice remained relatively free of industry, there was substantial activity at the periphery. Coal consumption was hardly limited to the locomotives that had been puffing into the city since the construction of a railway bridge in 1843. Whereas, in the 'Ten O'Clock' lecture, Whistler delighted in the transformation of Thames-side chimneys into campanili, nineteenth-century Venice saw the campanile of the former church of San Girolamo converted to a steam-engine chimney. A mid-nineteenth-century engraving (fig.39) records this odd landmark which startled tourists by emitting smoke instead of chimes.[72]

In the early 1840s a French firm opened a gasworks which, by the end of the 1860s, was consuming, annually, approximately 10,000 tons of English coal and 2,400 tons of coke. To this was added the effluent from a substantial number of blacksmiths and mask makers, whose furnaces had been in use long before the advent of the steam engine.[73]

Whistler arrived in Venice at the cusp of a major leap into industrialisation. Commencing in the 1880s, this development was accompanied by a relaxing of the air pollution regulation that dated back to French control in 1810, and which had been continued under Austrian rule. Like Victorian Britons, Venetians associated ill-health with miasmatic exhalations from organic material.[74] Consequently, it was not smoking chimneys that concerned them, but rather two manure plants on the Giudecca, which were ordered to be shut down in 1883.[75]

Fig.39 Giovanni Pividor, **Former Church of San Girolamo, Venice, after conversion to a Steam-Powered Mill** *c.*1850, engraving.
Musei Civici Veneziani, Venice

Toughened by his London experience, Whistler remained unruffled and made no mention of odour in his letters home. On the contrary, he wrote to his mother of how, in the aftermath of wet weather:

> the colours upon the walls and their reflections in the canals are more gorgeous than ever – and with sun shining upon the polished marble mingled with rich toned bricks and plaster, [this] amazing city of palaces becomes really a fairy land – created one would think especially for the painter . . . One could certainly spend years here and never lose the freshness that pervades the place![76]

Such undistracted joy strikes a common chord with the scorn expressed by Henry James in 1882 for jaded tourists who focused on the fact that the canals stank.[77] For refined sensibilities, there were pleasures to be had in the Venetian contrast between decay and pedigreed refinement.[78]

Venetian industry makes a peripheral appearance in a few of the products of Whistler's trip, notably the plume of smoke rising from the Giudecca in the etching *Upright Venice* (K 205).[79] More significantly, the polluted air of Venice provided the dense atmospheric ambient of some of the pastels, in which buildings and shore are atomised in the cold light of a soot-charged sunset.[80]

The industrialisation of Venice had progressed significantly by the time that Monet arrived in late 1908. The Giudecca now had a major concentration of factories, including a huge, smoke-belching pasta factory, built in 1896 by the Swiss industrialist Stucky at the western end of the island.[81] This is not far from San Giorgio Maggiore, which sits off the eastern end of the Giudecca. Given this environmental context, it is not difficult to square the intense hues in Monet's painting of *San Giorgio Maggiore at Dusk* (no.106) with the artist's commitment to on-site observation.

Guided by distinct artistic temperaments, Monet and Whistler exploited different aspects of nineteenth-century urban pollution. In the muffled Thames-side light Monet sought extraordinary combinations of hue, which offered the affluent buyer the riches of a well-tended garden. In the twilit fog of the Nocturnes, Whistler's nuanced tonal range subsumed a poignant tension between urban toughness and aesthetic subtlety. His delight in urban decay stemmed from an aspect of French Realist art and Naturalist literature in which Monet was uninterested.

Monet, by contrast, appreciated the transient effects of illuminated fog with an eye keened by a lifetime as a *plein-airiste*. Lacking Whistler's taste for slumming, Monet viewed the fog-bound Thames with as little sign of concern for environmental degradation as when he painted the factory chimneys and impure Seine at Argenteuil in the 1870s.[82]

Whereas the cosmopolitan Whistler was apparently aware of the Victorian association of the polluted Thames with bodily sin – and, in *Wapping,* he recast this British theme with French Realist cool – there is no evidence that Monet was aware of the moral and religious urgency with which Victorian sanitary reformers viewed the degraded urban environment. That distinctly British point of view was informed by the national legacy of Natural Theology. According to this perspective, nature is a work of divine design, and the study of the natural world complements revelation as a pious means to approach the divine will. The subject of some excellent works in the history of science[83] – but rarely mentioned in the art-historical literature – Natural Theology guided the study of nature in Britain between the late seventeenth century and the publication of Darwin's *Origin of Species* in 1859; and it remained tenaciously vital in popular science writing long afterwards. Such sentiments had little presence in nineteenth-century France, with its Enlightenment heritage of conflict between faith and rational inquiry. It is the legacy of Natural Theology, as well as the earlier and more serious pollution of the Thames, that imbued the state of London's river with an evocative urgency unparalleled in France. Thus there is no French equivalent to either the British Sanitary Reform Movement or to the emotionally charged art and literature provoked by the Victorian environmental crises. The Thames was a source of shame for the seat of an empire recently traumatised by the

Indian Mutiny, and the Great Stink of 1858 forced parliament to provide a legislative mandate for the construction of Bazalgette's sewers.[84] The Seine, in contrast, was so potent a symbol of French pride that Haussmann had to struggle to overcome his compatriots' preference for its waters over those of distant springs.[85]

While the visible, atmospheric effects of nineteenth-century pollution most evidently impacted the art of Monet and Whistler, it is important to bear in mind that the smells that surrounded these artists were not without effect. As Alain Corbin has demonstrated, response to smell has a culturally contingent history.[86] Whistler's attraction to the polluted Thames indicates the extent to which he was willing to delve into the most rebarbative features of modern urban experience. Monet grew up breathing the bracing salt air of the Normandy coast. That this master of delicious culinary still life and fragrant floral landscape was willing to leave Giverny for the sulphurous fog of London speaks to his uncompromising devotion to his art. Underlying this hard-fought accomplishment was a tenacious commitment to working from direct observation, even when – as in the case of the London and Venice paintings – his canvases were completed in the Giverny studio. This Realist foundation was acknowledged by Octave Mirbeau when, in his truculent introductory essay for the catalogue of the 1904 exhibition of the London paintings at Durand-Ruel's gallery, he blasted the critics Charles Morice and Camille Mauclair for their Symbolist demand that Monet freight his visual experience with philosophical baggage. Expressing amazement at his friend's seemingly miraculous ability to render such 'splendid and magical lighting effects'[87] from the polluted air of London, Mirbeau inadvertently touched on a capacity shared by Monet with Whistler and Turner: each wrought enduring art from tainted air.

Catalogue

Authorship of the catalogue entries is indicated as follows:

IW Ian Warrell KL Katharine Lochnan
JH John House SP Sylvie Patin
JR Jonathan Ribner ST Sarah Taft
JS John Siewert

Dimensions are given in centimetres, height before width.
For prints, measurements refer to the image size.

Turner's legacy: the artist's bequest and its influence

Ian Warrell

When Turner died in December 1851, his high standing as 'the greatest landscape-painter of the English school', and perhaps 'of any other – ancient or modern', appeared reasonably assured.[1] His close and long involvement with the Royal Academy meant that he was the most revered of its recent members, while his intention that the finished pictures he had hoarded in his studio would form an adjunct to the national collection, as a distinct Turner Gallery, seemed a certain means of ensuring that his achievement remained at the heart of British art. Within a decade, however, the legacy he had worked so diligently to effect had been only partly realised, its implementation delayed by an extended legal dispute over his will and its various codicils in the Court of Chancery, which was then compounded by the unwillingness of an overly prudent government to support his munificence with the outlay for a building to house the collection. In a typical rhetorical flourish, Ruskin summarised the position in 1856, protesting that the nation's greatest artist had been buried 'with threefold honour, [Turner's] body in St Paul's, his pictures at Charing Cross, and his purposes in Chancery'.[2] It was all a very British way of commemorating one of its heroes, and continues to have ramifications more than one hundred and fifty years later. Consequently, far from representing a constant reference point during this period, Turner's life and art have undergone major fluctuations of esteem and re-evaluation, of discovery and reinterpretation, each stage of which was determined by the ever-expanding range of his works available for all to see.

From his earliest successes of the 1790s onwards Turner experienced these fickle reversals for himself, seeing his pictures celebrated and reviled in equal measure. Although he claimed he was largely indifferent to such attacks, he was undoubtedly aware that many of those who conceded his significance to the achievements of British landscape painting remained critical of the lack of precision in his handling, of the indistinctness that became the trademark of his mature work.[3] Never altogether lacking supporters who were prepared to defend his work, he was, nonetheless, by the 1840s out of step with the much greater emphasis on fine draughtsmanship which underpinned contemporary practice, and it was therefore a great boost to his beleaguered reputation when, in 1843, Ruskin published the first of his five volume defence of Turner: *Modern Painters*.[4] Despite the fact that it was somewhat partial in its understanding of the range of Turner's art, ignoring his engagement with contemporary themes, this book contributed substantially to the revival of interest in the artist during his final years, and in its modified version of 1846 became a crucial text for all later admirers. The knowledge that Ruskin was himself a collector of Turner's works, and that the two men were personally acquainted, lent his writings an unrivalled authority, and he was thereafter invariably seen as 'the great exponent of Turner's genius'.[5]

It should be noted that the accuracy and validity of Ruskin's pronouncements did not always go unquestioned.[6] Yet the force and beauty with which he wrote about his hero, and moreover the inordinate extent of these opinions, generally overwhelmed any opposition, from whatever source, in the art world. Indeed, even though Whistler's libel trial of 1878 constituted an important challenge to his influence, it was not really until the turn of the century, when Ruskin himself was being evaluated after his death in 1900, that a new generation was prepared to look again at Turner without the lens so lovingly crafted by his most ardent admirer. Writing in 1903, for example, the foremost Turner scholar A.J. Finberg noted that: 'To this day Turner's works are obscured by the cloud of [Ruskin's] words.'[7] With the benefit of hindsight he was in a position to see how Ruskin had in some sense become synonymous in the public mind with his subject, and though this was unintentional, it was nevertheless a perilous eclipse. This is an acute observation that is borne out in the experience of many nineteenth-century gallery goers, who first encountered Turner's works through Ruskin's exultant and poetic word-pictures, and who then found the originals somehow uninspiring, or bewildering and, therefore, frustrating. In such circumstances, his effusive praise was like 'a red rag to a bull'.[8] And, in fact, as Finberg concluded, 'The unwise zeal of Ruskin goaded envy, dullness, and sometimes, it must be admitted, common sense to the countercharge.'

Much earlier, Turner had himself attempted to restrain Ruskin's enthusiastic applause, which insensitively pitted him against his friends and colleagues, and isolated him from the playfully competitive associations that he so evidently enjoyed. For in reality Turner's ambition to be accepted as a great artist, as epitomised by his bequest, was founded not on an idea of self-contained genius, but on a lifelong series of vital dialogues with

No.4 J. M. W. Turner **Mortlake Terrace: The Seat of William Moffatt, Esq.: Summer's Evening** (detail)

artists both living and dead. As the National Gallery already included contemporary pictures at the time he drew up his first will, including examples by his sometime rival David Wilkie, he clearly felt that he would there be guaranteed the multiple contexts he desired.

Even before his death, the representation of pictures by contemporary artists was consolidated by Robert Vernon's bequest of 165 art works, which was accepted by the National Gallery at the end of 1847. This included four by Turner, dating from 1832 to 1842, which were the first of his paintings to go on permanent public display as part of the collection (see nos.14, 99).[9] Though he had by then repeatedly honed his will, the central desire to leave the gallery many of the pictures with which he had established his reputation remained essentially unchanged.

Sadly, the matter was not as easy to conclude as he had supposed, and accordingly the intricacies of his will were slowly unpicked by lawyers during the five years after his death, resulting in a decision in March 1856 that satisfied no one, except perhaps Turner's collateral relatives who received a bigger share of his capital than they might have done otherwise.[10] Most significantly, the protracted case, which threatened to exceed even the lengthy familial dispute of *Jarndyce* v. *Jarndyce* in Dickens's *Bleak House* (1851–3), ultimately resolved that the nation would receive anything in Turner's studio considered to be by his own hand. This greatly surpassed the hundred or so oil paintings he had envisaged going to the National Gallery, and embraced a further two hundred sketches in oil, plus around twenty thousand works on paper. The majority of the latter were pencil sketches, contained in around three hundred notebooks. A much smaller percentage of the collection was made up of the exquisitely detailed watercolours prepared as the basis for sets of topographical prints, such as the *Rivers of England* or *Turner's Annual Tour*, along with most of the original designs for the *Liber Studiorum*, though the majority of the finished drawings had been sold soon after they were painted. There were also numerous portfolios of broadly painted colour studies from all periods of his career, created by Turner to test his palette, to set out compositions, or simply for his own pleasure.

As the recipient of this huge body of work, the National Gallery was perhaps less excited than it might have been by a more focused selection. The problem was a fundamental lack of space. At that date the gallery occupied only five rooms in the western wing of the existing building in Trafalgar Square, the eastern half of which was inhabited by the Royal Academy until 1868. Thus, it scarcely had sufficient room to display its growing collection of old masters adequately, and by 1850 had already been forced to exile the recent Vernon bequest to Marlborough House, at the other end of Pall Mall. Furthermore, it had no policy of collecting or displaying works on paper, because drawings and watercolours were seen as the preserve of the British Museum. Its Keeper, Ralph Wornum, referred to the sketches as 'mostly quite superfluous, and an annoying incumbrance'.[11] The unresolved nature of much of the material was also an issue, as it was felt that few, except other artists, would find Turner's sketches intelligible.

After its removal from Turner's dilapidated gallery in Queen Anne Street in October 1854, the badly maintained collection had languished in the basement of the National Gallery, though somewhat earlier, in anticipation of the resolution of his will, the two pictures Turner had asked to be hung between landscapes by Claude had gone on display in December 1852 (see no.2).[12] With the passing of the decree by the Court of Chancery, pressure mounted during the second half of 1856 for the other paintings to be exhibited, but it was not until November that the first twenty had been prepared for public view at Marlborough House, to which a further fourteen were added by the end of the year.

The autumn of 1856 had also seen the beginnings of a concerted campaign by Ruskin, which drew attention to the much bigger problem of making the watercolours and sketches accessible. In a letter to *The Times* on 28 October he offered to arrange the material so that it would present 'a perfect record of the movement of the master's mind during the whole of his life'.[13] But the Trustees at that stage were still in some confusion as to whether they were legally responsible for this part of the bequest. Once this was resolved, it was quickly decided that the room in Marlborough House given over to Turner's pictures should be fitted out with screens, and by early February 1857 these were densely hung with the 102 finished watercolours in the collection, which quickly became a popular attraction.[14]

Anticipating that such an arrangement might become permanent, to the detriment of the light-sensitive works on paper,

Ruskin had proposed a method of storing the watercolours and related sketches in frames within wooden cases so that they could be examined individually by students, while a changing selection would be available at any moment on the walls. Surprisingly, at this stage the gallery's director, Sir Charles Eastlake, did not rush to take up the offer, even though Ruskin proposed to pay for the costs of developing the prototype of the casing he wanted to introduce. Eastlake's apparently dilatory response can be attributed to a personal antipathy to the writer, which was exacerbated by Ruskin's presumption in publishing a catalogue of the group of oil paintings on display, which pretended to be an official publication, but which contained criticism of the gallery's policy.[15]

Personal differences were eventually put to one side, and in February 1857 Ruskin was allowed to demonstrate how his system might work. He did this with a selection of one hundred of Turner's final sketches, which he arranged as a tour to Venice, passing through France, Germany and Switzerland.[16] Each study was to be mounted under glass, and framed in light pine for ease of movement. A catalogue was prepared, providing a commentary on each item, and the reader was able to identify the framed work in question by an ivory tablet bearing the relevant number.[17] When he showed this system to the gallery's Trustees in June the plan was readily accepted, but contrary to the impression given by Ruskin's catalogue, the group was never actually exhibited together and was mostly afterwards absorbed into the reference series of finished drawings, stored in cabinets, which were available on application.

Privately, Eastlake had, in fact, resolved on a much more ambitious implementation along the same lines back in February. Now convinced of the efficacy of this approach, he invited Ruskin to continue his work in order to prepare the much bigger survey of the sketches originally outlined. After an intensive period of great industry, Ruskin's new series of ultimately 338 drawings, arranged chronologically, began to go on show in late October, accompanied by a catalogue which stressed Turner's technical facility, and the preliminary nature of the studies.[18] This was a necessary point, for up to this date such rudimentary works had not been displayed publicly. Consequently this selection, together with contemporary displays at the British Museum, and the subsequent practice of exhibiting sketches at the Society of

Painters in Water-Colour from 1862, can be seen to pave the way for the looser aesthetic of the 1860s.

Significantly, Whistler was in London in the autumn of 1857, while the watercolour display at Marlborough House was undergoing this temporary state of flux. He could, nevertheless, have seen there over a hundred of the bequest's oil paintings, including a handful of unfinished works, such as *Chichester Canal* (no.10), *Fire at Sea*, and *Mountain Glen*, which clearly amazed French visitors like the critic de Pesquidoux.[19] Whistler's real objective was the vast *Art Treasures* exhibition in Manchester, which included many works by Turner from private collections, amounting to some twenty-four oil paintings and an extraordinarily comprehensive selection of eighty-three finished watercolours, in which many of the highlights came from the *Picturesque Views in England and Wales* series (1825–39), though there were also a couple of the late views of Switzerland.[20]

During the following months Ruskin continued to sift the huge collection of sketches, and his new cabinet series was hence not fully installed at Marlborough House until May 1858. Typically, it was not to remain in place for long, since the grand town house was required for the Prince of Wales. New galleries for the Vernon and Turner bequests were therefore prepared at the South Kensington Museum (the precursor of the Victoria and Albert Museum), which opened to the public as the National Gallery, British School, in December 1859 (fig.40). The importance of this as a study collection was underlined in the fact that three days and one evening were given over to art students, while the general public were admitted on the other three days, as well as on two evenings. In the advance publicity, the press announced that the sequence of three rooms filled with paintings and sketches showed 'Turner as probably no other landscape painter has ever been seen'.[21] But, though the display was hitherto the most inclusive and well devised, it is possible that Wornum, who oversaw this process, followed Ruskin's recommendation, and suppressed some of the pictures that they both felt did Turner's reputation no good.[22]

Inevitably, the new display heightened interest in Turner's work, benefiting, in particular, the engravers who had worked closely with him during his lifetime. Several of these men were engaged to reproduce his paintings in the *Art Journal* between 1859 and 1861, a long series that was afterwards bound up as

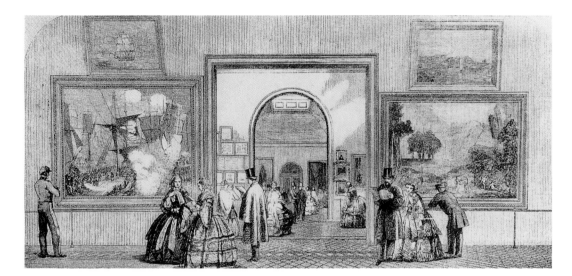

Fig.40. **The Turner and Vernon Rooms
in the South Kensington Museum**
*c.*1859–62
Woodcut, *Illustrated London News*,
4 February 1860

Turner's Gallery with an accompanying text by Wornum.[23] It was also around 1860 that some of the *Liber Studiorum* drawings were photographed to answer the demand created by Ruskin's recommendation of them as exemplary reference models in his manual, *The Elements of Drawing* (1857).[24]

With the tenth anniversary of Turner's death rapidly approaching, concerns were raised in May 1861 that the display at South Kensington, though administered by the National Gallery, was not actually within its building, and did not actually meet the legal requirement that Turner's pictures be accommodated alongside the main collection in Trafalgar Square within ten years. So, in order not to forfeit them, plans were made, yet again, for a new display, even though the gallery's wall space was more constrained than ever. The related problems were discussed by a meeting of a Select Committee of the House of Lords in July. Among the evidence it considered from its expert witnesses are two issues of special interest in this context. Eastlake claimed that Turner had never envisaged the entire collection being shown at any one moment, which prompted Lord Overstone to wonder whether there were areas that could be trimmed. 'Are not some of the unfinished pictures of great importance in art?' he asked provocatively, to which Eastlake gave an unequivocally affirmative response, even though he felt the distinction between them and

the works Turner had actually exhibited was lost on the public, which was perhaps the reason no more had been added to the display after its first move.[25] The artist-administrator Richard Redgrave was also questioned, in his case about the watercolours, for he had lamented the fact that there was no permanent display of Turner's best work in this medium, especially in view of the widely accepted idea that he was the 'father of water-colour art in this country'.[26] By this he clearly relegated Ruskin's selections of pencil outlines and colour studies to a secondary function, as illustrations of Turner's process, not of his fully resolved achievements.

By October the oil paintings were back at Trafalgar Square, with more than ninety of them somehow crammed together in the West Room. The series of nearly 200 framed sketches, however, was retained at South Kensington, while all the other watercolours, arranged in mahogany cases, were stored in a basement room at the National Gallery, where they were only available on request. Having satisfied immediate concerns about the potential loss of the collection, this dispensation remained largely unchanged until 1869.

Although these years were a reprieve for the paintings from their peripatetic wanderings, it was at this time that Turner's reputation suffered a major blow in the form of the biography

Fig.41. Henry Edward Tidmarsh,
Interior View of the National Gallery Showing Two Copyists in the Rooms in the Basement Given Over to Turner Watercolours c.1883
Bodycolour wash on paper
102 × 133 cm
Guildhall Library Main Print Collection, London

written by the opportunist journalist Walter Thornbury. Seemingly encouraged by Ruskin to adopt a thoroughly prurient investigation of Turner's 'dark side', Thornbury shocked his teetotal, mid-Victorian readers with allegations of drunkenness, evidence of illegitimate children, as well as unfounded tittle-tattle insinuating debauchery in brothels at Wapping.[27] Such stories were the price of Turner's secretive existence during his life, which only he could have checked, and though friends rallied to his defence, Ruskin remained aloof from all this, actually congratulating Thornbury on his book.[28] He had earlier been horrified by various erotic sketches that documented Turner's actively sensual nature, and these had been responsible for the more qualified exploration of the artist's work found in the final volume of *Modern Painters* (1860).[29] Aware that this side of Turner's personality threatened to jeopardise the heroic claims he had previously made for him, Ruskin attempted to create a distinction between the man and his art. Nevertheless, the anecdote about Turner's lost weekends in Wapping (which he had probably frequented in order to collect the rent on property he owned there) was repeatedly retold among the younger generation, and would have been familiar to Whistler, who was himself fully conversant with the unconventional pleasures of the area (no.26).

After this, the next major upheaval for the bequest came once the Royal Academy vacated the National Gallery building, which was, at last, followed by a period of expansion of the building itself. These were not the best circumstances for a stable display, but the gallery always maintained spaces devoted to Turner's pictures, which were not immediately diluted when all the other works by British artists were recalled in 1876. During Monet's and Pissarro's sojourn in London in 1870–1, for example, two rooms were given over to Turner's paintings, but the Frenchmen would have needed to visit South Kensington to sample his graphic works, unless they had applied to visit the framed series, generally held in reserve, which were made available for the first time at the National Gallery in February 1870, on the lower floor on student days (fig.41).[30] By 1878 these works were a more permanent feature of the eastern rooms, below the public galleries, though visitors were still restricted and were forced to sign in when they arrived.[31] That year Ruskin returned to select drawings that could be sent to Oxford as an instructive series, and he subsequently added more works to the National Gallery's group, fully revising its order to take account of these changes in 1881, and again in 1890.[32]

By the end of the century, when Monet was once more in London for lengthy periods, there was indeed a greater number

Fig.42. Bertha Mary Garnett, **A Corner of the Turner Room in the National Gallery** 1883
Oil on canvas 25.2 × 35.8 cm
National Gallery Archives, London

of works on paper on display in the basement rooms than at any earlier time, which were now 'easily accessible to the public'.[33] However, by that date, around thirty of the core group of oil paintings had been consigned to regional art galleries, and a rump of only about fifty pictures remained on the walls of the West Room, which meant that whereas the overall impact was concentrated in force, it was somewhat diminished in its range. The display, of course, continued to feature masterworks such as *Frosty Morning*, *Hannibal Crossing the Alps*, *Ulysses Deriding Polyphemus*, *The Fighting Temeraire* and *Rain, Steam and Speed*, but only four of the group of ten views of Venice remained, and none of the monochromatic late whaling scenes was displayed.

It was not until the early years of the twentieth century that a younger generation of officials looked at the situation afresh. Given the endurance of Ruskin's system for the preceding fifty years, the collection was ripe for reappraisal. As a result, E.T. Cook unearthed numerous 'hidden treasures' in a series of tin boxes containing bundles of the uncatalogued watercolours, and these and the rest of the collection were shortly afterwards fully listed by Finberg for the first time.[34] Equally exciting was the discovery, among the numerous rolls of canvas that had still not been accessioned, of the magical pared-down images created in the second half of Turner's career, such as the *Evening Star* and *Norham Castle, Sunrise*. When these unfinished studies first went on display at the Tate Gallery (a recently opened outpost of the National Gallery) in 1906 they caused a sensation, seeming to some critics to provide evidence that Turner had anticipated aspects of Impressionism. The normally conservative *Daily Telegraph* went so far as to suggest that Ruskin had perhaps condemned some of the best works in the collection to obscurity, while the French critic Robert de la Sizeranne welcomed the rediscovery enthusiastically.[35]

Regrettably these discoveries came too late for Monet to see them, though news of the revelation they represented would undoubtedly have reached him. Ironically, the Parisian art world had already known at least one example of these dazzling prismatic studies since 1887, when Camille Groult exhibited his group of pictures by (and optimistically attributed to) Turner at the Ecole des Beaux-Arts. *Junction of the Severn and the Wye* (no.22), now in the Louvre, made a huge impact on those who saw it, for its dream-like distillation of light and form, appealing alike to those steeped in the impressionist aesthetic, as well as symbolists like J.K. Huysmans, the Goncourt brothers and Gustave Moreau.[36]

This was clearly not the end of the story, as Turner's pictures have continued to be regularly exhumed, like Pompeian artefacts, until comparatively recently, challenging notions of what was known of his life and how he worked. But even in this summary outline it is apparent that, in spite of the vicissitudes affecting the physical whereabouts of his bequest, the immensity of Turner's legacy never failed to stimulate debate, remaining in view to all successors as an intractable obstacle, to be skirted round, or tackled head on, but certainly not ignored. Its prominence has, in fact, invariably acted as an impetus to the creativity of others, just as Turner himself was inspired by Claude and Titian. And though Whistler and Monet were to some extent ambivalent about the question of his influence on their work, they were not the first to use his conclusions as a touchstone for their own endeavours, and they will not be the last.

Moonlight, a Study at Millbank exh. 1797

Oil on mahogany panel 31.4 × 40.3 cm
B&J 2
Tate, London. Accepted as part of the Turner Bequest 1856;
displayed from 1856

Turner began his public career by submitting water-colours to the annual Royal Academy exhibitions from 1790, when he was only fifteen, but it was not until 1796 that he exhibited any work in oils. Typically, his first essay in this media was an ambitious marine subject, focusing on some fishing boats plying the waters off England's southern coast (*Fishermen at Sea*, Tate, London; B&J 1). Though the difficulty of capturing the motion of the sea was in itself a daunting challenge for a young artist, Turner raised the stakes by choosing a nocturnal effect of pale moonlight to illuminate the scene.

Encouraged by the favourable critical responses he had to that picture, Turner exhibited this small but evocative scene the following year. The subject he selected lay a couple of miles upriver from his home in central London, and was, coincidentally, not far from Chelsea, where he spent his final years. The controlled handling of paint in this strikingly simple image, with its sparkling reflections of moonlight, perhaps confirms that it originates from the earliest, most tentative stages of his work in oil paint, and that it possibly even predates the larger *Fishermen* picture, something that was hinted at in posthumous accounts of his development as an artist. There is, indeed, an uncharacteristically apologetic note to the use of the word 'Study' in the title, though the Academy occasionally featured other exhibits with this kind of designation. The description effectively meant that they appeared as unfinished works which were demonstrative of an artist's potential. A small-scale study like this, for example, might invite a patron to commission the image to be reworked on a bigger canvas. But in other respects Turner's qualification seems unnecessary, at least to a modern eye, as the picture appears to be a complete statement of its theme.

Though these early moonlight subjects dealt with explicitly English subjects, Turner was evidently influenced in his delineation of nocturnal effects by the earlier tradition of Dutch seventeenth-century painters, which had also stimulated the work of Joseph Wright of Derby and William Pether. Despite his success, Turner later expressed a view that he found painting moonlight particularly difficult. He was, however, drawn to it repeatedly in later life when introducing a Romantic mood to his images, especially in the well-known illustrations he produced to accompany the poetry of Samuel Rogers and Lord Byron around 1830 (nos.8, 9).

After Turner's death the picture was a staple part of the displays of his pictures at the National Gallery, though chiefly as a means of demonstrating his rude beginnings. In 1857, for example, Ruskin praised the painting's basis in close observation, but lamented its 'feeble execution, and total absence of apparent choice or arrangement in the form of boats and buildings' (*Works*, XIII, pp.101–2). And a few years later, it was described by the National Gallery's Keeper, Ralph Wornum (1875, p.x), as 'somewhat hard and heavy'. IW

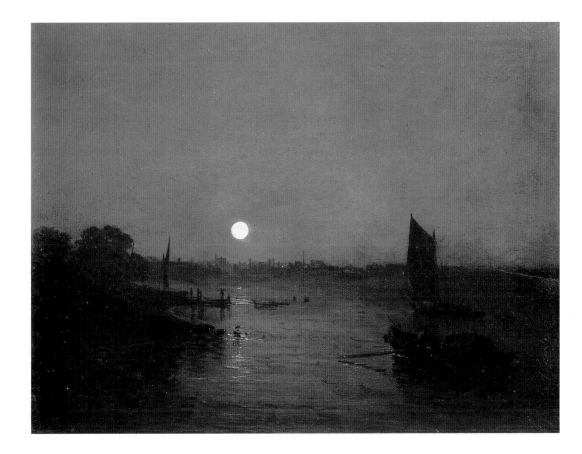

2 J.M.W. Turner

**Sun Rising through Vapour; Fishermen
Cleaning and Selling Fish** exh. 1807

Oil on canvas 134 × 179.5 cm
B&J 69
National Gallery, London. Accepted as part of
the Turner Bequest 1852; displayed from 9 December 1852
EXHIBITED IN LONDON ONLY

By 1807, when he first exhibited this painting, Turner had studied and assimilated the work of a wide range of earlier artists. Those he strove most to emulate were Titian and Claude, but he nevertheless remained an admirer of many Dutch and Flemish painters. The present picture, for example, indicates his high regard for the tranquil images of becalmed vessels by Cuyp and Jan van de Cappelle, at the same time revealing a taste for the patterns created by the interplay of hulls, sails and rigging that he had absorbed from Willem van der Velde. The pile of assorted fish in the foreground is a further detail derived from seventeenth-century Dutch art, echoing the long tradition of sumptuous still-life paintings.

Works by Dutch artists featured in the collections of many of Turner's patrons. Their generally conservative taste undoubtedly incited him to demonstrate that he was the equal of these earlier masters, and his competitive nature was similarly goaded by the most acclaimed work of his contemporaries. Indeed, the exhibition of this and a second picture in 1807 can be seen as a response to the success of the Scottish new-comer, David Wilkie, whose Dutch-inspired genre-painting had been the highlight of the previous year's show. Some of Turner's colleagues were astounded at the overt nature of his rivalry. Sir Benjamin West, the Royal Academy's President, reportedly declared that Turner 'seems to have run wild with conceit'. However, the press were, for once, on his side, and the *St James's Chronicle* asserted that 'This picture is without doubt one of the very best Mr. Turner has ever produced.' The painting also stimulated perhaps the first positive review of his work in a French publication, the *Magazin Encyclopédique*, though the critic's concluding comment perhaps arises less from the imprecision of the brushwork and more from the prevailing disdain among the reviewer's compatriots for the painterly handling of the English school: 'The inventiveness of this picture is quite good; the fog which fills the atmosphere, and which seems to disperse at the approach of the sun, is accurately rendered, but in general the execution is negligent.'

The picture was owned for some years by Sir John Leicester, who built up an important collection of contemporary paintings. From his correspondence with Turner it is evident that the artist insisted that the title make reference to the specific atmospheric effect he had painted, even if 'Mist' or Haze' were used to describe what can be seen, instead of his own preferred word 'Vapour'. When Leicester died in 1827 his estate was sold, and Turner then bought back the painting for 490 guineas, paying 140 guineas more than he had received for it only nine years earlier. This is a clear indication of how much he valued it as one of his *chef-d'oeuvres*. Yet it was not until 1831, when he revised his will of 1829, that he stipulated that it was to be one of two pictures he would leave to the National Gallery, on condition that they hung between paintings by Claude. This revision provided greater variety than his original idea of leaving the more obviously related pair of seaports showing the founding and the decline of Carthage (National Gallery, London; B&J 131 and Tate, London; B&J 135). His reasoning for the change presumably harked back to the multiple aims and rivals he had been addressing when painting the canvas. Seen next to the Claudes, the subtly graduated light of Turner's sky not only triumphs in the context of the adjacent canvases, but also bears comparison with the other artists represented in the national collection.

After his death, once his specifications had been carried out, it appears that most visitors felt the juxtaposition worked in his favour, if they were, however, astounded by the presumption of his request. In 1856, for example, long before Whistler questioned the validity of this arrangement (see p.33), the critic of *The Times* suggested that Turner's sparring with Claude was unnecessary and had weakened his art. Reflecting the period's preference for exacting realism, he claimed that Turner's ambition ought not to have been 'to out-paint Claude, but to interpret nature' (13 November 1856, p.7). IW

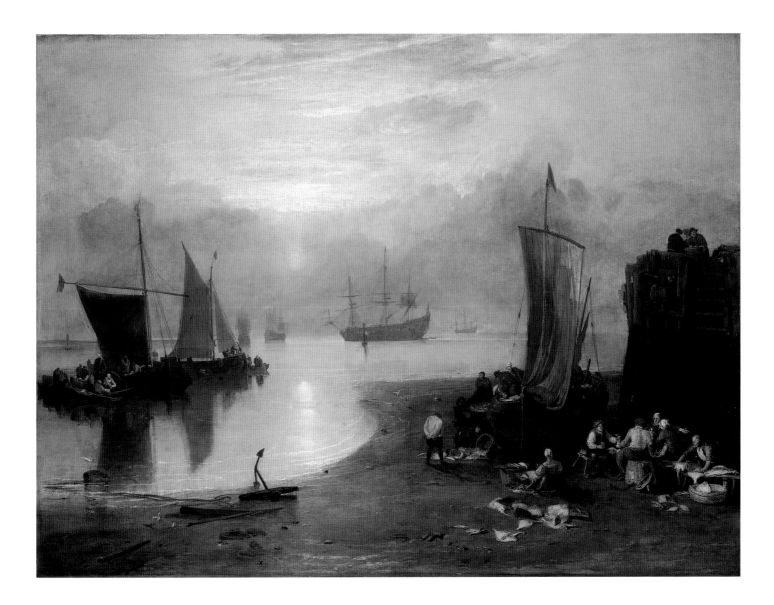

3 J.M.W. Turner

London from Greenwich Park exh. 1809

Oil on canvas 90.2 × 120 cm
B&J 97
Tate, London. Accepted as part of the Turner Bequest 1856;
displayed from 1856
EXHIBITED IN TORONTO AND PARIS ONLY

Between 1805 and 1810 Turner exhibited a series of about twenty oil paintings focusing on the river Thames, its tributaries and its estuary. The subjects of most of these works are situated to the west of London, upstream from Richmond, on a stretch of the river that Turner invested with Arcadian associations borrowed from the poetry of Alexander Pope and James Thomson, and which also induced him to pen his own, less distinguished poetic ramblings (see Wilton and Turner 1990). Several of the pictures are founded on the prototypes of idealised landscape: in one instance a group of bathing Etonians are introduced where a classical scene might have favoured languorous nymphs (Petworth House, Sussex; B&J 88). But, for the most part, the series engages with the incidentals of the working lives of modern shepherds, farmers, bargemen and sailors. Turner had sketched their activities while making excursions on the river, during the course of which he also painted batches of *plein air* oil studies, one of the rare occasions in his early career when he worked in colour directly from the motif.

This is the only painting in the sequence of exhibited pictures to depict contemporary London, suggesting that Turner could not at this date reconcile the thrusting modernity of his native city with a sensibility wedded to the established aesthetics of an earlier age. Indeed, his subject was itself a traditional one, much favoured by earlier prospect painters, and was distinguished by the presence of the royal and maritime buildings below in Greenwich. In the lines that were appended to the title of the picture when it was first exhibited in his own gallery on Queen Anne Street, there was a sense of rhetorical outrage at the polluted state of contemporary London, though this was possibly conceived chiefly to appeal to an audience similarly weaned on Augustan verse:

> Where burthen'd Thames reflects the crowded sail,
> Commercial care and busy toils prevail,
> Whose murky veil, aspiring to the skies,
> Obscures thy beauty, and thy form denies,
> Save where thy spires pierce the doubtful air,
> As gleams of hope amidst a world of care.

Turner subsequently etched the picture for his *Liber Studiorum* (an ambitious set of mezzotints conceived in imitation of the published version of Claude's *Liber Veritatis*). It was at that time owned by his greatest patron Walter Fawkes, but was thereafter returned and eventually became part of the Turner Bequest. Reports in the press in the 1850s remarked that the painting's rendering of the dull skies over London was still accurate. *The Times*, for example, described it as 'a view as one may see any gray afternoon from the park – a foreground of bank with Scotch firs and deer, and an outlook over [Greenwich] hospital, along Limehouse Reach and the Pool, to where the mighty smoke cloud of London drifts up before a steady wind along the horizon' (10 November 1856, p.7). IW

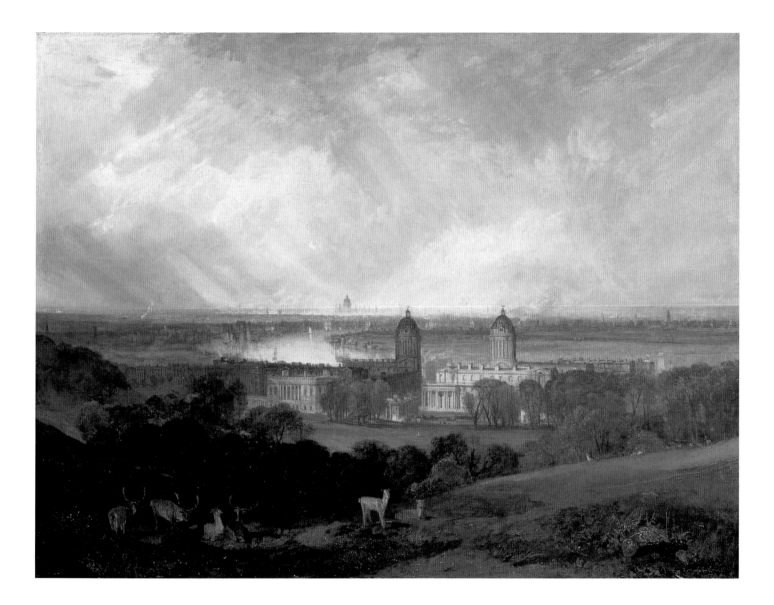

4 J.M.W. Turner

**Mortlake Terrace: The Seat of William Moffatt, Esq.:
Summer's Evening** exh. 1827

Oil on canvas 92 × 122 cm
B&J 239
National Gallery of Art, Washington.
Andrew W. Mellon Collection, 1937

In 1857, thirty years after it had first been exhibited in London, this picture was one of the highlights of the group of Turner's paintings gathered at the *Art Treasures* exhibition in Manchester, where it was presumably seen by Whistler. The French critic Théodore Thoré, writing as W. Bürger, certainly saw it then and was among its admirers, drawing his reader's attention to its recreation of the physical sensation of light: 'I too have seen beside the Thames these remarkable effects of the conflict of sun and fog and dust, and I reckon that this landscape of Turner's is a masterpiece.' He further claimed that it demonstrated that by the 1820s Turner was 'completely independent of any influence from the Old Masters' (*Trésors d'Art en Angleterre*, 1862, pp.424 et seq.; trans. Gage 1987, p.10). This was a strange assertion to make, since the picture is palpably an amalgam of Turner's fondness for the works of Cuyp and Claude Lorrain, albeit in an English setting.

It was, indeed, painted at a time when Turner's enthusiasm for Claude's work had been reawakened, following his direct experience of the Italian landscapes immortalised by his hero in 1819–20, which had since been consolidated by closely analytical studies from canvases and drawings by the master. Thus while the picture depicts the water-borne pageantry of the Thames, even featuring the Mayor's ornamented barge,

it is structured around the centrally placed setting sun in a way that recalls Claude's famous classical seaports, such as *The Embarkation of the Queen of Sheba* (among the first works acquired for the newly opened National Gallery), which represented the measure against which Turner constantly assessed his own achievements.

This was actually Turner's second painting of the riverside terrace at Mortlake, which lies to the west of London, not far from his old haunts at Isleworth and Twickenham; the previous year he had produced a companion view, looking down river towards the sunrise (Frick Collection, New York; B&J 235; see Galassi 1996). Both were painted for William Moffatt, the owner of the depicted landscape, and represented a return to a type of picture that had helped to establish Turner's name as a young artist, but which he had by then otherwise abandoned.

Here he transcended the limitations inherent in this kind of view-making by focusing explicitly on the effect of hazy sunlight, most notably in the way its dazzling brilliance appears to dissolve the solid geometry of the terrace. The glare is heightened by Turner's decision to contrast it with the black silhouette of a dog, positioned alongside the most intense light on the parapet. This was famously an addition to the picture, painted on paper and then stuck on afterwards. IW

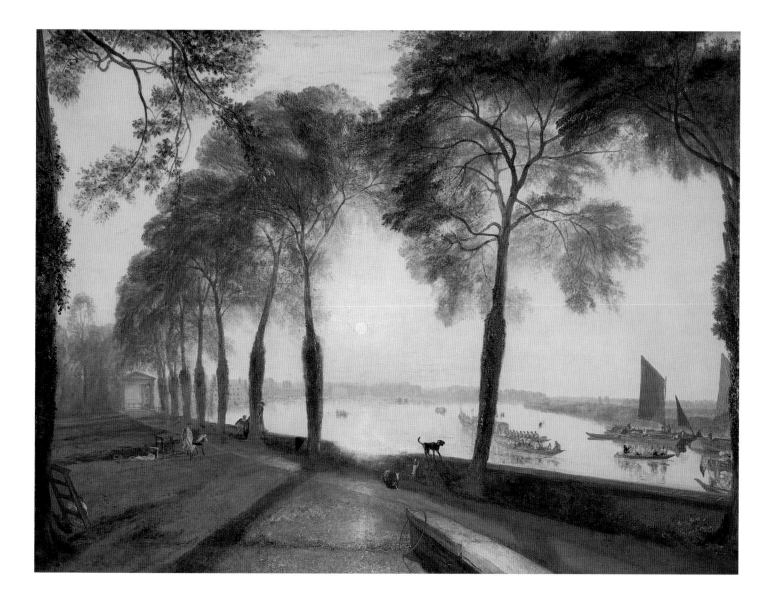

5–7 J.M.W. Turner

5 St Michael's Mount
(study for the 'Little Liber' mezzotint)
*c.*1823–5

Watercolour and pencil on paper 24.1 × 30.3 cm
TB CCLXIII 311
Tate, London. Accepted as part of the Turner
Bequest 1856; displayed from 1857

6 Shields Lighthouse
(study for the 'Little Liber' mezzotint)
*c.*1823–5

Watercolour on paper 23.4 × 28.3 cm
TB CCLXIII 308 (a); W 771
Tate, London. Accepted as part of the Turner
Bequest 1856; displayed from 1857

7 Shields Lighthouse
(study for the 'Little Liber' mezzotint)
late ninetheenth-century impression

Mezzotint on India paper 15.2 × 22 cm
R 801
Tate, London. Purchased 1981

During the second half of the nineteenth century Turner's reputation was enshrined for many admirers in the sequence of about seventy mezzotints known as the *Liber Studiorum*, which he had produced (with the assistance of a team of engravers) between 1807 and 1819 (Forrester 1996). These set out the range of his art in six different landscape categories: Pastoral; Marine; Mountainous; Historical; Architectural. The final type was listed as 'E.P.', and was an elevated form of pastoral, based on the idyllic compositions of Claude Lorrain, whose *Liber Veritatis*, in its engraved version, had been a stimulus for Turner. The posthumous celebrity of the series stemmed from Ruskin, who had devoted large parts of his manual, *The Elements of Drawing* (1857), to detailed praise of his favourite designs; this had encouraged artists, students and collectors to prize the prints, and especially the etchings, for what they revealed about Turner's draughtsmanship.

The *Liber* was intended to contain one hundred images, but Turner had been distracted from completing the set at the beginning of the 1820s by lack of public support and a number of competing fresh interests. These included a much smaller group of twelve mezzotints that he seems to have embarked on as a means of testing whether the newly available steel engraving plates were capable of reproducing the dynamic effects of chiaroscuro he had achieved in his watercolours for series such as the *Rivers of England* 1823–7, or its sequel, the *Ports of England* 1825–8. His fascination with the potential reproductive and expressive qualities of steel was a matter of some importance to the dissemination of his work, as the more durable material was an innovation that was to permit far greater print-runs, reducing the risks associated with producing engraved series.

5

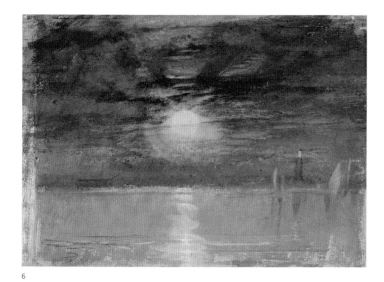

6

7

Generally known, somewhat misleadingly, as
the 'Little Liber', the twelve images, which were
unpublished in his lifetime, are based on watercolours
that would not have been considered finished by
Turner or his contemporaries (nos.5–6), a circumstance
that further highlights the experimental nature of
the undertaking. Indeed there are considerable
variations between different states of the resulting
mezzotints, indicating that it was an evolving process
that allowed Turner to understand how his vibrant
colours could be translated into black and white.
Furthermore, unlike the earlier *Liber*, Turner seems to
have engraved them independently, making his own
revisions to each plate; some on traditional copper,
some on steel.

Because they were never issued publicly, the
current titles for some of the set post-date Turner's
death, though he had actually referred to them in an
abbreviated form in a private memorandum of around
1830 (TB CCXXXIX, inside cover). As a group they are
characterised by a focus on brooding storm clouds set
against radiant but obscure light effects. Most often
the light comes from the moon, though some of the
designs, such as *St Michael's Mount* (no.5), intimate a
desire on Turner's part to incorporate both natural
light sources within the span of a single image. This
is played out extensively in his later pictures, most
famously in *The Fighting Temeraire Tugged to her Last Berth
To Be Broken Up 1838* (1839, National Gallery, London;
B&J 377).

Only a very few early impressions exist of each
subject. However, later printings were made from some

of the plates in the early 1870s by Francis Seymour
Haden, Whistler's brother-in-law, around the time
when the many thousands of proof impressions Turner
had hoarded of all his engraved designs were broken
up in six sales that created a heightened interest in his
graphic work. Nearly twenty years earlier Ruskin had
included a few of the original watercolours in the
survey of sketches and drawings available from 1857
(nos.5, 6). His catalogue entry for the second of these
works alluded to the related print, but in the case of
another design, known as the *Ship in a Storm* (TB CCLXIII
309(a); W 772), he actually displayed the drawing and
mezzotint together in one frame to allow students
to see how the watercolour was not an end in itself,
and that Turner had improved and resolved the image
in the print. A similar process can be witnessed in
the *Shields Lighthouse* subject, where the halo of light
emanating from the rising moon becomes more
concentrated as it arrives at the last of three states
(no.7; see Dupret 1989). Ruskin was intrigued by the
indented surface of the watercolour. He thought
this had arisen because the paper had been folded up
round a parcel, when, in fact, the size of the indentation
matches that of the engraver's plate, suggesting that
Turner was anticipating a need to transfer his design
without having to modify its dimensions. Building on
his slight misapprehension, Ruskin used the water-
colour to celebrate what he saw as Turner's peerless
technical accomplishment, a point he was at pains to
stress throughout his commentaries: 'It is not necessary
to make drawings always on paper that has come off
parcels; but it *is* necessary to be able to do so.' IW

8 A Villa, Moon-Light

(for Samuel Rogers's *Italy*) *c*.1826–7

Pen and ink, pencil and watercolour on paper 24.6 × 30.9 cm
Engraved by Edward Goodall for the 1830 edition of Rogers's *Italy*
TB CCLXXX 165; W 1175
Tate, London. Accepted as part of the Turner Bequest 1856;
displayed from 1856

9 The Field of Waterloo Seen from Hougoumont

(for Byron's *Life and Works*) *c*.1832

Watercolour, bodycolour, pencil and scraping-out on wove paper
15.2 × 25.4 cm (vignette) on thin card 19.6 × 27.6 cm
Engraved by Edward Finden for vol.XIV of *The Life and Works of Lord Byron*
W 1229
Private collection. On loan to the Art Gallery of Ontario, Toronto

From the beginning of the 1830s Turner found fewer buyers for his oil paintings and relied increasingly on income from the production of sets of engraved images based on his watercolour designs. Throughout the 1820s these publications had been topographical in scope, covering diverse aspects of the British land-scape, from its coasts and ports to its rivers and cities. However, as the 1830s got under way, Turner's name became more closely involved with many of the most celebrated literary figures of the age as a result of the intense and skilfully crafted images he painted for lavish editions of their writings.

The first and most significant of these were painted for the 1830 edition of *Italy*, a collection of poems by Samuel Rogers (1763–1855), now little regarded, but then a figure at the hub of London's literary circles. Rogers's anthology had first been published with little success from 1822, but the inclusion of Turner's tightly focused vignettes in the new edition reversed its fortunes so that it became a best-seller. With its companion volume of *Poems*, published in 1834, its sales greatly exceeded most rival literary endeavours (Piggott 1993, pp.18–19). As a result, Turner's services were sought by a number of publishers to enliven their editions of John Milton, Thomas Moore, George Crabbe and Thomas Campbell, as well as popular writers like Sir Walter Scott and Lord Byron.

No.8 is one of the three watercolours, among the twenty-five designs prepared for Rogers's *Italy*, in which Turner represents the transformative magic of moonlight, coinciding with the poet's own romantic evocation of the nocturnal effect. No specific setting has been identified, but, in the context of the book, the scene is linked with the festive balls in the palaces of Genoa.

The other design is one of three vignettes Turner painted on the subject of Waterloo, the inescapable landmark of recent European history, which cast its shadow long into the nineteenth century on either side of the Channel. Two of Turner's images were for Robert Cadell's edition of the *Prose Works of Sir Walter Scott*, which included his *Life of Napoleon Buonaparte* (see W 1097, and W 1116). The work shown here, however, comes from the slightly earlier group of vignettes that illustrated the officially sanctioned version of Byron's *Life and Works*. Turner seems to have responded directly to Byron's humanitarian lament for the loss of so much life in the third part of *Childe Harold's Pilgrimage*:

> Last noon beheld them full of lusty life;
> Last eve in Beauty's circle proudly gay;
> The midnight brought the signal – sound of strife;
> The morn the marshalling of arms – the day,
> Battle's magnificently stern array!
> The thunder clouds close o'er it, which, when rent,
> The earth is covered thick with other clay
> Which her own clay shall cover, heaped and pent,
> Rider and horse – friend, foe, in one red burial
> blent!

These words were appended as a commentary to Turner's oil painting, *The Field of Waterloo*, exhibited in 1818 (Tate, London; B&J 138), which resisted the prevailing triumphalism of many contemporary depictions of the battle.

Engraved versions of these and many other Turner images were widely available in Britain and abroad throughout the nineteenth century, bringing his work to those who had never seen his paintings, including the young John Ruskin. Though the book illustrations certainly helped to sustain Turner's reputation at a time when sympathy for his work in oils was at a low ebb, the neatly ordered black and white designs may not have been the best introduction to the dynamic extremes of his use of colour, and the discrepancy between the two can be seen to have heightened the public's bewilderment when encountering the full-blown reality. IW

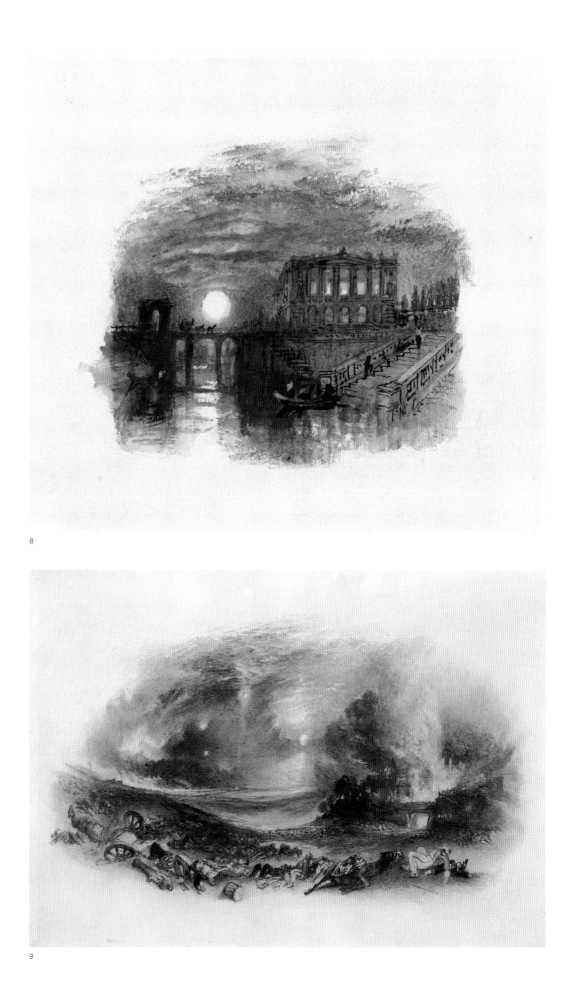

8

9

10 J.M.W. Turner

Chichester Canal; Sample Study *c*.1828

Oil on canvas 65.4 × 134.6 cm
B&J 285
Tate, London. Accepted as part of the Turner Bequest 1856;
displayed from June 1857

From 1825 onwards Turner resumed his earlier friendship with the third Earl of Egremont, whose country house at Petworth, set amid the rolling downs of West Sussex, was a magnet for many contemporary artists. Although Egremont's acquisitions tend to suggest a preference for genre subjects and portraiture, he was a loyal admirer of Turner's landscapes, and eventually owned twenty oil paintings, more than any other collector. Two-thirds of these dated from the decade between 1802 and 1812, but he also commissioned a set of four views to decorate the dining-room at Petworth House in the later 1820s. Ornamented by some of Grinling Gibbons's finest carvings, this grand state room was then undergoing a major refurbishment, in which Turner's canvases were installed like a series of predellas, below full-length family portraits (see Rowell, Warrell and Brown 2002). The limited space available to Turner was presumably a significant influence on the elongated format he adopted in this set, though other works produced around the same time indicate he was intrigued by the possibilities of panoramic compositions.

There was clearly some debate about which subjects were most suitable for the series, which induced Turner to set out his ideas in fully developed studies, like this view of Chichester Canal, before completing more conventionally finished versions of the same scenes. The subjects that were eventually approved all had a connection with Egremont. Two depicted 'Capability' Brown's verdant landscape, visible beyond the windows, so were essentially estate views, while a view of the Chain Pier at Brighton reflects Egremont's involvement in local innovative projects. The choice of Chichester Canal is more puzzling, for though the waterway was also undertaken as a means of creating better transport routes for produce within the county, it had already disappointed its investors

(one of whom was Egremont) long before Turner embarked on his picture. It seems possible that it was selected chiefly for its sunset subject, which harmonised better with the rest of the group than two proposed sunrise scenes.

All but one of the studies for the commission became part of the Turner Bequest. From 1857 onwards, the present picture and one of the views of Petworth Park (Tate, London; B&J 283) were part of a group of five unfinished works that were displayed alongside the paintings Turner had exhibited in his lifetime (the other three studies were a preliminary design for Turner's vast picture of the *Battle of Trafalgar*, B&J 251; *Fire at Sea*, B&J 460; and the *Mountain Glen*, B&J 439; all Tate, London). Critical responses to the inclusion of these avowedly incomplete works were apparently universally favourable, challenging the fears of National Gallery officials, who had thought that such images would not prove intelligible to the public. Thus, in June the *Spectator* considered this canvas 'extremely fine', while two months later the *Illustrated London News* excepted it 'from the charge of unreality', praising the 'placidity of its calm water reflecting the opalescent sky, the stillness of its stripe of distant grey-blue hills, and the purity of its peaceful sky' (13 June 1857, p.631; 29 August, p.227). A French critic was astounded to find such works displayed in a public gallery: 'For a moment, seeing the word *unfinished*, in front of the most eccentric of these canvasses, I thought that these unruly paintings were no more than bizarre lay-ins, which the painter had used as experiments or as guides; but the Englishmen I was with assured me that most of these pictures were in fact finished, and were complete expressions of the master's ideas. And they told me that these were the works which they and the London public preferred' (Gage 1987, pp.8–9). IW

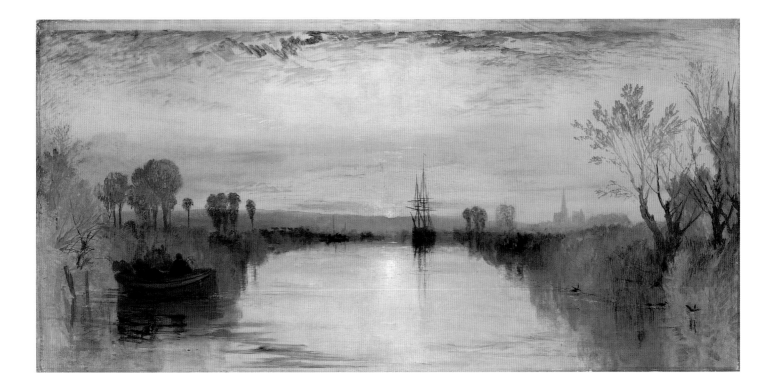

11 Le Havre: Tour de François Ier *c.*1832

Watercolour and bodycolour and on blue paper
14 × 19.2 cm
TB CCLIX 134
Tate, London. Accepted as part of the Turner Bequest
1856; displayed from 1856

12 View on the Seine between Mantes and Vernon (Rolleboise on the Road from Bonnières) *c.*1833

Watercolour and bodycolour on blue paper
14.3 × 19.4 cm
TB CCLIX 114
Tate, London. Accepted as part of the Turner Bequest 1856;
displayed from 1856

13 St Denis *c.*1833

Watercolour and bodycolour on blue paper
14 × 19.2 cm
TB CCLIX 121
Tate, London. Accepted as part of the
Turner Bequest 1856; displayed from 1856

Of the 102 watercolours selected in 1856 for the first display of Turner's watercolours at Marlborough House, thirty-five were views on the river Seine. *St Denis, Havre: Twilight outside the Port* and *Between Mantes and Vernon*, as they were then called, were all part of that group. Before their exposure at Marlborough House the three designs were known solely from engravings published in the 1834 and 1835 volumes of *Turner's Annual Tour* alternatively known as *Wanderings by the Seine*. Turner's project to depict modern and picturesque French river scenery began in the later half of the 1820s when he visited the Continent to sketch views along the Loire and Seine. His subject matter ranged widely from places of national significance, such as the busy commercial port of Le Havre, to serene domestic scenes on the banks of the Seine. The resulting designs on blue paper and their subsequent engravings formed the popular image of the French rivers in Turner's time. It was a series which attracted admiration from the press, critics and artists alike. Several later editions were published, and some of the images also appeared in pirated editions in France (Warrell 1999, p.76).

Once the Turner Bequest joined the national collection, John Ruskin took over in promoting the value of these watercolours. Following their initial display the views on the Seine were placed in cabinets, but were frequently shown alongside Ruskin's selections of Turner's sketches and drawings at the National Gallery. In the introduction to Ruskin's *Notes on the Turner Gallery at Marlborough House* (1856) he wrote, 'Of the drawings at present exhibited, the vignettes, Italy and the Rivers of France series on grey paper exhibit his power at its utmost' (*Works*, XIII, p.97). He was referring to the finished watercolours painted in vibrant colour with great attention given to the smallest of brush marks for building subtle detail. Ruskin advocated students examining and copying Turner's French views: 'The best practice, and the most rapid appreciation of Turner will be obtained by accurately copying those in body colour on grey paper . . . the student will soon find that the advantage gained is in more direction than one' (*Works*, XIII, p.248). The port at Le Havre, though somewhat changed in appearance since Turner's watercolour of it, was interpreted by Monet in his celebrated canvas *Impression, Sunrise* (no.39).

In his 1881 catalogue Ruskin placed all three of these watercolours in a group he regarded as containing the best Seine drawings. The delicately painted sky of *Le Havre* was already the subject of Ruskin's approval in *Modern Painters*, in the chapter 'Of Truth of Clouds' (*Works*, III, p.367). *St Denis* was similarly discussed as an exemplary work within the same chapter, in a section marked 'Sunset in tempest. Serene midnight' (*Works*, III, p.418). The extraordinary night sky in this work almost surpasses the topographical significance of the view. It stood out clearly in the Bequest as one of Turner's most powerful representations of moonlight. The moon is the focus of the scene, perhaps more so than the town of St Denis itself which is seen as a mere silhouette in the middle distance. The only building highlighted is the cathedral, where its spires catch the white glow. It was known from the works Turner exhibited during his lifetime and from his published work that he was content to use the moon, planets and meteors in a symbolic way, inviting his viewers to interpret their meaning. This and certain other examples of Turner's moonlit views might be seen as precursors of Whistler's Nocturnes on the Thames. ST

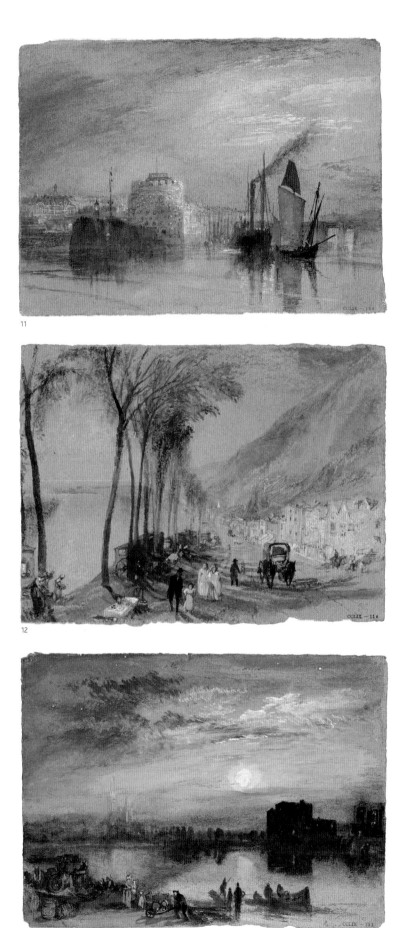

11

12

13

The Golden Bough exh. 1834

Oil on canvas 104.1 × 163.8 cm
B&J 355
Tate, London. Presented by Robert Vernon 1847;
displayed from 1848

First exhibited in 1834,when it was paired with a picture entitled *The Fountain of Indolence* (Beaverbrook Art Gallery, Fredericton, New Brunswick; B&J 354), *The Golden Bough* was executed towards the end of Turner's long series of idealised classical landscapes. He doggedly insisted on producing these variants on the historical landscapes of Claude and Poussin right up to the end of his life, despite the fact that they rarely found buyers. He had intended that this painting should be interpreted with the aid of an extract from his own unpublished (and much derided) poem, 'The Fallacies of Hope', but this was suppressed in the Royal Academy's catalogue. The subject, however, was one he had treated twice before, and can be related to the sixth book of Virgil's *Aeneid*. There Aeneas is forced to seek the advice of the Cumaean Sibyl, who tells him that, in order to visit his father in the Underworld with impunity, he must obtain a branch from a sacred tree as an offering to Persephone. Aeneas himself does not appear in the image, but the figure on the left, holding aloft the golden bough, may be intended to be the Sibyl or one of the Fates. The setting is Lake Avernus, near Naples, as this was thought to offer a route down to the realm of the dead. The landscape is bathed in a luminous light that is barely distinguishable from the mists rising from the lake, which acts to unify the whole composition. When painting the sky Turner built up a caked layer of white paint on the surface of the canvas, much as he did in his picture *Regulus* (Tate, London; B&J 294), presumably adding more and more paint until he had achieved the harmonious effect he wanted.

This was one of four works by Turner that entered the national collection late in 1847 as part of Robert Vernon's gift of more than 150 contemporary British paintings (see also no.99; Hamlyn 1993). Until the earliest display of pictures from the Bequest in 1856 these were the most readily accessible of Turner's paintings to the public, their popularity further ensured by their reproduction as line engravings for S.C. Hall's two-volume publication, *The Vernon Gallery of British Art* (1850–1). They were initially displayed at Trafalgar Square, but were then transferred to the South Kensington Museum, where they remained in the 1860s after the paintings of the Turner Bequest (briefly shown in an adjacent gallery) went back to the National Gallery.

Surprisingly, once it was in the national collection, the painting very largely escaped Ruskin's critical attentions. However, the commentary accompanying the engraving of the image in Hall's book was celebratory:

No painter has ever represented Italian scenery with such high poetical feeling as does Turner; the land as he shows it us seems a paradise where nothing of impurity or wretchedness could be found; and if we knew it only through the medium of his magic pencil, such only would be the opinion entertained of it: one cannot help regretting, as we look on a picture like this, that it is only a painter's dream, not a reality – but the dream is pleasant to contemplate, even if it bring not complete satisfaction.

IW

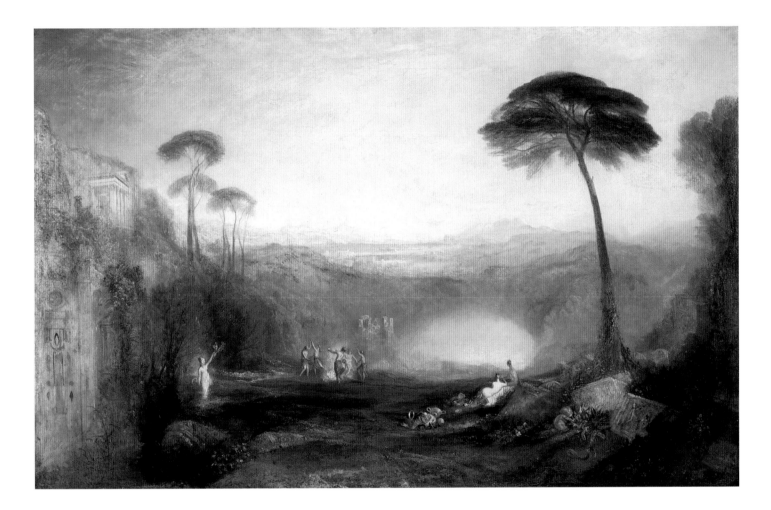

15 J.M.W. Turner

The Scarlet Sunset: A Town on a River

1830–40

Watercolour and bodycolour on blue paper 13.4 × 18.9 cm
TB CCLIX 101
Tate, London. Accepted as part of the Turner Bequest 1856;
displayed from c.1881

The curling brushstrokes and vivid colour used to create the effect of the reflected evening sun in *The Scarlet Sunset* have often attracted comparison with the bold marks in Monet's striking view of the Seine: *Impression, Sunrise* 1872–3 (no.39). There are also compositional similarities between the two images. Despite this, however, it is quite unlikely that Monet would have seen this work by the time he painted *Impression, Sunrise*, as Turner's watercolour was not included in Ruskin's catalogues of the Bequest until 1881.

In the 1881 catalogue, Ruskin placed 'Scarlet Sunset', as he then called it, into a group entitled 'Finest Colour on Grey (Late)'. The other twenty-five drawings in the group comprised fine rapid-colour studies of French views, but Ruskin singled this one out with a special note of praise: 'This last magnificent drawing belongs properly to the next group, which is almost exclusively formed by drawings in which the main element is colour, at once deep and glowing' (*Works*, XIII, p.385). The river view lacked a topographical attribution, though it was suggested tentatively by Ruskin that it might show the river Loire at Tours. This vague but poetic identity stayed with the drawing for over a century. Recent alternative identifications include the river Rhine, though Ian Warrell has suggested that the image could be loosely based on the sketches Turner made of Prague in 1835. ST

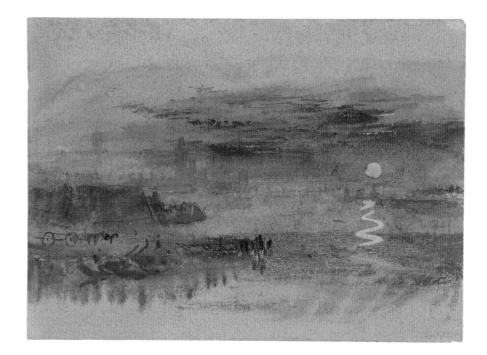

16 J.M.W. Turner

Venice: Moonlight on the Lagoon 1840

Watercolour and bodycolour on paper 24.5 × 30.4 cm
TB CCCXVI 39
Tate, London. Accepted as part of the Turner Bequest 1856;
displayed from 1881

A considerable proportion of the sketches Turner made in Venice in 1840 depict the city after dark (see Stainton 1985, Warrell 2003). These studies show that Turner's fascination with the city's appearance extended beyond the brilliant sunsets and atmospheric mists which allowed him to produce watercolours with a distinctive vaporous look. Turner commonly used sheets of dark brown paper for his nocturnal views: the dark support allowed him to use white and bodycolour to obtain the most effective highlights and to portray scenes with carnival fireworks shooting into the night sky. Such sketches provide an interesting contrast to the Venice in daylight for which Turner is so well known. This is one of the few nocturnal Venetian views that he chose to execute on a sheet of white paper. The main focus of the sketch is the effect of the lights glimmering out from the boats on the Lagoon. The luminosity of this watercolour, despite being richly painted, seems to owe a lot to the choice of paper.

In 1890 Ruskin placed this sketch in a section of some 237 miscellaneous framed drawings at the National Gallery (see *Works*, XIII, pp.637–44). These were selected to serve as additional examples for students of Turner's work, amplifying all his different styles and periods already catalogued by Ruskin. ST

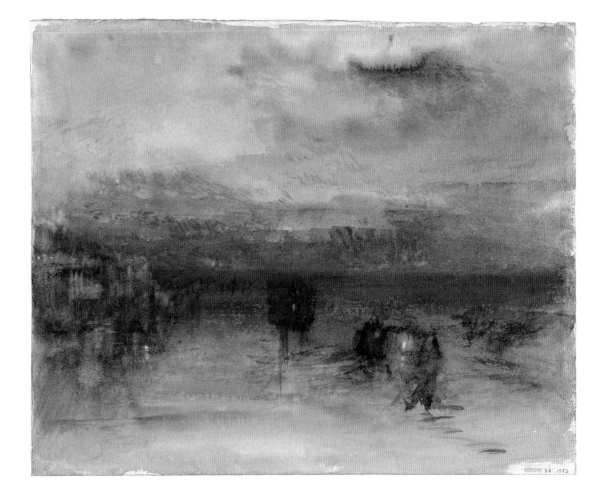

17 J.M.W. Turner

Venice by Moonlight 1840

Watercolour on paper 22 × 31.9 cm
TB CCCXV 10
Tate, London. Accepted as part of the Turner Bequest 1856;
displayed from 1857

Ruskin's first attempt at cataloguing the watercolours of the Turner Bequest included twenty sketches of Venice (*Works*, XIII, pp.210–15; Warrell 1995, pp.95–116). It was perhaps the ethereal quality of this watercolour that led him to choose it for this selection. One of the most significant points of this experimental catalogue, produced only for private circulation, was that Ruskin acknowledged the value of some of Turner's preliminary sketches. Though he still drew a clear distinction between finished watercolours and elaborate studies such as this one, he began to promote an interest in the looser style of Turner's work. Like other Venetian views in the 1856 catalogue, this sheet was originally bound into a 'roll' sketchbook. Ruskin dismantled the book so that the pages could be framed and displayed individually. Although this important catalogue was not accompanied by a corresponding display, some of the most highly prized works from the selection were shown along with hundreds more at the National Gallery from the early 1860s, after a temporary exodus to South Kensington.

In describing *Venice by Moonlight*, Ruskin wrote (*Works*, XIII, p.214):

A highly finished study, but the locality here is also uncertain. There are so many campaniles in Venice of the class to which this tower belongs, that it is almost impossible to identify one of them under Turner's conditions of mystery, especially as he alters the proportions indefinitely, and makes the towers tall or short just as it happens to suit the sky.

The exact topography of this view continued to elude him, for he later catalogued it as 'Venice: Suburb' (*Works*, XIII, p.112). However, it has recently been suggested that the view records the western end of the Giudecca Canal, with the campanile of Santa Marta (Warrell 2003, p.188).

A few of Turner's paintings of Venice were engraved during his lifetime, with others produced posthumously. These would have made it plain that moonlight and approaching night was a recurring element in his conception of Venice. Although he frequently used the moon as part of his symbolic imagery, it was perhaps used with most power and purpose for Venice, where it appeared both beautiful and portentous. Turner's knowledge of Lord Byron's poetry helped to inform his perception of Venice. The poet's vision of the city was of a place fallen from greatness but still transcendent in beauty and spirit. Turner not only translated this viewpoint visually, but adopted extracts from Byron's verse to accompany exhibited pictures: 'The moon is up, and yet it is not night, The sun as yet disputes the day with her' (modified from *Childe Harold* IV: xxvii for *Approach to Venice* 1844 [National Gallery of Art, Washington DC; B&J 412]). ST

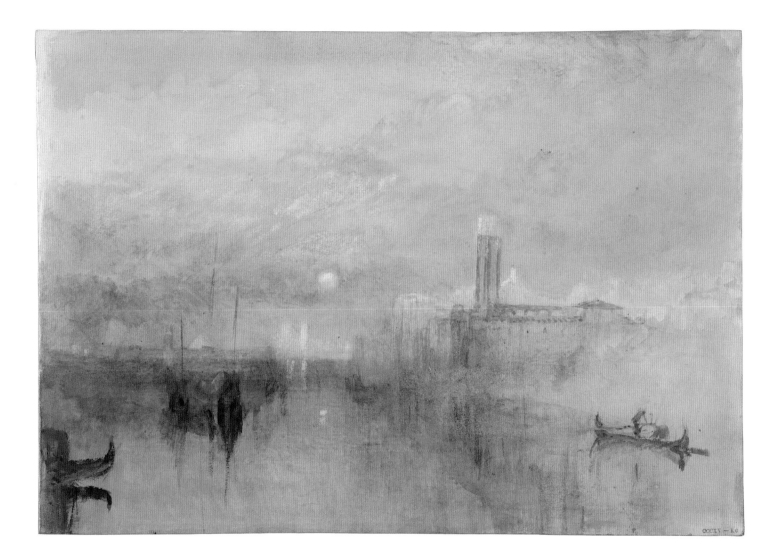

18 Moonlight on Lake Lucerne, with the Rigi in the Distance c.1841

Watercolour on paper 22.9 × 30.6 cm
W 1478
Whitworth Art Gallery, University of Manchester

19 The Dark Rigi: Sample Study c.1841–2

Watercolour on paper 23.1 × 32.4 cm
TB CCCLXIV 279
Tate, London. Accepted as part of the Turner Bequest 1856; displayed from 1857

Lake Lucerne and the view across its reflective waters to Mount Rigi were the subjects of sustained study by Turner while he was making annual visits to Switzerland between 1841 and 1844. The Rigi was a place swamped by tourists in the nineteenth century, but for Turner it was an ideal motif, best viewed from a distance, for his work of this period. Its appeal as subject matter was a combination of the mountain illuminated by changing light and the spectrum of colours reflected in the lake. He set out with determination to observe and record it at various times of day under different atmospheric conditions. A virtually identical viewpoint is adopted for the three finished watercolours of the Rigi that he produced in 1842: *The Dark Rigi* (W 1532), *The Blue Rigi* (W 1524), and *The Red Rigi* (W 1525). It is very tempting to look for the significance of the titles of these works, which differentiate them by their prevailing tone. However, these titles cannot be traced back directly to Turner himself, though the emphasis on a single colour was clearly intended (see Warrell 1999, p.143).

Turner produced a considerable body of preliminary work, including the corresponding sample studies that precede these finished works. The initial sketches consisted of swiftly drawn pencil lines which were coloured afterwards with broad, liquid washes (see for example TB CCCLXIV 174, 186). Sometimes Turner went straight to the watercolour with no under-drawing. By contrast, the sample studies, like their finished counterparts, were made quite differently, with areas carefully painted in a mass of small brushstrokes which combine to create the tones. It was partially this technique that prompted Turner's agent Thomas Griffith to declare that the finished watercolours may be difficult to sell. Ruskin reported that Griffith said to Turner: '(after looking curiously into the execution, which you will please note, is rather what some people

might call hazy): They're a little different from your usual style' (*Works*, XIII, p.479).

In fact Turner sold all three of the Rigi watercolours mentioned above in 1842. Two of the sample studies for these finished pictures, including the sketch for *The Dark Rigi*, were placed in Ruskin's 'First Hundred' in 1857 (Warrell 1995, nos.31, 35). By including the two Rigi sample studies Ruskin acknowledged Turner's repeated use of the motif and the apparently deliberate scheme of creating a complementary series of views. Studies of the Rigi at dawn and by moonlight were both executed in the same year and exemplify Turner's attempt at demonstrating his mastery of all different conditions of light. Ruskin wrote of *The Rigi at Sunset* (TB CCCLXIV 275; Warrell 1995, no.35): 'The same view as No.31 ['The Rigi at Dawn'] by evening instead of morning light. I cannot tell why Turner was so fond of the Mont Rigi, but there are seven or eight more studies of it among his sketches of this period' (*Works*, XIII, p.204). The two sample studies stayed together, virtually as a pair, while at the National Gallery. Ruskin listed them side by side in his 1881 catalogue, declaring the group of later Continental drawings 'Of the finest quality of pure Turnerian art' (*Works*, XIII, p.371).

The public outside London got a chance to see some of the late finished Swiss watercolours at the Manchester *Art Treasures* exhibition, held in 1857, a blockbuster display attended by Whistler. Two works from H.A.J. Munro of Novar's collection were loaned to the show: *Lucerne: Moonlight* 1843 (British Museum; W 1236) and *Kussnacht, Lake of Lucerne* 1843 (Manchester City Art Gallery; W 1534). No.18 is one of a small group of sample studies to have found their way outside the Bequest through Thomas Griffith. It is thought to belong to the first set of twenty sketches deriving from Turner's 1841 visit to Switzerland (Warrell 1995, p.149).
ST

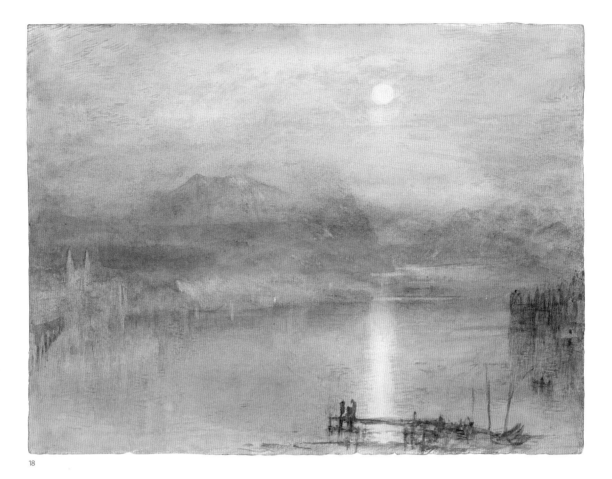

18

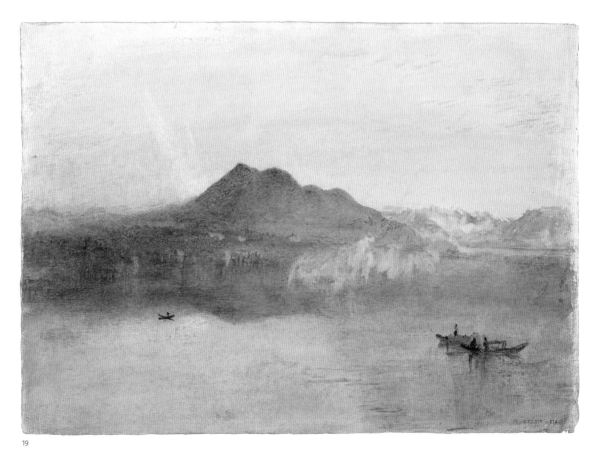

19

20 J.M.W. Turner

Constance: Sample Study c.1841–2

Watercolour on paper 24.2 × 31.1 cm
TB CCCLXIV 288
Tate, London. Accepted as part of the Turner Bequest 1856;
displayed from 1857

Turner produced around fifty sketches or 'sample studies' between 1841 and 1845, some of which were intended for showing to his principal patrons. Although these were presented as sketches, they are somewhat more formal than the loose or minimal impressions Turner executed on the spot while touring Switzerland in his later years. They confirm his ability to use his visual memory in conjunction with his mastery of observation when painting back in the studio. At the time when Ruskin was forming displays for the visitors to the National Gallery, he saw 'sample studies' such as this work strictly as preliminary sketches. In his preface to the catalogue Ruskin explained: 'They are not, strictly speaking, sketches from nature, but plans or designs . . . They indicate, therefore, a perfectly formed conception of the finished picture' (*Works*, XIII, p.189).

The finished version of this sketch showing Lake Constance on the Swiss border of Germany was among the group of late watercolours owned by Ruskin (York City Art Gallery; Warrell 1995, p.57, fig.19). As he approached his sixties, Ruskin recalled that the day

he brought the watercolour home was 'one of the happiest in my life' (*Works*, XIII, p.483). The circumstance of his ownership, along with his evident fondness for the finished picture, undoubtedly motivated Ruskin to select the sketch for it in his provisional catalogue of 1856, which included a hundred of the finest works from Turner's later period in the Bequest. The entry for this study read: 'The original sketch of a drawing made in 1842 at his own choice, for delight in the subject, and now in my possession. The sketch is however of little importance, except on the grounds of Turner's liking it himself. In the drawing made from it, he altered and enriched it exceedingly: the buildings being no more grey, but deep purple' (*Works*, XIII, p.199).

Ruskin's *Constance* was shown at the Fine Art Society's Gallery in 1878 and again in 1900 when the exhibition was repeated. In the catalogue he discussed further the heightening of colour in his watercolour, noting that it was 'unique in its luxury of colour' (*Works*, XIII, p.455). ST

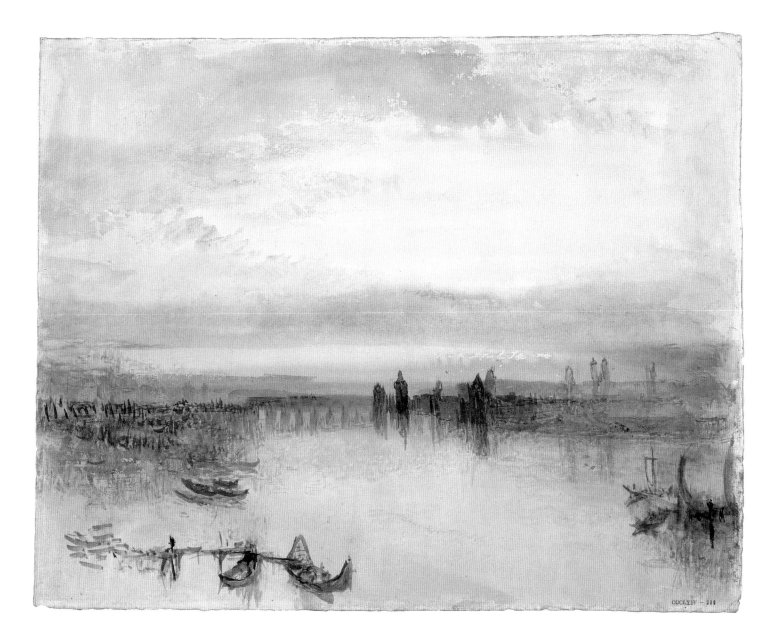

CCCLXIV — 288

War. The Exile and the Rock Limpet exh. 1842

Oil on canvas 79.4 × 79.4 cm
B&J 400
Tate, London. Accepted as part of the Turner Bequest 1856;
displayed from December 1856

From 1840 Turner began to exhibit a series of canvases that were roughly square in shape (see B&J 382, 394–5, 399–400, 404–5, 424–5). Though some of these have since been displayed with their corners cropped to make an octagonal image within the frame, the earliest three works in the sequence are documented as having appeared in frames that presented the image on the canvas through a round window (or slip frame), in a way that would seem to link them to the *trompe l'œil* ceiling paintings Turner had studied in Italy, especially in Venice. But there is, furthermore, in all of the series an approximation of the intense concentration of brilliant colour found in his numerous vignette book illustrations of the 1830s. With one exception, these late canvases were all paired images, with the predominantly cool blue tones of one painting finding an opposition in the much warmer reds and yellows of its companion. Such pendants rehearse Turner's interest in the colour theories of the German theorist and poet Johan Wolfgang von Goethe (1749–1832), which he specifically challenged in the pair of paintings he exhibited in 1843.

The picture *War* recalls Napoleon's exile on the remote island of St Helena, where he died in 1821. It was juxtaposed with an image of moonlit *Peace*, depicting the steamship on which Turner's fellow Academician Sir David Wilkie had died during his return from Constantinople. By contrast with the brooding stillness of that work, *War* is aflame with a glaring crimson sunset that suggests the blood spilt during Napoleon's long campaign to subdue Europe by force. Turner presumably also intended his viewers to contrast the fate of Wilkie's body, committed to the sea off Gibraltar in a simple marine ceremony, with the pomp that had attended Napoleon's corpse during its installation at Les Invalides in Paris a few months before the picture was exhibited. In the Royal Academy catalogue he alluded to Napoleon's enforced captivity in some cryptic lines from 'The Fallacies of Hope'. These imagined the former Emperor chafing at the loss of his liberty and resenting the fact that he is indefinitely confined to his rock in the ocean, unlike the limpet he contemplates whose movements are not so constrained.

It is perhaps not surprising that *War* and *Peace* incensed conservative critics, inducing them to compare the pictures unflatteringly with the supposedly unintelligible and formless music of Berlioz, greatly to Turner's detriment. Elsewhere the novelist William Makepeace Thackeray, in one of his playful jibes, proposed that the paintings could just as well be hung upside down (*Ainsworth's Magazine,* vol.1, 1842, p.322). And though attitudes to these later pictures were subsequently modified as a result of Ruskin's writings, many visitors to the National Gallery in the second half of the nineteenth century would undoubtedly have seen this picture as evidence of Turner's reputed eccentricity. Indeed, in spite of its sublime colouring it was frequently mocked for the spindly, doll-like form of Napoleon, which was at odds with the much more rigorous figure-drawing expected at art academies. IW

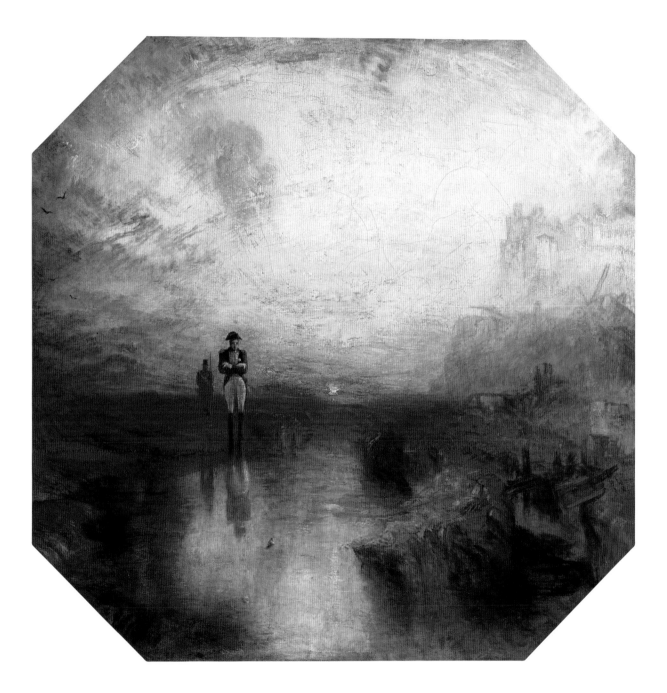

Junction of the Severn and the Wye (also known as **Landscape with a River and a Bay in the Distance**) *c*.1845

Oil on canvas 93.4 × 123.5 cm
B&J 509
Musée du Louvre, Paris
EXHIBITED IN TORONTO ONLY

Opportunities for French artists to see genuine paintings by Turner were limited in the nineteenth century, unless they were able to make a trip to London (Gage 1983a). Nevertheless, it was in Paris in the late 1880s that examples of his unfinished canvases of the 1840s were first given a public airing, some twenty years before comparable works in the Turner Bequest were displayed at the London galleries. No.22, for example, seems to have surfaced among the works included in the 1887 exhibition at the Ecole des Beaux Arts: *Exposition des Tableaux des maîtres anciens au profit des inondés du Midi*. It was there described in tones of wonder by Joris-Karl Huysmans: 'One finds oneself in front of a pink mist and burnt Sienna earth, of blue and white, rubbed with a rag, sometimes turning one way, sometimes turning in a straight line, or forking in zig-zags' (*Certains* 1889, pp.201). The picture was then, or soon afterwards, part of Camille Groult's well-known Parisian collection, one of a substantial group of 'Turners', of which three have proved to have water-tight attributions (the other two are the Claudian pastiche *Ancient Italy – Ovid Banished from Rome*

1838, which was nearly acquired by the Louvre in 1894 (private collection; B&J 375); and the unfinished picture known as *Val d'Aosta c*.1845, which may, in fact, show the Falls of the Rhine at Schaffhausen (National Gallery of Victoria, Melbourne; B&J 520).

Among those who saw and admired the unfinished canvas when it was owned by Groult were Mallarmé, the de Goncourt brothers, and Pissarro, all of whom were amazed by its opalescent layering of colour glazes, and its lack of precisely rendered forms. Some viewers even made comparisons with Monet's contemporary works. Goncourt, for one, noted in his *Journal*, on 18 January 1890, that for him it seemed to exceed 'the originality of Monet'. Though responses to the picture appear to have implicitly accepted its unfinished state, this was not specifically mentioned in the way it was for those studies exhibited in London (see no.10). Rather, it was the picture's mysterious qualities, especially as they seemed to have an affinity with European symbolism, that exuded a special appeal. In fact the precise nature of this painting, and its place in a sequence of ten radically pared-down versions of

Fig.43. J.M.W. Turner,
The Junction of the Severn and the Wye, first published state, 1811
Etching, aquatint and mezzotint on paper
Liber Studiorum plate 28
18.1 × 26.3 cm
Tate, London

images from Turner's *Liber Studiorum,* has only emerged as a result of scholarly discussions in the last thirty years. The group of canvases returns to images the artist had first created almost forty years earlier, and seems to be his last homage to Claude Lorrain, perhaps conceived in opposition to Ruskin's hostility to the French painter, as expressed in *Modern Painters* (1843), where Turner and Claude are set up against one another. This canvas is based on plate twenty-eight of the *Liber*, one of several in the publication to depict the landscape bordering the river Wye, which had first been celebrated for its picturesque qualities in the 1790s by William Gilpin (fig.43; Forrester 1996, pp.78–9). IW

23 J.M.W. Turner

Sun Setting over a Lake *c.*1840–5

Oil on canvas 91.1 × 122.6 cm
B&J 469
Tate, London. Accepted as part of the Turner Bequest 1856;
first accessioned 1932, but probably not displayed until *c.*1947

Owing to the immense size of the Turner Bequest, many of the paintings, watercolours and sketches it contains have remained largely unfamiliar until comparatively recently. It was only in 1972, for example, that a group of fourteen remarkable oil studies on board was accessioned for the first time (B&J 487–500). Their rediscovery falls into the much longer pattern of sporadic bursts of administrative activity that have gradually made more of the collection available, a process that was chiefly dictated by the constraints on the space available for British pictures at the National Gallery (though this policy was later continued at the Tate). Yet the way in which the core group of paintings was steadily expanded was also fundamentally affected by issues of taste. This first came to the fore at the time of Turner's death, when even those sympathetic to him were inclined to think that the display of his pictures needed to be carefully restricted. His unfinished works, in particular, were felt to be intelligible only to other artists, and there was a fear that his aims in preparatory studies of this kind would be misunderstood, which might harm his reputation. It was one thing to include fully resolved composition studies, such as *Chichester Canal* (no.10), in the National Gallery's displays, but no one would have felt it appropriate to show pictures like this work, which would have been seen as merely the first stage of a design that should have received much more attention before it was considered fit for exhibition. In fact, it probably represents the state in which Turner submitted some of his later canvases to

the Royal Academy exhibitions, which were then transformed by him during the three Varnishing Days before the public were admitted. One contemporary describes these late works as being mere dabs 'of several colours, and 'without form and void, like chaos before the creation' when they first arrived (see Joll, Butlin and Herrmann 2001, pp.354–7).

At the start of the twentieth century, once official taste in Britain had begun to assimilate the developments in French landscape painting, Turner's unfinished pictures were looked at again with a more sympathetic eye, seeming to some viewers to justify the patriotic idea that he and Constable had paved the way for Impressionism. So from 1906 onwards his most pared-down, atmospheric canvases began to feature in the displays, by then at the Tate, challenging accepted ideas of Turner's art.

The example shown here seems to date from the mid-1840s, and demonstrates Turner's use of a scumbled surface of predominantly white paint upon which he began to suggest imprecise forms, and the early stages of what is already an intense sunset. This was the period in which Turner embarked on a set of four paintings charting the activities of whaling fleets (B&J 414–15, 423, 426), while also developing images of the Swiss lakes for an Irish patron. It may be, therefore, that the image could have been completed as one or other of these types of subject, depending on the requirements of the market. IW

24 David Carrick after J. M.W. Turner
Rockets and Blue Lights published 1852

Chromolithograph on paper 56.2 × 75.8 cm
R 850
Tate, London. Purchased 1992

25 James McNeill Whistler
Copy after Turner's **Rockets and Blue Lights (Close at Hand)**
to Warn Steam-Boats of Shoal Water 1855

Watercolour on paper 51.1 × 72.7 cm
M 176
Cortland Cammann, New York State

During his year in London in 1848–9 Whistler became a great admirer of Turner. After returning to America, his only access to Turner was probably through prints after paintings. On 9 February 1854 George Lucas of Baltimore bought an impression of a newly published chromolithograph after Turner's painting *Rockets and Blue Lights (Close at Hand) to Warn Steam-Boats of Shoal-Water*, exh. 1840 (Sterling and Francine Clark Art Institute, Williamstown; B&J 387), for Whistler's half-brother, George Whistler, who lived in Brooklyn, New York. Whistler copied the chromolithograph at his brother's house in Brooklyn, demonstrating his enthusiasm for, and first-hand knowledge of, Turner's effects in watercolour. As Margaret MacDonald has noted (MacDonald 1995, p.53), he used scraping out to create the highlights found in the rockets, reflections and waves, and 'washing out' to create the tones on the lighthouse. Whistler's was not a slavish imitation: he altered the foreground figures and extended their reflections.

Mrs Whistler, who mistakenly believed that her son had made this watercolour at West Point, saw it as one of his finest accomplishments. On 18 July 1855 she asked him to have it framed for her to give to Dr George Philip Cammann, Whistler's uncle and physician. She wrote to Whistler saying:

I wish you would call at Barretts & have your W Point painting framed in the old Peter GT frame, have it re-gilded & sent by Barrett per Propelle Line to NY. Tell them to direct the bill to me, but if you dear Jemie approve I wish to present Doct Cammann with that piece [*sic*], as under God – his skill & attendance enabled you to profit by your last year at West Point. I am sure it would gratify him as a token of your grateful remembrance of his disinterestedness
(Anna Matilda Whistler [Scarsdale] to James McNeill Whistler, Baltimore [18 July 1855], GUL MS Whistler W456, GUW 06461).

Margaret MacDonald has pointed out that the frame was probably made during the reign of Peter Romanov I (1672–1725), Tsar of Russia. It was probably brought back to America from St Petersburg where the Whistlers had lived from 1843–9. It appears to have been a prized possession and the use of it reflects her admiration for Whistler's copy.

Whistler did this just before leaving America to study art in France. His passport was issued on 28 July, and on 10 October, having come into his small inheritance from his father, he set sail for England. KL

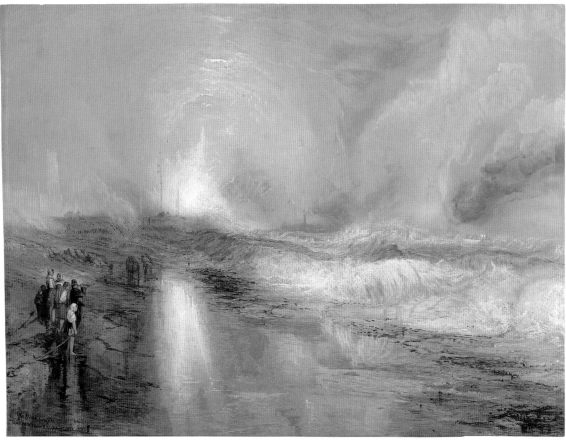

24

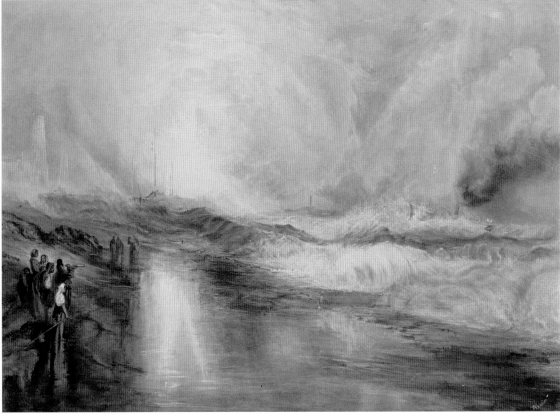

25

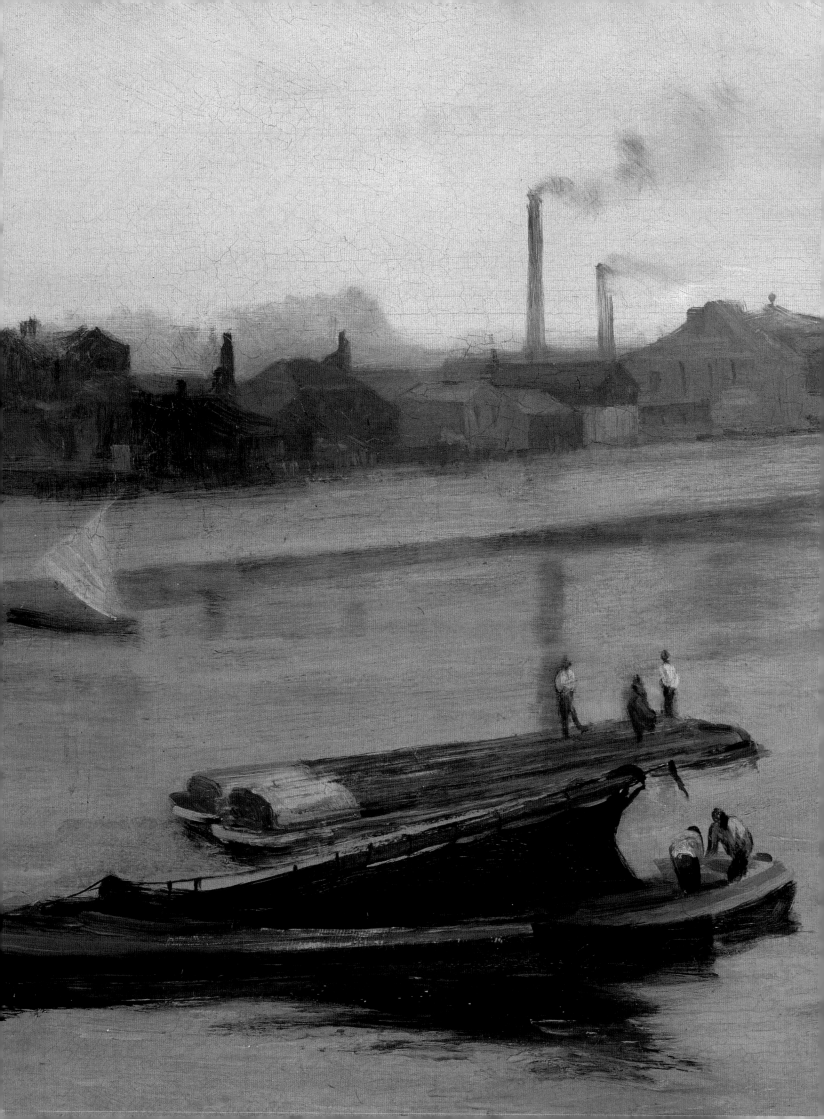

From realism to the 'impression'

John House

Through the 1860s and 1870s, Whistler's and Monet's careers ran on parallel paths, though their aims and practices diverged in certain crucial ways. Both of them first made their mark as 'realist' painters, as painters of contemporary life, and both, by the later 1870s, had become preoccupied by effects of light and atmosphere.

From his arrival in Europe in 1855 until 1867, Whistler sought to exhibit his work and develop his career in both Paris and London, home of his half-sister Deborah and her husband the surgeon and etcher Francis Seymour Haden. The roots of his art lay in France; he briefly studied in the studio of the academic artist Charles Gleyre, but quickly reacted against the discipline of academic draughtsmanship, and became a member of a loose grouping of younger painters around Gustave Courbet, treating everyday subjects in a relatively broad, sketch-like technique.

After moving his base from Paris to London in 1859, Whistler focused on explicitly modern subjects, and especially on the river Thames and its banks, in both paintings and etchings. By choosing such explicitly contemporary scenes he was staking a claim as a realist, committed to the representation of all facets of modern life. His etchings, later named the 'Thames Set', explored the buildings, boats and characteristic figures of London's Docklands, treating parts of each scene in fine detail but adopting deliberately informal compositions in order to evoke the idea that the scene was being viewed casually, as if in passing. This reach of the Thames also formed the background for *Wapping* (no.26), his first ambitious oil painting of an outdoor scene, begun in 1860. *The Thames in Ice* (fig.44), painted in the same year, is the first canvas that reveals his interest in London's characteristic mist and fog, a theme that was to become central to his and Monet's art. In his smaller oils of the early 1860s depicting the reach of the Thames from Westminster upstream to Chelsea and Battersea (nos.32, 33), Whistler increasingly eliminated detail from his canvases in favour of simplified atmospheric effects. By conventional standards the scenes he chose were not picturesque, with their factory chimneys and warehouses; it was the mists that transformed them into scenes that were worth painting.

Whistler's vision of the Thames stood in marked contrast to the stock British views of the river in these years, by painters such as David Roberts, which celebrated its most famous sights and treated them with great specificity and precise detail. In his

pursuit of the 'effect', Whistler was far closer to the concerns of contemporary French landscapists, and notably Jean-Baptiste-Camille Corot and Charles-François Daubigny, both of whom were criticised in the 1860s for focusing on the 'impression' – the fleeting atmospheric effect – at the expense of the material subject in their landscapes. Yet Turner offered a precedent for a vision that saw London's landscape, and specifically the Thames, in terms of light and atmosphere rather than topographical detail. Moreover, the delicate and muted colour schemes in some of Turner's watercolours – a far cry from the lavishly coloured effects in his exhibition paintings – offer precedents for Whistler's

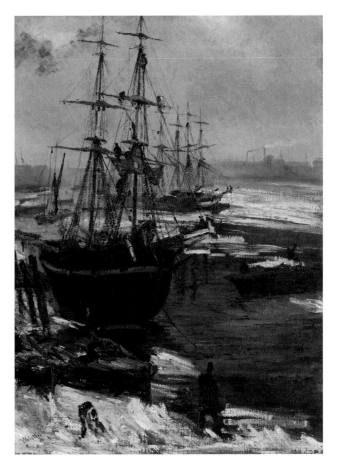

Fig.44 James McNeill Whistler, **The Thames in Ice**, 1860
Oil on canvas, 74.6 × 55.3 cm, YMSM 36. Freer Gallery of Art, Smithsonian Institution, Washington DC. Gift of Charles Lang Freer

low-key harmonies. Turner's example, endorsed by Haden's enthusiasm for his art, offered a sanction for Whistler's experiments.

Monet made his exhibiting debut at the Paris Salon in 1865 with two scenes of the coast around the Seine estuary that signalled his commitment to the realist vision of Daubigny and Johan-Barthold Jongkind, both of whom became friends and mentors to him. By 1865, too, he knew Gustave Courbet, though the often-repeated story that Monet and Whistler worked together with Courbet on the Channel coast at Trouville in autumn 1865 is unfounded, since Monet did not visit the coast in these months. We do not know when Monet and Whistler met, but it seems very likely that their paths crossed between 1865 and 1867, through one of their mutual friends and acquaintances, such as Courbet or Daubigny, or perhaps Edouard Manet – a key point of reference for both Monet's and Whistler's figure paintings in these years.

In the later 1860s Monet's prime interest in his landscape painting was in exploring ways of representing direct sunlight in paint, and his palette became increasingly brightly coloured as he came to use colour-contrasts as a means of conveying these effects of light. However, he was also fascinated by winter scenes, and for the first time in the winter of 1867–8, in *Ice Floes on the Seine at Bougival* (no.35), he tackled a monochromatic misty effect very comparable to Whistler's Thames scenes. Even if the two artists were not personally acquainted at this point, Monet would have been able to see several of Whistler's Thames scenes, including nos.26 and 32 and *The Thames in Ice*, on exhibition in Paris in 1867.

In that same year Whistler wrote a manifesto-letter to Henri Fantin-Latour in which he repudiated 'realism', insisting that Courbet had exerted no influence on him, and declaring a wish that he had been trained under the French academic master Jean-Auguste-Dominique Ingres, who had just died.[1] For several years he had been in close contact with Dante Gabriel Rossetti and his circle in London, and in his figure paintings of the mid-1860s, much influenced by Japanese art, he had pursued an aesthetic of decorative beauty, in contrast to the explicitly contemporary subject matter of his Thames scenes. Between 1867 and 1870, working closely with Albert Moore, he embarked on a number of figure-painting projects that combined the influences of the arts of Classical Greece and Japan, creating an entirely

imaginative vision of women at leisure that marked his categorical rejection of any notion of 'realism'.

Yet in one canvas, *The Balcony* (fig.50 on p.141), begun in 1864–5, he combined just such decorative female figures with a background scene of the Thames in mist, with the exotic figures on the balcony set off against the skyline of Battersea, with its chimneys and the distinctive silhouette of the Morgan Crucible Company building. In 1870 he reworked the canvas and exhibited it at the Royal Academy in London, at just the moment that he was returning to the Thames subjects that he had treated in the early 1860s. These new Thames scenes, to which he gave musical titles such as 'Nocturne' and 'Variations', were still simpler and more broadly executed than their predecessors, minimising descriptive detail in favour of atmospheric effect and delicate harmonies of colour and tone; paintings of this type played a central part in his work through the 1870s and formed his most distinctive, and most controversial, contribution to the art of the period (see nos.43–9).

It was at this point, in the autumn of 1870, that Monet visited London to escape conscription into the French army during the Franco-Prussian War, arriving too late to see *The Balcony* at the Royal Academy, and leaving London before Whistler exhibited the first of his Nocturnes (no.43) in autumn 1871. Although there is no documentary proof that the two men met during that winter, the visual evidence suggests strongly that they did. Monet's three Thames scenes all focus on subjects that Whistler had treated in his 'Thames Set' etchings, the Pool of London at Billingsgate (nos.28–30, see no.37), and the new Houses of Parliament (no.27; see no.36). Moreover, Monet's technique, particularly the liquid washes of subtly harmonised colours in *The Thames below Westminster* (no.36), shows close similarities to the paint handling in Whistler's latest canvases, the first Nocturnes (nos.43, 46).

This visit to London also marked Monet's first encounter with the art of Turner, in the displays of his work in the National Gallery and at the South Kensington Museum (Victoria and Albert Museum, London). What evidence we have about his initial reaction to Turner derives from reminiscences in later years (see pp.42–4, above), but it seems that at this point in his career he felt that Turner's use of colour was too extravagant and not based closely enough on direct observation of natural effects. However,

Turner and his art offered him a challenge, both through his use of colour to suggest form and space, and through his commitment to painting the most extreme forces of nature and effects of light.

Monet's art in the 1870s was very diverse, as he explored a very wide range of subjects in all seasons and types of weather. If his archetypal scenes of summer sunlight on the Seine at Argenteuil carry no echo of either Turner or Whistler, other subjects and effects suggest that he remained well aware of their art and of what it could offer him. In a number of delicate and atmospheric canvases of 1872 and 1873, he continued to use fine and broadly swept veils of liquid colour that were reminiscent of Whistler, and in *Impression, Sunrise* (no.39) he harnessed this technique to a subject that was clearly inspired by Turner, and specifically to his *Sun Rising through Vapour* (no.2). On occasions in the mid to late 1870s and early 1880s, too, he tackled dramatic sunset effects (e.g. nos.40, 41) that can be viewed as continuing responses to this leitmotiv in Turner's art.

In broader terms, clear parallels remain between Monet's and Whistler's art throughout the 1870s. They both remained committed to an aesthetic theory that put prime emphasis on the sensation – on the artist's unique personal sensory response to the scene in front of him – as the sum of human experience. All of the Impressionists' statements of their aims in their art emphasised the subjectivity of their vision, and insisted that their knowledge of the world around them had to be based on their sensations alone, stripped of any accretions of prior knowledge. In these terms they were attacking the bases of academic art and artistic training, and at the same time rejecting any notion that

the visible world was the reflection of any higher reality or God-given purpose. Whistler's defence of his artistic position in the 1878 Whistler–Ruskin trial was conducted in very much the same terms, with its emphasis on the painter's personal 'artistic impression'.[2] However, Whistler's cultivation of memory as an integral part of his working practices contrasts with Monet's commitment during the 1870s to painting in front of the motif. Despite this difference between their methods, though, both Monet and Whistler repudiated academic notions of 'finish' in painting, insisting that the artist alone could judge when his work was 'complete'. More specifically, too, their shared admiration for Japanese colour prints encouraged them to view natural forms in terms of decorative pattern, as can be seen, for instance, in the foreground reeds in no.40 by Monet and no.46 by Whistler.

Turner's interest in mythological subjects (see e.g. no.14) would have held little interest for either Whistler or Monet, but his sustained commitment to exploring the possibilities of an explicitly modern form of landscape painting would have been a vital stimulus to them. In particular, his images of the Thames, such as *Mortlake Terrace* (no.4) and the Seine, in the *Rivers of France* watercolours (e.g. nos.11–13), presented the most celebrated rivers of the two countries as the focuses of both their historical monuments and their contemporary life, social and commercial. Beyond this, his iconic *Rain, Steam and Speed* (fig.18 on p.39) showed that even the fruits of modern technology could form the subject matter for landscape painting. For Monet, the lessons of Turner's colour became more relevant after his next visit to London in 1887 (see pp.44–5, above, and nos.60–2,).

26 James McNeill Whistler

Wapping 1860–4

Oil on canvas 71.1 × 101.6 cm
YMSM 35
National Gallery of Art, Washington.
John Hay Whitney Collection, 1982

Set in a grimy section of London's riverfront, *Wapping* embodies the attachment to modern-life subjects that attracted Whistler and his Parisian friends Alphonse Legros and Henri Fantin-Latour ('Les Trois') to the art of Gustave Courbet. While working on no.26, Whistler wrote to Fantin-Latour that it would feature a prostitute, with bared cleavage (subsequently chastened), taunting a sailor. They are accompanied by another male (a pimp, perhaps), modelled on Legros; the artist's lover, Joanna Hiffernan, sat for the woman. In its unflinching portrayal of louche riverside mores, *Wapping* recalls *Young Women on the Banks of the Seine (Summer)*, exhibited by Courbet in the Salon of 1857 (Musée du Petit Palais, Paris). Indeed, out of fear that Courbet would steal his subject, Whistler kept it secret. At the same time, like Manet and Degas – and unlike either Courbet or Monet – Whistler was both a dandy and an urban *flâneur*, whose taste for slumming in no way conflicted with his thirst for aesthetic refinement. Whereas Courbet sought to celebrate the mundane – imbuing unidealised, triumphantly palpable bodies with a rhetorical amplitude worthy of the Old Masters – Whistler's eye for nuance seized intricate visual subtleties amid the most seemingly barren of settings. An ability to enliven the banal also characterised 'Jimmy's illuminating power' as a storyteller, according to fellow artist Thomas Armstrong (1912, p.181):

> He did not tell us anything he had not heard or leave out anything important, but by putting the accent in the right place he made an interesting word picture, just as he could illuminate for us a bit of a Thames mud-bank at low water (and there was a mud-bank along the Thames in those days) with a barge lying on it and a stump or two, things we should have passed by without notice left to ourselves.

Executed prior to the completion of the sewer system that would soon spare London the stench of Thames-borne excrement, *Wapping* recasts, according to the amoral curiosity of French Realism, the Victorian coupling of turbid Thames and carnal sin (see pp.59–60, above). Avoiding the hackneyed, sentimental facial expression of conventional nineteenth-century genre paintings, Whistler invests his figures with an oddly inexpressive aspect, which – as in the work of Manet – blurs the distinction between figural painting and still life.

Of Whistler's penchant for detached observation the critic Philip Gilbert Hamerton wrote: 'Whether he really loves anything I have never been able to determine, but he has a predilection for the wharves of the Thames, which, in a warmer temperament, would have grown into a strong affection. Whistler seems from his works . . . to be not altogether expansive or sympathetic, but self-concentrated and repellent of the softer emotions.' When in *The Gentle Art of Making Enemies* Whistler mockingly quoted Hamerton ('If beauty were the only province of art, neither painters nor etchers would find anything to occupy them in the foul stream that washes the London wharves'), the artist omitted the insightful, appreciative passage that followed: 'but even ugliness itself may be valuable if only it has sufficient human interest and fortuitous variety of lines . . . It takes some time to analyse any of Whistler's more complicated river subjects, and we have a pleasure in the occupation, which is much enhanced by the singular skill of the designer' (Hamerton 1868, pp.112–13, 115). Directed at Whistler's 'Thames Set' etchings, Hamerton's words apply equally to *Wapping*. JR

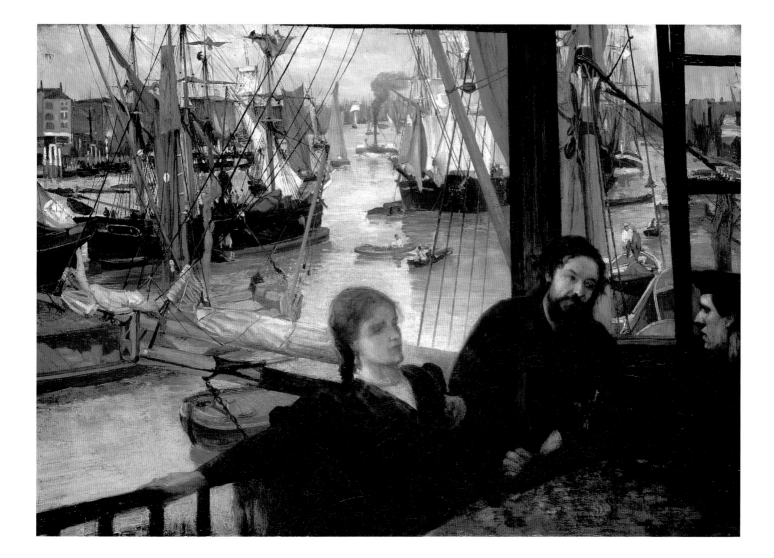

27 James McNeill Whistler
Old Westminster Bridge 1859

Etching on laid paper 7.3 × 18.4 cm
K39, only state
S.P. Avery Collection, Miriam and Ira D. Wallach Division of Art, Prints and Photographs,
The New York Public Library, Astor, Lenox and Tilden Foundations

This is probably Whistler's first Thames plate, made between his move to London from Paris on 6 May 1859 and the end of the month. When he made this etching the clocktower was all but complete: still surrounded by scaffolding (as Jessica Morden has noted) its great bell, Big Ben, was being hoisted into position. It rang out for the first time at the end of the month, on 31 May 1859. In this plate Whistler created (in reverse) a portrait of a place which was undergoing rapid change. The bridge, with its distinctive silhouette, was slated for demolition the following year, and the riverfront for embankment.

Just as Turner had witnessed the destruction of the old parliament buildings in 1834, Whistler witnessed the opening of the new Houses of Parliament. In May 1859 they were nearly completed and were much admired internationally. The seat of empire, they symbolised Britain's resilience, wealth, and might.

By recording the appearance of Westminster Bridge prior to its demolition Whistler may have been 'referencing' Turner's famous *The Burning of the Houses of Lords and Commons, 16th October 1834* (no.78).

In July 1859 Whistler gave Fantin-Latour impressions of two etchings, a Thames and a Greenwich subject (the latter made with Fantin-Latour present), to take back to friends in Paris. Fantin-Latour wrote on 5 August to tell Whistler how much they were admired, and mentioned that Ernest Delannoy 'is very much pleased with the Thames [view]' (Henri Fantin-Latour, letter to Whistler, 5 August 1859: GUL MS Whistler F5, GUW 01074). It is probably this etching that Fantin-Latour took back as it was not until after Fantin-Latour returned to Paris that Whistler moved to Wapping where he began work on the large, bold etchings of dockland that were to make his reputation. KL

28 Black Lion Wharf 1859

Etching in black ink on japon mince
15.1 × 22.3 cm
K 42, II/III
Art Gallery of Ontario, Toronto.
Gift of Sir Edmund Walker Estate, 1926

29 The Pool 1859

Etching in brown ink and plate tone on old handmade
cream-coloured laid paper 13.8 × 21.3 cm
K 43, III/IV
S.P. Avery Collection, Miriam and Ira D. Wallach
Division of Art, Prints and Photographs, The New York
Public Library, Astor, Lenox and Tilden Foundations

30 Billingsgate 1859

Etching in black ink with plate tone on wove paper
22.6 × 31.1 cm
K 47, III/VIII
S.P. Avery Collection, Miriam and Ira D. Wallach
Division of Art, Prints and Photographs, The New York
Public Library, Astor, Lenox and Tilden Foundations

In July 1859 Fantin-Latour and Whistler discussed Baudelaire's review of the Salon of 1859. In part VIII the critic lamented the absence of 'a genre I can only call the landscape of great cities, by which I mean that collection of grandeurs and beauties which result from a powerful agglomeration of men and monuments – the profound and complex charm of a capital city which has grown old and aged in the glories and tribulations of life'. He praised Charles Meryon for etching 'the gloomy majesty of this most disquieting of capitals', and said that he had 'rarely seen the natural solemnity of an immense city more poetically reproduced. Those majestic accumulations of stone; those spires "whose fingers point to heaven", those obelisks of industry, spewing forth their conglomerations of smoke against the firmament; those prodigies of scaffolding around buildings under repairs' (Baudelaire 1964, pp.200–1).

Whistler's search for a realist subject led to his focus on the contemporary urban landscape along the Thames, the 'highway' of London. In 1859 the Thames reeked nearly as much as it had the previous summer during the 'Great Stink' (see p.59, above). Whistler lived at a public house in Wapping from August to October. His brother-in-law, Dr Seymour Haden, who was well aware of the health hazards of this area, where 'miles of ditches served as open sewers' (de Maré 1973, p.4) tried unsuccessfully to discourage Whistler from staying there.

Wapping provided Whistler with easy access to the vast area covered by the London docks. He could go back and forth to Rotherhithe through Brunel's underwater tunnel, the Great Bore. The warehouses, wharves and Pool of London provided him with subject matter he knew would appeal to Courbet

and Baudelaire: it was contemporary, working class, combined the elements of cityscape, seascape, and industry, and was, above all, novel. He selected sites that were threatened by plans to embank the river and set about recording their vanishing 'beauties'. He ventured as far west as Billingsgate Fish Market, close to the office of Charles Haden, Seymour's brother, who worked at the Customs House at 77 Lower Thames Street.

Whistler executed these plates on a large scale using the strong, dark line associated with engraving that was employed by French Realist etchers. They were greatly admired by Baudelaire when they were shown in Paris at Martinet's Gallery in January 1862. Echoing his Salon review of 1859, Baudelaire found them 'subtle and lively as to their improvisation and inspiration, representing the banks of the Thames; wonderful tangles of rigging, yardarms and rope, a hotchpotch of fog, furnaces and corkscrews of smoke: the profound and intricate poetry of a vast capital' (Baudelaire 1964, p.217). Whistler complained to Fantin-Latour saying that 'Baudelaire says many poetic things about the Thames, and nothing about the etchings themselves' (Whistler, letter to Fantin-Latour, [Oct. 1862], LC PCW 1/33/3, GUW 07951).

These etchings established Whistler's reputation in Britain, France and America and, like Turner before him, linked his name inextricably with the Thames. Monet could have seen Whistler's early Thames etchings at Martinet's Gallery or in London where they were finally published as a set in May 1871 (see p.40, above). A reference to these plates can be detected in Monet's choice of subject and the compositional structure of the three paintings he made of the Thames in 1870–1 (nos.36, 37, and W 167). KL

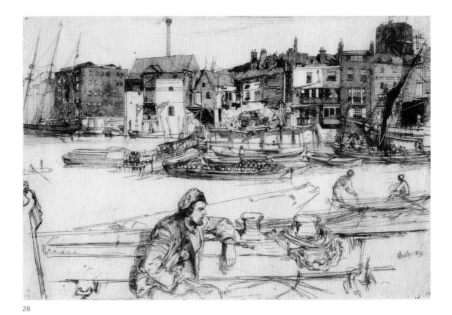

28

29

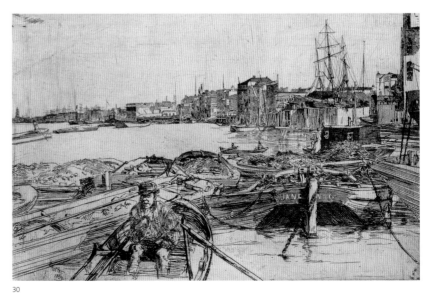

30

31 James McNeill Whistler

Westminster Bridge in Progress 1861

Etching in black ink on creamy antique laid paper 15 × 35.3 cm
K 72, only state
S.P. Avery Collection, Miriam and Ira D. Wallach Division of Art, Prints and Photographs,
The New York Public Library, Astor, Lenox and Tilden Foundations

Whistler found another modern urban subject in the construction of the new Westminster Bridge. It was built in two phases, the new one parallel to the old, which was largely demolished by late April 1861. This etching shows the scaffolding being erected prior to building the second phase of the new bridge, which opened in 1862. The stone construction of the first phase is faintly visible behind the scaffolding (YMSM, I, p.20).

Whistler's father was an engineer and bridge builder. He was Consulting Engineer of the Hydraulic Works in Lowell, Massachusetts, for three years. Prior to the family's move to Russia he not only oversaw the building of railroads, he designed and supervised the construction of three bridges in Connecticut

(Mrs Whistler, Diary, LC WPC box 33). When Whistler asked his permission to become an artist he advised him to apply his interest in art to a career in engineering or architecture. In this etching and the related painting, *The Last of Old Westminster* 1862 (fig.45), made at a later stage in the process, Whistler demonstrated his interest in, and knowledge of, bridge building. However, according to Arthur Severn, 'it was the piles . . . that took his fancy, not the bridge'. The presence of an observer directs our attention to the scaffolding, a characteristic of modern life to which Baudelaire had drawn the attention of artists. Whistler's interest in the geometry of wooden bridges was expressed in his many depictions of Old Battersea Bridge. Monet was later to follow suit (no.38). KL

Fig.45 James McNeill Whistler
The Last of Old Westminster
1862
Oil on canvas 61 × 78.1 cm,
YMSM 39
The Boston Museum of Fine Art,
Shuman Collection

Brown and Silver: Old Battersea Bridge 1863

Oil on canvas 63.5 × 76.2 cm
YMSM 33
Addison Gallery of American Art, Philips Academy, Andover, Massachusetts.
Gift of Cornelius N. Bliss
[Illustrated on p.122]

After studying at Gleyre's Academy, Whistler gravitated into the Courbet circle. His first painting of the Thames was commissioned in 1859 but appears to have been executed in 1863, the date inscribed on the painting (Dorment and MacDonald 1994, p.100). It appears to have been made from the second floor of 7 Lindsay Row (now 101 Cheyne Walk) in Chelsea, to which Whistler moved in March 1863. It is executed in a synthetic style and demonstrates an interest in atmospheric effect which, as John House has noted, is much more consistent with this later date than with Whistler's earlier realist paintings.

The selection of the site is significant for our narrative as it is only a short distance from the house where Turner died in 1851. Greaves the boatbuilder (who appears in the foreground) rowed Turner on Battersea Reach. However, it is far from Turnerian, and demonstrates Whistler's allegiance to the realism of Courbet and Baudelaire. This modern urban cityscape depicts a grimy industrial scene on the muddy banks of the Thames, and makes no attempt to idealise the dirty water, the decrepit wooden bridge (considered an eyesore at the time), or the working men who

plied their trade on the river. The Thames was horribly polluted at this time, gave off vile odours, and was a source of disease (see p.59, above).

The industries on the Battersea shore are clearly visible, as well as the smoke and haze to which they gave rise. They are, from left to right: Swan's Tavern (white building to the left of the bridge); the white lead works (black buildings with smokestacks); the timber yard and chemical works (the grey buildings along the waterfront with red roofs); and the tall smokestack of an iron foundry (see fig.46). The bridge and the building to the right at the end of it can be seen in a photograph by Henry W. Taunt (fig.3 on p.19). With its sombre palette of dirty blacks, greys, and browns, Whistler's painting conveys the mood of the industrial landscape and those who toil within it.

A ray of light falls on the roof of the Crystal Palace on the horizon, setting up a discourse between old and new. Whistler was no lover of new constructions. He would later point out in his 'Ten O'Clock' lecture that 'the windows of the Crystal Palace are seen from all points of London. The holiday-maker rejoices in the glorious day, and the painter turns aside to shut his eyes.' This view was painted in anticipation of the drastic changes which would soon take place with the embanking of the waterfront and demolition of Old Battersea Bridge. By the end of the 1870s the old waterfront, traditional river craft and river life would all but disappear. Like the oversize foreground figures in Whistler's 1859 Thames etchings (see nos.28, 30), Greaves appears to confront the viewer as if to question the desirability of change.

After making the switch from realism to aestheticism Whistler painted a nocturnal view of the same subject (no.47). KL

Fig.46 Detail from 'Map of London and its Suburbs' in *Stanford's New London Guide: With Two Maps*, Edward Stanford, London 1862

33 James McNeill Whistler

Grey and Silver: Old Battersea Reach 1863

Oil on canvas 50.9 × 69 cm
YMSM 46
The Art Institute of Chicago. Gift of Honoré and Potter Palmer
[Illustrated on p.123]

Whistler painted this view looking west from 7 Lindsay Row. The composition picks up where no.32 leaves off and completes the panoramic sweep of the view to the east. It is executed in the same style and palette.

Although Whistler's windows overlooked the same section of the river that Turner had observed so closely, the Battersea shore had changed from a relatively bucolic to an industrial one since Turner's death. The London Gas-Light Company moved from Vauxhall to Battersea in 1863 to comply with an Act of Parliament of 1859 which prevented gas companies from 'erecting other works for the manufacture of gas within ten miles of London' (Simmonds 1879, p.10). The odour of gas-works was one of the most unpleasant imaginable and was a daily reality for the Whistler household.

By this time the air of London consisted of a lethal mixture of fog and coal smoke which rose in a dense blanket to a height of 100–200 ft and led to 'the almost perpetual obscuration of the prospect, the blurring of distant objects, and the complete veiling on nine days out of ten of everything beyond two miles in the horizontal plane' (Simmonds 1879, p.11). Whistler became increasingly interested in depicting the atmospheric effects created by smoke and fog.

The industries visible on Battersea Reach include (from left to right) the saw mills, timber yard, turpentine works, chemical works, and flour mill. Founded in 1856, the Morgan Crucible Company grew rapidly, eventually becoming the largest supplier of crucibles in the world. In 1857 it was fined for emitting too much smoke (Bennett 1956, p.13). The raw materials, clay and plumbago, also contributed grey and white particulate to the atmosphere. By 1862 Morgan Crucible dominated the industrial landscape: its structures include the three smokestacks and the buildings to the right in the centre of the composition. The foreground figures pushing a rowing-boat out onto the river are reminiscent of Turner's staffage which Whistler had studied when making his copy after Turner (nos.24, 25).

After his conversion to aestheticism, Whistler painted a nocturnal view of the same scene, *Nocturne in Blue and Silver* (no.48). KL

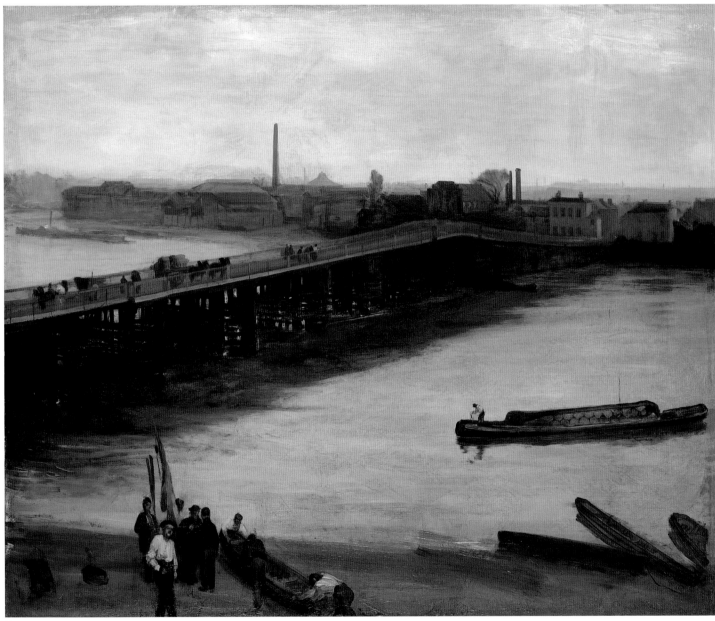

32

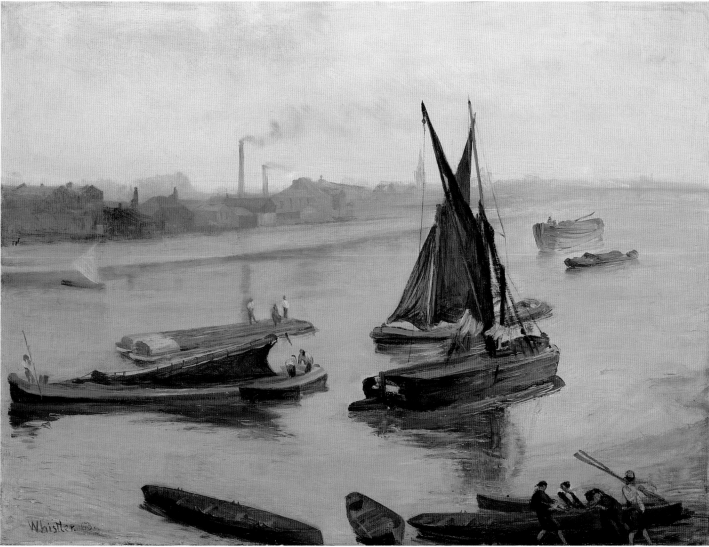

33

34 James McNeill Whistler

Chelsea in Ice 1864

Oil on canvas 44.7 × 61 cm
YMSM 53
Private collection, USA.
Courtesy of Thomas Colville Fine Art
EXHIBITED IN TORONTO ONLY

This view of the Thames from Whistler's house in Chelsea, which was probably made in January 1864, captures the ephemeral effect of ice on the river. The artist's interest in transience not only included bridges and buildings, but seasons, states of water, light and darkness, and meteorological effects. Silhouetted on the other side of the river are the roofs and chimneys of the Morgan Crucible Company. The smoke from the chimneys mixes with the mist rising off the water.

The figures in the foreground observe the frozen river, prefiguring the silent observers in Whistler's Nocturnes. Their appreciation of the atmospheric effects which cloak the industrial landscape herald the shift in Whistler's work from realism to aestheticism. The flatness of the composition, the simplification of form, the diagonal band formed by the wall, and the small foreground trees may have been suggested by the Japanese prints which Whistler was collecting. The figure wearing red injects a subtle note of colour into the otherwise drab palette. In this work the artist seized only the impression; his mother considered this work unfinished (YMSM, I, note to no.53). KL

35 Claude Monet

Ice Floes on the Seine at Bougival 1867–8

Glaçons sur la Seine à Bougival

Oil on canvas 65 × 81 cm
W 105
Musée du Louvre, Paris
EXHIBITED IN PARIS ONLY

Monet's first snow scenes, of *c*.1865–6, showing roads near Honfleur on the Normandy coast, are treated with firm, distinct strokes of the brush and a dense impasto. By contrast, *Ice Floes on the Seine at Bougival*, painted in the winter of 1867–8 and showing a branch of the Seine around ten miles west of Paris, is more economical in its execution and delicate in its effects. The figures and other details in the foreground are captured with crisp, deft strokes that vividly characterise their forms; however, the river and the background are handled with great simplicity, in broad sweeps of near-monochrome paint that capture the misty, overcast effect and the stillness very effectively.

It seems very likely that Whistler and Monet were acquainted at this date. However, even if they were not, Monet would have been able to see in exhibition in Paris in the summer of 1867 a number of paintings by Whistler whose execution invites comparison with *Ice Floes on the Seine at Bougival*. *Brown and Silver: Old Battersea Bridge* (no.32) was on view at the *Exposition Universelle*, together with *Wapping* (no.26), while *The Thames in Ice* of 1860 (fig.44 on p.109), with its floating ice, was shown at that year's Salon. It seems very likely that the simplicity and economy of Whistler's paint-handling were the catalyst that helped Monet when he came to tackle the mist effect in *Ice Floes on the Seine at Bougival*; at the same time, the painting was his first representation of floating ice, a motif that played an important part in his later career (see no.42), and in turn foreshadowed the floating lily-pads of his late water-lily canvases. JH

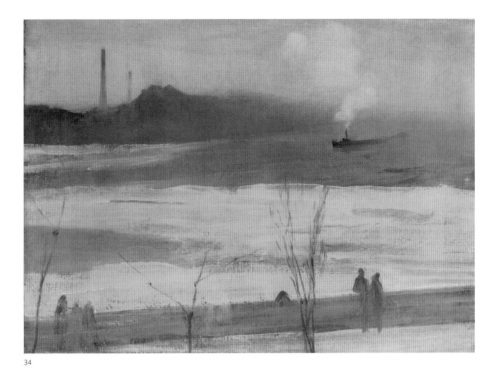

34

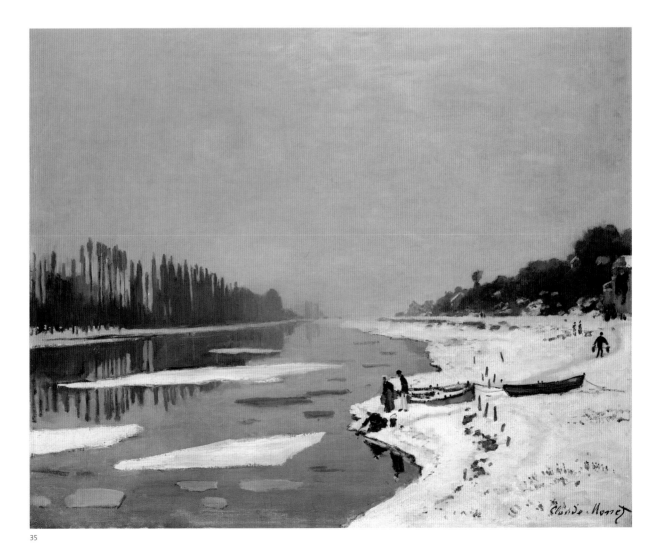

35

The Thames below Westminster 1871

La Tamise et le Parlement

Oil on canvas 47 × 73 cm
W 166
National Gallery, London

In choosing to paint the Houses of Parliament, Monet was working in the footsteps of both Turner and Whistler. It is probable that he was unaware of Turner's canvases of the burning of the Houses of Parliament (see no.78), showing the destruction of the old Parliament buildings in October 1834, but he very probably knew Whistler's etching *Old Westminster Bridge* of 1859 (no.27), showing the new Houses of Parliament, looking upstream from much the same viewpoint, with the Big Ben clocktower seemingly still incomplete. However, by the time that Monet painted the scene, little more than a decade after Whistler's etching, the site had been transformed. The Parliament buildings had been completed, with the addition of the monumental Victoria Tower, seen behind the clocktower; Westminster Bridge had been rebuilt in 1862, and, in the mists beyond it, St Thomas's Hospital was in the process of completion. Most significantly, the first stretch of the Victoria Embankment, in the right foreground of Monet's painting, had been constructed. This monumental undertaking created a major roadway alongside the Thames, comparable to the *quais* of Paris, with an underground railway beneath it; but its most significant function was to house a new drainage system – the first vital step in ameliorating the pollution of the Thames. The Embankment was opened in July 1870, but in Monet's canvas it is still incomplete: the vertical brushmarks on the wall at the right of the painting represent the stone base of one of the Embankment's elaborate lamp-standards, but the lamp-standards themselves have not yet been installed; the structure in the river on which men are working is clearly temporary, and presumably part of the construction process. The paddle-steamers complement this markedly contemporary scene.

However, the physical subject was not Monet's sole concern: *The Thames below Westminster* is also centrally concerned with London's distinctive light and atmosphere, and with the ways of translating this into paint. The structure in the river and the foreground reflections are crisply handled, but the remainder of the subject is veiled in mist and softly treated in broad sweeps of pastel colour, quite thinly applied across the light-toned canvas priming. This execution is simpler and more economical than any of Monet's previous canvases, and suggests comparison with Whistler's contemporary paintings of the Thames (nos.43, 46) which Monet could have seen in Whistler's studio. In one important sense, though, Monet's canvas is unlike Whistler's – in the soft, suffused salmon pinks that enliven both sky and water and suggest the warm light of the sun behind the mist; here we can sense the impact of Turner's later work, which Monet saw at the National Gallery during his stay in London in 1870–1.

Monet returned to the theme of the Houses of Parliament in the mist in his series of 1899–1904 (see nos.79–81). JH

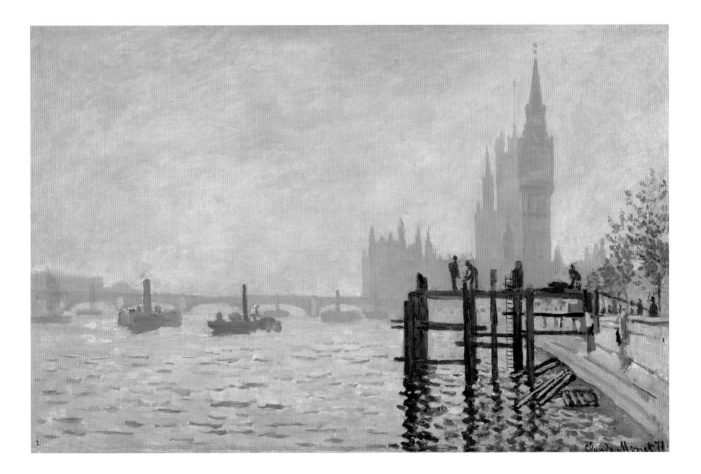

37 Claude Monet

The Pool of London 1871
Le Bassin de Londres

Oil on canvas 48.5 × 76.5 cm
W 168
National Museums and Galleries of Wales, Cardiff

Monet's view in *The Pool of London* looks upstream from a viewpoint at Tower Stairs, beside the Tower of London. On the right we see the Customs House and, beyond, the pyramid-capped tower of Billingsgate Fish Market alongside the taller tower of the church of St Magnus the Martyr; the silhouette of London Bridge closes off the left background. This was one of the most celebrated points from which to view the Pool; the same scene regularly appeared in illustrated books about the Thames. The Pool of London itself was viewed in these years as the hub of London's maritime commerce; in 1860, in a French guide-book to London, Elisée Reclus wrote: 'One cannot see this army of ships, come from every corner of the globe, without understanding that London is truly the meeting-point of the nations' (Reclus 1860, p.384). Whistler's etching *Billingsgate* (no.30) presents the same scene from a little further upstream, alongside the market, and Whistler's Thames etchings as a group treat the spectacle of London's ports and docks with a

comparable informality, as boats of all sizes and types go about their business.

As in *The Thames below Westminster* (no.36), the distinct elements in the foreground are notated quite crisply, but the open water and the misty background are treated in broad, simple sweeps of delicately nuanced grey paint that are comparable in handling to Whistler's early Nocturnes.

From the beginning of his career Monet had on occasion painted pairs of pictures of the same scene, in different weather conditions and with different groupings of figures and other details. The open fore-gound in *The Pool of London* contrasts with the complex unloading procedure and busy foreground of a second painting of the scene (private collection; w 167), clearly painted at very much the same date. Such pairs were one of the starting points for Monet's later practice of working in series (see nos.60–2); but there is no evidence that at this point in his career he intended such pairs to be viewed or exhibited together. JH

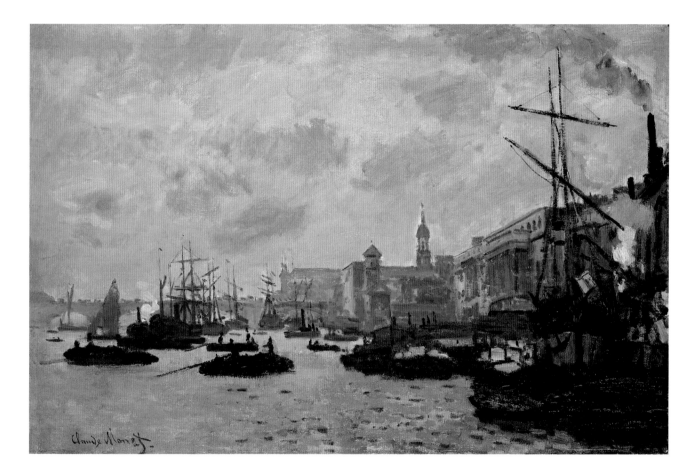

38 Claude Monet

Argenteuil, the Bridge under Repair 1872

Argenteuil, le pont en réparation

Oil on canvas 60 × 80.5 cm
W 194
Private collection, on loan to the Fitzwilliam Museum, Cambridge
EXHIBITED IN LONDON ONLY

When Monet went to live at Argenteuil, about eight miles north-west of Paris, late in 1871, the place was still bearing the scars of the Franco-Prussian War in which both road and rail bridges across the Seine had been destroyed. In *Argenteuil, the Bridge under Repair*, the structure of the new bridge seems largely complete amid the scaffolding. In Monet's first years at Argenteuil his paint-handling and treatment of his subjects were extremely varied, depending on the season and weather effect depicted. Some canvases are vibrant in colour and executed with an incisive and crisp brush-stroke. By contrast, in this scene, probably dating from spring 1872, the hazy effect and overcast sky give the whole canvas a subdued harmony, punctuated only by the dark accent of the boat and the light points on the scaffolding. Broad sweeps of liquid paint convey the stillness of sky and water, and invite comparison with Whistler; the conception of the subject, as well as its treatment, are particularly close to *The Last of Old Westminster* of 1862 (fig.45 on p.118), though it is not clear that Monet could have known this work.

Although this canvas has been interpreted as a positive image of France's renewal after war, its muted tonality and stillness convey little sense of energy or optimism; at the same time, the complex network of the wood scaffolding, together with the smoke from the boat's funnel, emphasise that this is an explicitly modern landscape. This is a far cry from the imagery of unspoiled rural France, so popular at the Salon exhibitions in these years that the repressive government of the early 1870s used it as a means of propagating notions of national recovery after the war. JH

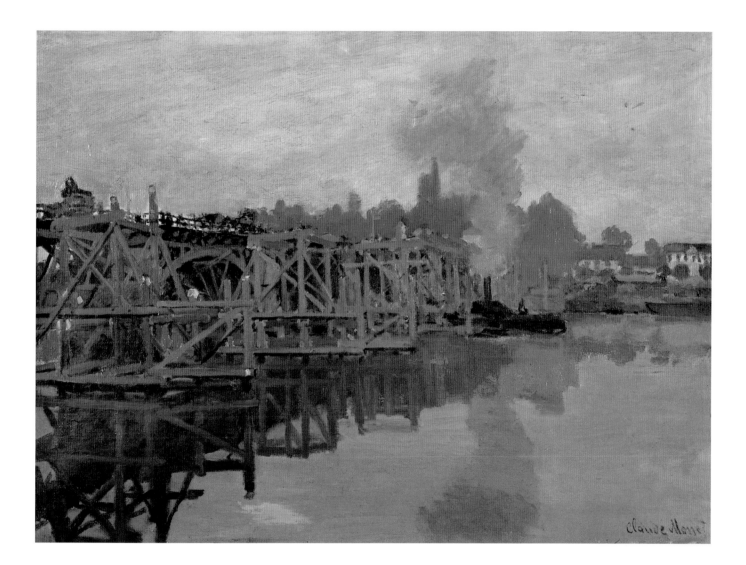

39 Claude Monet

Impression, Sunrise 1872–3

Impression, soleil levant

Oil on canvas 46 × 63 cm
W 263
Musée Marmottan, Paris
EXHIBITED IN PARIS ONLY

When Monet exhibited *Impression, Sunrise* at the first exhibition organised by the Société anonyme des artistes peintres, sculpteurs, graveurs, etc. in 1874, its title led to the group being named the 'Impressionists'. Alongside this painting Monet also exhibited another, larger canvas, showing much the same view of the port of Le Havre but treated in far more detail, on a rainy day. He gave this larger canvas the title *Le Havre, Fishing Boats Leaving the Port* (private collection; W 296); he later said that he had used the title *Impression* for the smaller picture because 'it could not pass as a view of Le Havre' (Guillemot 1898, p.[1]). The term 'impression' was already widely used to describe a rapidly notated painting of an atmospheric effect, but artists rarely, if ever, exhibited pictures so quickly sketched as *Impression, Sunrise*; indeed, no other painting in this first group show was so summarily treated.

Impression, Sunrise was executed in a very brief time, and probably in a single sitting; even the boats in the foreground and the sun with its reflections were added while the thin paint-layers beneath them were still wet (the shadowy darker shapes seen below the current picture surface are traces of a different picture that Monet had begun on the same canvas). Spontaneous though it is in its execution, the picture also testifies to Monet's study of the work of other artists, and specifically of both Turner and Whistler. The motif of the rising or setting sun and its reflections was extremely common in Turner, in works ranging from elaborately finished exhibition paintings such as no.4 to summary watercolours such as no.15; indeed, the image of the sun over a port is a distant echo of Claude Lorrain, next to one of whose port scenes Turner's *Sun Rising through Vapour: Fishermen Cleaning and Selling Fish* (no.2) hung in the National Gallery in London. At the same time, the broad washes of thinly applied oil paint and the delicacy of the treatment of the background ships bear the clear imprint of Monet's knowledge of Whistler's Nocturnes (nos.43, 46). The picture has come to be seen as a manifesto for the Impressionist movement, but its relationship to both Turner and Whistler locates it clearly within the wider history of landscape painting. JH

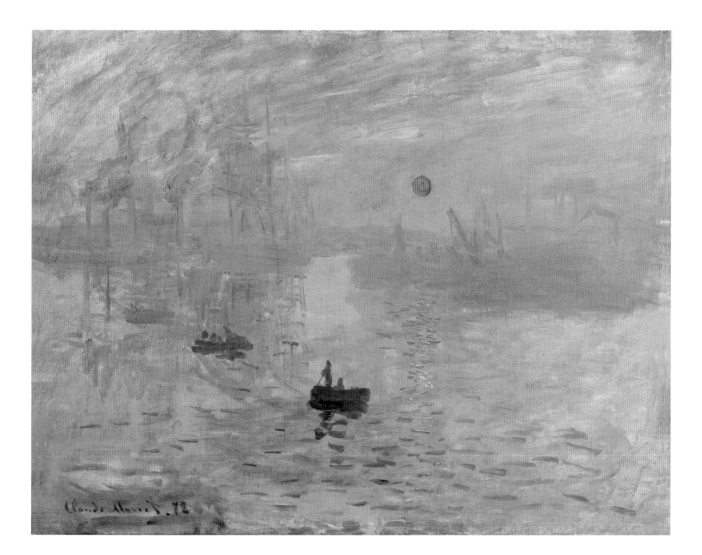

40 Claude Monet
Sunset on the Seine 1874
Coucher de soleil sur la Seine

Oil on canvas 49.5 × 65 cm
W 328
Philadelphia Museum of Art

Sunset on the Seine, probably painted in 1874, shows the view towards the downstream section of Argenteuil from the left bank of the Seine, with, in the centre, the mock sixteenth-century style house at the river's edge that appears in so many of Monet's Argenteuil river scenes. Another canvas, *The Seine at Argenteuil* (fig.47), shows virtually the same scene in very different weather conditions. In both pictures, the reeds that frame the foreground are treated in crisp calligraphic strokes reminiscent of the Japanese colour-prints of which Monet was already a keen collector. Beyond this, though, the two paintings are strikingly different. Both scenes are explicitly contemporary. But in *The Seine at Argenteuil* the smoking factory chimney in the distance indicates the industrial developments in the region, while in *Sunset on the Seine* the prominent sailing boat shows Argenteuil in its guise as a centre for recreational boating. The chosen weather effects complement these details – the muted, overcast day for the more industrial subject, and the spectacular sunset for the leisure scene. This pairing shows the wide range of effects and moods

that Monet could find in a single scene – evidence of his determination to explore many different ways of creating an overtly modern form of landscape painting.

Beyond this, the two pictures clearly reveal Monet's continuing awareness of the art of Turner and Whistler. The extravagant sunset in *Sunset on the Seine* appears as an explicit response to the challenge of Turner – a tribute, in its lavish brushwork and colour, but also perhaps a critique, since the constantly nuanced contrasts of warm and cool colours in Monet's canvas seem more closely based on direct observation than the more generalised effects in Turner's exhibition paintings. By contrast, the subject, the misty effect and the fluid paint-handling of *The Seine at Argenteuil* echo Whistler, and even the *japoniste* reeds can be compared to the plant-forms in the foreground of *Nocturne in Blue and Silver – Cremorne Lights* (no.46) ; it is very possible that this was the painting that Whistler exhibited at Durand-Ruel's Gallery in Paris in January 1873 with the title 'Nocturne in Blue-Silver'. JH

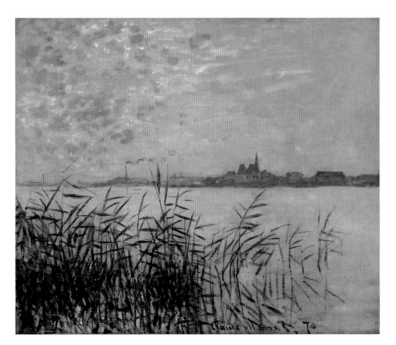

Fig.47 Claude Monet
The Seine at Argenteuil 1874
Oil on canvas 55 × 65.2 cm, W 327
Kunstmuseum, Bern. Donated by
Robert Vatter

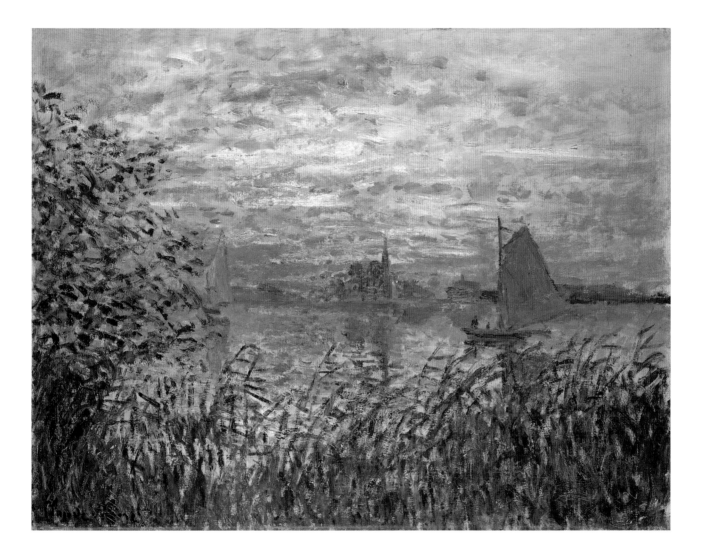

41 Claude Monet

Sunset on the Seine, Winter Effect 1880

Soleil couchant sur la Seine, effet d'hiver

Oil on canvas 101.5 × 150 cm
W 576
Petit Palais, Musée des Beaux Arts de la ville de Paris
EXHIBITED IN TORONTO AND PARIS ONLY

In 1880 Monet decided to submit again to the Paris Salon, after ten years of seeking alternative outlets for his art. *Sunset on the Seine, Winter Effect*, a canvas far larger than his usual work, was painted in his studio, using smaller paintings executed outdoors as studies; it shows the hamlet of Lavacourt, seen across the Seine from his home at Vétheuil. However, he decided not to submit the canvas to the Salon, feeling that it was 'too much to my own taste', and instead submitted 'something more sensible, more bourgeois' (letter to Théodore Duret, 8 March 1880, in Wildenstein 1974–91, I, letter 173), together with the large version of *Floating Ice* (see no.42). The subject of *Sunset on the Seine, Winter Effect* is clearly reminiscent of *Impression, Sunrise* (no.39), and Monet presumably felt that memories of his most notorious past painting might lead to its rejection by the Salon jury.

Monet had not revisited London since 1870–1, but *Sunset on the Seine, Winter Effect* is one of his most overt echoes of Turner's sunset scenes. The scale of the canvas and the elaboration of the colour effects is very unlike the stark simplicity of *Impression, Sunrise*, and emphasises its status as a significant exhibition painting, inviting comparison with the glaring suns in the Turner Bequest that Monet had seen in London, such as *Sun Rising through Vapour: Fishermen Cleaning and Selling Fish* (no.2). It was later in the same year, 1880, that Monet declared his intention to return to London to paint there. It would be mistaken, though, to view the painting solely in terms of Turner. Monet's old mentor Charles-François Daubigny, who had recently died, had tackled similar subjects, and *Sunset on the Seine, Winter Effect* can best be seen as an ambitious attempt to pay tribute to, and at the same time to transcend, the work of two past masters who had played a major part in his artistic evolution (see Clarke and Thomson 2003, pp.158–60). JH

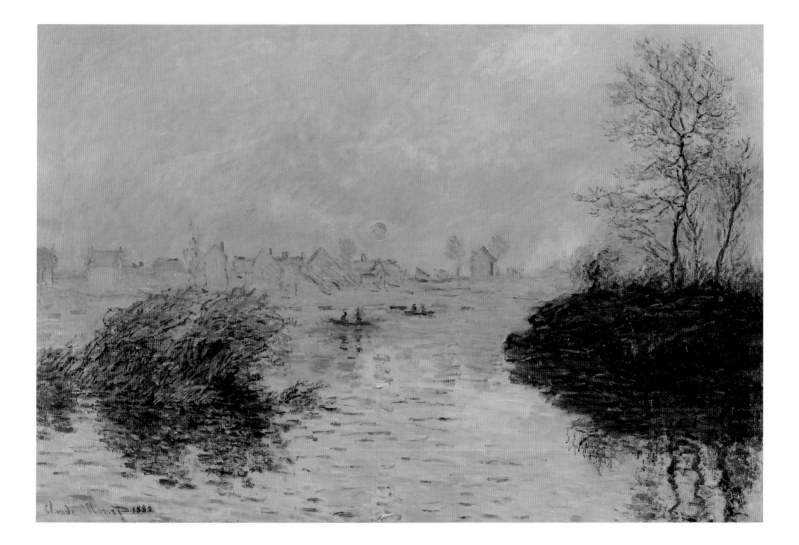

42 Claude Monet

Floating Ice 1880
Les Glaçons

Oil on canvas 61 × 100 cm
W 567
Musée d'Orsay, Paris

In 1878 Monet moved his home from the Paris region to Vétheuil, a rural village on a remote loop of the Seine about forty miles north-west of the capital. With this move he abandoned the explicitly contemporary landscape subjects that he had favoured over the previous decade in favour of images of the village and its surroundings, in all seasons and weather conditions. A long period of extreme cold at the end of 1879 was followed by a sudden and dramatic thaw, which sent a mass of ice floes down the Seine; *Floating Ice* is one of the sequence of canvases that Monet painted of this spectacular natural event. He had first painted ice floes in 1867–8 (see no.35), and the effect of this motif anticipates the floating lily pads of his later water lily canvases.

Monet used this scene of water, ice and winter sunlight as the basis for one of the most delicately harmonised colour compositions of his career to this point. Warm salmon and pink tones are played off

against blues and greens throughout the canvas; the brushwork is dynamic and assertive in the mass of broken ice at bottom right, but the central band of trees is treated quite softly, with individual touches integrated into the overall ensemble. This concern with treating the whole canvas in terms of a closely integrated colour scheme suggests parallels with Whistler's interests, though Monet's high-key colour is more comparable to the palette of Turner, as seen, for instance, in the background of *The Golden Bough* (no.14).

Soon after completing *Floating Ice*, Monet made a larger copy of it in his studio (97 × 150 cm; Shelburne Museum, Vermont; W 568), specifically intended to be submitted to the jury of the Paris Salon, which rejected it. Although the present picture served as the study for this large canvas, Monet viewed it as an independent picture in its own right, and sold it in 1880 to the critic and art historian Charles Ephrussi. JH

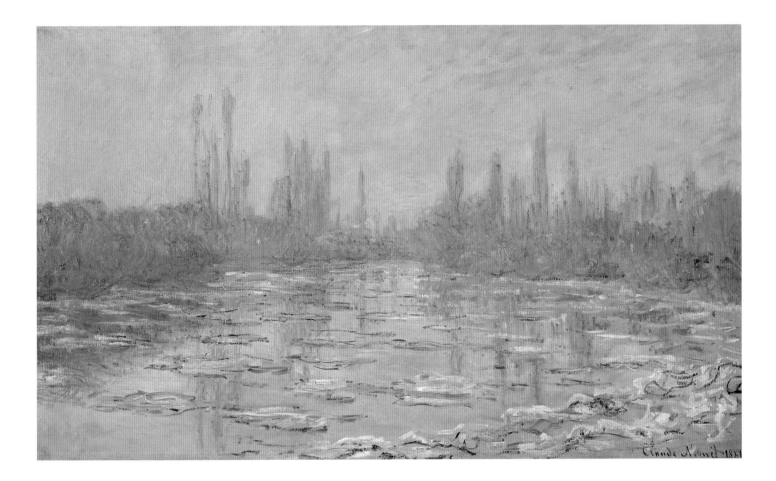

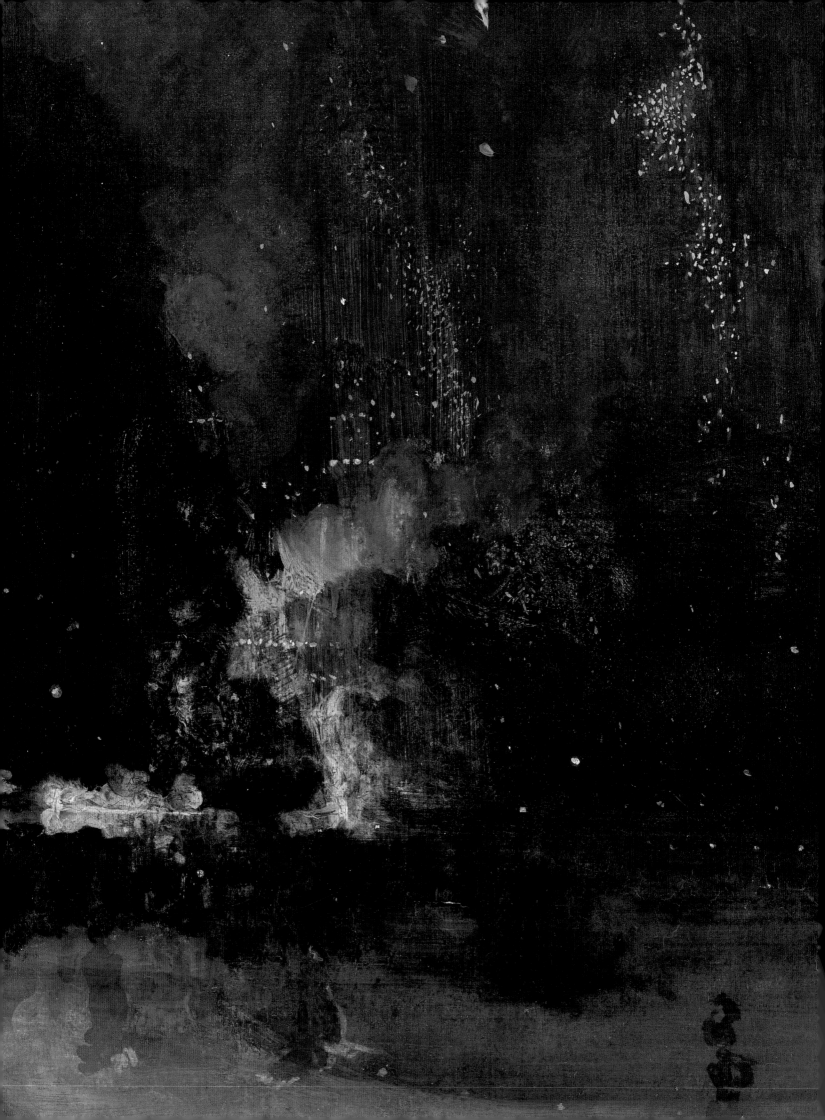

Art, music, and an aesthetics of place in Whistler's Nocturne paintings

John Siewert

And when the evening mist clothes the riverside with poetry, as with a veil, and the poor buildings lose themselves in the dim sky, and the tall chimneys become campanili, and the warehouses are palaces in the night, and the whole city hangs in the heavens, and fairy-land is before us – then the wayfarer hastens home; the working man and the cultured one, the wise man and the one of pleasure, cease to understand, as they have ceased to see, and Nature, who, for once, has sung in tune, sings her exquisite song to the artist alone, her son and her master – her son in that he loves her, her master in that he knows her.
(James McNeill Whistler, 1885) [1]

Early in 1873 Whistler exhibited seven oil paintings at the Durand-Ruel gallery in Paris, including *Variations in Flesh Colour and Green: The Balcony* (fig.50). The picture, started in 1864 and reworked as late as 1870, looks back in certain respects to the earlier naturalism of *Wapping* (no.26), reprising its subject of figures placed against a riverside scene in modern, industrial London. But if *The Balcony* affirms again that important theme, this pivotal work even more emphatically hints at the quite different inflections that Whistler would give to his representations of the city during the decade of the 1870s. A familiar, grey and brown Thames setting co-exists in the picture with the conspicuously exotic and colourful, in the presence of an extravagantly costumed group of women gathered on the balcony to make music and contemplate the view, so prosaic in contrast to these models' own immediate environment of floral arrangements and fluttering butterflies. Taken together, these are the ingredients – observation and imaginative elaboration, allusions to musical expression and an exploration of colour combining to create a mildly mysterious and vaguely feminine realm within the urban landscape – that Whistler would weave together throughout the 1870s in the paintings he called Nocturnes.

In addition to *The Balcony*, Whistler sent two of his earliest Nocturnes – probably *Nocturne: Blue and Silver – Chelsea* (no.43) and *Nocturne in Blue and Silver* (fig.51) – to the 1873 exhibition at Durand-Ruel, where they were noticed by the French critic Ernest Chesneau.[2] The following year, at another Paris venue, Monet exhibited his *Impression, Sunrise* (no.39), an image of the port at Le Havre that seems to reflect upon his memories of the fluid brushwork and liquid facture he had seen in paintings in Whistler's London studio. The two artists were brought together again in an unwitting but telling remark about Monet's picture – and, once more, the critic was Chesneau. Writing about the exhibition of 1874, but apparently with his own memories of Whistler's Nocturnes in mind, he mistakenly called the *Impression* a view of the Thames.[3] That the Nocturnes could play a role in prompting this momentary confusion suggests something of

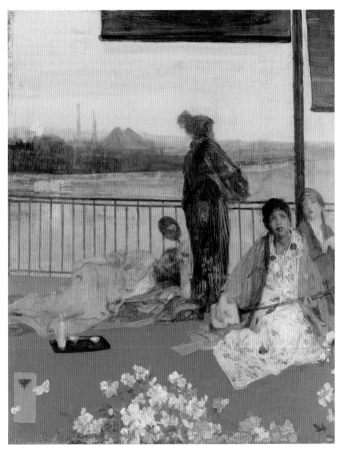

Fig.50 James McNeill Whistler, **Variations in Flesh Colour and Green: The Balcony** 1864–1870s
Oil on wood 61.4 × 48.8 cm, YMSM 56
Freer Gallery of Art, Smithsonian Institution, Washington, DC.
Gift of Charles Lang Freer

No.50 James McNeill Whistler **Nocturne in Black and Gold:
The Falling Rocket** (detail)

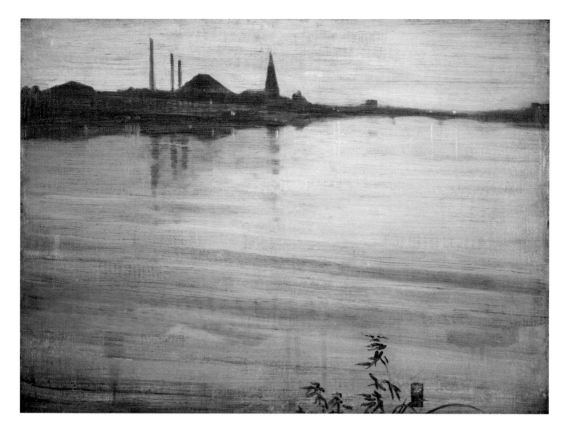

Fig.51 James McNeill Whistler,
Nocturne in Blue and Silver 1871–2
Oil on wood 44.1 × 61 cm, YMSM 113
Courtesy of the Fogg Art Museum,
Harvard University Art Museums.
Bequest of Grenville L. Winthrop

the challenge they posed for critics, and from the beginning commentators frequently noted the often indeterminate nature of the places and times that inspired them. Edmond Duranty recalled the Durand-Ruel exhibition several years later, remembering its 'remarkable portraits and paintings with colour variations of infinite delicacy in dusky, diffused, and vaporous tints that belong to neither night nor day', the latter observation reflecting the inherent ambiguities of the two Nocturnes shown.[4] In 1874 Whistler organised another, larger one-man exhibition, this time at the Flemish Gallery in London. On that occasion, as at Durand-Ruel the year before, critics noted in the figure studies and Nocturnes displayed a strong influence of Japanese art. One prominent English writer, however, concluded that Whistler's work might be described most effectively as a *'tertium quid'*, related to the art of Europe and Japan yet distinct from both as a category apart.[5]

In the thirty-two extant oil paintings that make up the Nocturne ensemble, Whistler confirmed his role as a singular interpreter of the London landscape. But what remains juxtaposed in *The Balcony* finds a more integrated expression in *Nocturne in Blue and Silver*. Whistler's open-air realism of the 1860s, still a prominent factor in his handling of the Thames backdrop in *The Balcony*, combines in the Nocturnes with his disciplined

memories of the landscape motif in the activity of the studio, as empirical perception, remembrance, and imagination merge.[6] Colour, existing as if in a separate sphere in the garments and accoutrements of the female figures in *The Balcony*, now suffuses the entire landscape of the Nocturne with multiple washes of thinned blue oil paint. And the decorative, 'Japanese' elements of the earlier painting – again, the women posing in the foreground and the accessories surrounding them – are reconceived and inserted more subtly but no less pointedly in the *Nocturne in Blue and Silver*. There, Whistler painted several leafy branches that break into the composition from its lower edge, a passage rendered freely and economically with calligraphic brushstrokes. Next to that sprig he placed his butterfly signature in a cartouche that resembles the seals and stamps found in the Japanese woodblock prints he admired. These pictorial touches, pushed to the periphery yet hardly incidental, shape the 'decorative' aspects of *The Balcony* into a role that emerges from the nocturnal landscape itself, a landscape that now melds these individual entities into a hybrid expression of the artist's originality.[7]

That preoccupation with distinction, however, did not preclude an awareness of precedent; as his first biographers remind us about this very moment in their subject's career:

'Whistler believed that to carry on tradition was the artist's business . . . and, in the endeavour to develop his personality, he was passing through a moment of experiments, difficulties and discouragements.'[8] One of those experiments, and a connection to recent tradition, may well have been Whistler's deliberate development of an oil-painting technique and a liquid facture for his predominantly waterside Nocturnes adapted from his study of English watercolourists, including Turner.[9]

Although like Turner (see no.1), he initially referred to his earliest night-time landscapes as 'moonlights', Whistler responded with delight when Frederick R. Leyland, his friend and important patron, suggested the title 'nocturne', a term borrowed from music, as a more evocative alternative. Since the late 1860s Whistler had exhibited paintings with musical titles such as 'symphonies', 'arrangements' and 'harmonies' in an effort to emphasise the aesthetic experience of his paintings over any literary or didactic purpose they might be expected to serve. The artist appreciated the fluid possibilities of the Nocturne designation, exulting in a note of gratitude to Leyland over its ability to 'so poetically say all I want to say and no more than I wish!'[10] The Nocturne paintings exploit this ambiguity, bringing the realist properties of place into dialogue with artistic nuance and prompting a critical debate in which viewers often attempt to ground Whistler's aesthetic achievement in the actuality of an identifiable site.

Unlike the widely praised descriptive realism of Whistler's earlier landscape etchings and paintings of the 1860s, the dark mysteries of the Nocturnes provoked quick dismissal far more often than prolonged and appreciative contemplation. A young Oscar Wilde, in 1877 already assuming the stance of the insouciant art critic, encountered four Nocturnes as part of the work Whistler had submitted to the inaugural exhibition of the Grosvenor Gallery in London, a venue recently established as an independent alternative to the annual exhibitions of the Royal Academy. Noting in particular the subtle burst of fireworks at the upper right of *Nocturne: Blue and Gold – Old Battersea Bridge* and the more obvious pyrotechnics in *Nocturne in Black and Gold: The Falling Rocket* (see nos.47, 50), Wilde concluded that the paintings were 'certainly worth looking at for about as long as one looks at a real rocket, that is, for somewhat less than a quarter of a minute'.[11] Wilde's remark was one of the wittier shots in what by the late

1870s had become a critical barrage: the Nocturnes appeared to many viewers to signal that Whistler's work had degenerated from the laudable to the laughable.

The exhibition of *The Falling Rocket* at the Grosvenor provoked words more venomous and consequential than those of Wilde. The ostensible focus of a scathing commentary published in 1877 by the pre-eminent English critic John Ruskin, the picture precipitated the infamous libel trial pitting artist against writer in the following year. For Ruskin, *The Falling Rocket* seemed nothing less than a slapdash assault on conventional privileging of pictorial subject over style. Ruskin argued that a canvas should communicate conceptual coherence and significance in addition to declaring the painter's facility with a brush. Writing as an 'art economist', the critic further held that a picture's price ought to reflect the value of the labour it had entailed. Submitted to Ruskinian standards, Whistler's painting, the only one he exhibited at the Grosvenor priced for purchase, appeared ill formed and unfinished, and Ruskin channelled the full weight of his rhetorical powers against the Nocturne, condemning its author for 'flinging a pot of paint in the public's face'. Convinced that these words were actionable, Whistler sued Ruskin and an instantly infamous lawsuit unfolded over two days in November 1878 in a London courtroom (see pp.24–8, above).[12]

The Falling Rocket is one of six loosely related paintings, a subset of the Nocturnes that takes its motifs from a site in Victorian London known as Cremorne Gardens, a public pleasure park in Chelsea where the daily diversions and scheduled entertainment concluded at night with an elaborate fireworks display.[13] The inky darkness that envelops these Cremorne-inspired images differs significantly from the luminous, pervasively blue-and-green palette of the Thames Nocturnes. Whistler's interest in the motif and the potential of fireworks as a subject may have been reinforced by the appearance on the art market in 1873 of Turner's *The Burning of the Houses of Lords and Commons* (no.78).[14] While admittedly different in their scope, the incendiary spectacles in both Turner's painting and *The Falling Rocket* unfold before witnessing figures gathered in the foreground. In Whistler's case a trio of shadowy forms are positioned along the edge of a circular garden near the fireworks platform – another anomaly in the usually vacant terrain of the Nocturnes. Although the painting accurately locates elements such as the illuminated towers of the Grotto

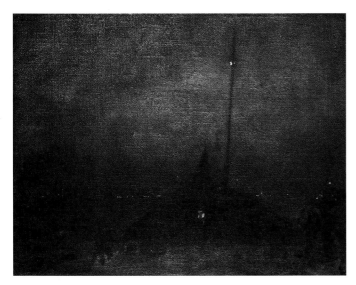

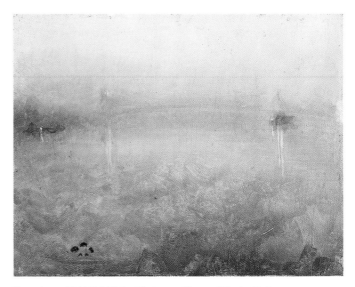

Fig.52 James McNeill Whistler, **Nocturne in Black and Gold:**
Entrance to Southampton Water c.1876
Oil on wood 47.6 × 63.1 cm, YMSM 179
Freer Gallery of Art, Smithsonian Institution, Washington, DC.
Gift of Charles Lang Freer

Fig.53 James McNeill Whistler, **Nocturne: Silver and Opal – Chelsea**
early 1880s
Oil on wood 20.3 × 25.7 cm, YMSM 309
Freer Gallery of Art, Smithsonian Institution, Washington, DC.
Gift of Charles Lang Freer

where the fireworks were launched, Whistler claimed during his trial testimony that his picture 'wouldn't give the public a good idea of Cremorne', and *The Falling Rocket*, like the larger Nocturne project, historically has discouraged attempts to obtain from it a literal accounting of location. In 1883, for example, Whistler exhibited a selection of fifty-one recently completed etchings and drypoints, including his 'Second Venice Set', in New York – an exhibition that also included *The Falling Rocket*. According to one newspaper review, this representation of fireworks prompted at least one pair of visitors to pause before the picture:

> One assumed it was Venetian in subject, like most of the etchings, and tried to imagine and recall to his friend the exact spot in Venice where the tower stood, which is dimly seen in the distance. He was surprised to learn that the scene was laid in London, and concluded that his attempt to discover where it was and what it all meant was partly a failure.[15]

The journalistic notices the Nocturnes received as they were shown publicly during the 1880s and 1890s frequently raise the issue of locale and the representation of place. At the 1882 Grosvenor Gallery exhibition, Whistler presented, among other work, his *Nocturne in Blue and Silver – Cremorne Lights* (no.46) and another painting, not of a London subject, *Nocturne in Black and Gold: Entrance to Southampton Water* (fig.52). The latter, one of the darkest of all the Nocturne paintings, provoked considerable comment. One writer termed it 'a delicate study, with each scanty clot of colour precisely in the right place, of a night effect, broken by artificial light, and happening – somewhere or other; it does not matter where'.[16] Such admiration, which mirrored Whistler's own inclination toward the indeterminate, was a

minority view, for the last point, the indefinite setting of the scene, more often inspired ridicule. The *Southampton Water* Nocturne was likened to a 'blackened sheet of paper', and to 'a dark slate, upon which a child has been rubbing in a rough design of an uncertain character'.[17] Another critic suggested that the publication of the pictures' titles in the exhibition catalogue offered more information than the paintings themselves, and compared their effect to the black sheets of paper that were promoted as intentionally comic 'photographs taken in the dark' by Albert Smith, one of the Victorian era's most popular showmen. 'Pictures in the dark', this same reviewer concluded, 'are contradictions in terms.'[18]

For an English audience, the potential for such contradiction was all the more pointed when the subject matter announced in the picture's title was located in London. Taking note of one such Nocturne (fig.53), a critic for a provincial paper focused attention on this 'evening effect of Chelsea . . . which shows the painter's penchant for vague indistinctness. The study represents mist or smoke, with a dark line which may be meant for Chelsea or any other bridge.'[19] The equivocal 'dark line' here indicates Chelsea Suspension Bridge, downriver from Battersea. Its suspension cables are all but lost within the nearly monochromatic palette and broken surface created by Whistler's short, shifting brush-strokes, which give to the foreground water an autonomy seemingly unrelated to the description of form.

The imagery of the London Nocturnes most frequently eschews well-established landmarks in favour of places with a more commonplace, often nondescript character. When Whistler did choose a distinguished London setting away from his familiar Chelsea and Battersea, invariably it was to play that selection of

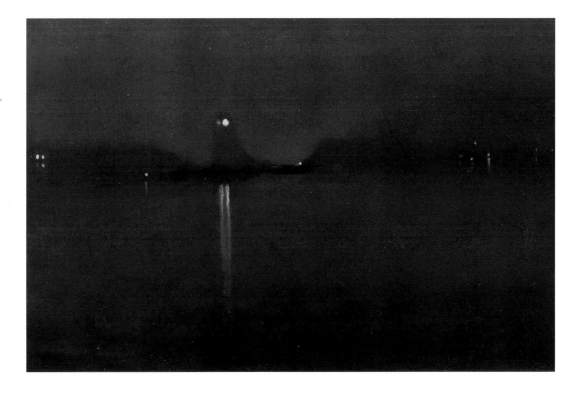

Fig.54 James McNeill Whistler
Nocturne 1872–8
Oil on canvas 50.7 × 76.7 cm,
YMSM 153
The White House Historical
Association (White House Collection),
Washington, DC

site against its own monumentality. *Nocturne: Grey and Gold –
Westminster Bridge* (no.45), for example, seems only incidentally to
include an unassuming, barely articulated corner of the Houses
of Parliament. The stately Waterloo Bridge is engulfed in darkness,
obscuring the distinctive stone arches that might immediately
locate the subject for a London audience. Later, Whistler applied
much the same approach to a well-known edifice in painting
historical structures of Venice. One of the Nocturne paintings
from the artist's nearly fourteen-month Venetian sojourn in
1879–80 takes as its motif the elaborate facade of the basilica of
San Marco. Much more than a topographic account, *Nocturne:
Blue and Gold – Saint Mark's, Venice* (National Museum of Wales,
Cardiff; YMSM 135) offers an image in which architectural form
dissolves on canvas under the joined forces of darkness and the
artist's brush. As with the Nocturnes in general, here the role of
drawing as the delineation of form is made an almost irrelevant
part of the creative process. The Saint Mark's Nocturne, while
still representing the defining features of a distinctive building,
works in the direction of erasing the solid structure nearly as
much as it constructs it.[20]

Yet identities – or, to use another appropriate word, subjects –
are not effaced altogether in the Nocturne paintings. Identity
remains an essential component of the picture, there to be read
and misread. 'Suspension', rather than effacement, is a more apt
term for the effect that the Nocturnes ultimately accomplish.
Indeed, Whistler's own words, partly quoted in the epigraph that

opened this essay, suggest as much. In his 'Ten O'Clock' lecture,
delivered in 1885 to a fashionable, invited audience, he presented
what amounts to a public manifesto of his mature aesthetic as
he had developed it in the Nocturnes, climactically evoking that
moment when 'the whole city hangs in the heavens'. Whistler's
richly worded imagery is usually interpreted in terms that remake
the stark realities of a modern industrial landscape into a more
palpably poetic site that denies its own basis in particularity. But
the factual and the artistically arranged *collaborate* to produce
the Nocturne. Whistler's artistic strategies keep references to
both musical aesthetic and actual place suspended within a
representational reordering of context.

One of the most striking and consistent compositional features
in a number of the London Nocturnes is a lighted tower that
establishes itself as a conspicuous presence even in the midst of
the darkness that threatens to eclipse it. It can stand out starkly,
oddly, for example, casting long reflections on the surface of the
river (fig.54). Or it can appear more subdued by the surrounding
haze, where the same lights nevertheless signal its existence
(see no.48). In *Nocturne in Grey and Silver* (no.49), the most muted
image of it, the top of the tower and its light are all that orient
the viewer to the painting's uncertain space. The structure in
these paintings housed the offices of the Morgan Crucible
Company in the Battersea area, an edifice known popularly in its
time as 'Mr Ted Morgan's Folly'.[21] This Italianate tower with its
illuminated clock faces may well have been on Whistler's mind

Fig.55 The Morgan Crucible Company
viewed from the Thames, 1910
English Heritage,
National Monuments Record

Fig.56 View of the Morgan Crucible
Company showing the clocktower, 1912
English Heritage,
National Monuments Record

when he made his memorable observations about that nocturnal moment when 'tall chimneys become campanili' and the identity of an ordinary office building becomes suspended momentarily in the transfiguring darkness.

But the very paucity of pictorial information presented in *Nocturne in Grey and Silver* inspired some of the most penetrating commentary on Whistler's work. French critic Gustave Geffroy, describing the *Grey and Silver* in 1891, noted: 'It is Night walking on the water, swallowing the town, absorbing the air, night which dominates the landscape, which gives it that indeterminate colour seen with closed eyes, which renders it a visible Shadow, the fantastic portrait of Darkness.'[22] Writing at almost exactly the same time, Anglo-Irish author George Moore called the Nocturne a 'luminous blue shadow, delicately graduated . . . purple above and below, a shadow in the middle of the picture – a little less and there would be nothing'.[23] And Théodore Duret, French journalist, critic, and collector – who acquired the *Grey and Silver* Nocturne from Whistler in the early 1890s – offered these words that evoke the character of the painting while they also aim to indicate more generally what the Nocturnes accomplish: 'He arrived there at a limit one does not know how to go beyond; he reached that extreme region where painting, having become vague, in taking one more step would fall into absolute indeterminacy and could no longer say anything to the eyes.'[24]

Each of these passages, redolent with a *fin-de-siècle* sensibility of culmination, places the Nocturnes at the 'limits' of perception and painting, at a point where vision and representation are almost – but not quite – rendered obsolete. Writing in 1889, Joris-Karl Huysmans reinforced these themes, seeing in the Nocturnes 'locations of air and water stretching endlessly into the distance . . . carrying us on magical means of transport into unfinished times, into limbo. This was far removed from modern life, far from everything, on the furthermost bounds of painting, which seemed to evaporate into invisible wisps of colours, on these delicate canvases.'[25] And yet, if this singular place and suspended time could appear in danger of dissipating entirely from view, Whistler emphatically preserves this encounter with the nocturnal landscape, both in his paintings and his own commentary, which returns us for a final time to the words with which we began. In the 'Ten O'Clock', directly following his evocation of the city that 'hangs in the heavens', he conjures that moment when 'Nature, who, for once, has sung in tune, sings her exquisite song to the artist alone'. Read one way, these phrases seem to imply that the nocturnal moment of transformation is one that only the painter is privileged to recognise and communicate to a larger audience. But the imagery of these words may also suggest that it is particularly in the solitary contemplation of an ordinary landscape that such discovery might originate. Indeed, the multiple possibilities contained within Whistler's eloquently phrased observation intimate the essential character of the Nocturne paintings themselves – the visual embodiments of an aesthetic experience caught, like the trailing embers of fading fireworks, on a threshold between description and subtle dissolution.

43 James McNeill Whistler
Nocturne: Blue and Silver – Chelsea 1871

Oil on canvas 50.2 × 60.8 cm
YMSM 103
Tate, London. Bequeathed by Miss Rachel and
Miss Jean Alexander, 1972

The earliest of Whistler's London Nocturnes presents a view across the Thames from Battersea towards Chelsea, the square tower of Chelsea Old Church at the right. Shown at the Dudley Gallery in 1871 as *Harmony in Blue-Green Moonlight*, critics quickly elaborated on the title's allusion to music. The painting, one writer remarked, 'may be likened to strains of the Æolian harp, or to the sighing of the wind through a cracked casement. At best such pictorial melodies are as the pipes of Pan; thus they remain at a wide distance from orchestral compositions by Beethoven.' Such apparent appreciation of its lyricism, however, was compromised somewhat by the comment that immediately followed: 'As pictures they are a dreamland of cloud, vapour, smoke; and so little subject have they that they are just as comprehensible when turned upside down' (Anon., 'Winter Exhibitions,' *Saturday Review*, 28 October 1871, p.559).

Long horizontal strokes of the brush, subtly rippled when intended to indicate water, reiterate the insistent horizontality of the composition that some critics found so objectionably minimal. Those lateral rhythms, reinforced by the barge floating at the lower left, are broken only by the intermittent lights reflected in the river, the silhouette of the church and its reflection, and the slightly painted figure standing in the mud of the riverbank to complete the alignment of these larger vertical accents. Whistler typically inserted such a human presence in the foreground of a number of his 'Thames Set' etchings, which were first published at the very time he produced this painting. In subsequent Nocturnes, however, the represented observer disappears – as if Whistler meant that the viewer of the picture, together with the artist, present here in the butterfly signature at the painting's lower edge, should now be understood as the privileged and discerning witnesses to the subdued nature of the night. js

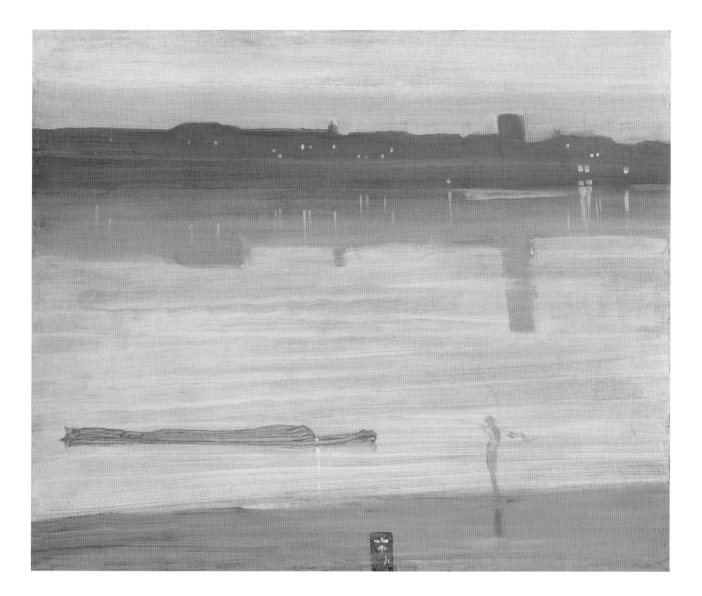

44 James McNeill Whistler

Nocturne: Blue and Gold, Southampton Water 1872

Oil on canvas 50.5 × 76 cm
YMSM 117
The Art Institute of Chicago. The Stickney Fund

By using the term 'nocturne' in favour of 'moonlight', Whistler meant to direct the reception of his paintings away from literal associations towards a more poetic potential. With comparable indirection, his pictures rarely depict the moon itself. This Nocturne, one of the earliest, is an exception. It compares in this respect to Turner's *Moonlight, a Study at Millbank* (no.1) and Monet's *Impression, Sunrise* (no.39), both of which were relatively early works in the careers of these painters. According to his biographers, Whistler objected to just this kind of literal representation in Turner's work (see p.33, above).

It must be remembered, however, that Whistler made his negative assessments of Turner much later in life, when the bitterness of his disastrous lawsuit against Ruskin, Turner's champion, and the accumulated critical abuse (real and imagined) from the British press conspired to colour his attitude towards many things English.

Whistler made the most of the rare lunar presence in this Nocturne, a view along the English Channel some eighty miles south of London. A ship's mast cuts into the buttery wafer, an effect indicated merely by allowing the tone of the sky to interrupt the moon as negative space. The orb's golden glow echoes, dimly, in the artist's signature at lower right, and in the tiny points of light along the horizon, some of which are reflected in the water. JS

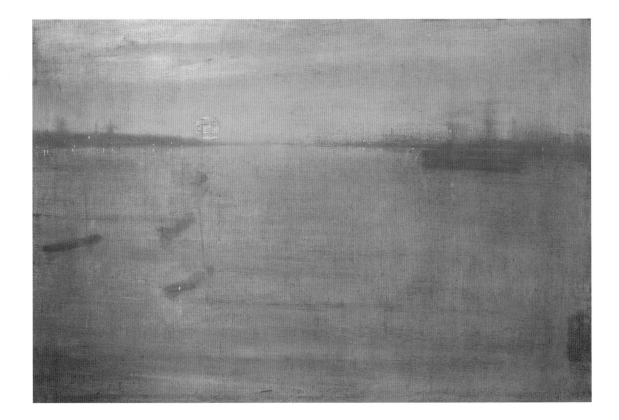

45 James McNeill Whistler

Nocturne: Grey and Gold – Westminster Bridge 1871–2

Oil on canvas 47 × 62.3 cm
YMSM 145
Burrell Collection, Glasgow
EXHIBITED IN LONDON ONLY

Painted as if from a vantage on Westminster Bridge, Whistler's representation of the Houses of Parliament is characteristically idiosyncratic. The renowned structure appears only as a dark wedge at the far right, the majority of the composition given over to the effects of shadows and reflections on the Thames. Shown at the Grosvenor Gallery in 1877, this picture nevertheless won particular approval from Sidney Colvin, Slade Professor of Fine Art at Cambridge (see p.23, above). While he surely would have known Turner's epic images of Westminster Palace destroyed by fire (see no.78), the quiescent tone of Whistler's Nocturne has more in common with the approach Monet would later take in painting his views of Parliament, using the venerable architecture as something

of a pretext for an exploration of atmospheric effects.

The London Whistler depicted in the Nocturnes was rarely defined by its architectural monuments. In the same way that he would later claim to have discovered a 'new' Venice by focusing on that city's less familiar canals and alleyways, Whistler approached the landscape of London to uncover areas that existed alongside its well-known landmarks. When he did represent a distinguished setting, away from the precincts of Chelsea and Battersea, invariably it was to play against monumentality, as in this painting. In the Nocturnes, Whistler seems to say, the combination of darkness, fog, and the painter's vision are quite sufficient to transfigure the commonplace and the impressive alike. JS

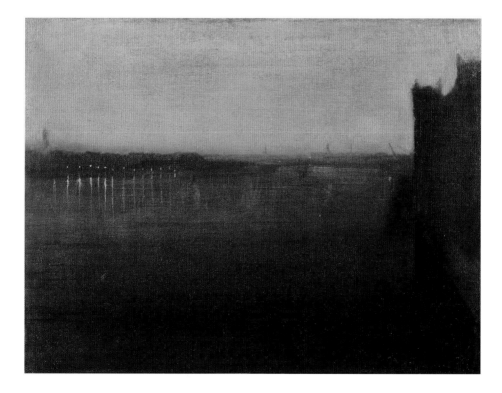

46 James McNeill Whistler

Nocturne in Blue and Silver – Cremorne Lights 1872

Oil on canvas 50.2 × 74.3 cm
YMSM 115
Tate, London. Bequeathed by Arthur Studd, 1919

With this painting Whistler introduces a particular view of Battersea that he would repeat in a number of subsequent Nocturnes (see no.48). He establishes a thin strip of cityscape near the top of the composition, a suggestion of human 'culture' as a counterpoint to the preponderant presence of 'nature', the freely brushed water that occupies roughly three-quarters of the painting. At left, a wedge of skyline comprised of factory chimneys, roofs and the spire of St Mary's Church locates it in Battersea. A complementary segment of Chelsea across the river includes the lights of Cremorne Gardens, indicating that the nocturnal amusements to be found there were well under way. The vantage, therefore, must be from Battersea Bridge, which underscores the sensation that the viewer hovers suspended over the water. Only a calligraphic piece of foliage breaks into the bottom edge of the composition to suggest the solid ground of the riverbank below.

By the time this Nocturne was exhibited at the Grosvenor Gallery in 1882, Whistler's musical nomenclature was no longer such a novelty. Still, one periodical found the punning potential irresistible and published a caricature that transforms the painting into a musical staff, with the punctuating city lights forming the notes of the score (fig.57). The accompanying commentary presses the issue perhaps as far as it might go:

Mr. Whistler paints musical landscapes. This is a picture of the blue Danube, and the silver is the price of it. The nocturne can only be rendered by the musical composition affixed to it . . . The high lights in this picture are in the artist's phraseology, the D lights on the line, and are naturally delighted at finding themselves above high-water mark. Try and play the air, and then you will understand why the picture is in the blues. (Anon., *Society*, 13 May 1882)

JS

Fig.57 Caricature of Whistler's **Nocturne in Blue and Silver – Cremorne Lights**, shown as no.2 in the Grosvenor Gallery exhibition of 1882, from *Society*, 13 May 1882

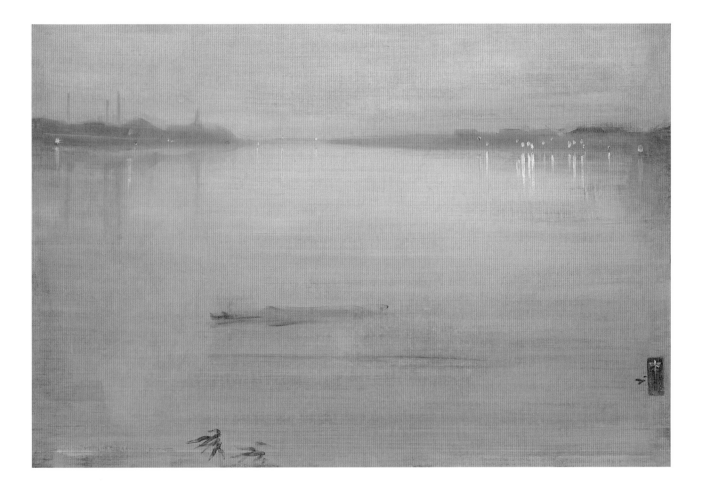

James McNeill Whistler

Nocturne: Blue and Gold – Old Battersea Bridge 1872–5

Oil on canvas 68.3 × 51.2 cm
YMSM 140
Tate, London. Presented by the National Art Collections Fund, 1905

When Whistler exhibited four Nocturnes at the first Grosvenor Gallery exhibition in 1877, one critic contended that 'these moonlights are spoiled by the introduction of Cremorne fireworks, or by being taken from fantastic points of view, from the foot of some incredible timber arch, or from the top of some unaccountable elevation' (Colvin 1877, p.832). This Nocturne, with its bursting rockets and looming fragment of bridge, must have seemed especially capricious to those viewers who might have expected a more conventional presentation of the wooden bridge spanning the Thames between Chelsea and Battersea.

A sense of disorientation also plagued the reception of the Battersea Bridge Nocturne in court when it was introduced during the hearing of *Whistler* v. *Ruskin* in 1878. Among the strategies aimed at discrediting Whistler's art was the effort made by Ruskin's lawyers to read this painting. As the critic's counsel proceeded to interpret the image alternately as a telescope or a fire escape, spectators responded with the laughter the tactic was designed to provoke.

At the same time, however, this Nocturne clearly states its origins in the particular place from which it may appear so detached. The vertical pier of the bridge sharply bisects a vague strip that indicates the horizon. On the left is the Chelsea riverbank, a dark, solid silhouette of buildings dominated by the square tower of the Old Church. To the right a much less distinct passage of painting, anchored by Whistler's butterfly emblem on the frame he designed, includes scattered lights flickering in the distance. This part of the picture represents the construction site of Albert Bridge, begun in 1871 and completed two years later. Despite its 'fantastic' properties, and the well-established connections between this Nocturne and nineteenth-century Japanese prints (particularly bridge compositions by Hiroshige), Whistler was concerned to represent the contemporary, the actual, and the observed. JS

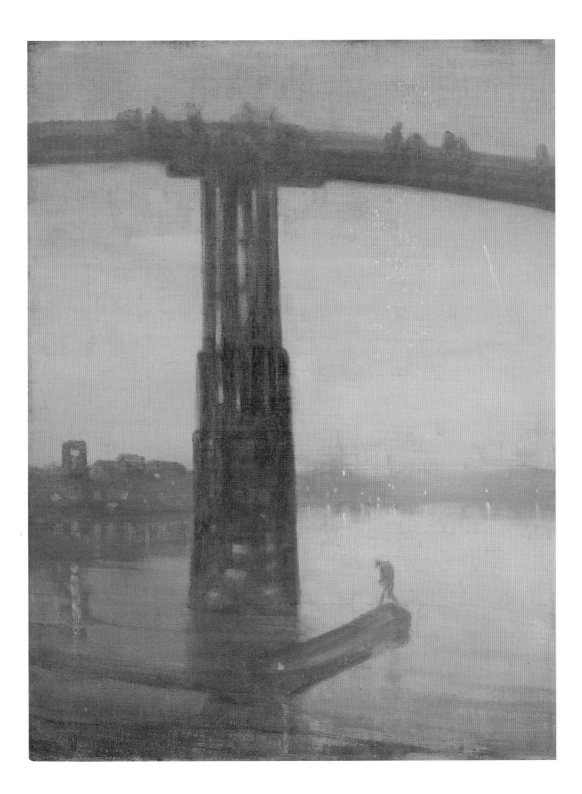

48 James McNeill Whistler

Nocturne in Blue and Silver 1872–8

Oil on canvas 44.4 × 61 cm
YMSM 151
Yale Center for British Art, New Haven, Connecticut
EXHIBITED IN PARIS ONLY

The methods Whistler used in making his Nocturnes were grounded in visual memory and repetition. He habitually took pictorial notes in charcoal and chalk on brown paper, memoranda of buildings on the riverbanks and lights reflected in the water, which one contemporary recalled as sketches 'drawn in the dark, by feeling not by sight' (Way 1912, p.14). One such study from the early 1870s (fig.51) shows a view readily available to Whistler as he looked across the Thames from his Chelsea home to Battersea. Such sketches were a key element in the formation of the Nocturne paintings, and the silhouette prominent here recurs repeatedly in Whistler's work (cf. fig.51 and no.46).

Just as the artist often repeated this Battersea motif on paper and canvas, repetition of another sort formed a foundation for his Nocturne paintings. Whistler systematically committed urban vignettes to memory without the aid of drawing, turning his back on the scene and reciting its essential features to a companion who would verify the artist's accuracy (Way 1912, pp.67–8; Menpes 1904, p.11; Sickert 1908, pp.111–12). As various eyewitness accounts of the procedure attest, the memory exercise often led to its recollection in the studio, in the form of a painting such as this Nocturne. The artist Bernhard Sickert noted: 'It is clear that this method of painting is simply painting from nature, the only difference being a long interval between observation and execution' (Sickert 1908, p.112). That passage of time between memorisation and realisation played a crucial role in Whistler's method, during which the image undoubtedly was further edited. According to Mortimer Menpes, however, the artist announced that he would make his mind 'a blank' until he painted the scene he had studied (Menpes 1904, p.11). It is tempting to see in this declaration an awareness of photographic process, as if the latent image need only be developed upon the canvas. JS

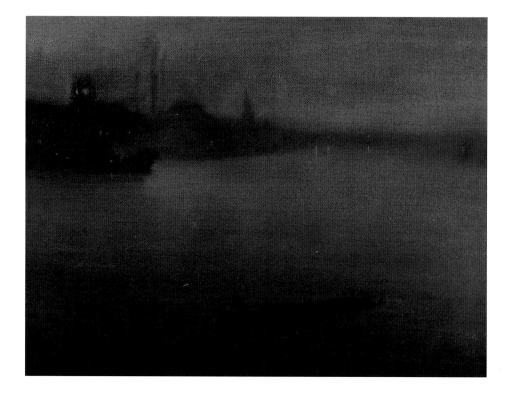

49 James McNeill Whistler

Nocturne in Grey and Silver *c.*1873–5

Oil on canvas 31.1 × 51.4 cm
YMSM 156
Philadelphia Museum of Art

Whistler's incorporation of English watercolour technique into oil painting may be at its most extreme in this Nocturne, which exploits the effects of wet-in-wet washes to create more of a stain than a representational substance on canvas. The critic George Moore described the composition as 'a shadow in the middle of the picture – a little less and there would be nothing' (Moore 1893, pp.22–3). Moore's comment is characteristic of a certain strain in *fin-de-siècle* and turn-of-the-century writing about Whistler's work that emphasised its ephemeral construction. In 1896 the German scholar Richard Muther called the Nocturnes 'landscapes of the mind . . . breathed upon the surface and encompassed with mysteries' (Muther 1896, III, p.662). And early in the twentieth century, at the time of the Whistler Memorial Exhibitions of 1905 in London and Paris, French critic Camille Mauclair may have been describing this very painting when he wrote: 'At times, the surface is so delicate that it appears like steam on a mirror' (Mauclair 1905, pp.311–12).

The artist's own words establish a basis for such evocative literary imagery: as a contemporary recalled, one of Whistler's favourite aphorisms established that 'Paint should not be applied thick. It should be like breath on the surface of a pane of glass' (Bacher 1908, p.31). The immaterial execution that Whistler extolled combines with atmospheric obscurity to make the exact site of this painting difficult to determine at first glance. When it was shown at the Grosvenor Gallery in 1878, the picture was described as representing the Parliament clocktower, and it was exhibited in Pittsburgh in 1897 as *Westminster Palace in Fog* (*The Times*, 2 May 1878, p.7). It was hardly characteristic of Whistler, however, to select so obvious an urban monument as his subject, and the tower barely discernible here is the more modest office building of the Morgan Crucible Company known as Morgan's Folly, which appears frequently in the London Nocturnes. js

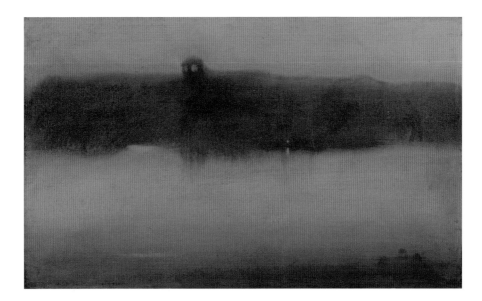

50 James McNeill Whistler

Nocturne in Black and Gold: The Falling Rocket 1875

Oil on canvas 60.3 × 46.6 cm
YMSM 170
The Detroit Institute of Arts

In much the way that Monet's *Impression, Sunrise* (no.39) gave a name to 'Impressionism' while being somewhat atypical of the artist's approach, this painting, perhaps the best known of the Nocturnes due to its notoriety as the object of Ruskin's ire, is in certain respects unusual within the larger Nocturne project. Unlike the majority of the other Nocturnes, it leaves the river to depict a fireworks display at London's Cremorne Gardens, and its palette departs from the blues and greens prevalent in those riverside scenes. Nevertheless, the status of *The Falling Rocket* as one of Whistler's most representative works is well deserved. The painting exemplifies the creative indeterminacy and imaginative play with the aesthetics of place that characterise the entirety of the Nocturne ensemble.

During the trial of the libel charges brought against Ruskin in 1878, Whistler insisted that *The Falling Rocket*, while representing the Cremorne fireworks, was to be seen primarily as an 'arrangement of line and form and colour'. The picture, he said, took its place among a group of 'night pieces' he chose to call Nocturnes because the title 'generalises and simplifies the whole set of them'. Such a statement might have signalled that *The Falling Rocket* could be appreciated best in the context of other Nocturnes. But Ruskin's lawyers persisted in submitting individual paintings as evidence, without concern for the series. In the process, the focus of the court shifted from *The Falling Rocket* to a nocturnal image of Battersea Bridge (no.47).

Whistler painted a companion piece, *Nocturne: Black and Gold – The Fire Wheel* (1875, Tate, London; YMSM 169), where a crowd gathers to witness a whirling Catherine wheel. For all its singularity, the fireworks theme perfectly embodies the painter's effort in all the Nocturnes to preserve the ephemera of perception through the resources of art. JS

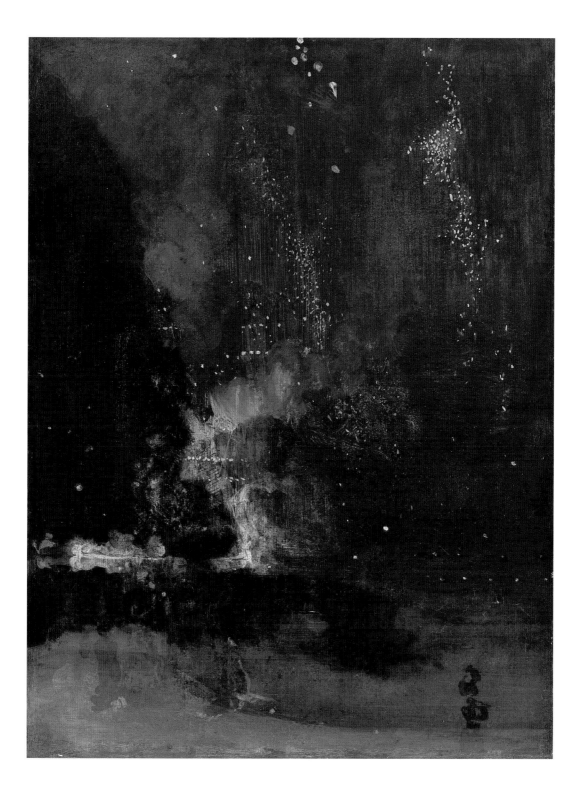

51,52 James McNeill Whistler

51 Nocturne: The River at Battersea 1878

Lithograph on blue-grey chine collé 17.2 × 25.8 cm
S 8, II/II
Art Gallery of Ontario, Toronto. Gift of Mr Arthur Gelber,
in memory of Mrs Esther Gelber, 1984

52 Early Morning 1878

Lithotint in black ink, with scraping, on a prepared half-tint ground,
on cream wove proofing paper 16.5 × 25.9 cm
S 9, I/IV
The Art Institute of Chicago. Mansfield-Whittemore-Crown Collection
on deposit at The Art Institute of Chicago

Prior to the *Whistler* v. *Ruskin* court case, Whistler tried to spread appreciation for the works exhibited at the Grosvenor Gallery. Well aware of the effectiveness of Turner's *Liber Studiorum* in the spread of the artist's reputation (see nos.5–7 and fig.43 on p.102), Whistler decided to make a series of lithographs which he hoped to publish as a set. Rather than copy his own paintings, he made variations on them.

These two lithotints were made directly onto stone, working from memory at the office of his printer, Thomas Way in Covent Garden. They depict (in reverse) the familiar Battersea silhouette of Morgan Crucible, 'Morgan's Folly', and the steeple of St Mary's Church at dawn and at dusk. The nocturne is closely related to two paintings with identical titles: *Nocturne in Blue and Silver* 1872–8 (no.48) and *Nocturne in Blue and Silver* 1871–2 (fig.51 on p.142) both of which were shown at the Grosvenor Gallery in 1877. The latter, described as 'the Thames in a mist, as we infer from what looks like a clock tower gleaming through the haze' (*The Times*, 2 May 1878), was presented in court as evidence.

Whistler regularly transported ideas from one medium to another, in this case from oil painting to lithography. Believing that the artist could best capture the atmospheric effects found in his Nocturnes using lithotint, Way introduced Whistler to the liquid medium. Whistler applied tusche to the stone with a brush, simulating the appearance of watercolour wash. The Nocturne lithotint, with its beautiful reflection, printed on pale blue paper, recalls Turner's blue watercolours of the Swiss Lakes such as *Moonlight on Lake Lucerne, with the Rigi in the Distance c.*1841 (no.18).

By 1878 industrial development had greatly intensified along the Battersea shoreline, and the last picturesque elements were rapidly disappearing (Simmonds 1879, pp.103–4). The hunched boatman introduces an elegiac note. Whistler abandoned the Thames nocturne subject at this point, returning to it only to make the lithotint *The Thames* (no.69), in 1896. KL

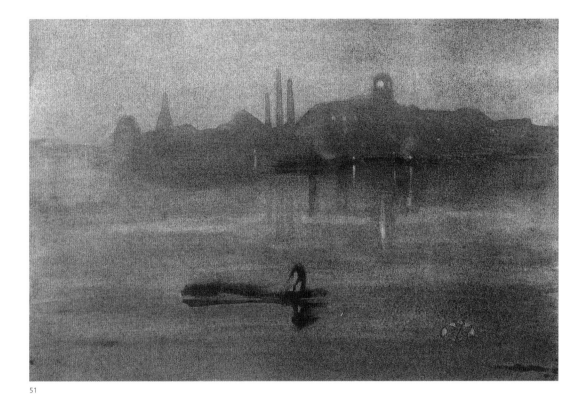

51

52

Mallarmé, Whistler and Monet

Luce Abélès

Whistler's 'Ten O'Clock' lecture appeared in French in 1888 in a translation by the poet Stéphane Mallarmé (fig.58). 'Having learned English for the sole purpose of better understanding Poe',[1] Mallarmé, as a teacher of English and author of educational works designed for students of the language,[2] could not help being interested in what was happening across the Channel. At the age of twenty he had gone to London to study English and to live with the woman he loved: he married her there some months later, in August 1863. From this stay Mallarmé brought back photographic reproductions of two of Turner's paintings, *Portsmouth* and *St Michael's Mount, Cornwall*, that he was to keep for the rest of his life. This would seem to prove an interest in Turner's work, although there is no record of Mallarmé ever having spoken of it.[3] Little inclined to travel, the poet would return to England for short visits on only three occasions – in 1871, 1875 and 1894 – but he corresponded with British Symbolist writers, contributing in this way to the intellectual exchange between the two countries.[4] He would, above all, become intimately acquainted with Whistler, who moved between England and France.

A few years after the death in 1883 of his close friend Edouard Manet, in his eyes the artist *par excellence*, Mallarmé began to grow closer to Monet and also started a friendship with Whistler. The poet apportioned between the two painters the roles previously held by Manet alone. In his 1876 article 'Les Impressionnistes et M. Edouard Manet',[5] Mallarmé had declared Manet the leader of the *plein air* school: to Monet then fell the task of fulfilling Manet's pictorial legacy (Manet had confided to Mallarmé: 'Monet has genius'[6]). Whistler, on the other hand, would take the place of the friend that Mallarmé lost when Manet died. To these two companions who saw him as a mentor, the writer dedicated, in return, prose portraits that paid homage to them as much as individuals as artists.[7]

It was in January 1888, during a lunch organised by Monet, that Mallarmé and Whistler became aware of the bond they shared.[8] A contemporary of Manet,[9] Whistler had also started out in the Realist circle of Courbet, and his life-size portrait *Symphony in White, No.1: The White Girl* (National Gallery of Art, Washington; YMSM 38), exhibited at the Salon des Refusés in 1863, enjoyed a notoriety comparable to that of Manet's *Le Déjeuner sur l'herbe* (Musée d'Orsay, Paris). The following year Henri Fantin-Latour,

with his *Homage to Delacroix* (Musée d'Orsay, Paris),[10] presented Whistler and himself as the leaders of the younger generation of painters: Baudelaire, who had praised Whistler's 'Thames Set' etchings when they were exhibited in Paris in 1862, was also included as a figure in this painting.[11] The relationship that Whistler had developed as a young man with Baudelaire and Manet, two of Mallarmé's mentors, undoubtedly played a role in the poet's desire to meet the artist. The two men took to each other immediately. In Whistler, Mallarmé found the easy grace

Traduction française de M. Stéphane Mallarmé

LE " TEN O'CLOCK "

de M. WHISTLER

LONDRES
PARIS

1888

Fig.58 Front cover of **Le 'Ten O'Clock' de M. Whistler**, translated by Stéphane Mallarmé. Bibliothèque littéraire Jacques Doucet, London and Paris 1888

Fig.59 James McNeill Whistler, **Stéphane Mallarmé** 1892
Lithograph on Holland paper, signed by Whistler in crayon 'à mon Mallarmé',
9.7 × 7 cm. Vulaines-sur-Seine, musée départmental Stéphane
Mallarmé

and charming way with words that had attracted him to Manet:
'mocking and elegant at Tortoni's', he said of Manet; and of
Whistler: 'argumentative, enthusiastic, precious, and worldly'.[12]
The correspondence between the artist and the poet faithfully
conveys the fascination that Whistler's temperamental dandy
personality exercised over Mallarmé, who was always prepared
to follow the artist on his crusades and flights of fancy. Mallarmé
put all his resources at Whistler's disposal, both in private life
(he recommended purveyors for the fitting out of the pavilion
that Whistler rented in Paris on the rue du Bac) and in public
life, where he exerted influence on the French government to
acquire the artist's *Arrangement in Grey and Black, No.1; Portrait
of the Painter's Mother* 1871 (Musée d'Orsay, Paris; YMSM 101). This
purchase brought about the official recognition that Whistler
hoped and prayed for, and resulted in his being made Officer of
the Légion d'honneur.[13]

Various collaborative writing projects were envisioned by
the two men: indeed, it was a text that originally brought them
together, for Mallarmé wished to translate Whistler's 'Ten O'Clock'

lecture.[14] Speaking with most of London's artistic and fashionable
community gathered before him, Whistler had developed a thesis
on art directly opposed to the socialist position of his adversary,
the critic John Ruskin. He deplored the idea that art should be at
the beck and call of everyone, threatening to invade all aspects of
life, from interior decorating to fashion. In fact, he believed that
the 'masses' had always proved themselves incapable of under-
standing beauty, far preferring 'tawdry' manufactured goods to
the perfect form of an object created by an artist. The artist, 'with
the light given to him alone', was able to see the beauty hidden
in nature, as in London by night. Only he was capable of grasping
and conveying the poetry with which the evening mist veiled the
industrial landscape, transforming what were shops and industrial
sites during the day into a 'fairyland' of campanili and palaces. By
painting works that revealed the nocturnal beauty of the city, the
artist accomplished his task of extracting the grace and harmony
concealed in nature. Whistler maintained that he should not
concern himself with anecdote or literary allusions in his works,
to which critics who were blind to beauty clung in desperation;
nor should the artist believe in the concept of progress in art,
something historians wanted to demonstrate at all cost.

'A whimsical and capricious goddess', Art flitted from place to
place, attaching herself not to peoples but to individuals, passing
from the glorious Greek author of the Parthenon marbles to the
Spanish master at the gallery in Madrid – lighting for a moment
'on Hokusaï's fan – at the foot of Fusi-yama'. The fundamentally
idealistic concept developed by Whistler in the course of the
lecture was as capricious as the goddess the orator invoked to
do his bidding, and Mallarmé could only have found it appealing.
Under the influence of the theory of Art for Art's Sake, notably
championed by his mentors Théophile Gautier and Baudelaire,
the poet had adopted in his youth positions close to those of
Whistler, believing that access to poetry should be the purview
of an elite, and denouncing the confusion that frequently
clouded the distinction between the beautiful and the good.[15]
Since that time, the poet's judgement with respect to the place
of poetry varied little, even though he admired the energy of
popular novelists such as Emile Zola.

One can understand why Mallarmé wished to translate
Whistler's lecture. Having earned the recognition of his peers
and the younger generation of poets who flocked to his Tuesday

salons, he had undertaken to compile in a single volume his texts that had been previously published in various journals.[16] The translation of the 'Ten O'Clock' lecture, which was guaranteed speedy publication,[17] would enable him to increase the number of his publications and effect an introduction in England, where Whistler once again enjoyed an influence that had been briefly compromised.[18] Completed in March 1888, the translation, with which Whistler said he was delighted, first appeared in May 1888 in a periodical, then in a slim volume modelled on the English pamphlet designed by Whistler.[19] The meticulous placement of the text on the page and the refinement of the cover designed by the artist were in keeping with the exigencies of the poet, who exercised great care in the physical appearance of his texts.

This formal aspect would play a key role in the volume that Whistler proposed to publish four years later in England containing the *quatrains-adresses* (or postal riddles) with which Mallarmé embellished his envelopes. 'The publication must be a little jewel – in presentation as well as format', he told the editor he approached.[20] For these *Récréations Postales* (the chosen title), Mallarmé conceived a cover in the form of an envelope, entrusting the design of the stamp to Whistler. The decorative character of the compilation was thus clearly affirmed, as the foreword pointed out: 'Nothing has been spared in the presentation of these precious trifles. One finds here, combined with a poet's wit, a typographic Parisian gem in the most refined taste.'[21] Had it been published, the volume would have formed part of the decorative tradition of *L'Après-midi d'un Faune*, 'one of the first costly volumes, a bag of sweets, but dream-like and rather Oriental', born of the brotherly collaboration of a poet and a painter, in that case Manet. The project was never realised, but Whistler would soon have the opportunity to participate in a collection of Mallarmé's writings entitled *Vers et Prose*[22] (fig.60), for which he designed a frontispiece (no.53), a lithograph portrait of the poet[23] that echoed, in a minor key, the one Manet had executed sixteen years earlier. Théodore Duret, a mutual friend of Mallarmé, Manet and Whistler, and the biographer of the two artists, both of whom would paint his portrait, noticed 'the astonishing resemblance' in this sketch-like portrait: 'the image is like a breath of air, emerging from the most rapid stroke of the chalk. It is an improvisation, but one cannot improvise such a striking likeness

Fig.60 Title page from Stéphane Mallarmé', **Vers et Prose: Morceaux Choisis**, Perrin et Cie, Paris 1893, corrected and annotated by Mallarmé himself in prospect of a second edition. Collection of Jacques Doucet, Paris

of a human being without knowing the subject intimately if one is to convey such intensity of life and character.'[24]

Three years later Mallarmé would, in turn, create a portrait of the artist, a literary one this time, intended for inclusion in the volume entitled *Portraits du prochain siècle* that the editor Edmond Girard planned to accompany the eponymous exhibition organised at the gallery Le Barc de Boutteville.[25] The work did not see the light of day and the portrait of Whistler appeared only in 1897, alongside that of Manet, in *Divagations*, the last collection published during Mallarmé's lifetime. Whistler was featured in a double portrait, like the two sides of a coin. The obverse illustrated the flamboyant public figure – 'argumentative, enthusiastic, precious, worldly', while the definition of his painting appeared on the reverse: 'a work such as his is innate, eternal, and reveals the secret of beauty; it elicits miracles and defies authorship.'

There can be no doubt that Mallarmé responded to the magical charm of Whistler's etchings. The poet Henri de Régnier attested to this in a passage written in February 1894: 'Sunday at Whistler's. Mallarmé, handling some of the master's etchings . . . said to me: "I feel like I am touching paper money from an imaginary fairyland. One has the feeling that it is extremely precious and could serve as currency for supernatural beings." And, when contemplating a young, Psyche-like, dancer [in one of Whistler's works]: "I feel that the look of Greek art that she projects is not the result of imitation but the recurrence of the same qualities yet again, in their own right."'[26] On the other hand, de Régnier's silence regarding the painted work of Whistler makes one think that he never really shared the same feeling for that aspect of his work.

The fact is that Mallarmé never diverged from the artistic opinions he arrived at during the 1870s, even when confronted by the lack of understanding of his peers. A contemporary of the Impressionists, whom he supported in their struggle and with whom he remained on friendly terms, Mallarmé remained faithful to their work, even if later on he associated with artists of the Symbolist movement such as Redon and Gauguin.[27] Of primary importance was Manet, his alter ego, whom he considered the leader of the Impressionist movement. Mallarmé's only two critical essays on art, published in 1874 and 1876,[28] began as apologias for the painter, some of whose Salon submissions had been rejected. In his second article, 'Les Impressionnistes et M. Edouard Manet', he explained the appearance of Impressionist painting, of which he saw Manet as initiator, in terms of a crisis: 'And here occurs one of those unexpected crises which appear in art.' The article was devoted to the analysis of this crisis: 'Let us study it in its present condition and its future prospects, and with some attempt to develop its idea.' Manet's painting *The Washing* 1875 (Barnes Foundation, Merion, Pennsylvania),[29] 'a complete and final repertory of all current ideas and the means of their execution', would act as a catalyst for explaining the guiding principles of Impressionist painting, considered part of the *plein air* school: 'simple colour, fresh, or lightly laid on', corresponding to the transparency of the air, cutting off the composition abruptly at the frame to produce a sense of illusion, simplification, total absence of self in the interpretation of nature. At the end of his article and after having defined the style of each Impressionist painter (Monet was characterised by his 'special gift for representing the mobility and transparency of water') Mallarmé returned to the notion of crisis: 'I trust we shall have thoroughly considered our subject when I have shown the relationship of the present crisis – the appearance of the Impressionists – to the actual principles of painting – a point of great importance.' He maintained that it would be necessary for art, which had reached the limits of its development, to return to its ideal source, 'immersed in its principles, and its relationship to nature', not to imitate it, for art will never succeed in equalling a model which has the advantage of life and space, but for 'the pleasure of having recreated nature, touch by touch'. The new element that Impressionism introduced to painting, which provoked a crisis, was the possibility of capturing 'that which perpetually lives yet dies every moment, which only exists by the will of Idea, yet constitutes in my domain the only authentic and certain merit of nature – the Aspect'.

Twenty years later, Mallarmé detected a new crisis, to which he devoted a chapter in *Divagations* entitled 'Crise de Vers'. This time, it was literature itself which was at issue: 'Literature is undergoing an exquisite and fundamental crisis.' While the article takes as pretext the undermining of classic poetic form by free verse, the scope is soon broadened: 'The crisis lies more in the treatment, so captivating, of pause and interval, undergone by versification, than in our unsullied mental circumstances.' The origin of this crisis stemmed from the appearance of an 'Idealism that rejects natural materials and, as harsh, a precise thought arranging them; retaining nothing but the suggestion'. The interpretation of the term 'suggestion' can be explained by an example taken from nature: 'Abolished, the claim, an aesthetic error, despite its governance of masterpieces, to include in the delicate paper of the book something other, for example, than the horror of the forest, or the silent thunder of the leaves; not the intrinsic and dense wood of the trees.' Further on, the poet gave another example, taken from the same source: 'I say: a flower! And, from the oblivion where my voice banishes no contour, as something other than the known calyx, musically arises, the very sweet idea, the one absent from all bouquets.'

The crisis in painting unleashed by the Impressionists stemmed from the removal of the subject (in both senses: the motif on the one hand and the artist on the other) in favour of

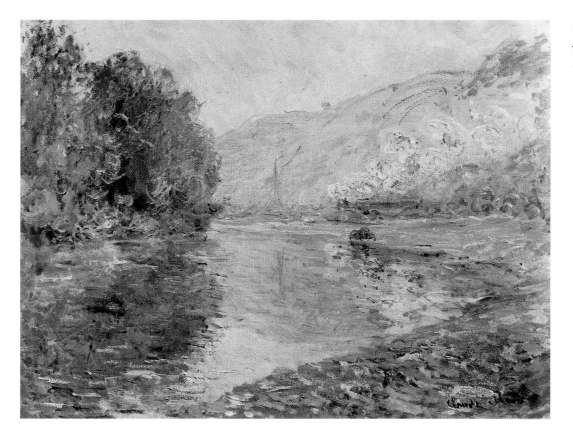

Fig.61 Claude Monet, **The Train at Jeufosse** 1884
Oil on canvas 60 × 81 cm, W 912
Whereabouts unknown

the *aspect*, the moment captured on canvas. The crisis in poetry arose out of the awareness that poetic language cannot be reduced to its referential function ('to speak of things does not convey their reality except in a commercial sense'), and encapsulates a symbolic dimension which goes beyond the referential. It is significant that to illustrate his thesis Mallarmé chose as examples two natural elements, the tree and the flower, that occupy a privileged position in Impressionist painting, especially in the work of Monet. For Mallarmé, nature is a given fact; he corroborates its existence as follows: 'Nature occurs, we need not add to it; only cities, railways and several inventions which constitute our material world.'[30] He expresses his joy in 'simply being on earth in all simplicity'.[31] The Impressionists dared to confront nature directly, without preconceptions.

More than any other artist, Monet was devoted to this task. From 1890 on, his 'series',[32] in which he strove to capture the '"moment", in particular the *enveloppe*, suffused with the same light throughout the painting',[33] constitutes the best illustration of the thesis advanced by Mallarmé fifteen years earlier. By painting the same motif at different times of day, the artist attempted to capture, out of the constantly changing effects of light and atmosphere, the appearance of a particular moment – what Mallarmé called '*aspect*'. The painter deliberately confined his choice to simple motifs, stripped of all detail – grain stacks, poplars, mornings on the Seine (nos.60–2) – in order to concentrate exclusively on his work as a painter – on colour, facture, and composition – without being encumbered by detail.[34]

Mallarmé paid homage to Monet's first series by letting him know that it had transformed the way in which he saw the things portrayed: 'Your recent *Grain Stacks* have blown me away, Monet, so much so that I find myself looking at fields from the perspective of my memory of your painting; that is how strongly they affected me.'[35] When Monet was in Paris he would meet Mallarmé at Berthe Morisot's house. Two months before Monet began his series of grain stacks, Mallarmé went to Giverny with Berthe Morisot, and brought back a landscape Monet had executed at Jeufosse near Giverny in September 1884 (fig.61). Against a hilly background, the Seine flows lazily between woods and fields, forming a curve. A train passes by in the distance in a cloud of smoke. Touches of red in the trees hint at the advent of autumn. Mallarmé felt utter joy: 'One does not disturb a man experiencing a joy such as the one the contemplation of your painting brings me, dear Monet. My mental health benefits from being able to lose myself in this dazzling sight, at my leisure. I slept little the first night, looking at it.'[36] The choice of this painting, if it can be ascribed to Mallarmé, is significant, for its subject recalls the prose poem 'La Gloire' that Mallarmé had asked Monet to illustrate in a collection to which his Impressionist

friends were invited to contribute.[37] 'Glory' is what the forest displays rather than the vain notoriety dispensed by newspapers and posters. On the train to Fontainebleau one autumn day, Mallarmé went from the one – 'a hundred posters betraying the word and counterfeiting the incomprehensible gold of the days' – to the other – 'waiting at an entrance to the forest at the time of its apotheosis' to be anointed a royal intruder before crossing the threshold, while 'the train which had dropped him on his own, slowly regained its normal momentum, and was reduced to the scale of a juvenile chimera, on its way to somewhere else'.[38]

Mesmerised by the 'uninhabited splendour of autumn',[39] when 'Nature prepares her sublime and pure Theatre',[40] Mallarmé believed for a moment that Monet could recreate in pencil in the body of the text the flaming quality of the season. In doing so, he was forgetting the fact that the Impressionist landscape, for which he had himself articulated the principles a decade earlier, could not arise from a pre-existent text, however multi-layered it might be. Moreover, the implementation of these principles required the liberal format of the canvas rather than the restrictions of the page: painting – 'this art made up of oils and colours'[41] – was the only means to express *l'aspect* (according to Mallarmé) or *l'enveloppe* (Monet's term). Monet understood this, and apologised to Mallarmé:

> I really am ashamed of my conduct and I deserve your reproaches. It is not, due, however, as you might think, to any lack of desire on my part; the truth is that I find myself incapable of producing anything of value, perhaps I am too proud, but honestly, as soon as I attempt the least thing in pencil, it appears to me absurd, uninteresting, and consequently unworthy to accompany your exquisite poems (I adore 'La Gloire', and am afraid I don't have the necessary talent to do something worthy of you). Please don't think of this as a vulgar admission of defeat, unfortunately it is the plain and simple truth. So please forgive me, especially for having taken so long to make this confession.[42]

In compensation, the painter offered Mallarmé 'a small painting (an oil sketch) as a token of friendship', the one that Mallarmé brought back from Giverny a short time later. This was the only adequate response to the writer's request: to substitute for an illustration which could not be realised a painting which showed his ability.

The works that Whistler and Monet offered Mallarmé reveal the nature of their relationships with the writer. Whistler sketched Mallarmé's portrait and painted one of his daughter,[43] testifying to their close friendship. The artist also gave him some lithographs – portraits and genre scenes.[44] But they never discussed, as far as we know, Whistler's landscapes that constituted such an essential part of the artist's work.[45] Conversely, Monet is represented in Mallarmé's collection by a landscape. A testimony of the esteem in which the painter held the poet, this gift reflects Mallarmé's vision of Monet as painter of the French countryside.

53 James McNeill Whistler

Stéphane Mallarmé 1892

Transfer lithograph in grey-black on greyish ivory chine
laid down on off-white plate paper 9.7 × 7 cm
S 60, only state
The Art Institute of Chicago. Bequest of Bryan Lathrop

Monet invited Whistler to lunch with Stéphane
Mallarmé in 1888, realising that the poet would find
Whistler's ideas about art analogous to Mallarmé's ideas
about poetry. Mallarmé offered to translate Whistler's
'Ten O'Clock' lecture into French, inaugurating a close
collaboration, and an equally close personal friendship,
that lasted until Mallarmé's death in 1898. The
friendship between Monet, Whistler and Mallarmé
is indicative of their shared interest in elusive and
ephemeral effects which opens up their works to
multiple readings.

Attracted to Whistler's 'mysterious and thoughtful
art, full of subtle practices and complicated recipes'
(de Reginier 1931, pp.209–10), Mallarmé asked him to
make this portrait as the frontispiece to the 1893 edition
of *Vers et Prose*. The result was both a portrait and a
metaphor for the man himself. By placing a thin piece
of transfer paper over the buckram binding of a book
and shifting it periodically, Whistler achieved the
blurred and rubbed appearance of charcoal, an aesthetic
effect that coincided with Mallarmé's view of matter
as impermanent and evanescent (see Lochnan in Spink,
Stratis, Tedeschi 1998, I, pp.106–7). He made the form
and contours more enigmatic and elusive by drawing
the figure by firelight. Flames danced around the form,
throwing shadows on the wall and suggesting both
the creative energy and mysterious depths of the poet's
imagination. He redrew the portrait several times,
'condensing all the observations accumulated in making
the preparatory studies' (Duret 1904, p.124). Whistler
succeeded so well in capturing the characteristics of
his sitter that Duret wrote: 'Those who knew him
were able to believe that they could hear him speak'
(Duret 1917, p.84). KL

1856

54 Lake Lucerne: The Bay of Uri from Brunnen *c.*1830

Pencil and watercolour on paper 22.8 × 29.4 cm
TB CCCLXIV 387
Tate, London. Accepted as part of the Turner Bequest 1856;
displayed from 1891

55 Lake Lucerne: The Bay of Uri from Brunnen *c.*1841–2
Watercolour and bodycolour on paper 24.1 × 29.6 cm
TB CCCLXIV 313
Tate, London. Accepted as part of the Turner Bequest 1856;
displayed from 1857

**56 Lake Lucerne: The Bay of Uri from Brunnen;
Sample Study** *c.*1841–4

Pencil and watercolour on paper 24.4 × 30.3 cm
TB CCCLXIV 338
Tate, London. Accepted as part of the Turner Bequest 1856;
displayed from *c.*1890

**57 Lake Lucerne: The Bay of Uri from Brunnen;
Sample Study** *c.*1841–2

Watercolour and bodycolour on paper 24.2 × 29.7 cm
TB CCCLXIV 354
Tate, London. Accepted as part of the Turner Bequest 1856;
displayed from *c.*1890

58 Lake Lucerne: The Bay of Uri from Brunnen
*c.*1841–2

Watercolour on paper 24.4 × 29.9 cm
TB CCCLXIV 342
Tate, London. Accepted as part of the Turner Bequest 1856;
displayed from *c.*1890

59 Lake Lucerne: The Bay of Uri from Brunnen
*c.*1841–2

Gouache, pencil and watercolour on paper 24.4 × 29.5 cm
TB CCCLXIV 348
Tate, London. Accepted as part of the Turner Bequest 1856;
displayed from *c.*1890

These six studies are part of a larger group recording
the view down the southern-most stretch of Lake
Lucerne from above the small village of Brunnen.
Stimulated by his repeated engagement with this
spectacular amphitheatre of lake and mountain scenery,
Turner developed three larger watercolours for inclusion
in the sets of finished drawings he produced for a small
group of loyal patrons between 1842 and 1845, and it
is also apparent that he planned to complete an oil
painting of the same view (see W 1526–7, 1543; and
Warrell 1999a). Though the contemporary Rigi scenes
are perhaps now more celebrated, it was this view from
Brunnen that was the most constant source of inspira-
tion in these later groups of watercolours. Apart from
the sheer majesty of the setting as sublime nature, the
shores of Lake Lucerne were associated by Turner and
his contemporaries with the legends of William Tell
and his pursuit of liberty from Austrian oppression.

The consistent use of a near-monochrome palette
of limpid blues in these studies implies that they were
probably produced at much the same time, perhaps
during just a couple of painting sessions. One of the
few first-hand accounts of Turner's working practices
reveals that he created a kind of production line, going
from one sheet of paper to the next while his brush
was charged with a particular colour, and moving on
in this way to allow the paint to dry before returning
to the first in the group. Though this was especially
true for the watercolours he produced in the 1820s and
1830s, he seems to have occasionally worked in colour
on the spot, or in an improvised studio, when painting
some of his final Swiss and German studies, building
up generalised washes over a skeletal frame of often
rudimentary pencil outlines.

The serial nature of his method of working is also
reflected in the finished Swiss watercolours, which were
evidently conceived and developed as distinct groups.
Many of the works produced in 1842, for example,
share the same colour harmonies and are pervaded by
a sense of tranquillity, in contrast to the landscapes
in the 1845 set, which are most frequently harried by
turbulent rain clouds. Turner's concentration on a
dominant colour for each work, particularly in the 1842

set, challenged the conventions of naturalistic representation, offering instead something more sensory and elusive: a subjective vision of aesthetic unity. Indeed, his preference for these harmonised layers of vivid colour can perhaps be seen as a foretaste of the deliberately balanced but more nuanced images of Edward Burne-Jones, Albert Moore and Whistler.

Throughout his career Turner painted numerous sets of images, intending each to be seen as a linked sequence. As far as his exhibited work is concerned, this began in the 1790s with groups of watercolours depicting a single motif, such as Fonthill Abbey, from a variety of different viewpoints, at different times of the day (W 335–9). From this fairly conventional means of enlivening a group of pictures Turner embarked on a long sequence of topographical publications, issued in instalments or as bound volumes, which forced him to plan his work in interrelated batches. The designs for each project were generally of a uniform size and shared much the same materials. As well as these practical concerns, the topographical scope embraced by each series further imposed its own inevitable unity. In some projects, such as his views of the rivers Loire and Seine (nos.11–13), he also created explicit visual links by allowing the viewpoint in one image to be visible from the next in the sequence. He seems to have expected the viewer to make these connections between plates, and to see them collectively as an entity. It was these concerns that prompted him to comment on the images in his *Liber Studiorum:* 'What is the use of them, but together?' (*Works*, VII, pp.434–5).

All of these factors similarly shaped the late Swiss series, even though the relationships between the drawings would have been seen only fleetingly before they were distributed to their first owners. For most of the nineteenth century, in fact, these important watercolours remained in private collections that were largely inaccessible to the general public. But the assiduous reader of Ruskin's revised 1846 edition of *Modern Painters* could have gleaned some idea of the impact the watercolours had made on him. Writing of them in reverent tones, he mentioned

Two or three of the Lake of Lucerne, seen from above, [which] give the melting of the mountain promontories beneath into the clear depth, and above into the clouds; one of Constance [see no.20] shows the vast lake at evening, seen not as water, but its surface covered with low white mist, lying league beyond league, in the twilight, like a fallen space of moony cloud.
(*Works*, VII, p.552)

This is one of the many instances where Ruskin's word pictures stand in for the original work.

The studies displayed here include the preliminary ideas for some of the finished watercolours (nos.56–7), but this is the first time that they have been brought together with so many other related designs. Even so, in 1857 Ruskin included three watercolours of the view from Brunnen in his first public display from the Bequest (no.55, TB CCCXXXII 32, TB CCCLXIV 312), using them to illustrate his contention that Turner was, first and foremost, 'the painter of clouds':

All other features of natural scenery had been in some sort rendered before; – mountains and trees by Titian, sun and moon by Cuyp and Rubens, air and sea by Claude. But the burning clouds in their courses, and the frail vapours in their changes, had never been so much as attempted by any man before him. The first words which [Turner] ever wrote, as significative of his aim in painting, were Milton's, beginning 'Ye mists and exhalations'. And the last drawing in which there remained a reflection of his expiring power, he made in striving to realise, for me, one of these faint and fair visions of the morning mist, fading from the Lake Lucerne.
(W 1543; *Works*, XIII, p.316)

Most of the other studies of Brunnen were added to the range of material available in the National Gallery's ground floor rooms in the 1890s, but they were scattered through the selection, rather than being grouped together in a way that would have emphasised the connections between the images. IW

54

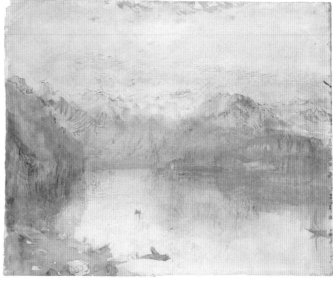

55

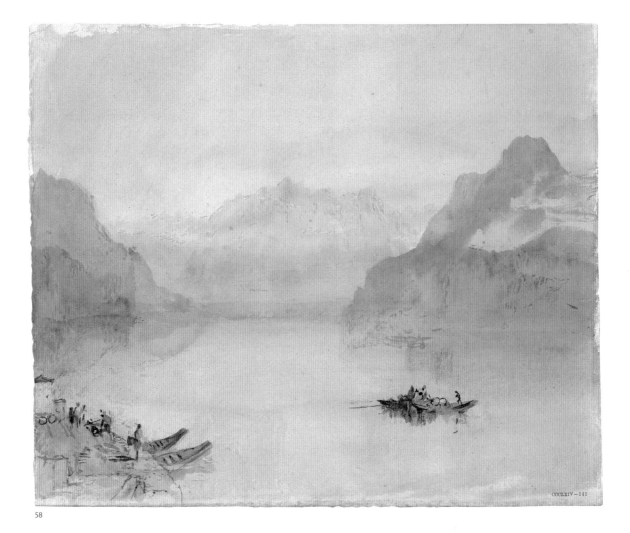

58

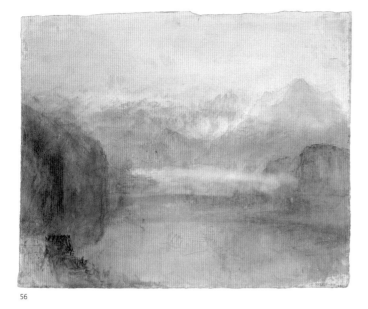

56

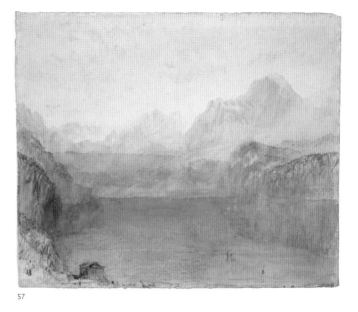

57

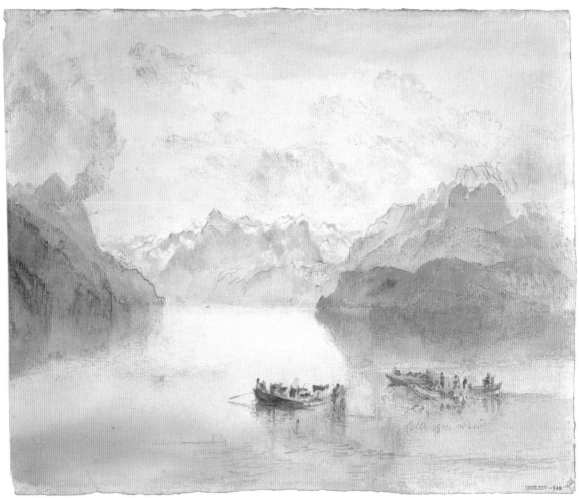

59

60–62 Claude Monet

60 Arm of the Seine near Giverny in the Fog 1897
Bras de Seine près de Giverny, brouillard

Oil on canvas 89 × 92 cm
W 1474
North Carolina Museum of Art, Raleigh

61 Morning on the Seine near Giverny
1897
Le Matin sur la Seine, temps net

Oil on canvas 81.6 × 93 cm
W 1482
Metropolitan Museum of Art, New York.
Bequest of Julia W. Emmons, 1956

62 Morning on the Seine near Giverny
1897
Bras de Seine près de Giverny

Oil on canvas 81.3 × 92.7 cm
W 1481
Museum of Fine Arts, Boston.
Gift of Mrs W. Scott Fitz

From 1891 onwards, Monet exhibited his paintings in series of canvases on a single subject, focusing on different effects of light, weather, and seasons. The starting point of all the paintings was his direct observation of the scene, but he reworked all the paintings in a series together as a group, before exhibiting them. The canvases were for sale individually, but Monet felt that the full impact of the paintings was only felt when a whole series was seen together, and the viewer could appreciate the individual paintings in relation to each of the others, and appreciate the endless variations of tone, touch and texture. Today, it is only through loan exhibitions and in certain museums (notably the Art Institute of Chicago and the Musée d'Orsay, Paris) that we can gain an idea of the effect.

In the summers of 1896 and 1897 Monet concentrated on a series of views of a branch of the Seine near Giverny, viewed in early morning light; the paintings were first exhibited in Paris in June 1898. These paintings are the most delicately coloured of all his series. Monet translated the morning light into subtle harmonies of blues, mauves and greens, punctuated in some canvases by warmer hues in the dawn sky. At the same time he explored the relationship between the patterns made by the trees silhouetted against the sky and the suggestions of receding space, evoked by subtle changes of texture and focus in the foliage of the trees and the water surface.

Like many of his contemporaries, Monet was at this date looking again at the art of Corot, whose work had been seen in a major retrospective exhibition in 1895. But the *Mornings on the Seine* series also invites comparison with Whistler's work, and especially his Nocturnes, in its use of silhouetted forms viewed against the sky and in the finesse of its colour harmonies.

However, there is a further dimension to his series. It was in these years that Monet spoke of his search for 'mystery' in his art, and his wish to paint canvases that went beyond the Impressionist sketch – paintings with more serious qualities with which 'one could live for longer' (Diary of Theodore Robinson, 3 and 9 June 1892, quoted in House 1986a, pp.220, 223). These concerns clearly parallel the aesthetic ideals of Stéphane Mallarmé, a close mutual friend of Monet and Whistler (see p.163, above, and no.53).

Turner's watercolours of Lake Brunnen (nos.54–9) also offer a precedent for Monet's series of variations of colour and atmosphere on a single theme. He would not have seen any of Turner's watercolours displayed in the same way as these views are in the present exhibition; however, the watercolours that he would have viewed in the National Gallery would have revealed to him the delicacy and finesse of Turner's use of colour in this medium, evidence of closer direct observation of natural effects than the rather more theatrical light effects that characterise his finished oil paintings. JH

60

61

176

62

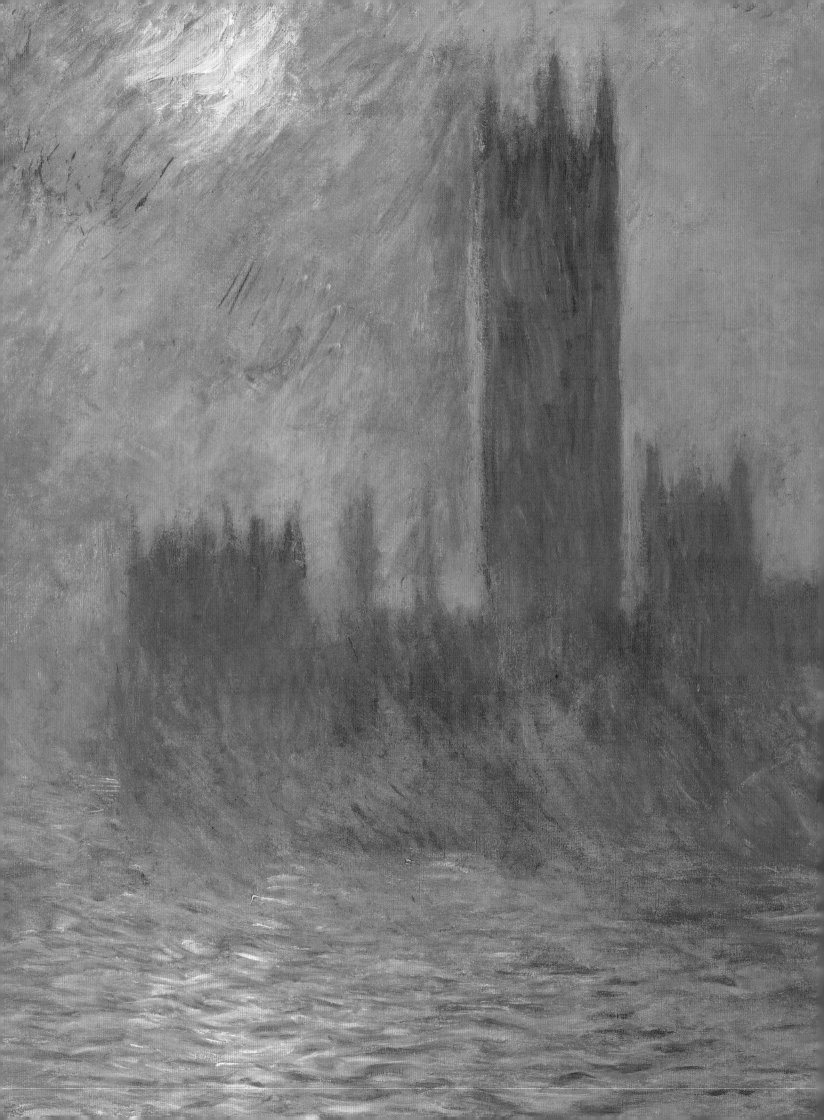

The return of Whistler and Monet to the Thames

Sylvie Patin

I hate London when there is no fog; shrouded in mist, it is an incomparable city. (Stéphane Mallarmé, 1863)[1]

In 1887 Monet confided to his friend Théodore Duret: 'Did you know that I went to London to see Whistler and that I spent about twelve days, very impressed by London and also by Whistler, who is a great artist; moreover he could not have been more charming to me, and invited me to participate in his exhibition.'[2] Pleased to inform the art critic that the American artist recognised his talent, Monet affirmed several times the feelings of 'affection and admiration'[3] that he felt for Whistler. After 1887 the two would correspond regularly, and their friendship was enriched through exchanges with Mallarmé, who translated Whistler's 'Ten O'Clock' lecture in 1884 (see p.163, above).[4]

For Monet, Whistler's name was associated with London, and if one adds to it that of Turner, his return to England in 1899 can be seen in the context of the 'pilgrimages' he undertook at the end of the 1890s to the landscapes he loved. This desire to revisit old haunts took Monet back across the Channel, carrying with him the memory of one of his works of 1871 and the discovery, made at that time with Camille Pissarro, of the art of Turner. His most spectacular composition of 1871 was the celebrated marine landscape *The Thames below Westminster* (no.36). It can be seen to anticipate *Impression, Sunrise* (no.39), executed in the Le Havre basin and exhibited in 1874, and, as with his Thames views of the early 1900s, echoes Turner's paintings.

It was during three successive years, in September–October 1899, in February 1900, and for a longer period between February and April 1901, that the dialogue between the painter and the city in which he had found refuge thirty years earlier was resumed with intensity. From this time on, landscapes known since his youth were viewed and treated in a different manner; to subjects represented earlier, the creator of *Grain Stacks*, *Poplars* and *Cathedrals* now applied the process of working in series. As he advanced in years, Monet observed ever more carefully the transformation of the motif under different lighting conditions.[5] Moreover, in recalling the past, the artist always remembered his first meeting in London with Durand-Ruel in 1870.[6]

Unlike the two painting campaigns undertaken on his own in the winters of 1900 and 1901, the trip to London in the autumn of 1899 was a family affair.[7] Monet was accompanied by his second wife, Alice, and his stepdaughter Germaine Hoschedé. He stayed at the Savoy Hotel (constructed in 1885 and opened in 1889) which is situated on the north bank of the river along the Victoria Embankment, and took advantage of its location to 'make a few scenes of the Thames'.[8] This was the fulfilment of a longstanding ambition first mentioned to Duret in 1880 and reiterated in 1887: 'I plan to go to London . . . I would even like to try to paint some effects of fog on the Thames there.'[9]

Monet's central concern during his three sojourns of 1899, 1900 and 1901 was to execute 'views of the Thames'. He dreamed of painting the river wrapped in the famous fog that was transformed by smoke and pollution into 'smog'. The nature of the exercise dictated his daily routine: the allocation of time was governed by the work to be accomplished in the locations selected, taking the position of the sun into consideration. The painter spent hours before his easel scrutinising what he called 'my Thames',[10] going so far as to make it his own. The presence of the Thames exerted the same hold over Monet as it had over Turner and Whistler: the motifs of the bridges and the Houses of Parliament pervade the work of the three artists following Turner's dramatic composition *The Burning of the Houses of Lords and Commons, 16th October 1834* (no.78).

Monet's favourite vantage point was his window at the Savoy with its precipitous view[11] over Charing Cross railway bridge to the right (which gave rise to about thirty-five canvases), and over Waterloo Bridge to the left (which gave rise to about forty canvases). This viewpoint may have been suggested by Whistler, who had stayed at the Savoy in 1896 and executed a series of lithographs there that are imbued with melancholy. He worked by the side of his wife Beatrice as she slowly faded away. A similar 'floating landscape', with bridges suspended above the water and a succession of planes establishing a sense of perspective, had been constructed by Turner in a watercolour view looking over the roofs of Zurich (fig.63) and in a study inspired by Lake Constance (no.20). Watercolours of this kind, which express a wonderful sense of space, were perhaps on Monet's mind when he painted his views of Charing Cross Bridge, notably the oil sketch now in the Indianapolis Museum of Art (fig.64). From the South Bank Monet depicted the Thames and the Houses of Parliament, which he observed at sundown from the terrace of St Thomas's Hospital. The flight of the gulls in two versions of *Houses of Parliament, Seagulls* (fig.67 and Art Museum, Princeton

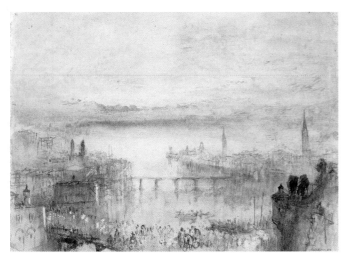

Fig.63 J.M.W. Turner, **A Fête Day at Zurich; Sample Study** 1845
Pencil and watercolour on paper 23.4 × 32.6 cm, TB CCCLX (a) 289
Tate, London

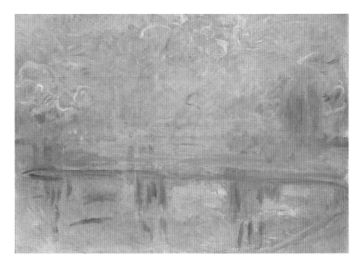

Fig.64 Claude Monet, **Charing Cross Bridge** 1889–1901 (no.70)

University, New Jersey; W 1612) brings to mind Whistler's *Savoy Pigeons* (fig.68). If certain of Monet's *Views of the Thames* evoke Whistler's Nocturnes, the three loosely painted oil sketches made by Monet in 1901 from the window of a London club of the 'nocturnal effects' inspired by the illuminations in Leicester Square (W 1615–17; fig.65) can be compared to *Nocturne in Black and Gold: The Falling Rocket* (fig.66).

Monet's daily routine in London was not only dictated by the sites he chose to paint, but was also subject to the weather conditions.[12] The artist longed for the sun, which could be capricious, calling it at times 'the pretty red ball'[13] and at other times 'an enormous ball of fire'.[14] If the last rays of the setting sun were observed from the terrace of St Thomas's Hospital, facing the Houses of Parliament, the painter observed the fiery ball at its zenith from his window at the Savoy: 'beginning at 10 o'clock the sun showed itself, a little veiled at moments, but with admirable effects of sparkles on the water: so I was well rewarded.'[15] The rippling water, sparkling in the sunlight (previously depicted by Turner) and the play of reflections on the surface of the water, interrupted by the flow of the river, characterise some of the Charing Cross Bridge canvases. Monet wrote: 'the sun rose . . . and was dazzling . . . The Thames was all gold. God it was beautiful, so fine that I began to work in a frenzy, following the sun and its reflections on the water . . . Thanks to the smoke a fog descended.'[16]

London was the city of fog *par excellence*; the painter assigned different qualifiers to this characteristic phenomenon.[17] Following Mallarmé's example, Monet analysed its different colours: 'at daybreak there was an extraordinary mist entirely yellow; I made an impression of it, not bad I think'.[18] Indeed, his London works evoke *Impression, Sunrise* (no.39). The artist noted to his wife: 'when I left for Chelsea, at every step I saw beautiful things because of the thick fog.'[19] Monet was not indifferent to Chelsea, the neigh-

bourhood of Turner and Whistler, and described 'a walk the along the Thames to Chelsea. What an attractive place and what fine things . . . views!'[20] The fog could be so opaque that it obscured his motifs: 'it's hard to have beautiful things to paint and to have suddenly in front of you a layer of darkness of an unnameable colour . . . Alas, the fog persists, from dark brown it has become olive green, but always just as dark and impenetrable.'[21] At times, however, he lamented the total absence of fog, in particular on Sunday when, since industrial activity largely stopped, the atmosphere was different from that which he observed during the week. The artist regretted that this deprived him of inspiration: 'As always on Sunday, there wasn't a wisp of fog, it was appallingly clear' and 'What a sad day is the blasted English Sunday, nature feels its effects, everything seems dead, not a train, no smoke, no boats, nothing that stimulates the imagination.'[22]

What disconcerted Monet in particular was the extremely variable nature of the weather. The incessant climatic changes gave rise to repeated complaints in 1900: 'what an irritation, for not one day is the same', and in 1901: 'the whole day kept changing, picking up one canvas then another, only to replace them moments later. In the end it was enough to drive me crazy, no longer knowing exactly what I was doing.'[23] As a result of the unstable atmosphere, he increased the number of works begun; their number approached a hundred. But if these variations in the weather prevented Monet from working rapidly, they were nevertheless the subject of his admiration: 'Each day I find London more attractive to paint.'[24] He saw himself 'advancing daily in his understanding of this unique climate' and fell under its spell: 'the beautiful effects I have observed on the Thames over a two month period are scarcely to be believed.'[25] Finding 'this country so changeable, but, for the same reason, so admirable', the artist expressed his enthusiasm as follows:

The weather as magnificent but unsettled . . . I can't begin to describe a day as wonderful as this. One marvel after another, each lasting less than five minutes, it was enough to drive one mad. No country could be more extraordinary for a painter.[26]

Watching for atmospheric effects that were different from those in *Mornings on the Seine* (for they were observed here in an urban environment), Monet did not hesitate to cut short his letters to Alice, reminding her that 'I have to go, the effect will not wait.'[27] He had to admit to her that 'I'm also having some good times. I'm seeing unique and wonderful sights and splashing about with paint . . . But here comes the daylight again, so I'll stop.'[28] Monet attempted to grasp the unique character of the city, and rejected some of the 'canvases that did not capture sufficiently the flavour of London'.[29]

Could Monet's approach to painting motifs in series have as a distant source paintings by Turner executed at different times of day, or the variant inkings so dear to Whistler? According to Camille Mauclair, Monet's views of the Thames

> come close to Whistler's nocturnes, containing as they do a nuanced musicality easily transferred from eye to ear, and can, in fact, be linked to the last glorious works of Turner which Monet, the French Turner, came to the artist's former city to honour not defy. The entire series, a symphony or orchestral suite on the Thames, is deeply infused with the character of London.[30]

It was from the perspective of Whistler rather than Turner that the critic Gustave Geffroy, who had visited Monet in February 1900, approached the art of his old friend:

> His efforts are related to those of Turner, but how different he is, free from all classical convention and, moreover, with a personality so distinct, so developed, that never, in the fullness of time, even if all the signatures were to disappear, could one ever mistake one of these Monets for a Turner. The canvases of Monet have a more unified light, a palette infused with light . . . If I had to make an analogy, I would make it with Whistler instead: even though he painted, especially in the nocturnes, nights of velvet blue flecked with gold, which are not relevant here. Claude Monet, like Whistler, painted harmonies, and like him, could have given his paintings titles based on the

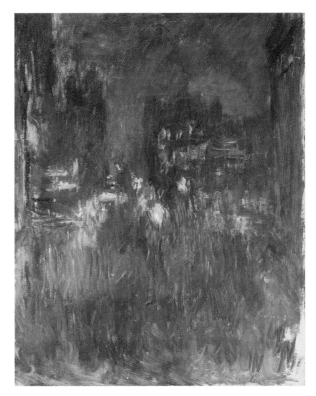

Fig.65 Claude Monet, **Leicester Square at Night** 1900–1
Oil on canvas 80 × 64 cm, W 1616
Galerie Larock, Paris

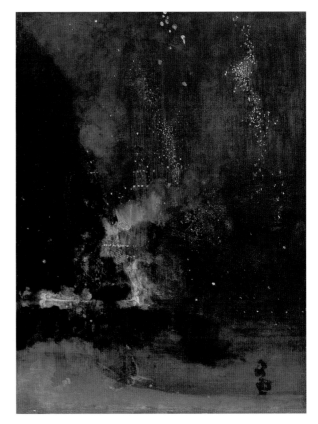

Fig.66 James McNeill Whistler, **Nocturne in Black and Gold: The Falling Rocket** (no.50)

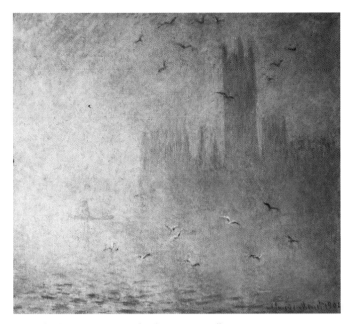

Fig.67 Claude Monet, **Houses of Parliament, Seagulls** 1904
Oil on canvas 81 × 92 cm, W 1613
Pushkin Museum, Moscow

Fig.68 James McNeill Whistler, **Savoy Pigeons** 1896 (no.68)

dominant colours and tones. In all honesty, Claude Monet is true to himself, and one of the most subtle and powerful painters that ever existed, but he is also a great poet.[31]

Monet considered his canvases to be 'beginnings'[32] and 'sketches', warning his wife: 'you mustn't expect to see any finished work; they are only essays, studies, sketches, in short ridiculous and vain research.'[33] He came to this conclusion upon revisiting the term 'impression': 'this is not a country where one can finish anything on the spot: the effect can never be found twice, and I should have done nothing but sketches, real impressions.'[34] Following Monet's return to Giverny in April 1901, the study of motifs on the spot was replaced by work in the studio. These paintings, which appear to have been executed all at once and exude sponteneity, were reworked on many occasions; 'transformed' to use Monet's expression. The painter recalled this experience when he spoke of his studies of light with the duc de Trévise in the 1920s.[35]

At Giverny, the osmosis between Monet and London extended beyond the cross-Channel sojourns of the painter. In 1903, nearly two years after his return from England, Monet sent a revealing letter to Durand-Ruel, in which he explained his working method:

No, I'm not in London unless in thought, working steadily on my canvases, which give me a lot of trouble . . . I cannot send you a single canvas of London, because, for the work I am doing, it is indispensable to have all of them before my eyes, and to tell the truth not a single one is definitively finished. I work them out all together or at least a certain number.[36]

Some of his paintings reveal layers of overpainting or significant retouching, attesting to this long period of gestation. In the case of the *Parliaments* and *Cathedrals,* Monet was accused of having worked from photographs, of creating canvases designed exclusively for their impact as a group, and in this way pushing to extremes his methodology of producing works in 'series' (with a commercial end in view, according to some of his detractors). As Durand-Ruel was disturbed by such criticisms, Monet explained his methods to him in the hope of putting an end to the debate.[37] While conceiving the dealer's long-awaited exhibition, Monet always thought in terms of 'series'; the very word was on the tip of his pen in justifying his approach: 'I've been working on the *Views of London* for almost four years . . . I don't share your opinion and am very glad I didn't send you a few of the paintings, since the overall view of the complete series will have much greater impact.'[38]

The exhibition of *Vues de la Tamise à Londres* took place from

9 May to 4 June 1904 in Durand-Ruel's gallery. As Octave Mirbeau declared in his laudatory catalogue preface, 'These paintings have a single theme . . . the Thames unites the three exhibited sub-series into an ensemble of thirty-seven views of *Charing-Cross Bridge . . . Waterloo Bridge . . .* and *The Houses of Parliament.*' The titles of the works[39] recalled those of the *Grain Stacks.* Fog played a central role in this representative exhibition, and it was with this element of the London landscape that Mirbeau decided to close:

> He saw London, he experienced London, in its very essence, its character, and its light . . . The London fog is even more changeable, elusive, and complicated than the sky of Normandy. Whether muted or bright, all the colours blend together; ethereal reflections, virtually imperceptible influences, transform objects or even deform them into fantastic shapes, pushing them back or pulling them forward according to immutable, cosmic laws.[40]

Mirbeau drew attention to the 'miracle' performed by Monet, who had known how to give back the city its 'sooty soul', a phrase coined by Émile Verhaeren.[41]

Monet, together with Geffroy, was delighted by the response: 'this time the Press has overdone it with the praise they've showered on me.'[42] Whistler had died on 17 July 1903, a loss that tinged Monet's London memories with sadness without lessening his interest in works inspired by the Thames that both artists loved. But it was to Turner that the critics of the exhibition wished to link Monet. Louis Vauxcelles saw him as a 'descendant of Turner',[43] while Gustave Kahn, an habitué of Mallarmé's 'Tuesdays', declared:

> If it is true that Turner liked to compare certain Turners to certain Claude Lorrains, then one might place certain Monets beside certain Turners. One would thereby compare two branches, two moments of impressionism, or rather – because the names of schools are deceptive . . . it would integrate two moments in a history of visual sensitivity.[44]

Geffroy also drew attention to the fact that 'one of the views of Charing Cross was sub-titled *Smoke in the Fog: Impression*, perhaps as a reminder of the famous term which was to serve as a banner for the group that exhibited in 1874'.[45] Turner was now put forward as a source for Monet's *Impression, Sunrise* (no.39).

GALERIES DURAND-RUEL
16, Rue Laffitte — 11, Rue Le Peletier

CLAUDE MONET

VUES DE LA TAMISE
A LONDRES

Exposition du 9 Mai au 4 Juin 1904

Fig.69 Front cover of the catalogue for the exhibition *Vues de la Tamise à Londres*, held at Galeries Durand-Ruel, Paris 1904

London lived on for a long time in Monet's thoughts, linked inextricably to Turner. Evidence of the long-lasting bond that tied the painter to the city is provided by the dealer and collector René Gimpel, who jotted down remarks made to him by Monet in his journal in 1918:

> I greatly loved Turner once, nowadays I like him much less . . . He did not emphasise colour enough and he often put on too much of it; I have studied him carefully . . . I love London, much more than the English countryside; yes, I adore London . . . What I like most of all in London is the fog.[46]

In the universe he created at Giverny, Monet introduced, through small touches, things he had appreciated in England. His familiarity with Whistler reinforced a passion for things Japanese in his home, such as prints and blue and white porcelain; among several customs he brought across the Channel the artist's table revealed 'place settings beautifully arranged, as in Whistler's home', as Jacques-Emile Blanche wrote.[47] On the walls of the salon-studio at Giverny certain paintings recalled the fascination exercised on Monet, together with Turner and Whistler, by the Thames.

63 James McNeill Whistler

By the Balcony 1896

Transfer lithograph in black with stumping and scraping,
on cream wove proofing paper 21.7 × 14.2 cm
S 160, only state
The Art Institute of Chicago. Mansfield-Whittemore-Crown
Collection on deposit at The Art Institute of Chicago

In mid-February 1896 Whistler brought his wife,
Beatrice, who was dying of cancer, back to London.
Drawn as always to the banks of the Thames, he took
a sixth-floor corner room in the new and luxurious
Savoy Hotel, which provided unobstructed views to
the west and south. There Whistler was able to keep
Beatrice company while making lithographs on
transfer paper from the windows or balcony. He was
involved with the ideas of Belgian Symbolist play-
wright Maurice Maeterlinck, who was a member of
the Mallarmé circle in Paris, and this image reflects
Maeterlinck's ideas regarding the 'tragedy of everyday
life' (Lochnan in Spink, Stratis, Tedeschi 1998,
pp.289–90). Whistler harnessed the tentative appear-
ance of the transfer lithograph to his summary
drawing style, and by positioning his wife before an
open window with the river as backdrop, appears to
have been alluding to the transience of human life.
He was devastated by her death a few weeks later and
the feelings this lithograph evoked were so personal
that he tried to recall the handful of impressions he
had given to close friends: impressions are consequently
very rare. KL

64-66 James McNeill Whistler

64 Little London 1896

Transfer lithograph in black with stumping
on ivory laid paper
19 × 14 cm
S 158, only state
The Art Institute of Chicago.
Bryan Lathrop Bequest

65 Waterloo Bridge 1896

Transfer lithograph in black on cream laid paper
17.2 × 12.7 cm
S 156, only state
The Art Institute of Chicago. Mansfield-
Whittemore-Crown Collection on deposit
at The Art Institute of Chicago

66 Evening, Little Waterloo Bridge 1896

Transfer lithograph in black with stumping, on cream laid paper
9.3 × 19.4 cm
S 155, I/II
The Art Institute of Chicago. Mansfield-
Whittemore-Crown Collection on deposit
at The Art Institute of Chicago

Whistler's themes and perspective anticipate Monet's London views of 1899–1901 (nos.70–3). The unobstructed views of the Victoria Embankment, Charing Cross Railway Bridge, Waterloo Bridge, Westminster Bridge, the Houses of Parliament and the industrialised South Bank provided Whistler with subject matter. Drawn on transfer paper, these lithographs, following their transfer to the stone, were printed the right way round. Their delicacy conveys the impression of memories or after-images. These evanescent souvenirs are among the most minimal statements Whistler made as an artist, and represent his last views of the river he loved so much.

No.64 appears to have been made from the roof of the hotel looking east toward St Paul's Cathedral. During the 1890s the visibility index, an early method of indicating the degree of smog, was measured each day from the dome of St Paul's. KL

64

65

66

67,68 James McNeill Whistler

67 Charing Cross Railway Bridge 1896

Transfer lithograph in black with stumping,
scraping, and incising, on cream laid paper
13 × 21.6 cm
S 157, only state
The Art Institute of Chicago. Mansfield-
Whittemore-Crown Collection on deposit
at The Art Institute of Chicago

68 Savoy Pigeons 1896

Transfer lithograph in black on ivory laid paper
19.9 × 13.8 cm
S 154, only state
The Art Institute of Chicago. Mansfield-Whittemore-Crown
Collection on deposit at The Art Institute of Chicago

Charing Cross Railway Bridge, which appears in both
these views, is properly called the Hungerford Bridge.
It was constructed in 1863 in place of Isambard
Kingdom Brunel's 1836 suspension bridge so that
trains could cross the river to and from Charing Cross
Station. The engineer was John Hawkshaw (Nikolaus
Pevsner, *London*, I, Harmondsworth 1973, pp.318, 388).
The large structure on the far shore in no.67 is the
Red Lion Brewery. Further along, towards Westminster
Bridge, is St Thomas's Hospital, from which Monet
would paint the Houses of Parliament. KL

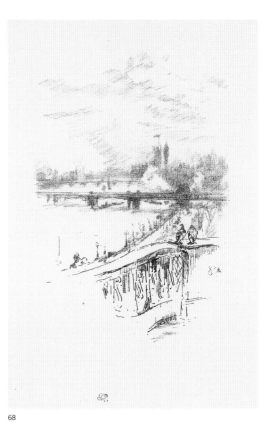

67

68

69 James McNeill Whistler

The Thames 1896

Lithotint, in black ink, with scraping, on ivory chine, laid down
on off-white plate paper 26.7 × 19.6 cm
S 161, III/III
The Art Institute of Chicago. Clarence Buckingham Collection

Whistler made his last view of the Thames working
directly onto a stone supplied by his printer, Thomas
Way, in nearby Wellington Street. In it, he used
lithotint, perfectly suited to tonal work, for the first
time since 1878 (nos.51–2). Because the work was
executed directly onto stone, the image was printed
in reverse. The flattened composition, which seems to
climb vertically up the picture plane, recalls Turner's
watercolours, and Japanese *ukiyoe* (woodblock prints).

While the image appears nocturnal, it is evident
from the pedestrians on the Embankment, the river
traffic, and the smoky emissions, that Whistler wanted
to capture the effect created on dark March days by the
blanket of coal smoke and fog that hung over London
(see p.60, above). Across the river we see, from right to
left, the Lambeth Lead Works and the Lion Brewery.

Whistler worked hard to ensure that the tone
was accurate (see Spink, Stratis, Tedeschi 1998, I, p.454).
The image engenders feelings of foreboding, resignation
and peace. It is full of subtexts: the river had been
central to Whistler's art and life, as it had been to
Turner's, and their names had become closely
connected with its depiction. Moreover, the river is a
universal symbol for life as darkness is for death. The
elegiac note no doubt reflects Whistler's state of mind.
This was his last variation on a Thames theme in any
medium.

In 1900 the lithotint was awarded a medal at the
Exposition Universelle in Paris. Duret wrote to Whistler:
'I was not familiar with the View of the Thames, that
sort of demi-nocturne crafted with a wholly new
quality. It is infused with transparency and incredible
lightness, and I was astonished by it' (quoted in Spink,
Stratis, Tedeschi 1998, I, p.457). It anticipates Monet's
'demi-nocturnes' such as *Charing Cross Bridge, Fog on the
Thames* and *Waterloo Bridge: Effect of Sunlight in the Fog*
(nos.73, 77). KL

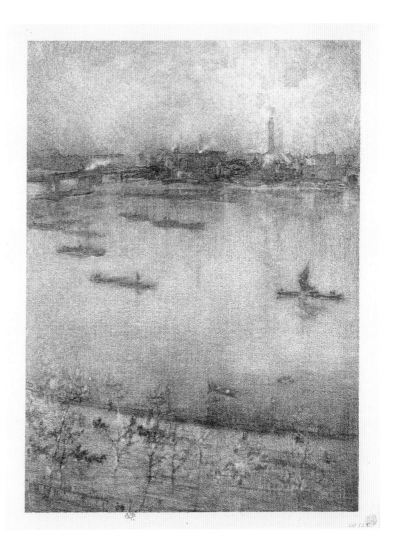

70-73 Claude Monet

70 Charing Cross Bridge 1899–1901
Charing Cross Bridge

Oil on canvas 66.0 × 92.7 cm
W 1530
Indianapolis Museum of Art.
Gift of Several Friends of the Museum

71 Charing Cross Bridge, the Thames 1903
Charing Cross Bridge, La Tamise

Oil on canvas 73.5 × 100 cm
W 1537
Musée des Beaux-Arts, Lyon

72 Charing Cross Bridge, Overcast Day 1900
Charing Cross Bridge, temps couvert

Oil on canvas 60.6 × 91.5 cm
W 1526
Museum of Fine Arts, Boston.
Given by Janet Hubbard Stevens in Memory of
her mother, Janet Watson Hubbard

73 Charing Cross Bridge, Fog on the Thames
1903
Charing Cross Bridge, brouillard sur la Tamise

Oil on canvas 73 × 92 cm
W 1554
Fogg Art Museum, Harvard University,
Cambridge, Massachusetts

Out of his window at the Savoy Hotel, overlooking the Thames and the trees on the Victoria Embankment, Monet had a panoramic view to the right of the railway bridge at Charing Cross and, to the extreme right, the Houses of Parliament at Westminster. The artist depicted Charing Cross Bridge, emphasising the rectilinear lines of its metal framework, on about thirty-five canvases, all of them morning variations. He inaugurated the theme in 1899 and returned to it over the next two years, hence the date '1900' on *Charing Cross Bridge, Overcast Day* (no.72).

At the beginning of his stay in 1901 Monet undertook 'a few pastel sketches' (letter to Alice Monet, 26 January 1901; Wildenstein 1974–91, III, letter 1588) because the crates containing his painting materials had been detained at customs and had not yet reached their destination. '[I] continue to experiment with pastel. I enjoy it very much even though I'm not accustomed to using it; it keeps me busy and may even help me', he wrote to Alice on 27 January 1901 (Wildenstein 1974–91, III, letter 1589). The artist saw value in this interlude: 'it is true that I am not wasting my time on this: I am looking a great deal and observing what I will be working on; I am making many pastel studies which function as exercises, however, I would prefer to be more gainfully employed' (letter to Alice Monet, 28 January 1901; Wildenstein 1974–91, III, letter 1590).

In March 1901 Monet developed symptoms of pleurisy, which cast a shadow over the final phase of his last London campaign. In this weakened state he began to work again in pastel to 'relieve the boredom' (letter to Blanche Hoschedé-Monet, 24 March 1901, Wildenstein 1974–91, III, letter 1627). All the paintings made in London (about a hundred) are executed in oil on canvas, to which can be added a few pastels (about twenty are listed in the catalogue raisonné of the artist's work). With the exception of a very few studies of fog and boats, these are primarily of the two motifs observed from his room at the Savoy: the bridges at Charing Cross (six variations) and Waterloo (sixteen in total, one of which is at the Musée d'Orsay in Paris). Pastel, a medium with which Whistler experimented before Monet (particularly in Venice), makes it possible to capture specific atmospheric effects: Monet's recall those of his two great predecessors in London: Turner and Whistler.

Pleased to be working with oils again, Monet told Alice on 1 February 1901: 'It is thanks to my pastels, made swiftly, that I realised how to proceed' (Wildenstein 1974–91, III, letter 1591). In fact his paintings show the effect of his experience with pastel in 1901, especially no.70. The oil sketch conveys the painter's tentative organisation of the elements of the composition realised in no.71. (See Isaacson 1965, pp.44–51, repr.)

In his preface to the catalogue for the exhibition *Monet, Vues de la Tamise à Londres* held in Paris in 1904 at Durand-Ruel's Gallery (where the Lyon version (no.71) was no.6 and the Fogg version (no.73) was no.7), Octave Mirbeau analysed the views inspired by this bridge across the Thames:

> These paintings of Charing Cross show the railway bridge suspended above the water between massive pylons which appear to evaporate, and further away, scarcely visible, are the delicate silhouettes where one senses the crowded dwellings and the uproar of the factories. On the bridge, above the arches of light, the trains follow in succession and pass: their undulating smoke, coming from different directions mixes, fuses, and vanishes into the air against the river. Oh how I love smoke with its vitality, its lovely fluidity, its elusiveness, then its disappearance!

The smoke of the trains on the bridge can be seen in no.71 as well as no.73 where, as Daniel Wildenstein notes, 'the sun is sufficiently high in the sky by late morning to be reflected in the waters of the Thames, despite the fog which partially shrouds the opposite bank'. SP

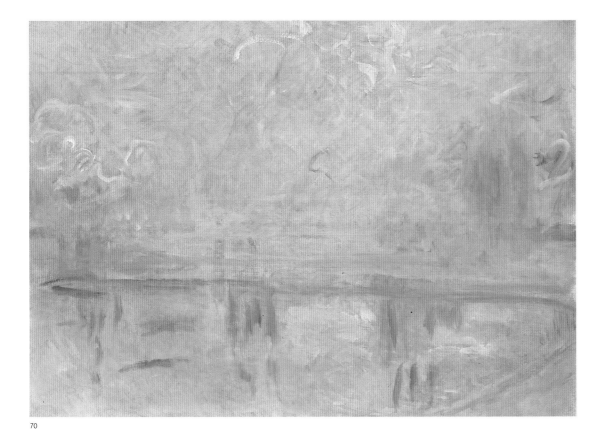

70

71

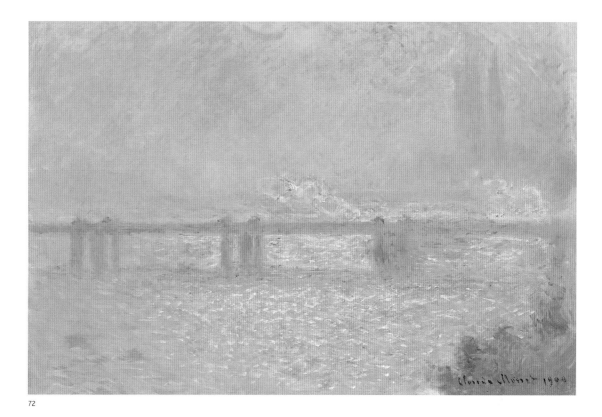

72

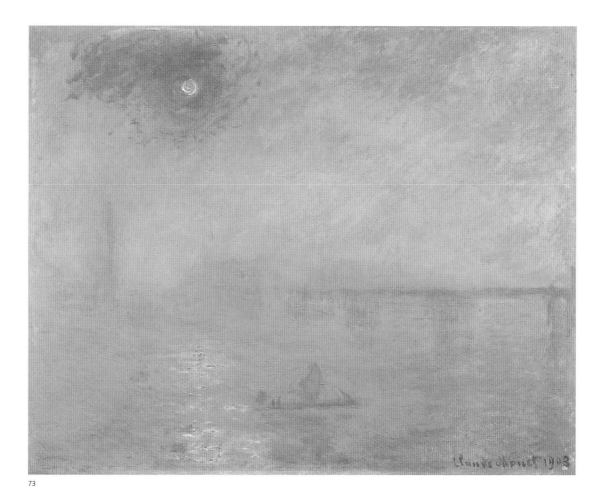

73

74 Waterloo Bridge, London 1900
Le Pont de Waterloo à Londres

Pastel on beige laid paper 31.1 × 48.5 cm
The Louvre, department of graphic arts,
with funds from the Musée d'Orsay, Paris

76 Waterloo Bridge 1903
Waterloo Bridge

Oil on canvas 65 × 92 cm
W 1568
Worcester Art Museum, Massachusetts

75 Waterloo Bridge, Sunlight Effect 1903
Waterloo Bridge, effet de soleil

Oil on canvas 65.7 × 101.0 cm
W 1586
The Art Institute of Chicago. Mr and Mrs Martin A. Ryerson
Collection

77 Waterloo Bridge: Effect of Sunlight in the Fog 1903
Waterloo Bridge, le soleil dans le brouillard

Oil on canvas 73.7 × 100.3 cm
W 1573
National Gallery of Canada, Ottawa

Looking out of his window at the Savoy, this time towards the left, Monet could see Waterloo Bridge, the curves of its stone arches contrasting with the geometric lines and metal silhouette of Charing Cross Bridge. His view took in the smokestacks of the factories on the opposite bank. Waterloo Bridge inspired about forty paintings, all of them showing morning effects, as can be seen in no.75.

In the preface to the catalogue that accompanied the exhibition *Vues de la Tamise à Londres* held in Paris in 1904 at Durand-Ruel's Gallery (see p.183, above), Octave Mirbeau stressed the play of the light on the bridge and conjured vivid images with his pen:

> This is Waterloo Bridge, with its dense vehicular and pedestrian traffic, illuminated by a ray of sunshine. It brings to mind a carnival procession, a floral garland in the middle of this dreary and indeterminate space, this foggy river where little tugs work relentlessly and small boats graze, like smoke, along the surface of the undulating water which moves the golden reflections and the blood-red, fractured, radiance of the invisible sun backward and forward.

In no.77 the morning fog that obscures the view of the opposite bank dissipates in front of the 'pretty red ball', as Monet referred to the sun in a letter dated 6 February 1901 (to Alice Monet; Wildenstein 1974–91, III, letter 1597). When the painting was exhibited at Durand-Ruel's in 1904 (as no.15), Gustave Kahn commented on its unusual tonality, which he associated with twilight:

> In Sun in the Fog the bridge slumbers in ever deepening tones of blue with long melting greenish reflections. A sulphurous crimson ray drags in the colour of the river Styx and smoulders beneath an arch where its glint turns to carbon . . . A boat glides or rises up like a violet shadow. In this setting the neighbouring canvases appear so brilliant, so limpid in their clear iridescence, vibrant with bright sparkles and golden flakes; in this image these merge with the blues as they sink away . . . (Kahn 1904, pp.87–8)

Gustave Geffroy lingers with pleasure over his evocation of Monet's discerning eye and acute sensitivity to light while working from his motif (the two bridges). His highly descriptive narrative succeeds in evoking what the author refers to as 'the ghostly magnificence of London', an aspect of the landscape which is just as inseparable from Turner's views:

> When Claude Monet was working on his views of the Thames in 1900, Clemenceau and I went to visit him . . . In front of us the waves of the Thames swelled, almost invisible in the fog. A boat passed by like a ghost. The bridges were barely discernible in space; on them an almost imperceptible movement animated the thick fog: trains crossed by each other on Charing Cross Bridge, omnibuses streamed across Waterloo Bridge, smoke was unfurled in vague arabesques which soon vanished into the thick and pallid infinity. It was an awe-inspiring, solemn, and gloomy spectacle, an abyss from which

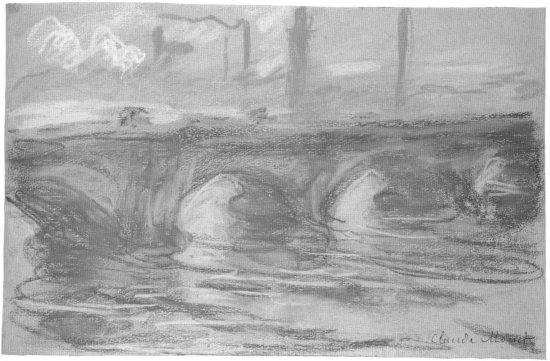

74

a rumble emerged. One could believe that everything was about to vanish, to disappear into colourless obscurity . . . Suddenly Claude Monet seized his palette and brushes. 'The sun has returned,' he said, but at that moment he was the only one who knew it. However hard we looked we still saw nothing but that grey, muffled space, a few hazy shapes, the bridges that appeared suspended in the void, the smoke quickly disappearing, and a few swelling waves of the Thames visible close to the river bank. We kept peering in order to try to penetrate the mystery, and, indeed, we ended up by distinguishing, we didn't know what distant and mysterious glimmer, which seemed to be trying to penetrate this motionless world. Little by little, things became brighter and began to glow and it was delightful to see, feebly illuminated by an invisible sun as if by an ancient star, this grandiose landscape which began to reveal its secrets . . . Charing Cross Bridge, geometric, rigid, metallic, was suddenly glimpsed inscribing its lines among clouds, patches of fog, and the steam from the trains. Waterloo Bridge which, being built of

stone is massive and solid, rises above the water as though airborne. Omnibuses pass, variegated and multi-coloured like flowers, sparkling like festival lights, in an endless parade: at times clear, gay, and explosive, and at other times rich and dark, for example a single lively red in a greenish atmosphere. Sometimes everything is set on fire by a sunbeam: the water, the bridge, the omnibus, the top of a high smokestack on the other side of the Thames. Then the thick fog returns, and the sunlight, suspended in the air, is no stronger than the still light of a lamp or night light. The fog is seen in all its guises: lemon yellow, thick and green like a pea soup, strewn with the colours of nasturtiums and hyacinths. One can glimpse barges slipping by, the smoke of the steamboats running along the surface of the water, smaller boats bobbing among the reflections, and others that are scarcely visible in the thick mist. Soot falls through the sources of light.
(Geffroy 1924, pp.308–11)

SP

75

76

194

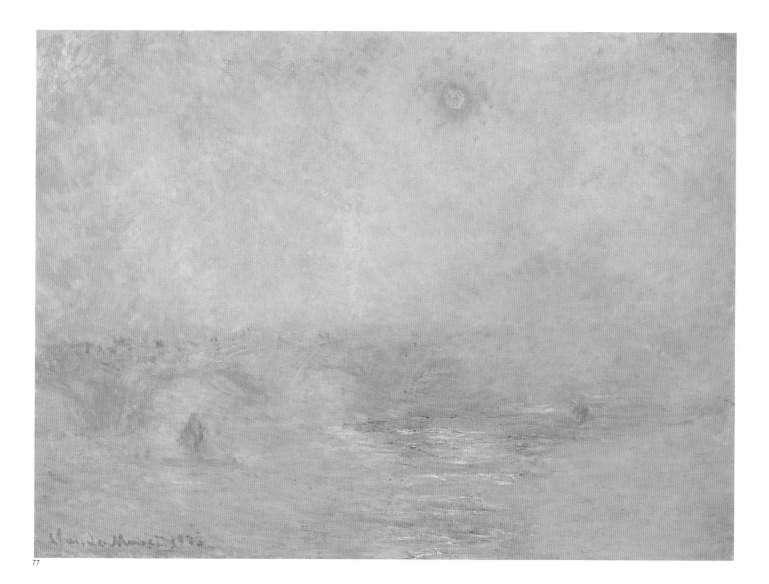

77

78 J.M.W. Turner

The Burning of the Houses of Lords and Commons, 16th October 1834 exh. 1835

Oil on canvas 92 × 123 cm
B&J 359
Philadelphia Museum of Art

On the evening of 16 October 1834, a spectacular fire consumed the Houses of Parliament as huge crowds lined the banks of the Thames to watch. Among those spectators was Turner, drawn to an epic confluence of fire, air, and water,that must have seemed readymade for his brush. Filling a couple of sketchbooks at the site with studies in pencil and watercolour, he later produced two oil paintings based on the scene of conflagration, the other version now being in the Cleveland Museum of Art (B&J 364).

For nearly four decades the Philadelphia canvas passed through a succession of private collections and dealers in London. It was on the art market more than once in the 1860s, and in 1873 it appeared on sale again through Thomas Agnew, at the very time that Whistler's dealer was marketing the artist's 'Thames Set' etchings. Whistler's keen attention to the economics of the enterprise drew him regularly to Agnew's premises, where he might have noted with particular interest

Turner's dramatic picture. He would have recognised in it the nighttime ambience and fluid facture (particularly in the treatment of the boats on the river) of the Nocturnes he had already begun to paint, and he may have provided something of an ironic answer to Turner's fiery composition in the infamous *Nocturne in Black and Gold: The Falling Rocket* (no.50).

If indeed Whistler was thinking of Turner when he painted his fireworks Nocturne, *The Falling Rocket* posits modest, man-made spectacle staged for a few wraith-like figures, in contrast to the English artist's sweeping vision of nature's intensity witnessed by the assembled throng. Yet these very distinctions between the aesthetic of arrangement and a painterly engagement of the elements may prove as instructive for our understanding of Whistler's ongoing interest in Turner's work as they were objectionable for Ruskin, champion of one artist and courtroom nemesis of the other. JS

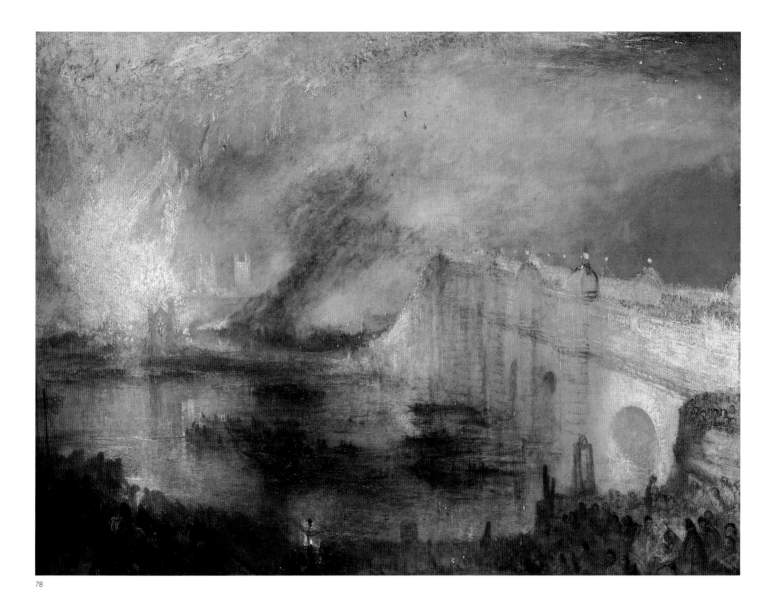

78

79–81 Claude Monet

79 Houses of Parliament, Sunset 1904
Le Parlement, coucher de soleil

Oil on canvas 81 × 92 cm
W 1607
Kunsthaus Zürich. Gift of Walter Haefner

80 Houses of Parliament: Effect of Sunlight in the Fog 1904
Le Parlement, trouée de soleil dans le brouillard

Oil on canvas 81 × 92 cm
W 1610
Musée d'Orsay, Paris

81 Houses of Parliament, Sunset 1904
Le Parlement, coucher de soleil

Oil on canvas 81 × 92 cm
W 1602
Kaiser Wilhelm Museum, Krefeld

82 Houses of Parliament, Sunlight Effect 1903
Le Parlement, effet de soleil

Oil on canvas 81 × 92 cm
W 1597
Brooklyn Museum of Art, New York

It was not until 1900 that the Houses of Parliament became a recurrent theme in Monet's work: this motif gave rise to about twenty variations in 1900 and 1901. Despite the fact that this landmark inspired the painter's most beautiful work during his sojourn of 1871 (no.36), and figures indistinctly in the background behind Charing Cross Bridge (nos.70–3), after 1900 it was primarily observed by Monet from the terrace of St Thomas's Hospital, on the opposite bank of the river close to Westminster Bridge. From this vantage point the artist could paint the Houses of Parliament in late afternoon and at sunset, except on Sundays when he did not have access to the terrace. During the week he 'only painted backlit and sunset effects' (according to Daniel Wildenstein). In his first letter to Alice, dated 10 February 1900, he describes the advantages of the newly discovered site which he planned to make good use of: 'I saw some superb things and can work there whenever I want, except Sunday' (Wildenstein 1974–91, III, letter 1503). From St Thomas's Hospital it would be possible to paint the effects of the setting sun on the Houses of Parliament '*en plein air* or at least from a covered terrace' (letter to Alice Monet, 12 February 1900; Wildenstein 1974–91, III, letter 1505).

Access to this location was given to Monet courtesy of Dr Payne, a friend of Mr and Mrs Hunter to whom Monet had been introduced by the American painter John Singer Sargent. On 14 February Monet was pleased to report to Alice that he 'had started work at the hospital. If only you could see how beautiful it was . . . it seems it was cold and I was oblivious to it in my enthusiasm for the work at hand and the novelty of it all, but how hard it's going to be!' (Wildenstein 1974–91, III, letter 1507).

Monet took some liberties with his depiction of the subject, most notably altering the appearance of the Houses of Parliament. The outline of the Neo-gothic monument was flattened and attenuated so that it would loom out of the fog like an apparition, recalling his *Impression, Sunrise* of 1872–3 (no.39; see Seitz 1960, pp.40, 148). Sky and water, painted in the same hues (since the latter reflects the former), take up most of the space in the composition. Paradoxically, the mist and fog, together with the Thames, are more tangible than the architecture which is evanescent and dissolves in the light. Here Monet revealed the closeness of his vision to that of Whistler, particularly the latter's *Nocturne: Grey and Gold – Westminster Bridge* 1871–2 (no.45).

In his preface to the 1904 catalogue accompanying the exhibition *Vues de la Tamise à Londres* in Paris, Octave Mirbeau praised the variations of this theme shown at Durand-Ruel's gallery:

Look at the Houses of Parliament, the tower is light here, massive there, and farther on scarcely indicated and lost among barely distinguishable shapes. Here gulls flock to the monument, dive through the air, skim the surface of the water, then soar in a whirlwind of balletic motion. There the light, like a green scarf, descends and drapes itself around the tower, extending as far as the river until the sun strikes it, and the water suddenly turns into a magical garden balancing flowers of gold and red on its surface. In the distance the city gradually disappears, is engulfed and obscured by all the subtlest shades of pink, yellow, green and blue, mixed together.

t is with this group of canvases that the concept of 'series' is most successfully realised, for the canvases are of identical size and made at the same time of day; their sole variation is chromatic. They recall Turner, whose sunsets on the Thames are among his most celebrated works, in particular his spectacular canvas *The Burning of the Houses of Lords and Commons, 16th October 1834* (no.78).

Louis Vauxcelles, at the end of his review of the 1904 exhibition, describes one of the thirty-seven canvases as being as 'flamboyant as a Turner' (Vauxcelles 1904). The painting he refers to is no.80 (Seiberling 1988, p.94). Focusing attention on the play of light, Gustave Kahn described the same work a few weeks later: 'The sun pierces through a gap in the fog, sweeping across and illuminating air and water, appearing to rotate. Where it bursts forth it lights each surface with the gleam of its luminous limbs, which resemble a multiplicity of filtered and endlessly modulated lamps' (Kahn 1904, p.86). Gustave Geffroy, on the other hand, focused on the colour effects created by the artist:

The third series of paintings focuses on the theme of the Houses of Parliament. The Palaces of Westminster are seen from the opposite bank, from the window of a hospice to which Monet had access. In the evening, the architecture of the building projects a darkened appearance, composed of a powerful blue, violet, or a greenish colour, and at times almost dissolves into the surrounding atmosphere, becoming confused with it: then all is lost, all is dead. In this obliterated landscape only a few gulls fly in a circle: it is miraculous to watch them tracing their silver arcs through the air. In another place a boat moves under a darkening sail. The clouds are outlined in red and gold. An ascendant violet sky follows in the direction of the vanished star.
(Geffroy 1924, pp.310–11)

Following Louis Vauxcelles's example, Camille Mauclair also mentioned Turner and Whistler when commenting on these works. SP

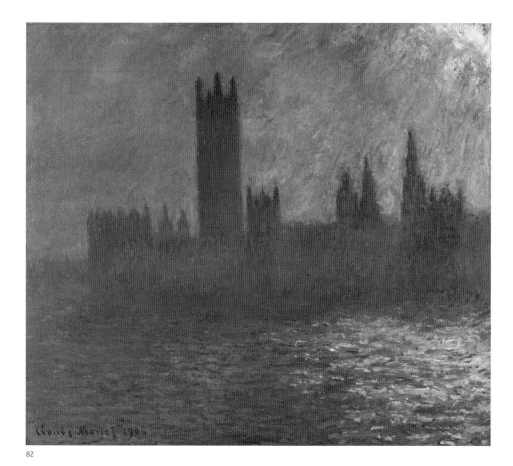

82

79

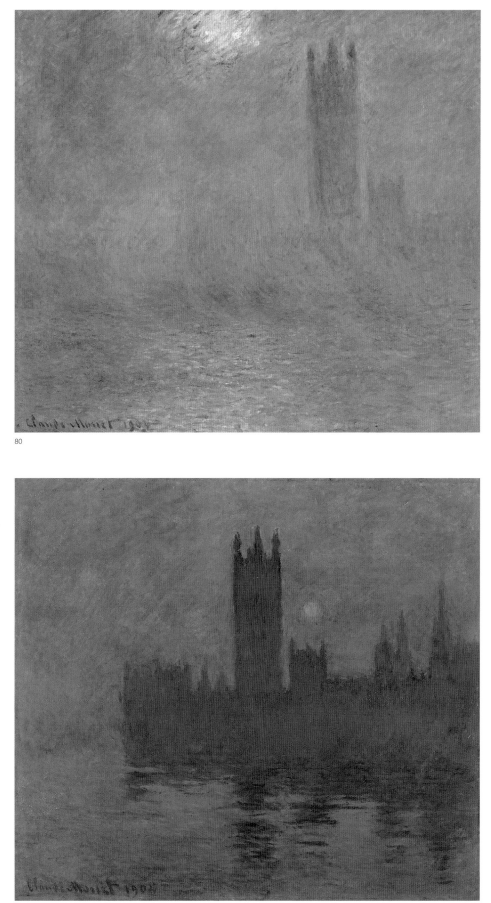

80

81

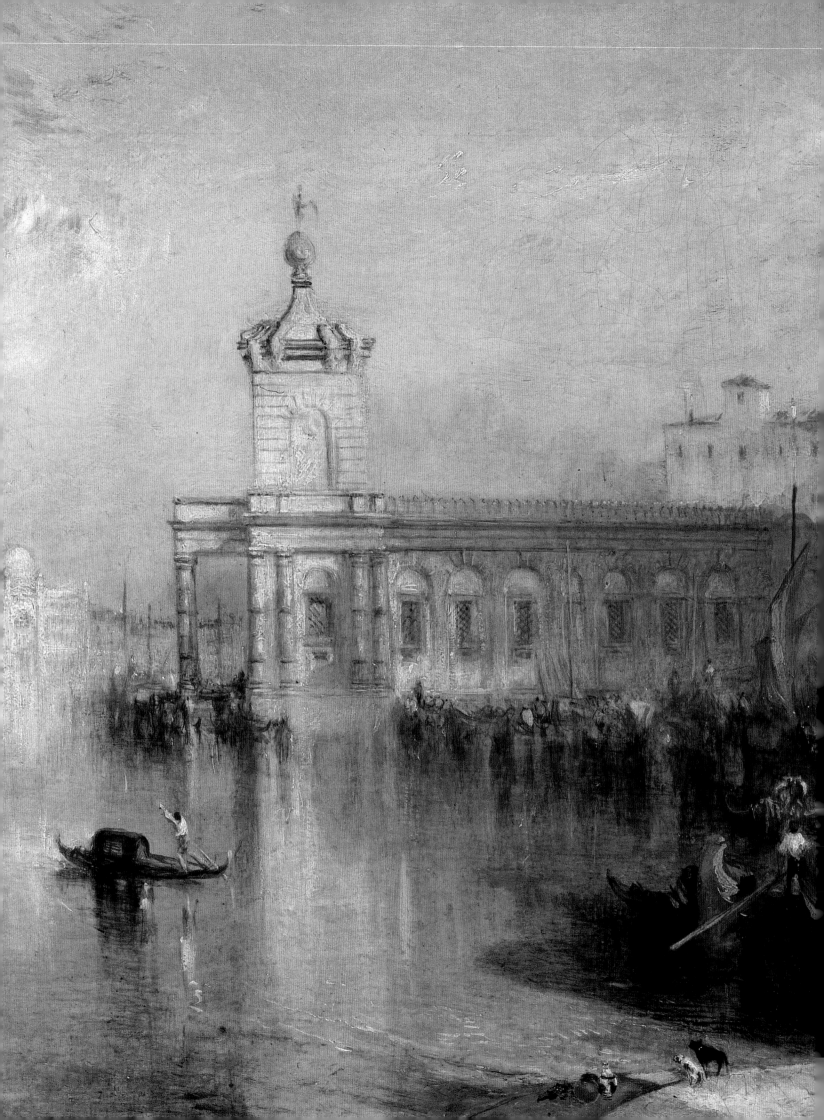

The last act: Turner, Whistler and Monet in Venice

Sylvie Patin

While in England in 1901 Monet had boldly declared: 'What marvellous things . . . there is no land more extraordinary for a painter.'[1] At that time he considered that no setting could possibly rival that of London and the Thames: however, this strongly held belief was to be swayed a few years later, when in 1908 he discovered the enchantments of Venice.

In his letters, Monet had never expressed any desire to go to Venice. Indeed, according to Octave Mirbeau ('I recall a comment of Claude Monet's') during one conversation the artist had even said to him, 'Venice . . . No . . . I will not go to Venice.'[2] Monet was sixty-eight before he undertook his first trip to Venice, a destination that usually holds a particular fascination for painters, who are sensitive both to the magic of 'La Serenissima' and to her artistic past. Was Monet reluctant to challenge the Old Masters? Geffroy, considering him in the context of his predecessors, contrasted his personal vision with theirs:

> he went to London, where his art had long since been accepted, and we remember the incredible portrayals of atmosphere incorporating fog, smoke and distant reflections . . . Then he went to Venice and his art looked in a new way at what had already been revealed to us in all its splendour, with such an appealing and picturesque precision, by Venetian painters from Carpaccio to Canaletto and Guardi.[3]

However, was it not more likely that it was a desire to emulate the example of the two painters he so much admired that brought him to Venice, rather than any need to measure his own achievement against the great masters of the Italian school? Monet was, in fact, still following in the footsteps of Turner and Whistler.

Turner had gone to Venice three times, first in 1819, then for longer stays in 1833 and 1840, when he took up residence in the Hotel Europa on the Grand Canal. Monet had seen Turner's Venetian works in 1871 when with Pissarro in London.[4] Pissarro referred to them in a letter to his son about ten years later: 'You have been to the National Gallery, you have seen the Turners, yet you don't mention them. Can it be . . . that at the Kensington Museum the View of Saint Mark in Venice, etc., did not impress you?'[5] Even more than his oil paintings, Turner's watercolours exerted an influence on Monet: made for the most part from nature in 1840, they are much more spontaneous than his oils. In 1956, Henri Matisse commented: 'it seemed to me that Turner

must have been the link between the academic tradition and impressionism. I have, in fact, observed a close relationship in the construction of works using colour between Turner's water-colours and the paintings of Claude Monet.'[6]

In Venice as in London, Monet also walked in Whistler's foot-steps, selecting as motifs the facades of decaying palaces that had inspired Whistler. Broken by the libel suit he had brought against Ruskin in 1878, and with serious financial concerns resulting from his bankruptcy, Whistler had sought refuge in Venice from September 1879 until November 1880. His purpose was to fulfill a commission for the Fine Art Society: the London gallery was waiting for twelve etchings, which were to be published by Christmas 1879. However, Whistler did not have them ready in time and stayed on in Venice, producing a hundred or so pastels, more than fifty etchings and a few paintings. His fourteen-month stay allowed him to start afresh after his ordeal with Ruskin. For Whistler this was not a sentimental pilgrimage as taken by other tourists inspired by Ruskin's *The Stones of Venice* (published from 1851 to 1858, with a new edition published in 1879). In his book on Whistler Duret devoted special attention to the artist's views of Venice.[7] Whistler depicted the facades of the palaces on the Grand Canal (for example in *The Balcony*, no.87), but he also ventured into places less frequented by tourists. Enthralled by this secret Venice he maintained: 'I have learned to know a Venice in Venice that the others never seem to have perceived.'[8]

The first exhibition of Whistler's Venetian views at the Fine Art Society in London in December 1880 included his twelve etchings of the 'First Venice Set', which had just been published; in January 1881 about fifty of his pastels of Venice were also exhibited there. In 1886 the twenty-six etchings of his 'Second Venice Set' were published in London by Dowdeswell, who organised an exhibition devoted to the artist in May that year. Turner's works had raised the issue of 'lack of finish'; Whistler's Venetian views were also criticised for their lack of finish and their elusive, subtle nature, just as his Nocturnes had been dismissed earlier by Burne-Jones as 'sketches'. Nevertheless, there were artists who admired Whistler's innovative work, and objected to the lack of understanding shown by art critics when his second series of Venice etchings was exhibited at the Fine Art Society in 1883. Pissarro, who was very knowledgeable about printmaking, elaborated:

No.99 J.M.W. Turner **The Dogano, San Giorgio, Citella from the Steps of the Europa** (detail)

Fig.70 Claude and Alice Monet in St Mark's Square, Venice, October 1908. Musée Marmottan, Paris

How I regret not to have seen the Whistler show; I would have liked to have been there as much for the fine drypoints as for the setting, which for Whistler has so much importance; he is even a bit too pretentious for me . . . Whistler makes drypoints mostly, and sometimes regular etchings, but the suppleness you find in them, the pithiness and delicacy which charm you derive from the inking which is done by Whistler himself; no professional printer could substitute for him, for inking is an art in itself and completes the etched line. Now we would like to achieve suppleness before the printing.[9]

If Monet revealed his susceptibility to Whistler's etchings, it is conceivable that their repetitive aspect influenced his method of working in 'series', although he said that 'he never drew except with a brush and colour'.[10] The only surviving Venetian drawing by Monet is a study of the Palazzo Dario (Musée Marmottan, Paris).

Shortly after his arrival, Monet conveyed his first impressions of the city to Paul Durand-Ruel: 'I am overcome with admiration for Venice, but unfortunately I can't stay here long so there's no hope of doing any serious work. I am doing a few paintings in any case, to have a souvenir of the place, but I intend to spend a whole season here next year.'[11] In the end it was from October to early December 1908 that Monet continued his struggle with the architecture, water and light, an exercise undertaken earlier on the banks of the Thames in London. He and Alice had been invited to Venice by Charles Hunter, an English friend he had met several times in London. Mrs Hunter had at her disposal the Palazzo Barbaro which belonged to an American, Mrs Daniel Sargent Curtis, a relative of the painter John Singer Sargent. During his Venetian sojourn in 1879–80 Whistler was a regular visitor at the Palazzo, which is situated close to the Accademia bridge on the left (north) bank of the Grand Canal. Monet and his wife spent the first two weeks of their trip to Venice there; then they took up residence a short distance down the canal, at the Grand Hotel Britannia (now the Hotel Europa e Regina), which had views over the Grand Canal to the Salute, and looking up towards the Accademia bridge and down to the canal's opening at the Dogana. This was not quite the same open view that Turner had enjoyed at his nearby hotel, in the Palazzo Giustinian, in *The Dogano, San Giorgio, Citella, from the Steps of the Europa* (no.99).

Monet wrote to Georges Clemenceau: 'I have been here in raptures for a month, it is wonderful and I'm trying to paint Venice';[12] and to George Bernheim-Jeune: 'while I'm excited by Venice and I've a few paintings of it underway, I'm very much afraid I won't be able to bring back anything more than some beginnings that will serve purely as personal souvenirs.'[13] In here describing the paintings as 'souvenirs' he thus repeats the term used in his first letter to Durand-Ruel. On 4 November, again to Durand-Ruel, he went into greater detail: 'I just don't know what I will be able to bring away with me, perhaps some studies or oil sketches.'[14] The motifs inspired thirty-seven canvases, which can be divided into several groups, the majority depicting the most famous palaces and churches of the city of the Doges.[15] Monet was the perfect tourist, submitting willingly to a variety of 'rituals' such as the gondola ride (he used the gondola as a studio, following the example of Turner and Whistler) and being photographed among the pigeons in the Piazza San Marco (fig.70). He was, however, at times more adventurous, seeking out less usual places to visit. Thus he crossed the Grand Canal to the south bank, going as far as the Zattere, a 'Ruskinian corner',[16] and towards the Rio della Salute. Far away from the crowd, on the Fondamenta Bragadin along the Rio di San Vio, he sketched his work *The Red House* (private collection; W 1771).

In Venice Monet found once again the special atmosphere of a landscape shrouded in mist (Mirbeau recalled that 'a rose veil hangs over Venice'[17]). Following the Seine of the *Mornings*, and the Thames of the London views, it was now the Lagoon, with the pollution found in Venice (see pp.59–60, above). Monet allowed himself to be seduced by this 'floating city', which he observed at water level as he had Argenteuil. From a gondola the frame of reference is horizontal: Monet's paintings are constructed with the horizon line placed high, above a vast expanse of water. In this way Monet's Venice recalls the 'floating world' of Japanese prints as well as Turner's approach to the city in watercolour.

As in the London series, the 'urban' motifs (stone facades, bridges) are components of a water landscape swimming in mist, but also bathed in sun which plays with the reflections. At three points in his career (excluding a few Parisian episodes, such as his images of La Gare Saint-Lazare; W 438–49), Monet, the painter of nature, became so interested in a specific work of architecture

that it became a recurring theme: the cathedral at Rouen in 1892–3, the Houses of Parliament in London in the early 1900s, and finally, in 1908, the Ducal Palace in Venice.

For the Venetian palazzi Monet approached the motif frontally, as Whistler had done. As with the cathedral at Rouen and the Houses of Parliament in London, he sacrificed the study of the stones of the buildings to the study of light: the facades float like 'apparitions'[18] above the water. Monet could have been accused of having ignored the important history of the city of the Doges in order to privilege a pictorial process which had, for him, become schematic: he only retained in these 'radiant and captivating canvases', with their 'sumptuous and exquisite tonalities',[19] the magical quality of Venice that had previously seduced Turner.

As Monet told Clemenceau, having to tear himself away from Venice filled him with regret: 'I am falling increasingly under the spell of Venice, but, alas, I must take my leave!'[20] He expressed his gratitude to Mrs Sargent Curtis: 'without doubt it is thanks to you that I came here. It has been a feast for an artist, a great joy for me.'[21] At the end of his visit, Monet indicated to Geffroy his feelings for the city:

> my enthusiasm for Venice. Well, it increases by the day and I'm very sad that I'll soon have to leave this unique light. It's so very beautiful! . . . I comfort myself with the thought that I'll come back next year, since I've only made some studies, some beginnings. But what a shame I didn't come here when I was a younger man, when I was full of daring![22]

In calling his Venice views 'studies' or 'beginnings' (as he had also earlier referred to his Thames views), Monet was using the very words Turner had used to describe his own work. Just as Monet had once dreamed of returning to London, his last letters from Venice are coloured by his hope of revisiting that city. But he never did go again (although several authors incorrectly refer to a second trip to Venice in the autumn of 1909). On 19 May 1911 Alice died. Overwhelmed by the loss of his 'adored companion', the artist gave up foreign travel. His only Venetian sojourn suddenly took on great emotional significance: it was not only his last foreign painting campaign, one of the few on which his wife had accompanied him; it was to become for him symbolic of his last shared moments of happiness with Alice. From Giverny, on 10 October 1911, he told Durand-Ruel: 'I am just starting to

CLAUDE MONET

"Venise"

Neuf reproductions de Tableaux

(un fac-simile et huit phototypies)

Avec une Préface

par

OCTAVE MIRBEAU

BERNHEIM - JEUNE & C^{ie}

Experts près la Cour d'Appel

===== 15, Rue Richepanse =====

25, Boulevard de la Madeleine

===== 36, Avenue de l'Opéra =====

===== PARIS =====

Fig.71 Front cover of the catalogue for the exhibition held in 1912 at the Bernheim-Jeune gallery, Paris

recover . . . For the moment I will try to finish some of my Venice canvases.'[23] While working 'very little and not without difficulty' on these paintings ('on my Venice', in his words), the artist grieved as he recalled the happy times he spent with his wife.[24] Forever infused with a melancholic nostalgia, these paintings were for him 'souvenirs of such happy days spent with my dear Alice'.[25]

As with his views of the Thames, the canvases Monet brought back from Venice were subjected to extensive reworking at Giverny where they were finished from memory in the studio. One of them appears in the background of a photograph of the artist in his studio-workshop at Giverny.[26] On going back to these canvases, some of which he completed, Monet took as his point of departure the work executed earlier on location. Dissatisfied as usual, and having been tempted to avoid what he always found an ordeal – the task of completing and exhibiting the canvases resulting from a campaign – Monet finally agreed to send them to the brothers Bernheim-Jeune.[27]

The exhibition, entitled *Claude Monet: 'Venise'*, took place from 28 May to 15 June 1912 at the Bernheim-Jeune gallery in Paris. Twenty-nine pictures were exhibited, divided in the catalogue into groups: 'The Grand Canal' (nos.1–6), 'The Ducal Palace' (nos.7–8), 'San Giorgio Maggiore' (nos.9–13), 'The Ducal Palace Viewed from San Giorgio Maggiore' (nos.14–18), 'Palazzo Dario' (nos.19–21; see no.88), 'Rio della Salute' (nos.22–4), 'Palazzo da Mula' (nos.25–6), 'Palazzo Contarini' (nos.27–8; see nos.89–90), and finally a 'Twilight' (no.29; see no.106). A catalogue was published at the time of the exhibition, with an introduction by Octave Mirbeau (fig.71). The author, who had also written the preface to the catalogue accompanying the Thames views at Durand-Ruel's gallery in 1904, emphasised the role of light in Monet's work:

Light defines and reveals objects. On the canals it is stronger and more overwhelming. The reflections fuse. One could say that water and light support and re-enforce each other [reflected] on the facades. But on the Adriatic it is more fluid and floating. A boat, a few palaces, and the church may be born and become visible depending on the light. The palaces cast a warm reflection on the dense water. At midday the atmosphere rests and expands sumptuously on the vertical surfaces of the walls; on the horizontal surface of the water

it mixes with the colour as though filtered through a stained-glass rose window. It has the moist freshness and verisimilitude of a rainbow . . . Claude Monet is the master of elusive lighting effects.[28]

Guillaume Apollinaire hailed Monet's 'new Venice',[29] while Paul Signac addressed a very touching letter to his fellow-artist:

My dear master . . . When I looked at your Venice paintings with their admirable interpretation of the motifs I know so well, I experienced a deep emotion, as strong as the one I felt in 1879 when confronted with your train stations, your streets hung with flags, your trees in bloom, a moment that was decisive for my future career. And these Venetian pictures are stronger still, where everything supports the expression of your vision, where no detail undermines the emotional impact, where you have attained the selflessness advocated by Delacroix. I admire them as the highest manifestation of your art.[30]

The paintings of Monet could be compared to the timeless Venice evoked by Marcel Proust in the pages of his *A la recherche du temps perdu* [*Remembrance of Times Past*]. Nicolas Ivanoff has liked 'to point out a coincidence: when Proust was writing the Venetian sequence in *Remembrance* Claude Monet's Venice exhibition was on display in the Bernheim gallery'.[31] Having read Ruskin's *Stones of Venice* and been tempted for some time to find out about its

setting, Proust took a trip to Venice with his mother in 1900. His description of the city is completely 'impressionistic':

the Ducal Palace surveyed the sea with the thought with which its architect had invested it and to which it clung in mute contemplation of the restoration of its vanished masters . . . while the gondola . . . travelled up the Grand Canal, we watched the passing procession of palaces reflect and change with the light and the time of day on their roseate flanks.[32]

In addition, Proust associated the name of Whistler with Venice.

Monet's views of Venice would be the last 'landscapes' he produced before his 'water landscapes' at Giverny. Before his death in 1926 the painter would create the *Water Lilies* that inspired Florence, in Claudels's *Conversations dans le Loir-et-Cher*, to compare him with the great English predecessor of Impressionism: 'It's the work of his old age, comparable in a way to that of Turner, when their deteriorating eyesight, dilated and losing its apprehension of form, saw nothing but light.'[33] However, for Monet the Venetian palazzi were the final 'Turnerian' and 'Whistlerian' themes on which he chose to focus. The dialogue instituted by these three artists finally came to an end in 1908, in front of the stone facades or looking out at the Lagoon, confirming the assertion of Octave Mirbeau: 'A final act . . . needs no other backdrop than Venice.'[34]

83 J.M.W. Turner

Venice: The Rio di San Luca, with the Palazzo Grimani and the Church of San Luca 1840

Bodycolour and watercolour on blue paper 19.4 × 28.2 cm
TB CCCXVII 31
Tate, London. Accepted as part of the Turner Bequest 1856;
displayed from 1881

'Twenty-five sketches, chiefly in Venice. Late time, extravagant, and showing some of the painter's worst and final faults; but also, some of his peculiar gifts in a supreme degree' (*Works*, XIII, p.384). With these words Ruskin introduced one of the groups of watercolours in his rearrangement of the Turner Bequest published in 1881.

In his manuscript catalogue prior to publication Ruskin noted that this watercolour, along with three others, comprised a 'glorious grey group': he was referring to the tone of the paper used for these sketches, although this sheet happens to be blue. Around twenty of the Venetian watercolours from 1840 utilise this type of coloured paper and Turner seems to have adopted it largely for a particular style of composition. Many of these sheets bear close-up views of the architecture and some show quite careful renditions of the buildings' facades. Unusual viewpoints offer glimpses down narrow canals and through the arches of bridges, giving an impression of the density of the city's architecture.

In Ruskin's 1881 catalogue this sketch was given the summary title 'The same, nearer', due to its being listed immediately after another watercolour bearing the same view, *On the Cross-canal between the Bridge of Sighs and Rialto* (National Gallery, London; TB CCCXVII 30; see Warrell 2003, fig.165). A close look at these two sheets provides an insight into Turner's methods of working whilst in Venice in 1840. A rapid pencil sketch on the back of the related view sets down the outline of this watercolour, which he may have worked up on this sheet from the study. It appears that Turner then reused the sheet bearing the pencil sketch, turning it over to complete another watercolour of the subject from a slightly different viewpoint (see Warrell 2003, pp.156–8). ST

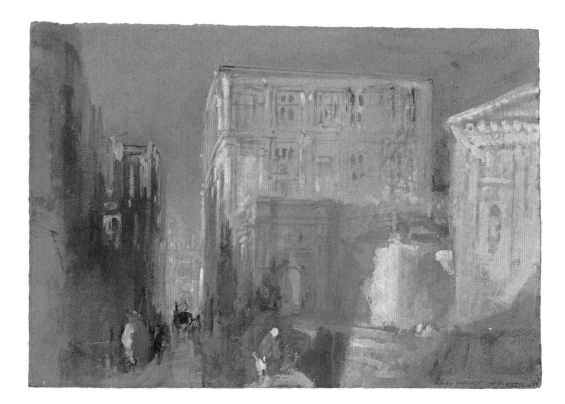

84-86 James McNeill Whistler

84 Nocturne: Palaces 1879–80

Etching and drypoint in warm black ink
29.8 × 20.0 cm
K 202, II/IX
Metropolitan Museum of Art, New York.
Gift of Miss G. Louise Robinson

85 Nocturne: Palaces 1879–80

Etching and drypoint in ginger-brown ink
wiped vertically with a bright centre 29.4 ×
19.8 cm
K 202, IX/IX
Metropolitan Museum of Art, New York. Gift
of Harold K. Hochschild, 1940

86 Nocturne: Palaces 1879–80

Etching and drypoint in ginger-brown ink
29.2 × 19.8 cm
K 202, VIII/IX
Metropolitan Museum of Art, New York.
Harris Brisbane Dick Fund, 1917

Whistler's desire to go to Venice was undoubtedly
kindled when he first saw Turner's Venetian views,
such as *The Dogano* (no.99), in his adolescence. He
carried his interest in nocturnal subjects with him, and
especially loved the evening, when the 'amazing city
of palaces becomes really a fairy land' (letter to Anna
Whistler from Venice, 1879–80, Freer Gallery of Art,
Washington, DC, folder no.176).

Turner had inaugurated a number of 'themes' on
which Whistler worked 'variations'. Turner's depictions
of palaces, such as no.83, anticipate this view of a
palace located at the conjunction of two canals. Seeing
'a Venice in Venice that the others never seem to have
perceived' (letter to Marcus Huish, January 1880, GUL
BP 11/c8), Whistler explored hitherto obscure nooks
and crannies on smaller canals. Despite the fact that
this is one of his two most important Venetian etchings,
the site defies identification (Grieve 2000, p.101).

Turner had made serial views of the same motif
viewed under different atmospheric conditions
(nos.54–9); Whistler followed suit in printing this
plate. By varying the tone of the ink and the pattern
of wiping, he 'changed' the temperature, time of day,
and atmospheric effect. A hybrid of the etching and
monotype techniques, every impression is unique.
This extraordinary group of impressions from the
Metropolitan Museum of Art shows the range of
effects that Whistler created.

Whistler's concept was adapted to canvas by Monet
when he began to make his series paintings in 189?.
This idea, inaugurated by Turner and taken up in turn
by Whistler and Monet, demonstrates the creative
dialogue between works on paper and canvas. KL

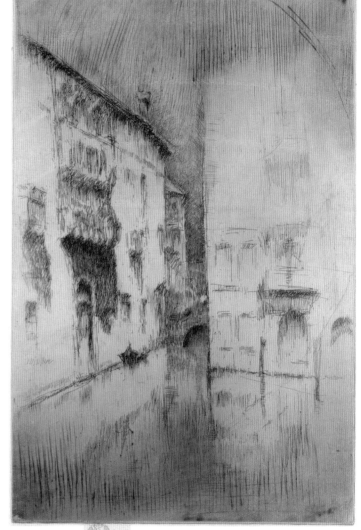

84

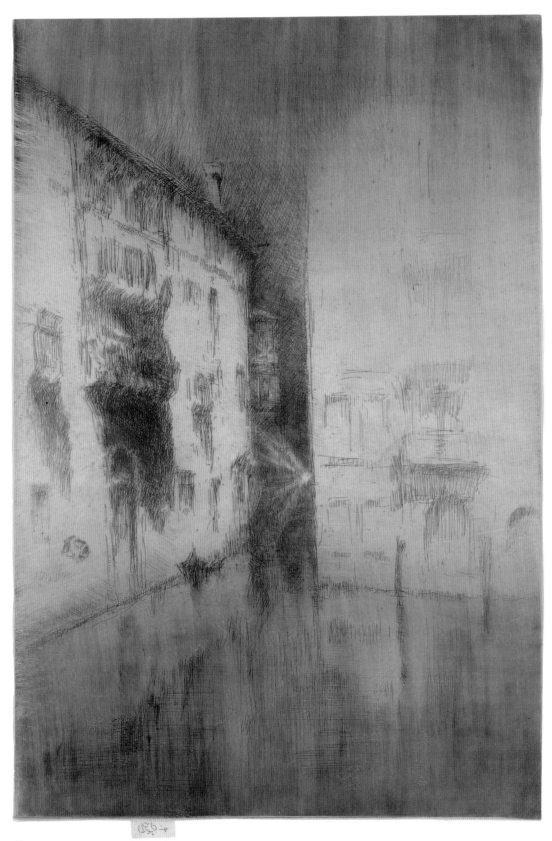

85

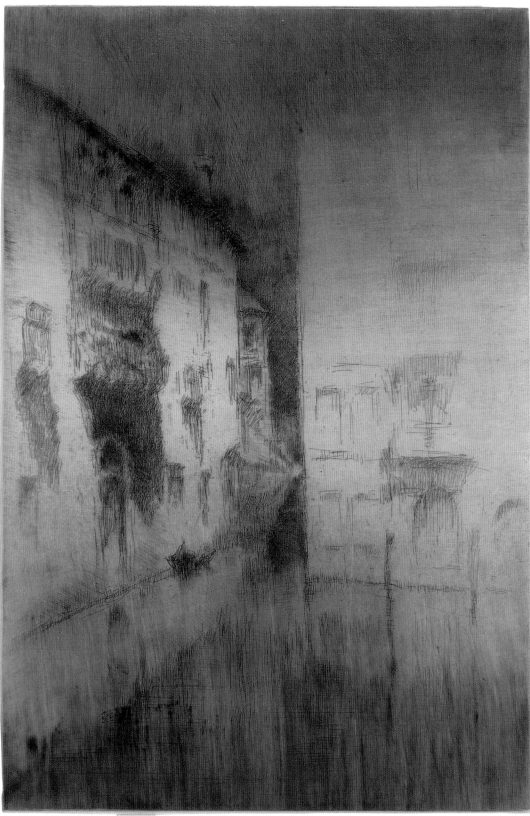

86

87 James McNeill Whistler

The Balcony 1879–80

Etching in black ink on old Dutch paper, trimmed with tab 29.4 × 20.0 cm
K 207, VIII/XI
S.P. Avery Collection, Miriam and Ira D. Wallach Division of Art, Prints and Photographs,
The New York Public Library, Astor, Lenox and Tilden Foundations

Whistler was to become as closely identified with Venice as Turner before him, inaugurating new 'themes'. Most notable perhaps are the vignetted frontal views of palace facades combined with his customary high horizon line and flattened picture space.

Whistler employed subtle 'artistic printing' methods to change the light and fall of shadow, creating variations on the same motif. These variations anticipate Monet's variations on the same theme in paintings of the Palazzo Contarini, Palazzo da Mula and Palazzo Dario (nos.88–90). KL

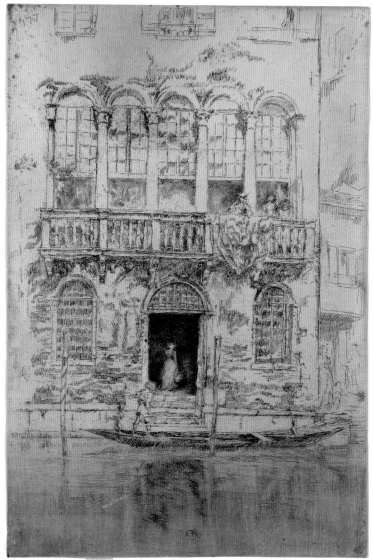

88–90 Claude Monet

88 The Palazzo Dario 1908
Le Palais Dario

Oil on canvas 64.8 × 78.8 cm
W 1757
The Art Institute of Chicago. Mr and Mrs Lewis
Larned Coburn Memorial Collection

89 The Palazzo Contarini 1908
Le Palais Contarini

Oil on canvas 73 × 92 cm
W 1766
Nahmad Collection, Switzerland

90 The Palazzo Contarini 1908
Le Palais Contarini

Oil on canvas 92 × 81 cm
W 1767
Kunstmuseum, St Gallen
EXHIBITED IN TORONTO AND PARIS ONLY

In Venice in 1908 Monet made a few paintings of the Palazzo Ducale and several other palazzi along the Grand Canal. In particular he depicted the Palazzo Dario, the Palazzo da Mula and the Palazzo Contarini, 'the reflections of whose firey or mossy facades, with their doors, windows, balustrades, and curved, pointed arches, elongate or broaden with the undulations of the flowing water' (Geffroy 1924, p.318). The angle which Monet adopted to paint their stone facades, considered lifeless by Geffroy, replicates that used by Whistler in etchings such as *The Balcony* 1879–80 (no.87).

The Palazzo Dario, 'a Renaissance palazzo famous for its multicoloured marble fascia' (as described by Daniel Wildenstein in his catalogue raisonné of Monet's work), is located on the south bank of the Grand Canal, to the west of the Salute. It appears in four canvases made from the north bank, including no.88, which demonstrates his debt to Whistler (no.19 in the 1912 exhibition of Monet's Venice paintings at the Bernheim-Jeune gallery). This palazzo can also be recognised in the only surviving drawing from Monet's Venice sojourn (preserved in a sketchbook in the Musée Marmottan in Paris).

Continuing to station himself on the north bank, Monet selected as the subject of two works the Gothic facade of the Palazzo da Mula, situated about half-way between the Palazzo Dario and the Palazzo Contarini-Angaran. He finished by painting two views of the Palazzo Contarini (nos.89, 90; nos.27 and 28 in the 1912 exhibition). It is, in fact, the Palazzo Contarini-Angaran (also known as the Palazzo Manzoni-Angaran or Polignac, according to Wildenstein), a Renaissance

palazzo situated on the south bank of the Grand Canal facing the Palazzo Barbaro, from which these views were executed.

In order to reconstruct Monet's method of working in 'series' from his Venice views, Gustave Geffroy studied the modifications made to a single motif depicted under a variety of lighting conditions at different times of day:

> It is no longer the minutely detailed approach to Venice that the old masters saw in its new and robust beauty, nor the decadent picturesque Venice of the 18th century painters, it is a Venice glimpsed simultaneously from the freshest and most knowledgeable perspective, one which adorns the ancient stones with the eternal and changing finery of the hours of the day.

Standing before the works of Monet, Geffroy found himself:

> in front of this Venice in which the ten century old setting takes on a melancholic and mysterious aspect under the luminous veils which envelop it. The lapping water ebbs and flows, passing back and forth around the palazzi, as if to dissolve these vestiges of history . . . The magnificence of nature only reigns supreme in those parts of the landscape from which the bustling city of pleasure can be seen from far enough away that one can believe in the fantasy of the lifeless city lying in the sun. (Geffroy 1924, pp.318, 320)

SP

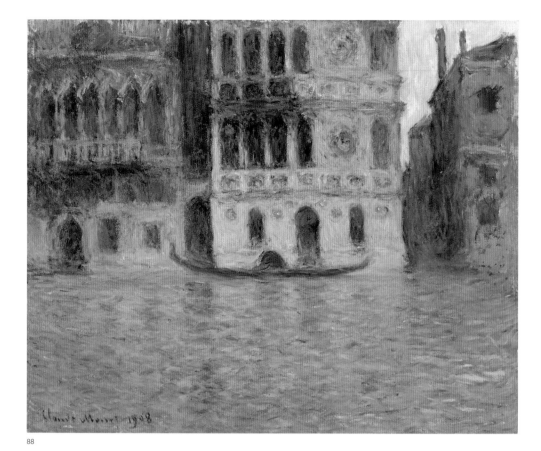

88

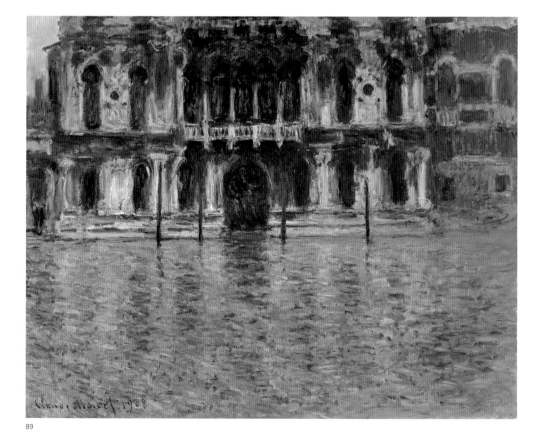

89

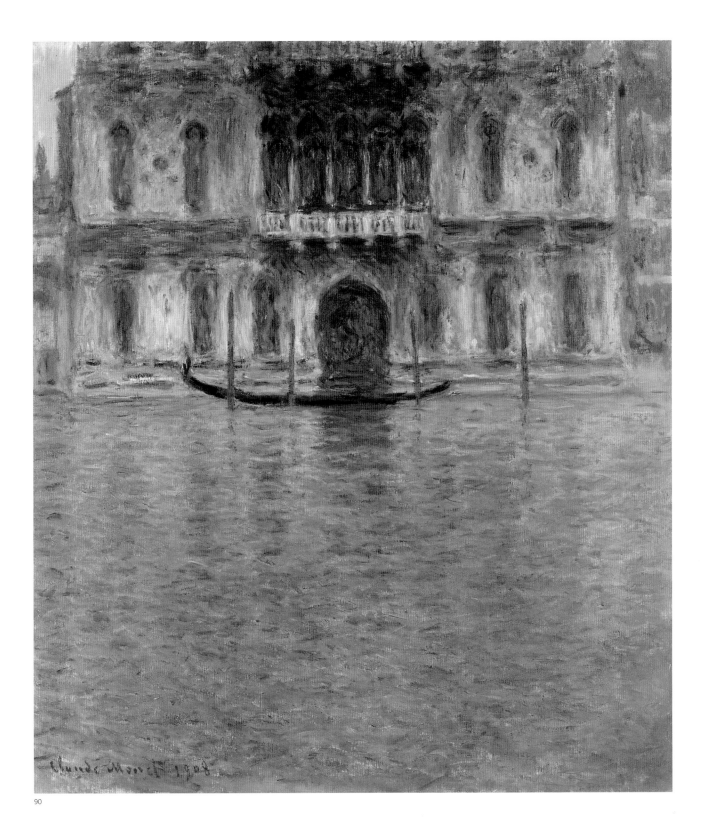

90

91 J.M.W. Turner

Venice: Looking across the Lagoon at Sunset
1840

Watercolour on paper 24.4 × 30.4 cm
TB CCCXVI 25
Tate, London. Accepted as part of the Turner Bequest 1856;
displayed from 1857

Of all Turner's watercolours showing Venice, this is perhaps the most boldly coloured. It was part of the section of Venetian sketches in Ruskin's 'First Hundred'. In his notes to the 1856 catalogue he explained his understanding of the view: 'Just after sunset. The position of the city is indicated by the touches of white in the vermillion cloud . . . I imagine from the position of the sun, that the subject is a reminiscence of a return from Torcello towards Venice' (*Works*, XIII, p.215). It is accepted that Ruskin's notion of this as a sunset view is correct, due to a partly legible inscription on the back of the sheet that makes reference to the setting sun (see Warrell 2003, p.236).

After the drawing had been made available among the works in the students' room at the National Gallery, Ruskin cast it into one of the groups of his 1881 revised catalogue of the Turner Bequest. Under the heading

'Twenty Sketches in Venice' he categorised the group as 'Characteristic of Turner's entirely final manner when the languor of age made him careless, or sometimes reluctant in outline, while yet his hand had lost none of its subtlety, nor his eye its sense of colour' (*Works*, XIII, pp.372–3).

Turner's use of colour makes this work stand out from his other sketches of the Lagoon. By laying the colours down in such distinct bands the work takes on a very different appearance from the more intricately painted watercolours where the washes are carefully blended. The detail here is minimal and this adds to the prominence of three main colours and their clear delineation. The gondola and the *bricole* (the posts marking the channel) receding into the distance serve as a device to draw attention back towards the horizon, placing even more focus on the sunset. ST

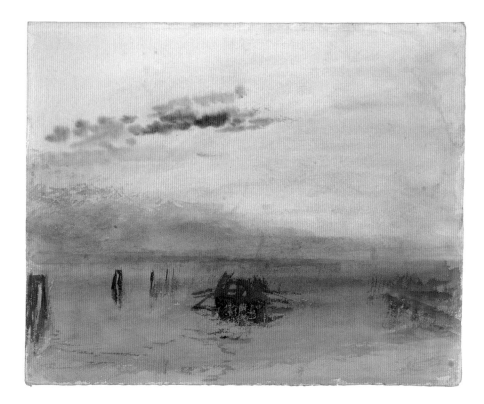

92 James McNeill Whistler
Red and Gold: Salute Sunset 1880

Chalk and pastel on brown paper laid down on card
20.2 × 30.8 cm
M 810
Hunterian Art Gallery, University of Glasgow

Whistler was not commissioned to make pastels in Venice. Nevertheless, perhaps inspired by the extraordinary pastels of his friend Degas, and the characteristics of the medium, he took pastels with him and used them to explore the colour of the city.

Venice was famous for its spectacular sunsets. Although Whistler had studiously avoided this subject, so closely associated with Turner, in his Thames views, he succumbed to their beauty in Venice. This pastel, and the two that follow, show the sun setting behind the Dogana and Santa Maria della Salute at different stages and probably at different times of the year. This view was probably made in summer from the Ponte della Ca di Dio on the Riva Schiavone between the Casa Jancowitz and San Marco. The stillness, reflection and atmospheric effect found in this pastel, the subtlety of tone, lack of 'finish', and poetic quality recall Turner's watercolours of Venice such as no.91.

Whistler had several pastels under way at any given time, and would go from place to place during the day to work on them (MacDonald 1984, p.48). This suggests a desire to capture specific fleeting effects, and anticipates Monet's method of working on his series paintings. Monet could have seen this pastel and no.94, which remained in Whistler's possession until his death.

Although it was embraced by the Impressionists, the role of pastel has yet to be fully appreciated in their work. Whistler used the soft medium on rough brown paper which fractured the line and broke up the form, suggestive of atmospheric effect. Monet also experimented with pastels (no.74), the chalky quality and distinctive palette of which are echoed in his London and Venice paintings. Just as Turner's watercolours would have been in Whistler's mind in Venice, Whistler's pastels must been in Monet's mind when he visited the city in 1908. KL

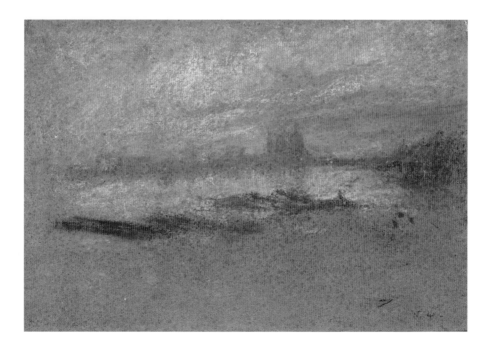

San Benedetto, Looking towards Fusina exh.1843

Oil on canvas 62.2 × 92.7 cm
B&J 406
Tate, London. Accepted as part of the Turner Bequest 1856;
displayed from December 1856

Although Turner first visited Venice in 1819, it was not until 1833, a few months before he decided to return there, that he began to select scenes of the city as part of the repertoire of imagery he exhibited at the Royal Academy. From then until 1846 there were only two years in which his annual group of exhibits did not include a view of Venice, resulting in a series of twenty-five canvases. Taken together, these can be seen as an indication of his enduring fascination with the city where impressions are barely perceived before being surrendered to time. Surpassing anywhere else for its sublime setting, Venice effortlessly condensed Turner's lifelong captivation with light and water.

Though the Venetian paintings Turner produced between 1833 and 1837 invariably drew on Canaletto's daunting legacy, from 1840 onwards, and especially after his final visit that year, he arrived at more individual responses, depicting an unfamiliar city, bathed in shimmering hazes that soften distinctive outlines, and illuminated by the more diffused light of dawn and twilight. And while he never ventured far from the centre of Venice, he generally opted for more obscure viewpoints than those made universally famous by his predecessor, such as the new cemetery island, or the wide stretch of the Giudecca canal in this painting.

The title of this work has long proved a puzzle because none of the churches on either side of the canal are named after the saint Turner invokes. However, the building on the left-hand side is the convent of Santi Biagio e Cataldo, which was one of several Benedictine institutions flanking the Giudecca canal. It seems probable that Turner had a recollection of this fact, and transformed the religious order into the name of the church itself (he had problems with the names of other churches in the area too; see Warrell 2003, p.183).

Ruskin greatly admired the picture, and the effect it depicted, but refrained from buying it for himself when it was first exhibited. Once it was part of the Turner Bequest, he highlighted its strengths in his catalogue of the collection, though his remarks on the peculiarity of Turner's title may have encouraged the National Gallery's authorities to alter its name to the less problematic *The Approach to Venice*, by which it was known for most of the later nineteenth century. As the decades passed the image became increasingly iconic, and even more so after 1883, when it was one of only four of Turner's Venetian canvases to remain in London. During this period it was seen by young artists as the epitome of his late style, and it was one of the most frequently copied of his paintings, eclipsed only by the *Fighting Temeraire* (National Gallery, London; B&J 377) and *Chichester Canal* (no.10). The use of strong vibrant colour, such as the greens for the wake of the gondola on the right, applied with apparently little sense of a need for naturalistic representation, was, by the last twenty years of the century, suddenly in tune with the more progressive attitudes of avant-garde painting. IW

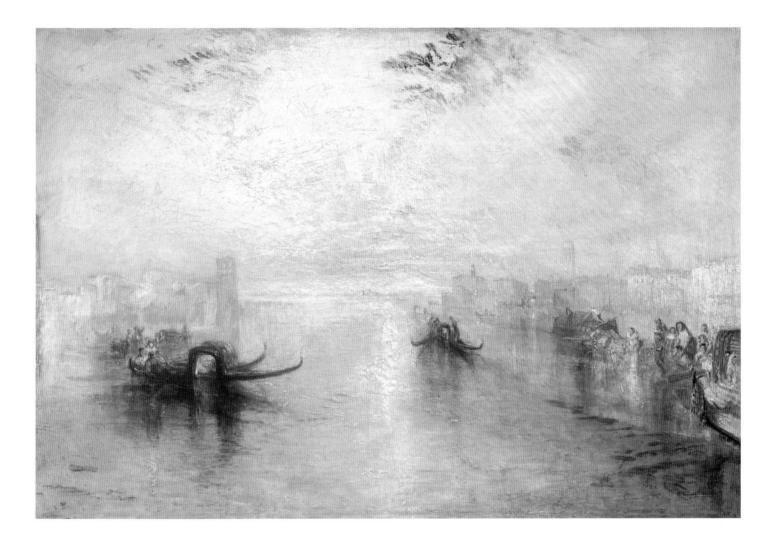

94 James McNeill Whistler

Salute: Sundown 1880

Chalk and pastel on brown paper 20.0 × 26.8 cm
M 809
Hunterian Art Gallery, University of Glasgow

Whistler made this pastel from the first-floor corner room of the Casa Jancowitz (now Pensione Bucintoro) looking across the Lagoon toward Sta Maria della Salute and the mouth of the Grand Canal. MacDonald noted that there are a dozen pin holes in this pastel at each of the upper corners (MacDonald 1984, p.49), suggesting that Whistler had worked on it on at least a dozen occasions. She quotes Otto Bacher who was with Whistler in Venice:

> I have known him to begin an etching as early as seven o'clock in the morning . . . take up another until twelve-noon – get a bit of lunch, and commence on a third . . . perhaps a pastel – then

take a fourth . . . and continue upon it until dusk, the subjects being wholly different. Whistler always had a half dozen under way, more or less complete. (Bacher 1908, p.98)

In this pastel Whistler shows the last rays of light disappearing behind the Salute. Monet also worked from a vantage point close to Whistler's former residence, the Casa Jancowitz. As Mark Evans has pointed out, when Monet made *San Giorgio Maggiore at Dusk* (no.106) he 'appears to have been looking south-west from near the water's edge, at the end of the via Garibaldi' (Evans 1992, p.71). KL

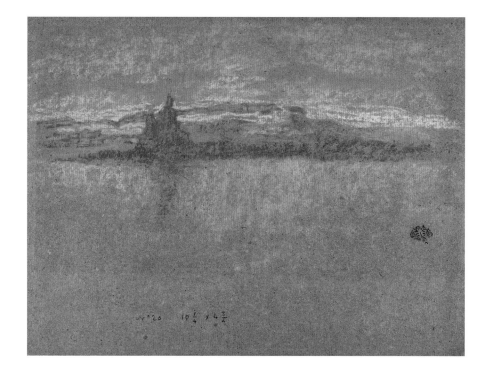

95 James McNeill Whistler

Sunset, Venice 1880

Chalk and pastel on beige paper 12.1 × 24.8 cm
M 813
Private collection, USA

This pastel was made from the first-floor room of the
Casa Jancowitz (now Pensione Bucintoro), looking
toward the Salute and the Dogana with the Giudecca
to the left. Whistler used stump on the pastel to
smudge and drag the forms downwards, creating
shadowed reflections on the water. This dusky work
shows the last traces of sunset, and the onset of
nightfall. It recalls Turner's nocturnal Venetian
watercolours such as no.16. KL

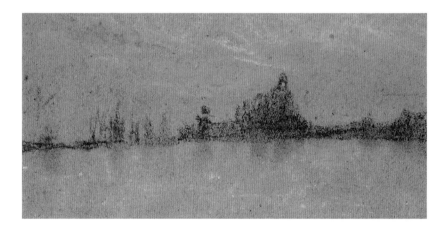

96 J.M.W. Turner

San Giorgio Maggiore and the Zitelle from the Giudecca Canal
1840

Pencil and watercolour on paper 24.5 × 31 cm
TB CCCXVI 40
Tate, London. Accepted as part of the Turner Bequest 1856; displayed from 1897

The characteristics of this pencil drawing suggest that it was almost certainly drawn on the spot. Its execution contrasts with the more elaborate, atmospheric watercolours. It is a rudimentary sketch which carefully defines the architectural forms, providing Turner with good visual information for later reference. The washes of watercolour merely hint at the tones of the buildings at a particular moment. The economy of line in this sketch shares a similarity with the delicate shorthand of Whistler's etchings.

This drawing was selected by Ralph Wornum, one of the officials of the National Gallery, for the fifth collection of sketches lent to regional museums around Britain, beginning in 1897. Prior to this it had not been displayed, since it was the type of drawing that Ruskin regarded as third-rate and not really suitable for display with the body of fine drawings in the Turner Bequest. However, he valued sketches of this kind for the potential value they had to provide insight into other important drawings, and as a means of illustrating Turner's techniques for amateurs and art students alike (*Works*, XIII p.319). ST

97,98 James McNeill Whistler

97 La Salute: Dawn 1879

Etching in very light brown ink with plate tone on old Dutch laid paper, trimmed with tab 12.5 × 20.0 cm
K 215, IV/IV
S.P. Avery Collection, Miriam and Ira D. Wallach Division of Art, Prints and Photographs, The New York Public Library, Astor, Lenox and Tilden Foundations

98 Long Lagoon 1879

Etching in very pale brown ink and plate tone, on old Dutch laid paper, trimmed with tab 14.9 × 22.4 cm
K 203, I/II
S.P. Avery Collection, Miriam and Ira D. Wallach Division of Art, Prints and Photographs, The New York Public Library, Astor, Lenox and Tilden Foundations

Whistler's panoramic views of the city from across the water make an interesting comparison with Turner's sketches such no.96 (other examples are TB CCCXVI 1 and 9): he may have seen some earlier sketches from Turner's first trip to Venice in 1819, at the National Gallery in London, where Ruskin selected for display twelve leaves from the *Milan to Venice* sketchbook (TB CLXXV; *Works*, XIII, pp.303–4). The selected pages show finely detailed pencil drawings of sites around the city, including some panoramas stretching over two pages. Both artists worked directly from nature in Venice, Turner in his sketchbooks and Whistler straight on to his grounded copper plates.

Whistler carried the concept of 'lack of finish' to extremes in his Venice etchings, at times reducing the linework to a delicate fretwork along the horizon. This is one of his distinctive long views of Venice in which the buildings appear to float on the Lagoon. The subject, handling and use of brown ink and surface tone can be compared with Turner's pencil sketch enhanced with brown wash (no.96), as can the flatness of the composition and the long horizon line. Both views appear to have been made from gondolas on the journey from the mainland to the city. The dramatic use of the *bricole* as *repoussoir* devices in the foreground marking the boat lanes may have been suggested by Turner (see no.91). KL AND ST

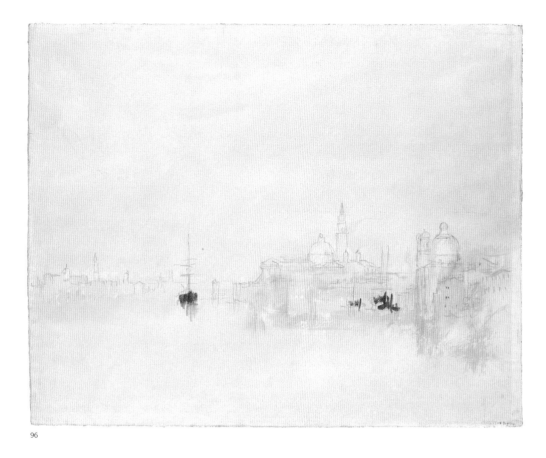

96

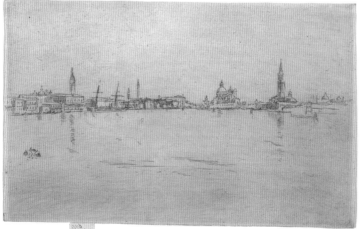

97

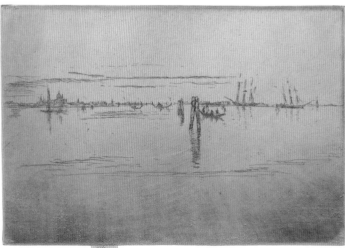

98

**The Dogano, San Giorgio, Citella, from the Steps
of the Europa** 1842

Oil on canvas 62 × 92.5 cm
B&J 396
Tate, London. Presented by Robert Vernon 1847;
displayed from 1848
EXHIBITED IN TORONTO ONLY

Turner's picture was first shown at the Royal Academy exhibition of 1842, nearly two years after his third and final trip to Venice. It records the panoramic view from the mouth of the Grand Canal, across to the churches of San Giorgio Maggiore and the Zitelle, which he had discovered and captured so memorably in watercolour during his first visit in 1819 (Warrell 2003, figs.74–5). By the time he returned in 1833, it was possible to stay at the Hotel Europa (situated in the Palazzo Giustinian; not the same building as the current Europa e Regina hotel) from the windows of which he could once again savour this spectacular prospect. The painting is, thus, most obviously, a recollection of the time Turner spent at the hotel on his two later trips, developing the twilight mood he caught so vividly in his studies. Its initial viewers, however, were not aware of this personal connection, and would have judged it primarily as a topographical representation, making the inevitable contrast with Canaletto's much sharper images.

The critical response to Turner's Venetian pictures of the 1840s was, in fact, generally much more favourable than the hostile and bewildered comments that were habitually bestowed on his other exhibits during the same period. The economy of his increasingly indistinct style required explanation. Writing about this picture, the *Athenaeum*'s critic enthused that Turner was like a magician in control of his materials, noting that the viewer himself became part of the process of transformation: 'As pieces of effect, too,

these works are curious; close at hand, a splashed palette – [but] an arm's length distant, a clear and delicate shadowing forth of a scene made up of crowded and minute objects!. This was in contrast to the *Literary Gazette*, which, though it acknowledged the picture was 'a gorgeous *ensemble*', contended that it must have been produced 'by throwing handfuls of white, and blue, and red, at the canvass, letting what chanced to stick, stick; and then shadowing in some forms to make the appearance of a picture' (see B&J 396–7 for more reviews).

This was one of the four paintings by Turner presented to the national collections by Robert Vernon in 1847 (see also no.14), two of which depicted Venice: the other, earlier picture of 1833 recalls the celebrated view towards the Doge's Palace from the Dogana, featuring Canaletto himself as an incidental figure (Tate, London; B&J 349). Although they are separated by nearly ten years and considerable stylistic differences, Vernon apparently considered them a pair. This would explain why for some time after this picture arrived at the National Gallery it was wrongly thought to date from 1834. Once in the National Gallery, it featured as part of the displays of the Vernon collection, first in the Trafalgar Square building, and then in South Kensington, but by 1883 it had been despatched to Leicester, where it remained until the 1930s. During this period, visitors to London would have known it only from the black and white engraving published in the *Art Journal*. IW

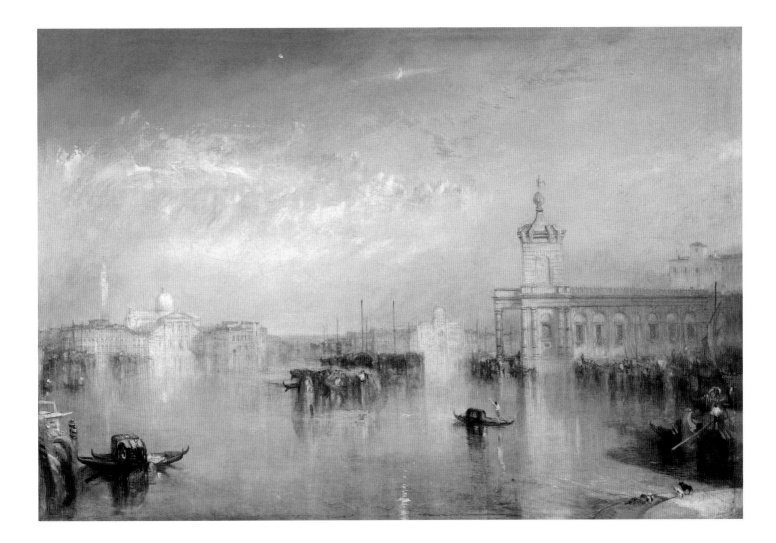

100 Venice: San Giorgio Maggiore at Sunset, from the Riva degli Schaivoni 1840

Watercolour on paper 24.4 × 30.6 cm
TB CCCXVI 24
Tate, London. Accepted as part of the Turner Bequest 1856; displayed from 1857
EXHIBITED IN PARIS AND LONDON ONLY

101 Venice: San Giorgio Maggiore, possibly from the Hotel Europa 1840

Watercolour on paper 22.1 × 32.3 cm
Private collection
EXHIBITED IN TORONTO ONLY

The island church of San Giorgio Maggiore is one of the buildings appearing with some frequency in Turner's Venetian sketches. The artist sketched it from numerous different viewpoints, including his bedroom window at the Hotel Europa. Lindsay Stainton has pointed out that Turner was also compelled to portray this landmark, like the Rigi, at different times of day (Stainton 1985, p.62). A passage from William Callow's autobiography alludes to Turner's determination to capture his subject thoroughly: 'One evening whilst I was enjoying a cigar in a gondola I saw in another one Turner sketching San Giorgio, brilliantly lit up by the setting sun. I felt quite ashamed of myself idling away the time whilst he was hard at work so late' (Callow 1908, p.66–7). The lack of pencil in no.100 suggests that Turner made it on returning to his hotel, having fixed a clear impression of the light and colour of the scene in his mind. Ruskin chose the sketch painted in pure watercolour for his first catalogue and noted that it was 'Exquisitely beautiful for tender colour and atmosphere' (*Works*, XIII, p.212). He catalogued it initially as 'The Cemetery and Church of St Michelle di Murano', later revising the title in 1881 to 'San Giorgio'.

There are around twenty Venetian watercolours outside the Turner Bequest, which in some cases can be traced back to Thomas Griffiths, his agent. This includes *Venice: San Giorgio Maggiore*, though it is not apparent that the watercolour was sold before Turner's death. It is a rare exception of a relatively highly finished Venetian watercolour by Turner: he did not make any finished watercolours of Venice, though some were worked up to a certain degree in a similar way to the 'sample studies' of Swiss views. Andrew Wilton has pointed out the traces of bodycolour used here which is very rarely seen in the watercolours of Venice on white paper (Wilton 1979, p.234). ST

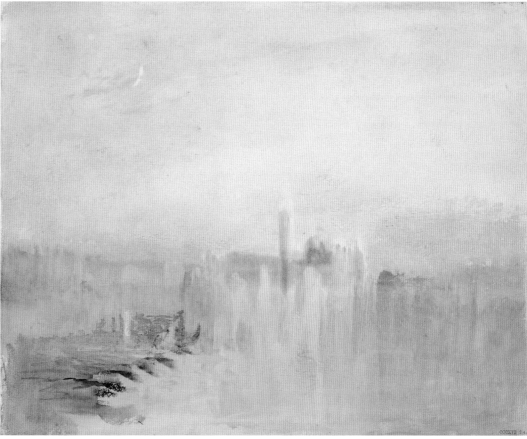

100

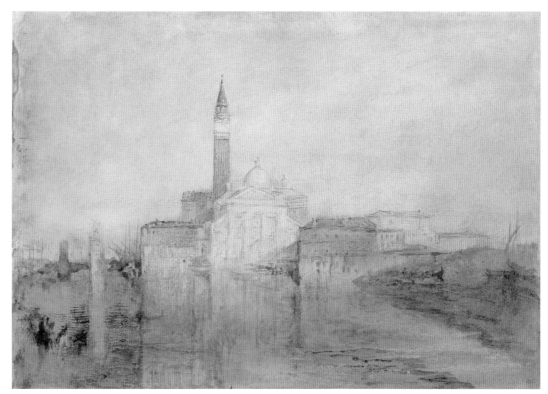

101

102-105 James McNeill Whistler

102 Nocturne 1880

Etching and drypoint printed in warm brown ink
on old laid paper 24 × 29.5 cm
K 184, IV/V
Art Gallery of Ontario, Toronto.
Gift of Touche Ross, 1978

103 Nocturne 1880

Etching in brown on paper 20.1 × 29.5 cm
K 184, IV/V
National Gallery of Art, Washington.
Rosenwald Collection 1943

104 Nocturne 1880

Etching and drypoint in dark brown on
off-white laid paper 20.1 × 29.3 cm
K 184, IV/V
National Gallery of Art, Washington.
Rosenwald Collection 1943

**105 Nocturne in Blue and Silver:
The Lagoon, Venice** 1880

Oil on canvas 51 × 66 cm
YMSM 212
Museum of Fine Arts, Boston.
Emily L. Ainsley Fund, 1942

Whistler went to Venice following the court case, with Ruskin and Turner on his mind. Adopting a theme made famous by Turner, the island of San Giorgio Maggiore reflected in the Lagoon (nos.100, 101), Whistler created nocturnal variations in painting (no.105) and etching. Nowhere did he come closer to Ruskin's image. This was ironic, for San Giorgio, designed by Palladio, was a building Ruskin disliked.

The static image found in the painting was animated in the etching in which he employed artistic printing techniques. By manipulating different amounts of ink over its surface he created an edition of unique impressions depicting a range of times of day and atmospheric effects. Most capture the effect of twilight. In a handful of darker impressions, including these extraordinary proofs from Washington (nos.102–3), the forms blend and flow into one another before they are swallowed up by darkness. The fluid way in which Whistler applied plate tone to give his etched nocturnes translucency recalls Turner's Venice water-colours (nos.100, 101).

Whistler's printed variation may have inspired Monet's series of paintings of San Giorgio, which he also depicted at different times of day (see no.106 and W 1745–50, 1768–9). KL

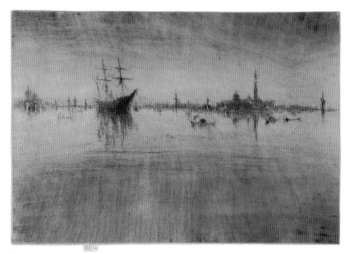

102

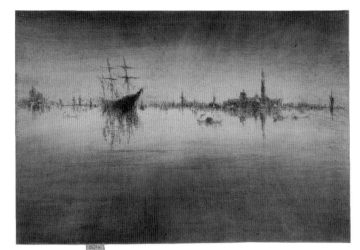

103

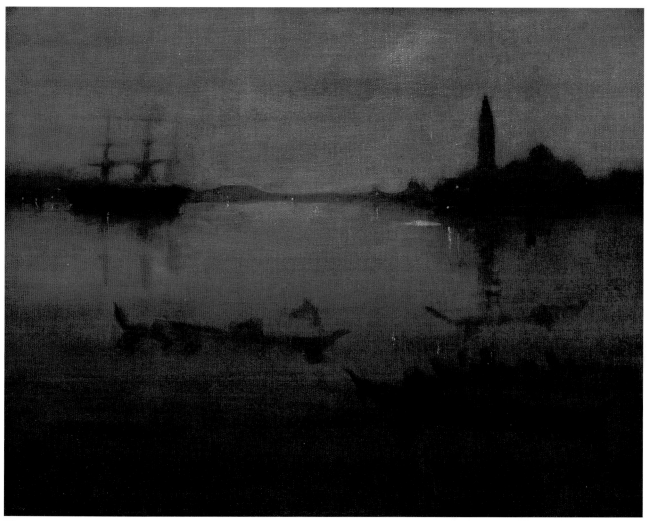

105

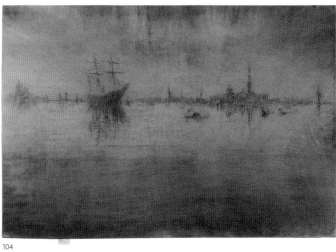

104

San Giorgio Maggiore at Dusk 1908

Saint-Georges Majeur au crépuscule

Oil on canvas 65.2 × 92.4 cm
W 1768
National Museums and Galleries of Wales, Cardiff

In addition to palazzi, some of the most famous churches in Venice attracted Monet's attention. He began with one he could see from the neighbourhood in which he lived: the Church of Santa Maria della Salute with the Grand Canal, viewed from the Palazzo Barbaro.

Later, from the Grand Hotel Britannia, he depicted 'the little island on which stands the basilica of San Giorgio Maggiore' (W 1745) on seven canvases. It is worth noting that the view of Venice that Monet gave Mrs Charles Hunter, who welcomed him during his London sojourn, and happened to be in Venice at the same time as the painter, comes from this series (*San Giorgio Maggiore*, private collection; W 1750).

Gustave Geffroy did not miss the opportunity to recollect the importance of 'air and light' to his friend:

Claude Monet also sees on the flat island, at water level, the silhouette of San Giorgio Maggiore, its tiny pediment, its delicate dome, and its soaring campanile whose dark tip is lit up by a patch of rose-coloured sunlight. Some days nacreous and sulphurous vapours half conceal the splendid church; on other days it stands rose coloured above the water, profiled against a lemon sky. Gondolas rise into view . . . And so it is on all the pages of this poem, where the reality of things is amplified by another reality, that of light and air. Claude Monet is a poet . . .
(Geffroy 1924, pp.318–19).

At the end of his stay Monet devoted two paintings to San Giorgio Maggiore at dusk. This version was no.29 in the exhibition *Claude Monet: 'Venise'* at the Bernheim-Jeune gallery in May 1912 (it was sold by Bernheim-Jeune to the Misses Gwendoline and Margaret Davies of Cardiff the following October). Daniel Wildenstein recalled that this painting was reproduced at the end of the exhibition catalogue written by Octave Mirbeau as if it were 'an adieu to Venice'. Wildenstein describes the painting thus:

this backlit scene at dusk makes it possible to appreciate the relative positions of the campanile, the central dome and the facade of the Church of San Giorgio Maggiore, as they appeared to Monet who was on the east bank of the St Mark's Canal, not far from the entrance to the Via Garibaldi. In the background on the right is the barely distinguishable form of Santa Maria della Salute.

According to Geffroy, the work shows Venice 'certainly present and recognisable, but she is not in the foreground, with all the details of her construction and ornament itemised; suspended in mist and seen at a distance she inspires meditation on the passage of time' (Geffroy 1924, p.318). The church stands out against a sky richly coloured by the setting sun, creating a spectacular effect. Here Monet reveals his closeness to Turner's 1840 watercolours of the sun setting on San Giorgio Maggiore, and to his canvas *The Dogano, San Giorgio, Citella, from the Steps of the Hotel Europa* (no.99). Monet's Venetian work also demonstrates his debt to Whistler the etcher (see nos.102–4).

Before Monet, Turner and Whistler had fallen under the spell of Venice and the Lagoon. The last fiery rays of the setting sun had been brilliantly captured both in Turner's paintings and in Whistler's pastels. For Monet, not only were his canvases of San Giorgio Maggiore at dusk a farewell to Venice, they were a final adieu to Turner and Whistler. The city of the Doges, this magical 'stage set', falls asleep in a blaze of fierce colours and the brilliant glimmer of gold embracing San Giorgio Maggiore. Although he would never forget Turner and Whistler, Monet would never resume the artistic dialogue he maintained over the years with his predecessors which was brought to a close 'under the spell of Venice.' Instead, he would devote himself to a long period of research into the world he had created at Giverny: future artists would instead have to enter into a dialogue with the painter of the water lilies. SP

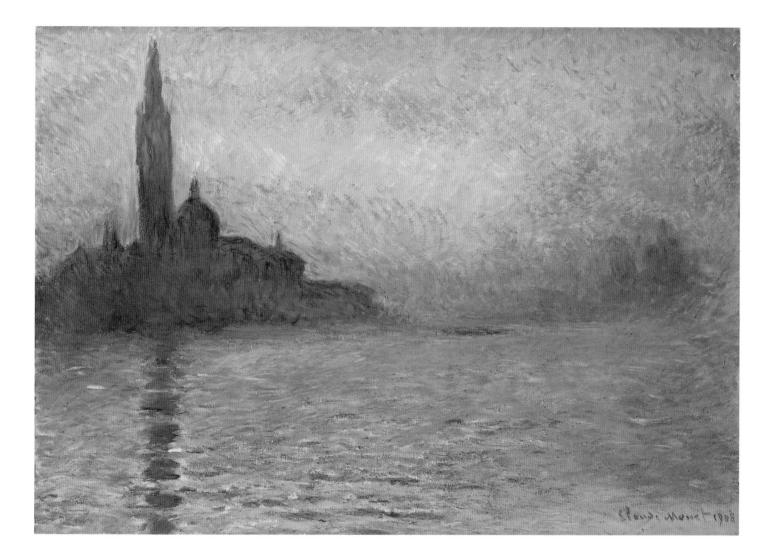

Notes

For full citation of bibliographic references,
see Bibliography, pp.252–7

PREFACE
Katharine Lochnan
(pp.12–13)

1 See Michael Kitson, 'Turner and Claude' in Ian
Warrell, *Turner et le Lorrain*, exh. cat., Musée des
Beaux Arts, Nancy 2002.

2 The term was coined by Griselda Pollock, in Pollock
1992. Pollock sees this as a three-stage process:
'reference', 'deference' and 'difference'. 'Reference
ensured recognition that what you were doing was
part of the avant-garde project. Deference and
difference had to be finely calibrated so that the
ambition and claim of your work was measured by
its difference from the artist or artistic statement
whose status you both acknowledged (deference)
and displaced' (p.14). See also p.37, below.

3 See Patrick Noon, 'Diamonds that Flatter and Ravish
the Eye: The Ascendancy of Watercolour', Noon 2003,
p.232. Etienne Delécluze wrote of the Salon of 1824,
in response to the groundswell of interest in the
English watercolour in France, that those artists
who '*drew* in watercolours for the ladies' rather than
'*painted* in oils for posterity' would ruin themselves
and the school.

TURNER, WHISTLER, MONET:
AN ARTISTIC DIALOGUE
Katharine Lochnan
(pp.15–35)

I would like to give special acknowledgement to authors
whose publications have paved the way for this thesis,
including Eric Shanes, Grace Sieberling, Mark Evans, and
Charles Tucker.

1 J.A.M. 'The Red Rag', in Whistler 1967,
p.127.

2 Finberg 1961, p.438; cf. no.1.

3 Gage 1987, p.153.

4 Finberg 1961, p.438.

5 Quoted by Rodner (1997, p.124) from Shelley's
poem 'Peter Bell the Third', in Thomas Hutchinson
(ed.), *Shelley: Poetical Works*, London: Oxford
University Press, 1967, p.350.

6 Wilton 1981, no.86, pp.168–9.

7 Rodner 1997, p.11.

8 P.B. Shelley, 'Defence of Poetry' (1821), reprinted in
M.H. Abrams (ed.), *The Norton Anthology of English
Literature*, I, New York 1962, pp.476–8.

9 Turner's obituary in *The Times*, 23 Dec. 1851, p.8,
quoted in Rodner 1997, p.18.

10 Warrell 1995, p.13.

11 Anna Matilda Whistler, Diary, Manuscript Division,
New York Public Library, quoted in Fleming 1978,
p.34.

12 George Washington Whistler, letter to James
McNeill Whistler, 9 Aug. 1848 (GUL MS Whistler
W656, GUW 06662).

13 F. Seymour Haden, Journal, entry for 1 Aug. 1844
(Glasgow University Library, Special Collections).

14 Schneiderman 1973, p.26.

15 Harrington 1911, p.406.

16 D. Seymour Haden, letter to Walter Brewster, n.d.
(Brewster Collection, Department of Prints and
Drawings, Art Institute of Chicago), in which she
says that she owned 'an early Turner drawing done
when they were sketching in Wales'. Andrew Wilton
has pointed out in conversation that this would
have been impossible, as Turner's last trip to Wales
was in 1809.

17 Reynolds 1981, Discourse III, p.31.

18 Whistler, letter to George Washington Whistler,
26 Jan. 1849 (GUL MS Whistler W661, GUW 06667).
He mentions his visit to the Vernon Gallery in the
same letter as he says that he wants to be a painter.

19 Robert Vernon had made a gift of his collection of
'progressive British art' to the nation in 1847. See
Hamlyn 1993.

20 *Works*, III, p.123.

21 Leslie 1848, pp.191–2.

22 Ibid., p.77.

23 Whistler's library at Glasgow University Library
contains C.R. Leslie's *A Handbook for Young Painters*,
London 1855, inscribed 'James Whistler from big
brother George'. It is tempting to think that he
gave this to Whistler prior to his leaving America
to study in Paris.

24 See Wilton and Barringer 2002.

25 Finberg 1961, p.336, says that this quote was
'misprinted as fault'. However, see Butlin and Joll
1984, I, pp.198–9 which quotes Adele Holcombe's
article confirming that C.R. Leslie reported Turner's
comment as 'indistinctness is my fault'.

26 Anna Matilda Whistler, letter to James McNeill
Whistler, 31 Dec. 1852, 4 and 7 Jan. 1853 (GUL MS
Whistler W419, GUW 06424).

27 Ibid.

28 'Minutes of Evidence' in the *Report from the Select
Committee on the National Gallery*, 1853 (National Gallery
Archives, London), 26 April 1853, p.12, para.153 and
p.13, para.161.

29 Ibid., p.12, para.156.

30 Ibid., p.13, para.166.

31 Ibid., 23 May 1853, p.245.

32 Anna Matilda Whistler, letter to Margaret Hill,
21 Feb. 1853 (LC PWC 34/45–50, GUW 07640).

33 Bradley 1978, p.119. Letter from John Ruskin to
John James Ruskin, 5 Jan. 1852, quoted in Warrell
1995, p.17.

34 Ian Warrell in Hewison, Warrell and Wildman
2000, p.61.

35 Ruskin, *Notes on the Turner Gallery*, 1857, p.1. See
Warrell 1995, p.24.

36 Ruskin, *Catalogue of the Turner Sketches at the National
Gallery*, 1858, reprinted in Warrell 1995, p.34.

37 Warrell 1995, p.28. This comment was made about
the display at South Kensington in 1859.

38 'Resumé of the Project by Frances Fowke, Capt., RE',
3 March 1859 (National Gallery Archives NG
14/1/1848–1862). It speaks of the 'unfortunate position
of the [*sic*] Turner's drawings room downstairs'
(floor area 900 sq.ft [84 sq.m]). By the arrangement
proposed a space would be obtained available for
exhibiting drawings of 12,000 sq.ft (1,115 sq.m). The
National Gallery exhibition space would expand
from 14,990 to 34,488 sq.ft (1,400 to 3,200 sq.m).

39 Blanc (1857, p.15) stated that there were over a
hundred watercolours; the figure of eighty-three
has been supplied by Ian Warrell: see p.69, below.

40 Waagen 1857, p.457: On peut de même apprendre à
connaître ici les paysagistes, depuis Wilson, Turner
(dans ses beaux tableaux aussi bien que dans ses
égarements) . . . La peinture de marine est illustrée
par des belles productions de Turner.'

41 See Lochnan 1984, p.73.

42 M. Ferlet, letter to Ludovic Barrie, 6 Jan. 1859,
quoted in Lochnan 1988, p.103 n.6.

43 See Lochnan 1988, pp.57–8.

44 Ian Warrell (pers. comm. to Katharine Lochnan,
11 April 2003) has identified the exhibitions that
Fantin-Latour was able to see at that time. See
Works, XIII, pp.229–316.

45 Letter to unidentified recipient, 15 July 1859,
Bibliothèque de Grenoble: 'je verrai bien plus
demain'; 'a donné à sa mort des tableaux, des milliers
de dessins, croquis etc. C'est, je crois, l'homme le
plus remarquable (anglais). Dans les marines,
paysages, effets de lumière, il est très remarquable.
Tous les Gudin, Roqueplan, Isabey, et beaucoup
d'autres romantiques sortent de là: je dirais même
que le Romantisme me paraît devoir être parti
d'Angleterre.'

46 Baudelaire, in 'Le Salon de 1959' (first pub. *Revue
Française*, 10 June – 20 July 1859), Baudelaire 1975–6,
chap.7, 'Le Paysage', p.666: 'le paysage des grandes
villes'; trans. in Baudelaire 1965, pp.200–1.

47 Ibid.: 'les obélisques de l'industrie vomissant contre
le firmament leurs coalitions de fumée'; trans. in
Baudelaire 1965, pp.200–1.

48 Baudelaire in 'L'Eau-forte est à la mode', Baudelaire
1975–6, p.735: 'la poésie profonde et compliquée
d'une vaste capitale'; trans. in Baudelaire 1965, p.220.

49 OC, II, pp.360–4.

50 He made a drypoint portrait of the editor of the
periodical, Zacharie Astruc, in 1859, which he
exhibited at the Royal Academy in 1860 under
the title *M. Astruc, rédacteur du journal L'Artiste* (K 53).
According to J. and E. Pennell (1908, I, p.70), Astruc
was 'painter, sculptor, poet, editor of *L'Artiste*'.

51 Simmonds 1879, pp.103–7; see note to no.33.

52 Ruskin visited Tudor House in June 1863, when he
was photographed in the garden with Rossetti. See
Lochnan, Schoenherr and Silver 1993, p.286.

53 Letter to Fantin-Latour, 8 Feb. 1864 (LC PWC 1/33/15,
GUW 08036): 'deux petits tableaux de la Tamise –
un vieux pont et un effet de brouillard': 'Je les ai
trouvés bien au moment où je les ai terminés mais
maintenant ils ne me plaisent pas beaucoup.'

54 In November 1862, reporting on a visit by Bracquemond to Haden, Whistler wrote to Fantin-Latour, 'Turner aussi lui a été administré', as if by doctor's prescription (LC PWC, AAA mfm 780–1).

55 Letter to Fantin-Latour, Jan.–Feb. 1864 (LC PWC 1/33/15, GUW 08036): 'Tu vois Legros dans les angoisses du premier moment! Cherchant dans les tons de soleil couchant du hasard à la Turner, ces dalles grises et calmes de son église bien aimée!!'; 'Ah! Vous avez ôté tout ça! eh bien! faites le mieux.'

56 Works, XXXVI, pp.xlviii–xlix. I am grateful to Stephen Wildman for drawing this letter to my attention.

57 Letter to Fantin-Latour, 16 Aug. [1865] (LC PWC 1/33/1, GUL 11477).

58 Burne-Jones in conversation with C.A. Howell, Fitzgerald 1975, p.110.

59 See Katharine Lochnan, 'The Thames from its Source to the Sea: An Unpublished Portfolio by Whistler and Haden', in 'James McNeill Whistler: A Re-examination', Studies in British Art, vol.19, 1987, pp.42–3.

60 Legros and Burne-Jones supported Haden, Mrs Whistler the Rossettis, and the Edwin Edwardses supported Whistler. Haden forbade his wife, Whistler's half-sister, to meet her stepmother and half-brother except in the home of mutual friends. This feud lasted until the end of their lives.

61 The Diary of W.M. Rossetti, Oxford 1977, pp.234–5.

62 Letter to Fantin-Latour [May or Sept.] 1867 (LC PWC 1/3/25, GUW 08045): 'de choses plus belles à faire.'

63 Ibid.

64 William Eden Nesfield, letter to Whistler, 19 Sept. 1870 (GUL MS Whistler N20, GUW 04263). William Eden was invited to arbitrate, and said that he thought they could both go on painting the same subjects without being confused.

65 Anna Matilda Whistler, letter to Margaret Hill, 14 Dec. 1868 (LC PWC 34/49–50, GUW 11473).

66 Baudelaire 1995, pp.100–3, 107–9.

67 When Mallarmé wrote to express his admiration for Swinburne's poetry in 1876, Swinburne sent him a copy of 'Nocturne' for his comments. Swinburne, letter to Mallarmé, 13 Jan. 1876, Bibliothèque Doucet, Paris, MVL 3062 1.2.

68 For Baudelaire, see p.29, below. In his poem 'Nocturne' Swinburne wrote: 'chante; ton chant assoupir l'âme et l'onde' (included in the second series of Poems and Ballads, Swinburne 1904, III, pp.161–2). In the 'Ten O'Clock' lecture Whistler wrote: 'Nature who, for once, has sung in tune, sings her exquisite song to the artist alone' ('Mr. Whistler's "Ten O'Clock"' in Whistler 1967, p.144).

69 Hackney 1994, p.697.

70 This may well have been intentional. Whistler and J.J. Tissot were friends at that time, and ambiguity is inherent in Tissot's work. See Lochnan 1999, pp.1–22.

71 Anna Matilda Whistler, Diary, 1850 (LC PWC). On 1 July 1850 she wrote: 'a glorious sunset peculiar clouds of olive green contrasted with the deepest blue I ever saw in the firmament . . . felt the glow of adoration I always do at such.'

72 Letter to James Gamble, 5 and 22 November 1872 (GUL MS Whistler W546, GUW 06553).

73 Letter to Edwin Edwards, 30 July 1870, Bibliothèque de Grenoble.

74 Anna Matilda Whistler was soliciting donations to assist the wife and child of an American artist, Louis Remy Mignot from Charbeton, born in 1831 in South Carolina, who died in Brighton on 22 September 1870. He appears to have been living in France, and sought exile in England during the Franco-Prussian War. She noted that Rossetti, 'a true friend', had given to the fund. Anna Matilda Whistler, letter to Catherine Palmer, 29 Oct.– 5 Nov. 1870 (LC PWC 34/71–76, GUW 11841).

75 Lochnan 1984, pp.127–34.

76 See Druick and Hoog 1983, pp.208–13.

77 Letter to Edwin Edwards, 15 July 1871, Bibliothèque de Grenoble: 'Monet, peintre, que vous connaissez.' Fantin-Latour's use of the verb 'connaître' indicates that Edwards and Monet knew each other personally.

78 Louis Vauxcelles (1905, p.88) commented on the fact that Monet's decoration at Giverny had a Whistlerian quality.

79 By 1880 Paris was surrounded by ammonium sulphate factories emitting a foul odour which caused people to choke. This was mixed with the odour of gas given off by fecal matter discharged into the Seine. The situation created a serious public health hazard: 'l'air que vous venez de respirer est complètement vicié' (Raspail 1880, pp.7–8).

80 Paul Hayes Tucker introduced the pollution issue in connection with Argenteuil in Tucker 1982, pp.176–81. Virginia Spate takes up the discussion in Spate 1992, p.99.

81 Clark 1984, pp.186–8, and Tucker 1995, pp.99–100.

82 Clark 1984, p.179.

83 Society of French Artists, fifth exhibition, Winter 1872, exh. cat., no.122.

84 Ruskin 1873, Works, XXIII, p.49. As Linda Merrill points out (1992, p.50), this attack anticipates the one in Fors Clavigera of 1877.

85 Illustrated London News, 30 Nov. 1878. The Times (27 Nov. 1878) reported that 'Whistler was almost the only impressionist in England, much outdoing in the qualities of this school those who are regarded as its leaders in France' (quoted in Merrill 1992, p.250).

86 Merrill 1992, p.108; D.G. Rossetti, letter to Frederick Leyland, 18 March 1872, in 'A Collector's Correspondence', Art Journal, Aug. 1992, p.251.

87 His sister and father played piano and flute duets; when Deborah inherited his grand piano she was accompanied by Haden on cello or violin. Edwin Edwards and his wife Ruth also played piano and flute. Whistler explained that subtle shifts of colour in the Nocturnes are analogous to playing the chords of F or G major followed by their relative minors.

88 Letter to F.R. Leyland, Nov. 1872 (LC PWC 6B/21/3, GUW 08794).

89 Letter to Whistler, 17 July 1877 (GUL MS Whistler L121, GUW 02585).

90 See Casteras and Denney 1996.

91 Ruskin, letter to Joan Severn, 13 June 1877, Ruskin Library, University of Lancaster.

92 Ibid.

93 I am grateful to Stephen Wildman for this observation.

94 Colvin 1877, pp.831–2, quoted in Siewert 1994, p.119.

95 Defined by 1859 as 'smoke, liquid industrial refuse, or sewage . . . discharged into the environment esp.

when serving as a pollutant', Webster's Dictionary, p.579.

96 Zaniello 1981, p.258. I am grateful to Dr Norman Macdonald of Glasgow University for drawing this article to my attention. Ruskin made this remark at the end of his 'storm-cloud' lectures in February 1884 (The Storm-Cloud of the Nineteenth Century', Works, XXXIV, pp.39–40). See also p.59, below.

97 Letter to Seymour Haden, 11 Jan. 1874, Avery Collection, New York Public Library, quoted in full by Schneiderman (1973, p.237 n.11); he notes that the letter was unpublished.

98 Letter to Edma Morisot Pontillon, Summer 1875, quoted in Rouart 1950, p.88: 'J'ai vu beaucoup de Turner (Whistler que nous aimions tant l'imite énormément).'

99 Works, XXIX, p.160, quoted in Merrill 1992, pp.46–7.

100 Eric Partridge, Dictionary of Slang and Unconventional English, 2 vols., London 1961, defines 'coxcomb' as 'punning cock's comb (late 16th–19th c.)' (I, p.186), and 'cock' as 'the penis' (I, p.164).

101 Ruskin relates the anecdote in Notes on the Turner Gallery at Marlborough House, repr. in Works, XIII, pp.161–2.

102 Literary Gazette, 14 May 1842, quoted in Merrill 1992, p.52.

103 Merrill 1998, p.276.

104 Hewison, Warrell and Wildman 2000, p.83.

105 Cook 1911, II, pp.404–5. See also Merrill 1992, pp.51–2. In 1882 Whistler's Nocturnes were seen as travesties of Turner.

106 Anderson Rose Papers, LC PWC.

107 This represents a reversal, as Whistler had previously denied the influence of other artists on his Nocturnes: he claimed in a letter to Walter Greaves, ([1871/1876], LC PWC 9/639–40, GUW 11468), that he 'invented' the 'moonlights': 'Never in the history of art had they been done'.

108 Pennell 1921, p.123; Pennell 1930, p.162.

109 See note 101 above. This comment became widely known as a result. Ruskin did not actively defend Turner from this criticism.

110 Anderson Rose Papers, LC PWC, quoted in Merrill 1992, p.397 n.8. This final speech was, in fact, never made: see ibid., p.266.

111 Quoted in Merrill 1992, p.266.

112 Ibid.

113 Ibid.

114 Ibid., p.227.

115 Letter to Joan Severn [27 Nov. 1878], quoted in Merrill 1992, p.108.

116 Grieve 2000, p.20.

117 Works, IX, p.17.

118 'W.', 'Mr. Whistler's Venice Pastels', Pan, 5 Feb. 1881, quoted in Grieve 2000, p.191.

119 The spirit of risorgimento which followed the unification of Italy in 1870 was articulated by King Vittorio Emanuelle II: 'political revival must follow the economic revival of the nation' ('Al risorgimento politico dovrà tener dietro il risorgimento economico della nazione': Caizzi 1965, p.257).

120 Anon., identified as Harry Quilter by Lynn Bell (1880, p.1587), quoted in Grieve 2000, p.190.

121 Letter to Lucien Pissarro, 20 March 1882 (Bailly-Herzberg 1980–91, I, letter 103): 'ce qui est grave, très

grave, car cet artiste Américain est un grand artiste, et le seul dont l'Amérique puisse se glorifier à juste titre.'

122 Letter to Lucien Pissaro, 28 Feb. 1883 (Bailly-Herzberg 1980–91, I, letter 120): 'la souplesse que tu constates, le moelleux, le flou qui te charme est une espèce d'estompage fait par l'imprimeur, qui est Whistler lui-même', trans. Rewald 1943, pp.22–3.

123 F. Wedmore, 'The Impressionists', *Fortnightly Review*, vol.33, Jan. 1883, pp.75–82; reprinted in Flint 1984, pp.46–55, see also p.7.

124 Walter Sickert wrote: 'it was always a grief and annoyance to those who loved and admired these rare and precious qualities in Whistler that he would so constantly leave his easel for his writing desk.' See also Sickert 1947, p.19; Lochnan 1986, pp.16–20.

125 Pennell 1908, I, p.218.

126 Alfred Thornton, Diary, pp.8–9, quoted in Cooper 1954, p.34.

127 Chesneau 1888, pp.25–8, cited in McConkey 1995, pp.31–2, n.8.

128 Burne-Jones 1904, II, pp.187–8.

129 Baudelaire 1995, p.100.

130 'But now it is evening. It is that strange, equivocal hour when the curtains of heaven are drawn and the cities light up. The gas-light makes a stain upon the crimson of the sunset. Honest men and rogues, sand men and mad, are all saying to themselves, "The end of another day!" The thoughts of all, whether good men or knaves, turn to pleasure, and each one hastens to the place of his choice to drink the cup of oblivion . . . [The artist] will be the last to linger wherever there can be a glow of light, an echo of poetry, a quiver of life or a chord of music.'

131 See p.61, below.

132 'Mr. Whistler's "Ten O'Clock"', reprinted in Whistler 1967, p.144: translated by Mallarmé as: 'Et quand la brume du soir vêt de poésie un bord de rivière, ainsi que d'un voile et que les pauvres constructions se perdent dans le firmament sombre, et que les cheminées hautes se font campaniles, et que les magasins sont, dans la nuit, des palais et que la cité entière est comme suspendue aux cieux – et qu'une contrée féerique gît devant nous – le passant se hâte vers le logis, travailleur et celui qui pense; le sage et l'homme de plaisir cessent de comprendre comme ils ont cessé de voir, et la nature qui, pour une fois, a chanté juste, chante un chant exquis pour le seul artiste, son fils et son maître – son fils en ce qu'il aime, son maître en cela qu'il la connaît.' (OC, II, p.842).

133 Whistler 1967, p.136. Translated by Mallarmé as 'cherchant et trouvant le beau dans toutes conditions, et tous les temps' (OC, II, p.838).

134 Whistler 1967, p.143. Translated by Mallarmé as: 'La nature contient les éléments, en couleur et forme de toute peinture, comme le clavier contient les notes de toute musique. Mais l'artiste est né pour en sortir, et choisir, et grouper avec science, les éléments, afin que le résultat en soit beau – comme le musicien assemble ses notes et forme des accords – jusqu'à ce qu'il éveille du chaos la glorieuse harmonie' (OC, II, p.841).

135 Monet, letter to Duret, c.13–20 March 1887 (Walters Art Gallery Library, Baltimore, Maryland, GUW 12300).

136 Monet, letter to Duret, 13 Aug. 1887 (Wildenstein 1974–91, III, letter 794): 'émerveillé de Londres et aussi de Whistler qui est un grand artiste; il a été on ne peut plus charmant pour moi du reste.'

137 Monet, letter to Duret, 13 Aug. 1887 (Wildenstein 1974–91, III, letter 794): '[Whistler] m'a invité à exposer à son exposition. Il avait manifesté le désir de venir à Paris et d'y avoir une installation.'

138 Monet, letter to Whistler, 25 Oct. 1887 (Wildenstein 1974–91, III, letter (796 bis b) 2727): 'ai-je bien le droit d'exposer avec vous puisque votre société n'est composée que d'artistes Britanniques, et ne craignez-vous pas qu'en me présentant vous n'allez pas vous attirer bien des ennuis?'

139 Monet, letter to Duret, 13 Aug. 1887 (Wildenstein 1974–91, III, letter 794): 'j'espère que le comité ne sera pas trop effrayé de ma peinture. Quant à moi, il me tarde de savoir l'effet produit.'

140 Monet, letter to Whistler, 1 Aug/Oct. 1887 (GUL MS Whistler M356, GUW 04086; Wildenstein 1974–91, III, letter 798).

141 'Current Art: The Royal Society of British Artists', *Magazine of Art*, Dec. 1887 in 1888 vol., p.110.

142 Whistler asked Mr W. Baptiste Scoones to second his nomination of Monet, describing him as 'the distinguished "Impressionist" very greatly to the fore in Paris – and a capital fellow here'. Letter to W. Baptiste Scoones [1887] (Huntington Library, San Marino, California, GUW 09417).

143 8 Dec. 1886, LC PWC. Printed Material, bound vol.35.

144 Monet, letter to Whistler, 30 Nov. 1888 (GUL MS Whistler M361, GUW 04091; Wildenstein 1974–91, III, letter 907): 'c'est mal car vous savez le plaisir que j'ai à vous voir.'

145 Barbier 1964, p.23: 'je sympathisais tout avec votre vision de l'Art'; Mallarmé said that he would be 'très heureux de mettre mon nom au dessous du vôtre.'

146 Monet, letter to Whistler, 1 Dec. 1889 (GUL MS Whistler 364, GUW 04094; Wildenstein 1974–91, III, letter 1019): 'Bravo, voilà enfin une récompense bien donnée. Je vous en félicite bien sincèrement et de tout cocur'.

147 Barbier 1964, p.44.

148 Monet, letter to Whistler, 3 Jan. 1892 (GUL MS Whistler M368, GUW 04098).

149 *Daily Telegraph*, 18 Feb. 1893, p.9 (quoted Flint 1984, p.11), noted that 'the productions of Impressionism permeated where they did not overwhelm the paintings of the younger generation. Since to stem such an onrushing stream, no artificial barriers will suffice . . . it is therefore, manifestly wiser to direct all efforts toward shaping and guiding a movement which has practically conquered all opposition'.

150 Whistler, letter to Mr Morris, Dec. 1892 (GUL MS Whistler M458, GUW 04188).

151 Tucker 1989, p.232. There was a huge retrospective of Corot's works in 1895, the centennial of his birth. Monet's first documented statement about Corot dates from 1897, the year he finished this series.

152 See Lochnan 1998, I, p.105.

153 Monet, letter to Whistler, 18 May 1896 (GUL MS Whistler M369, GUW 04099: Wildenstein 1974–91, III, no.1349): 'puisse le témoignage d'un vieil ami être pour vous une faible consolation . . . vous savez qu'en

dehors de l'admiration que j'ai pour vous, combien je vous aime. A vous de tout coeur'.

154 Menpes 1904, pp.80–1.

155 *Works*, XIII, pp.124–6.

156 Pennell 1908, II, pp.178, 291.

157 Pennell 1921, p.248.

158 Ibid., p.269.

159 Egerton 1995, p.278; Butlin and Joll 1984, no.131.

160 Select Committee Report, 23 May 1853, p.245, para.3983.

161 National Gallery Conservation dossier no.498, *Dido Building Carthage*.

162 I am very grateful to Martin Wyld, Chief Restorer at the National Gallery, London, for discussing the state of this painting with me.

163 Pennell 1908, II, p.223.

165 Tucker 1989, p.252.

164 Monet, letter to Théodore Duret, 9 Dec. 1880, in Wildenstein 1974–91, I, letter 203.

166 Ibid., pp.252–3.

167 Spencer cites E.R. Pennell's unpublished Journal, 1 Nov. 1920 (Library of Congress) in Spencer 1987b, p.69.

168 Alice Monet, 28 Nov. 1908, quoted in Evans 1992, p.71 (original publication not cited).

169 From D'Annunzio 1900, pp.86–7, 90–1, quoted in Evans 1992, p.72.

TINTED STEAM: TURNER AND IMPRESSIONISM
John House
(pp.37–49)

This essay is greatly indebted to the research of John Gage on Turner's reception in France, as published in his books *Colour in Turner: Poetry and Truth*, London 1969, pp.189–95; *Turner: Rain, Steam and Speed*, London 1972, pp.67–76; *J.M.W. Turner: 'A Wonderful Range of Mind'*, New Haven and London 1987, pp.8–17; and his essay 'Le Roi de la lumière: Turner et le public français de Napoléon à la seconde guerre mondiale' in *J.M.W. Turner*, exh. cat., Grand Palais, Paris 1983, pp.43–55. See also, more recently, Stevens 2001. I am most grateful to all my colleagues in this exhibition project, and notably to Katharine Lochnan, Sylvie Patin and Ian Warrell, for their help and encouragement.

1 The phrase 'tinted steam' was used by John Constable to describe Turner's exhibits at the 1836 Royal Academy exhibition; see letter from Constable to George Constable, 12 May 1836, in Beckett 1967, pp.32–3: 'Turner has outdone himself – he seems to paint with tinted steam, so evanescent and so airy.' This letter was first published in C.R. Leslie's widely circulated *Memoirs of the Life of John Constable* (1843/1845).

2 See e.g. Thoré 1859, p.12; Thoré 1870, I, p.356, reprinting review of the 1862 London International Exhibition; Mantz 1866, p.738; Chesneau 1882, pp.154–5.

3 Letter from Whistler to Fantin-Latour, ?Sept. 1867 LC PWC 1/33/25, GUW 08045.

4 Letter from Monet to Bazille, Dec. 1868 (Wildenstein 1974–91, I, letter 44): 'On est trop préoccupé de ce

que l'on voit et de ce que l'on entend à Paris, si fort que l'on soit, et ce que je ferai ici a au moins le mérite de ne ressembler à personne, du moins je le crois, parce que ce sera simplement l'expression de ce que j'aurai ressenti, moi personnellement.'

5 Bloom 1973, p.5. Bloom's six models of influence, outlined on pp.14–16 – 'revisionary ratios', as he calls them – offer a thought-provoking framework for the consideration of these issues.

6 Pollock 1992, pp.12–16.

7 Gage 1983a, pp.50–1.

8 Taine 1872, pp.332–3: 'sa peinture est devenue folle . . . [His late works] sont un gâchis inextricable, une sorte d'écume fouettée, un fouillis extraordinaire où toutes les formes sont noyées. Mettez un homme dans un brouillard, au milieu d'une tempête, avec le soleil dans les yeux et le vertige dans la tête, et transportez, si vous pouvez, son impression sur la toile; ce sont les visions troubles, les éblouissements, le délire d'une imagination qui se détraque à force d'efforts' (*Notes sur l'Angleterre*, Paris 1872, pp.350–1).

9 Goncourt 1979, p.412: 'il descendait un peu de cette hallucination du grand Turner, qui, sur la fin de sa vie, blessé par l'ombre des tableaux, mécontent de la lumière peinte jusqu'à lui, mécontent même du jour de son temps, essayait de s'élever, dans une toile, avec le rêve des couleurs, à un jour *vierge et primordial*, à la *Lumière avant le Déluge*.' The picture title is presumably a mistaken memory of *Light and Colour (Goethe's Theory) – The Morning after the Deluge – Moses Writing the Book of Genesis*, shown at the Royal Academy in 1843 and part of the Turner Bequest (B&J 405).

10 See e.g. Thoré 1859, pp.12–16; Chesneau 1864, p.91, reprinting review of the 1862 London International Exhibition; Thoré 1870, I, p.361, reprinting review of the 1862 London International Exhibition; Silvestre 1926, p.46; Mantz 1866, p.739; Blanc 1867 in Blanc 1876, p.489.

11 Thoré 1859, pp.12, 14; Chesneau 1864, p.93.

12 Thoré 1857, pp.426–7; Viardot 1860, p.43; Chesneau 1864, p 92.

13 Chesneau 1864, p.92.

14 See e.g. Blanc 1857, p.140; Thoré 1857, p.415. On Constable's reception in France, see Feaver 2002, pp.47–56.

15 Dubosq de Pesquidoux 1858, pp.215–16 (this essay was reprinted verbatim in *L'Artiste*, Sept. 1871, pp.358–71): 'Les Anglais et nous, nous n'avons pas le même criterium. Ils admirent, ils vantent beaucoup ce qu'ils appellent la nature métaphysique, le mystère, la magnificence de Turner, et c'est précisément ce que nous critiquons.'

16 Chesneau 1864, p.94: 'réalité éblouissante . . . imagination passionnée'.

17 Thoré 1859, p.14: 'l'infinité de la nature . . . panthéisme poétique'.

18 Thoré 1870, p.360, reprinting review of the 1862 London International Exhibition: 'cherchant partout des sujets fantastiques, grandioses, héroïques, splendides, où le ciel, la mer et la terre puissent être en quelque sort créés à neuf par son génie. La nature telle qu'elle est lui semblait morne, et le soleil ordinaire un peu pâle. Sa peinture est une féerie où les éléments sont exaltés à leur suprême puissance.'

19 For instance, *Towing a Boat, Honfleur* 1864 (Memorial Art Gallery of the University of Rochester, Rochester, New York; W 37); *The Seine at Bougival, Evening* 1869 (Smith College Museum of Art, Northampton, Mass.; W 151).

20 See 'The National Gallery', *Art Journal*, June 1869, p.183.

21 See letters from Pissarro to Lucien Pissarro, 20 Feb., 25 [June], 10 Nov. 1883 (Bailly-Herzberg 1980–91, I, letters 119, 164, 188).

22 Ménard 1872, p.283: 'tous montrant le génie de l'artiste dans ce qu'il y a de plus secret et de plus profond.' I am indebted to Ian Warrell for assuring me that these would have been watercolours that remained from the displays of Turner's work at South Kensington; Ménard does not indicate their medium.

23 See Wornum 1871, pp.158–9.

24 For identification of the site see Reid 1977, pp.251–7; for photographs of the site see Reed 1993.

25 See House 1978, pp.641–2. The landscapist Charles-François Daubigny, who was closely in touch with Monet in London in 1870–1, had known Whistler at least since 1865, and Whistler appears in his London address book.

26 Published in May 1871, but after Monet had painted the pictures.

27 Following Daniel Wildenstein's suggestion that *Impression, Sunrise* was painted in 1873 (W 263), it has been suggested that Monet's canvas reflects the influence of Whistler's work as displayed in this exhibition (see e.g. Geneviève Lacambre, 'Whistler and France', in Dorment and MacDonald 1994, p.44). However, there seems no reason to doubt the accuracy of the date, '72', that *Impression, Sunrise* bears; its handling is fully consistent with other canvases executed in 1872, such as *The Wooden Bridge* (Rau Foundation, Alexandria, Virginia; W 195).

28 Unidentified press cutting (GUL), quoted in Young, MacDonald, Spencer and Miles 1980, I, p.84: 'strictement d'un seul ton, ou bleu verdâtre, ou jaune clair'; on this exhibition see also Geneviève Lacambre, 'Whistler and France', in Dorment and MacDonald 1994, pp.44–5.

29 Robin Spencer in Fine 1987, pp.56, 62 n.34.

30 On this show see Spencer 1987a, pp.27–49.

31 See e.g. Thoré 1859, p.4; Mantz 1866, p.738; the contemporary French translations of the title of *Sun Rising through Vapour* also suggest comparison with *Impression, soleil levant*: Thoré named it *Soleil se levant au milieu du brouillard*, Mantz *Soleil se levant dans le brouillard*, and Viardot *Soleil levant dans le brouillard* (Viardot 1860, p.43).

32 Close examination of *Impression, Sunrise* confirms that it was executed in a single session before any of the underlying layers of the painting had time to dry; analysis of its surface is complicated by the traces of a previous painting on the canvas, of an unrelated subject, that can now be seen through its thin paint-layers. By this date, the term *impression* was widely used to describe rapidly painted notations of transitory atmospheric effects.

33 Chesneau 1874, reprinted in Berson 1996, I, p.18: 'soleil levant sur la Tamise'.

34 In 1876 Emile Blémont wrote: 'Turner created orgies of blue; Monet sometimes creates rainbow-coloured orgies' ('Turner a fait des orgies de bleu; M. Monet fait parfois des orgies d'arc-en-ciel'); in 1882, J.-K. Huysmans compared Renoir's use of colour to Turner. Texts reprinted in Berson 1996, I, pp.63, 397.

35 In this context it is interesting that Berthe Morisot, on first seeing the Turners in the National Gallery in 1875, saw clear analogies between Whistler and Turner, writing: 'Whistler, whom we so liked, imitates [Turner] enormously' (letter from Morisot to Edma Morisot Pontillon, summer 1875, in Rouart 1950, p.88: 'Whistler que nous aimions tant l'imite énormément').

36 Letter from Monet to Théodore Duret, 8 March 1880 (Wildenstein 1974–91, I, letter 173): 'trop de mon goût à moi et elle serait refusée.'

37 On this story see B&J 398, and Gage 1987, pp.67–8, 247 n.68.

38 See Merrill 1992, pp.178, 376–7 nn.45–7, 396 n.7.

39 See Levitine 1967.

40 See House 1986a, pp.17, 20–6, 140–3.

41 Letter from Monet to Théodore Duret, 9 Dec. 1880, (Wildenstein 1974–91, I, letter 203).

42 Letter from Monet to Théodore Duret, 25 Oct. 1887 (Wildenstein 1974–91, III, letter 797): 'je voudrais même essayer d'y peindre quelques effets de brouillard sur la Tamise.'

43 'Un groupe de peintres français, unis des mêmes tendances esthétiques, luttant depuis dix ans contre les conventions et les routines pour ramener l'art à l'observation scrupuleusement exacte de la nature, s'appliquant avec passion à rendre la réalité des formes en mouvement, ainsi que les phénomènes si fugitifs de la lumière, ne peut oublier qu'il a été précédé dans cette voie par un grand maître de l'école anglaise, l'illustre Turner.' The signatories of the letter were Monet, Pissarro, Renoir, Degas, Boudin, John Lewis Brown, Morisot, Cassatt and Sisley; it can be dated from the mention of an exhibition of their work in King Street, which took place in July 1882. The letter was first published in French and English in the catalogue, *Exhibition of Nineteenth Century French Painters,* Knoedler and Company, Bond Street, June–July 1923. On the letter see Shanes 1994, p.173. No Impressionist exhibition was mounted at the Grosvenor Gallery; however, in April 1883 the Dowdeswell Gallery in London mounted a substantial exhibition of their work, co-ordinated by the Paris dealer Durand-Ruel.

44 Chesneau 1882, p.162: 'Turner n'a point assez regardé la nature . . . Turner ne peignait point le soleil qu'il avait sous les yeux, mais celui qu'il rêvait.'

45 Koechlin 1927, p.33: 'cette oeuvre, il ne le cachait pas dans ses propos familiers, lui était antipathique par l'exubérant romantisme de sa fantaisie.'

46 Fels 1927, pp.101–2: 'Toute sa vie Monet répéta que Turner était un mauvais peintre.'

47 Moore 1914, p.158.

48 Gimpel 1963, p.88: 'Dans le temps j'ai beaucoup aimé Turner, aujourd'hui je l'aime beaucoup moins – il n'a pas assez dessiné la couleur et il en a trop mis. Je l'ai beaucoup étudié.' Another version of this comment is recorded in Gimpel 1927, p.174: 'He admired Turner very much when he saw his paintings in London, but today he considers that Turner did not draw sufficiently in the colour – that he did not give enough form to it.'

49 Rashdall 1888, p.196, reprinted in Flint 1984, p.307.

50 Theodore Robinson, Diary, 5 Sept. 1892, quoted in Lewison 1963, p.211.

51 Rutter 1927, cited in Shanes 1994, p.20.

52 Letter to Wynford Dewhurst, 6 Nov. 1902 (published in Dewhurst 1903, p.94, quoted in Bailly-Herzberg 1980–91, V, p.283): 'Les aquarelles et les peintures de Turner, les Constable, les Old Chrome [sic], ont eu certainement de l'influence sur nous. Nous admirions Gainsborough, Lawrence, Reynolds, etc. mais nous étions plus frappés par les paysagistes, qui rentraient plus dans nos recherches du plein air, de la lumière et des effets fugitifs.'

53 Dewhurst 1904, p.61.

54 Letter to Lucien Pissarro, 8 May 1903 (Bailly-Herzberg 1980–91, V, letter 2016): 'il dit . . . qu'avant d'aller à Londres, nous n'avions pas idée de la lumière, cependant nous avons des études qui montrent le contraire, il supprime l'influence de Claude le Lorrain, Corot, tout le XVIIIe siècle, Chardin surtout, mais ce dont il ne se doute pas c'est que Turner, Constable, tout en nous servant nous ont confirmé que ces peintres n'avaient pas compris l'analyse des ombres qui chez Turner est toujours un parti-pris d'effet, un trou. Quant à la division des tons, Turner nous a confirmé sa valeur comme procédé, mais non comme justesse ou nature, du reste le XVIIIe siècle était notre tradition. Il me semble que Turner avait aussi regardé Claude le Lorrain, et il me semble même qu'il y a un tableau, Soleil couchant, mis côte à côte avec un Claude?'

55 Letter to Lucien Pissarro, 6 Sept. 1888 (Bailly-Herzberg 1980–91, II, letter 505): 'N'est-ce pas idiot de ne pas avoir de Turner?'

56 Gsell 1892, p.404: 'Il me semble que nous descendons tous de l'anglais Turner. Ce fut lui le premier, peut-être, qui sut faire flamboyer les couleurs dans leur éclat naturel.'

57 Letter to Clément-Janin, 19 Feb. 1892 (Bailly-Herzberg 1980–81, V, letter 2075): 'Notre voie commence au grand peintre anglais Turner, Delacroix, Corot, Courbet, Daumier, Jongkind, Manet, Degas, Monet, Renoir, Cézanne, Guillaumin, Sisley, Seurat! Voilà notre marche.'

58 For these exhibitions see Gage 1983a, pp.52–3.

59 Letter to Lucien Pissarro, 23 June 1894 (Bailly-Herzberg 1980–91, III, letter 1017).

60 Geffroy 1894, p.64, reprinting essay of 8 December 1891 about J.-B. Jongkind: 'avec l'éblouissement du grand Turner dans les yeux.'

61 Lecomte 1892, pp.23–4. Lecomte's account repeats the widespread misconception that the effect of Impressionist painting was based on distinct juxta-posed touches of colour being mixed in the eye of the viewer, and described Turner's art as 'restricted to the colours of the prism alone': 'Fort intéressés par l'oeuvre de Turner qui s'était restreint aux seules couleurs du prisme, ils y trouvèrent la confirmation définitive de leurs recherches. Turner restituait les influences des couleurs les unes sur les autres par la juxtaposition des touches. Le mélange s'en effectuait sur la rétine.' Accounts such as this of Impressionist colour can be traced back to Edmond Duranty's pamphlet, La Nouvelle Peinture, of 1876 (see House 2004, chap.5).

62 Geffroy 1894, pp.16–17: 'une éruption de lave, une coulée incandescente . . . la joie d'apercevoir que ce que l'on cherche a déj hanté un autre esprit'.

63 Ibid., p.6: 'Il y a la prescience de ce que cherche Turner dans l'Embarquement pour Cythère de Watteau, autant que dans les toiles cuites et dorées de Claude Lorrain.'

64 Ibid., p.18.

65 Letter to Esther Isaacson, 5 May 1890 (Bailly-Herzberg 1980–91, II, 1986, letter 587).

66 Gsell 1892, p.404: 'le vrai poème de la campagne.'

67 On Monet, see House 1986a, esp. pp.150–3, 171–7; on Pissarro, see House 1986, pp.17–26.

68 Rashdall 1888, p.196, reprinted in Flint 1984, pp.307–8.

69 Rood 1879, p.279.

70 Bijvanck 1892, p.177: 'n'acquièrent toute leur valeur que par la comparaison et la succession de la série entière'.

71 On Monet's series see House 1986a, esp. pp.193–204, 211–16.

72 Geffroy 1894, p.16: 'Dans la brume qui pèse si lourde-ment sur la houle de la Tamise, Turner avait vu des irisations, des flamblaisons [sic] soudaines de soleil, il avait voulu exprimer ces écroulements de pierreries dans l'atmosphère, et il avait réussi, parfois, à donner la sensation de ces spectacles de féeries qui se jouent dans l'air.'

73 Turner's paintings of the fire are not mentioned in the first French monograph on Turner, Hamerton 1889, or in other French publications before 1900.

74 Kahn 1904, p.84: 'deux dates d'une histoire de la sensibilité visuelle.'

75 Geffroy 1924, II, p.133: 'Les toiles de Monet sont d'une lumière plus unifiée, d'une coloration plus soutenue dans la clarté, n'ont pas les aspects de cuisson, de feu, d'émail, du grand paysagiste anglais, admirable précurseur de la peinture de paysage moderne.'

76 Chesneau 1882, pp.156–7: 'Turner a reproduit les plus grands phénomènes de l'atmosphère dans les pays de brouillard. Mais cette brume, à la longue, lui a donné le spleen et la nostalgie des clartés incandes centes. Les tempêtes du ciel dans les montagnes ou dans les mers du Nord, les sérénités grises ne lui suffisant plus, c'est aux pays du soleil qu'il est allé demander la pleine réalisation de ses rêves de lumière.' This passage first appeared in Chesneau's review of the London International Exhibition of 1862 (Chesneau 1864, p.92).

77 Gimpel 1963, p.88: 'il n'a pas assez dessiné la couleur et il en a trop mis.'

THE POETICS OF POLLUTION
Jonathan Ribner
(pp.51–63)

This essay owes much to Katharine Lochnan and to the other contributors to this publication. I gratefully acknowledge the opportunity to work at the Yale Center for British Art, supported by a Visiting Fellowship in January 2003.

1 Gimpel 1966, p.73.

2 Fumifugium: or the Inconvenience of the Aer and Smoake of London Dissipated, reprinted in Lodge 1969, pp.14–15. I am grateful to Susan Brady, librarian at the Yale Center for British Art, for bringing to my attention B. Freese, Coal: A Human History, Cambridge, Mass. 2003.

3 Brimblecombe 1987, p.113.

4 The Natural History and Antiquities of Selborne (1788), ed. Sir W. Jardine, London 1853, pp.303–4.

5 Frend 1819, p.62.

6 Rodner 1997, chap.5.

7 Quoted in Ashby and Anderson 1981, p.2.

8 For British air pollution reform see Brimblecombe 1987, Ashby and Anderson 1981, and Wohl 1983, chap.8. For smoke abatement technology, see also Flick 1980, pp.29–50.

9 Quoted in Wilson 1955, pp.171–2.

10 Brimblecombe 1987, p.125.

11 Ibid., pp.11–12. The fog returned, with a vengeance, for five days in December 1952: see Bernstein 1975, pp.189–206. That the type of fog admired by Monet had already vanished by the time of the 1956 Clean Air Act is pointed out in Seiberling 1988, p.52.

12 Bernstein 1975, pp.189–206.

13 Wohl 1983, p.213.

14 Ashby and Anderson 1981, p.55.

15 The accompanying doggerel verse complains of the resulting social ills (river traffic halted, pubs full, theatres and schools empty) and the impact on public health: 'Such mischiefs were not small, but, oh dear, that wasn't all, for the death-rate was most dismally increased. / King Fog's a foe to life. Sudden suicides were rife, / and asthmatic age's gaspings grew – and ceased.' Punch, 21 Jan. 1888, pp.26–7.

16 Wohl 1983, p.21. The amount of coal carried to London by rail, sea and canal increased from 9,919,567 tons in 1880 to 15,746,003 tons in 1900. See Smith 1961, p.339.

17 'Smog' was coined by Dr H.A. Des Voeux of the Coal Smoke Abatement Society. The term eventually assumed its current, and quite different, usage, designating automotive exhaust catalysed by sunlight. That kind of smog – the Los Angeles variety – was not identified in London until the 1970s (Bernstein 1975, p.193).

18 Gimpel 1966, p.73.

19 Earlier, such conditions had been lamented by Daubigny – who, like Monet, found refuge in London during the Franco-Prussian War. In a letter of 15 Oct. 1870 to the painter Jules de La Rochenoire, the displaced Barbizon artist told his friend across the Channel: 'Je suis forcé d'interrompre votre lettre pour allumer une bougie: il est 11 heures du matin. Voilà pour le climat. Brouillard à ne pas voir à deux pas.' (Quoted in Etienne Moreau-Nélaton, Daubigny raconté par lui-même, Paris 1925, p.102). In contrast to the frustrated Monet, the British painter Sir William Richmond responded to such conditions with indigna-tion. Unable to read, let alone draw or paint, in the black fog cloaking London on 17 November 1898, Richmond wrote to The Times urging the vestries of London parishes to use the power, granted to them by the Public Health (London) Act of 1891, to prose-cute smoke polluters. For Richmond's letter, which sparked a wave of activism culminating in the Clean

Air Act of 1956, see Ashby and Anderson 1981, pp.83–4.

20 Letter to Alice Monet, 4 March 1900 (Wildenstein 1974–91, IV, letter 1523): 'en me levant j'étais terrifié de voir qu'il n'y avait aucun brouillard, pas même l'ombre de brume; j'étais anéanti et voyais déjà toutes mes toiles fichues, mais petit à petit, les feux s'allument, la fume et la brume sont revenues.'

21 *L'Anglais à Paris, comédie en deux actes et en prose, représentée pour la première fois, à Paris . . . le 12 mars 1783, par M. D' . . . l'aîné*, Paris 1787: 'Je n'aime pas les brouillards'.

22 Denège 1906, p.18: 'il faut recouvrir d'un manteau toutes les parties susceptibles de la toilette, autrement elles sont perdues . . . Quand on le respire, on tousse comme si on avait respiré le soufre d'une allumette . . . nouveau, et fort divertissant . . . J'ai payé d'une dizaine de jours au lit ma curiosité et mon imprudence à l'affronter.'

23 'News from our Parisian Correspondents,' *Courrier de l'Aisne*, 9 June 1904, trans. and reprinted in Stuckey 1986, p.225.

24 France 1883, p.1: 'Une tache d'huile jaunâtre, qui graisse d'une teinte rousse le brouillard chargé de la suie de huit cent mille cheminées et des haleines de trois millions de poitrines, jette sa lueur blafarde.'

25 Ibid., pp.1–2: 'C'est la noire saison du spleen, et bientôt . . . on entendra des coups de pistolet solitaires ou le râle étranglé de pendus, tandis que, le soir, contre les arches de *London-Bridge*, la Tamise heurtera le crâne des noyés.' See also Texier 1851, p.6: 'Rien n'est plus lugubre que la physionomie de Londres par un jour de brouillard, de pluie ou de froid. C'est alors que le spleen vous enlace. Ces jours-là cette immense cité a un aspect effrayant. On s'imagine errer dans une nécrople, on en respire l'air sépulcral.'

26 Jupilles n.d. [c.1886], p.8: 'Non seulement l'obscurité vous gêne, dans un brouillard londonnien, mais encore le goût et l'odorat sont affectés péniblement par ce bizarre composé de fumée de houille, d'odeurs de vase et d'œufs pourris, et tous les objets deviennent gras et visqueux au toucher.'

27 Ibid., p.1: 'paradis de pickpockets'.

28 Ibid., p.4: 'Le brouillard qui couvre d'un voile épais et nauséabond la capitale d'Albion est aussi favorable que possible aux attentats de tout sorte.'

29 I thank Katharine Lochnan for bringing this print to my attention. For earlier examples of this theme see Bill Luckin, citing *The Times* of 24 Dec. 1818 and 31 Oct. 1821, Luckin 1997, p.8.

30 The location of this horrid vision in the blighted atmosphere of London is reiterated in the accompanying text: 'There is no light along those winding ways / Other than lurid gleams / like marsh-fires fleeting; . . . June noonday has no power upon its gloom / More than the murky fog-flare of December; / A Stygian darkness seems its settled doom', *Punch*, 20 Sept. 1888, pp.150–1.

31 Despite the fact that the fog of October 1888 may have kept the murderer off the streets (according to Beadle 1995, pp.60, 63), the association of Jack the Ripper with London's fog has endured, as in Marx 1987, p.36. I am grateful to my colleague at Boston University – the Ripper authority, Martin Fido – for informing me that, while there was a mist when one

of the bodies was discovered, the murderer did not work under the cover of fog.

32 The meteorologist F.J. Brodie estimated that each year of the period 1886–90 London had seventy-four days of fog, plus or minus eleven (Brimblecombe 1987, p.111).

33 St John 1854, I, pp.24, 94–5.

34 Ludovici 1926, p.23: 'Regarde, nouveau, le beau soleil, tu n'en as jamais vu comme cela dans ton pays de brouillard.' Having lived in London, Ludovici was well aware that this Gallic jesting had a core of truth (p.188): 'One had to be continually washing one's hands, and the fogs in November and during the winter were of the real black and yellow variety, and often lasted for days. Boys would go about with torches to help citizens find their streets and homes. It is not surprising that Americans and other foreigners would never think of staying longer in London than their business obliged them to do, but would rush across to Paris out of the cold, foggy atmosphere. No wonder!'

35 'C'est pour ne pas l'oublier.' According to O'Rell, while London's pea-soup fogs are not as frequent as the French imagine, some fog is almost always present in the British capital (O'Rell 1883, p.87).

36 Quoted in John House, 'Monet: The Last Impressionist?', in Tucker 1998, p.9: 'pas assez londoniennes'.

37 Bernhardt 1906, p.7: 'Certains Français tenaient énormément à être témoins de ce phénomène. Ils avaient prolongé leur séjour à Londres jusqu'au mois de novembre dans l'espoir d'assister *aux ténèbres*.'

38 John House, 'The Impressionist Vision of London', in Nadel and Schwarzbach 1980, p.85. See ibid., p.85 for British illustrated publications of the 1890s which indicate that by this time modern London was typically represented cloaked in thick atmosphere.

39 See Herbert 1994. Virginia Spate makes the point that Monet's London paintings 'lay somewhere between the tourist series of the 1880s and his series of intimately known landscapes, for they were impregnated with time and with memory' (Spate 1992, p.246).

40 In this period London had an oppressive aspect, which, as French travellers remarked, diminished by the end of the century. See Gerbod 1995, pp.79–80.

41 See Seznec 1964.

42 For Doré's London see I.B. Nadel, 'Gustave Doré: English Art and London Life' in Nadel and Schwarzbach 1980, pp.152–62; and S.F. Clapp, 'Doré in London,' in Warner et al. 1987, pp.164–70.

43 Huysmans 1959, pp.132–4: '[U]n Londres pluvieux, colossal, immense, puant la fonte échauffée et la suie, fumant sans relâche dans la brume . . . Tout cela s'agitait sur des rives, dans des entrepôts gigantesques, baignés par l'eau teigneuse et sourde d'une imaginaire Tamise, dans une futaie de mâts, dans une forêt de poutres, crevant les nuées blafardes du firmament, pendant que des trains filaient, à toute vapeur, dans le ciel, que d'autres roulaient dans les égouts, éructant des cris affreux, vomissant des flots de fumée par des bouches de puits.' Quoted in Gerbod 1995, pp.80–1. This passage is quoted in association with Doré's *London* in Warner et al. 1987, p.163.

44 At the same time, it was from the perspective of the London Sublime that Gustave Kahn viewed the London paintings. For Kahn, the series was charged with reference to sin and death – the sun 'spreads like brimstone, like the sulfurated smoke over Gomorrah' and the Thames is likened to the Styx and the Phlegethon (Kahn 1904, trans. and quoted in Stuckey 1986, pp.227–8).

45 Returning to Paris after witnessing the immensity of London and the Thames, one Frenchman remarked: 'Je me croyais débarqué dans une paisible ville de province: la Seine, en mon absence, s'était réduite aux modestes proportions d'un joli ruisseau' (Wey 1856, p.314).

46 The number of passengers leaving French ports for England quadrupled between 1851 and 1905 (Gerbod 1995, p.72).

47 Mourey 1895, pp.71–4, quoted in Gerbod 1995, pp.84–5: 'Brouillard, fumé et vitesse [*sic*]: le chef d'oeuvre de Turner s'évoque à mes yeux . . . Tout à l'heure, disque de crème en liquéfaction, le soleil s'écoulait par traînées jaunâtres, éparpillant des reflets de neige salie . . . Et le voici qui s'éclipse de nouveau: tout redevient terne et morne . . . De nouveau, le soleil flambe, crevant la brume. L'eau miroite en larges nappes de plomb liquide striées d'or. Une ville de féerie surgit des flots: toute se colore et chante dans une apothéose de lumière.'

48 Pierret 1902, p.255: 'Et le Turner que j'avais jugé extravagant à Paris, je l'avais retrouvé magnifique et vrai comme la nature, sur le pont de Westminster.'

49 Ibid., pp.253–5: 'Ce rayon n'éclairait pas un point précis du paysage, comme nous avons coutume de le voir dans notre pays, mais il s'étalait en nappe, divisé à l'infini, sortant d'un nuage pour entrer dans le brouillard, brouillard très différent des autres, le brouillard londonien, fumés transparents, molles, flottantes, en même temps épaisses et lumineuses.' The passage continues: 'La masse noire, carrée, aux solides attaches, du colossal palais du Parlement, s'enlevait dans ces limbes avec des couleurs incertaines, comme un vague château de rêve entrevu dans le sommeil; derrière cette forêt de pierres fuligineuses et tremblantes comme la feuille, s'apercevaient, plus enveloppés encore d'incertitude, les profiles perdus de la Tour de Londres, des clochers de l'abbaye de Westminster. Et la vision s'étendait à l'infini, de la ville immense, prochaine et lointaine, de la ville ouvrière, charbonneuse, commerçante et trafiquante, aux milliers de bateaux marchands ancrés à son port, dont la vie coulait à mes pieds, par des millions d'hommes, tandis que ses palais, ses églises, ses clochers, ses tours, ses maisons, ses usines et ses cheminées, apparaissaient sans consistence, sans assises et sans fondements, perdus et confondus, semblables aux hallucinations d'une imagination délirante. Les eaux glisssantes de la Tamise, luisant dans la pénombre du crépuscule, dénouaient leur longue écharpe silencieuse et moirée. Dans le chaos de ces formes insaisissantes et fuyantes, tout n'était que dégradation, tonalitiés évanescentes, et reflets.'

50 John House, 'Monet: The Last Impressionist?', in Tucker 1998, pp.9–10.

51 Letter of 23 or 24 July 1863 (Mallarmé 1959, I, p.92, and quoted in Millan 1994, p.74 n.50): 'je hais Londres quand il n'ya pas de brouillards; dans ses brumes, c'est une ville incomparable.'

52 Barbier 1968–79, VI, p.162: 'il n'y a de vrai, d'immuable, de grand, et de sacré que l'Art.'

53 Letter of 13 or 14 Nov. 1862 (Barbier 1968–79, VI, p.65): 'Dans ma chambre le charbon de terre m'asphyxiait, et, si j'ouvrais la fenêtre, le brouillard sale de novembre m'emplissait les poumons.'

54 Translated in Millan 1994, pp.88–9.

55 *Punch*, 30 Jan. 1869, p.35.

56 'The Storm-Cloud of the Nineteenth Century', *Works*, XXXIV, pp.39–40. See Wheeler 1995 and Fitch 1982. Ruskin was not alone in his moral interpretation of the darkening sky. Between the 1870s and the beginning of the twentieth century, the bank of black cloud seen over London from the countryside was broadly associated with the evils of urbanism per se, as well as with the ruin of the atmosphere. See Luckin 1997, p.90.

57 Victorian London's water was supplied by eight private companies that drew from the Thames and the Lea. While legislation of 1852 required water drawn within five miles of St Paul's Cathedral to be stored and filtered by water companies prior to delivery, and after 1855 the companies were no longer permitted to draw from the region of London pollution, ratepayers remained vulnerable. For example, a brief distribution of unfiltered water in 1866 by the East London Company caused a cholera epidemic in East London that year; and in 1868 the Southwark Company's Battersea reservoir was still connected to the tidal Thames by an old conduit to Battersea Reach. Hardy 1993, p.160. See also Hardy 1991, pp.76–93.

58 See Halliday 1999. Public attention to the river's pollution was sensationally rekindled in 1878, when the passenger-laden *Princess Alice* sank in the filthy water near the sewer outfalls. See Wood 1982, pp.39–41. The legacy of the Great Stink, together with fears of fog poisoning, reverberates in the novel *After London; or, Wild England* by Richard Jefferies (1885). In this post-apocalyptic fantasy London has been destroyed, its place taken by a poisonous swamp surrounded by a lethal cloud: 'They say the sun is sometimes hidden by the vapour when it is thickest, but I do not see how any can tell this, since they could not enter the cloud, as to breathe it when collected by the wind is immediately fatal. For all the rottenness of a thousand years and of many hundred millions of human beings is there festering under the stagnant water, which has sunk down into and penetrated the earth, and floated up to the surface the contents of the buried cloacae.' (Jefferies 1975).

59 See Ribner 2000.

60 The reference is to a work exhibited at the 1858 Royal Academy exhibition by the distinguished marine painter Edward William Cooke, *A Sniff of the Briny – Day after a Gale*. This painting, listed in *The Exhibition of the Royal Academy of Arts, MDCCCLVIII, The Nineteenth*, exh. cat., London 1858, no.447, is not mentioned in Munday 1996.

61 'The Thames in its True Colours,' *Punch*, 3 July 1858, p.4. Katharine Lochnan brought this item to my attention.

62 Quoted in Williams 1987, p.23.

63 Moral outrage can even be detected simmering beneath the relentless statistics of the Benthamite Edwin Chadwick's *Report on the Sanitary Condition of the Labouring Population of Great Britain* (1842). Those who live amid bad sanitary conditions, Chadwick maintained, become 'reckless, intemperate, and with a habitual avidity for sexual gratification' (quoted in Williams 1987, p.79).

64 For *Wapping*, see Warner et al. 1996, no.27, entry by Charles Brock; Dorment and MacDonald 1994, no.33; Warner et al. 1987, no.155; Lochnan 1984; YMSM 35. For the comic aspect of the painting, as originally conceived, see Pyne 1994, pp.61–77.

65 For Haussmann's sewers see Reid 1991 and Pinkney 1958, chap.6.

66 See Lees 1973, I, pp.413–28.

67 '[A]nd now that it has taken to snowing I begin rather to wish myself back in my own lovely London fogs! They are lovely those fogs – and I am their painter!' Undated letter (Oct. or Nov. 1879) to the artist's sister-in-law, Helen Whistler (GUL MS Whistler W680, GUW 06686). Quoted in MacDonald 2001, p.141.

68 For the literary tradition in which Byron, Ruskin and others associated Venice with decline see Dieterle 1995. See also Evans 1992.

69 Here, for example, is Henry William Clifford (1825–87) in May 1858: 'The stink is almost intolerable in our Hotel and indeed everywhere owing to the wind – obliged to buy pastilles to stink out the stink . . . [We] returned to our rooms and found them stinking like a pest house. Venice is a stinking hole, it has lost all its romanticity in my eyes.' For this (p.81) and other examples (pp.74, 142, and 173) of such complaints see the valuable compendium, Motyka 1990. For Venice and the physicians see Stolberg 1996, pp.66–8.

70 See Grieve 2000, pp.114–16. The indispensable authority on this issue is Stolberg 1996.

71 In addition to Stolberg 1996, see Peruzza, Randolfi, Romanelli et al. 1980. For a recent history of nineteenth-century Venice, see Plant 2002.

72 See Franco Mancuso, 'Il patrimonio di Venezia città industriale. Dalla formazione al riuso', in Peruzza, Randolfi, Romanelli et al. 1980, pp.37–48. The conversion of the belltower took place by 1845, the date of the comments by tourists mentioned by Stolberg 1996, pp.62–3. I am grateful to Dr Camillo Tonini of the Museo Correr for providing a photograph of the print, which is included in the album 'Souvenir de Venise' in the collection of the Gabinetto di Stampe e Disegni (Cl. III, n.5933, Tav. 80).

73 There were 100 smithies active in 1869; 100,000 carnival masks were produced in 1866 (Stolberg 1996, pp.77–8). In Venice Whistler made an unfinished etching of a smithy, reproduced in MacDonald 2001, p.73.

74 According to Cipolla (1992, p.7), in the fifteenth century, Northern Italian sanitary reformers were guided by the same miasmatic paradigm that later informed the work of the Victorians.

75 Stolberg 1996, p.73. Complaints about a fertiliser plant on the Giudecca were frequently voiced in printed the paper *La Venezia* during the artist's stay (Grieve 2000, p.116).

76 Quoted in Lochnan 1984, p.187.

77 James 1992, p.11. Lady Elizabeth Eastlake, who visited Venice in September 1852, also expressed willingness to overlook the city's discomforts: 'be it what it may – let its people cheat, its mosquitoes sting, and its canals stink – it is unique in beauty!' Quoted in Motyka 1990, p.178.

78 Here I follow the lead of Hugh Honour and John Fleming, who indicated the affinity between Whistler's Venetian etchings and the author's 1881 account of his enjoyment of seeing Venetians posed before some 'great shabby façade of Gothic windows and balconies – balconies on which dirty clothes are hung and under which a cavernous-looking doorway opens from a low flight of slimy steps. It is very hot and still, the canal has a queer smell, and the whole place is enchanting' (quoted in Honour and Fleming 1991, pp.68–9).

79 See Grieve 2000, p.114.

80 See *Venice: Sunset* (Freer Gallery of Art, Smithsonian Institution, Washington, DC), *Sunset: Red and Gold – Salute*, and *Salute – Sundown* (both in the Hunterian Art Gallery, University of Glasgow), reproduced, respectively, in Grieve 2000, pp.109–10, figs.137–9.

81 For the Stucky mill, see Plant 2002, pp.173–4.

82 For Monet's handling of the less-than-pristine environment at Argenteuil see Clark 1984, chap.3.

83 See, for example, Brooke 1991, Knight 1986, and Lightman 1997.

84 The pollution of the Thames is associated with the 'moral panic' engendered by the Indian Mutiny in Nead 1988, p.121.

85 'For many reasons Englishmen are almost afraid to speak of the Thames. They . . . by common consent let alone their great river, which they have changed into a sewer. The French have not quite the same reason for silence. No Arab talks with more respect of the Nile than the Parisian of the Seine', St John 1854, I, p.26. For water supply, see Hassan 1998 and Goubert 1989.

86 See Corbin 1982.

87 Mirbeau 1904, p.8: 'splendides féeries de lumière.'

1 TURNER'S LEGACY: THE ARTIST'S BEQUEST AND ITS INFLUENCE
Ian Warrell
(pp.67–73)

This article is inevitably only a brief overview of the history of the Turner Bequest since it was acquired by the British nation in 1856. See also Cook and Wedderburn in *Works*, XIII, pp.xxii–lx; Finberg 1909, I, pp.v–viii; Warrell 1995, pp.21–8; Whittingham (various).

1 *Art Journal*, Obituary, Jan. 1852, p.47. Comparable opinions were expressed in many other obituaries.

2 Ruskin, *Modern Painters*, III (*Works*, V, p.4). By Charing Cross, Ruskin meant the basement of the National Gallery, in Trafalgar Square. For a concise summary of the Court of Chancery's ruling on Turner's will, see Joll, Butlin and Herrmann 2001, pp.382–4.

3 Throughout his career, there were many objections to Turner's lack of finish. See Finberg 1961, pp.99, 125–6, 168–9, 241, 336, 343, 370, 378, 390.

4 See *Works*, III–VII (1843–1860).

5 Thornbury 1862, I, pp.ix–x.

6 See, for example, Lady Eastlake's review of Thornbury's biography in the *Quarterly Review* (vol.3, April 1862, pp.450–82), which is overtly critical of Ruskin. Ironically, Thornbury ended his biography with an attempt to distance himself from some of Ruskin's opinions (Thornbury 1862, II, p.348). Several years before this, in 1856, reservations about the position Ruskin had assumed as Turner's interpreter had been expressed by Fredrick Pollack, and the writer of an anonymous letter to *The Times*, which was signed by 'A Turnerite' (see Warrell 1995, pp.21–2).

7 See A.J. Finberg's unsigned review of the biographies of Turner by Walter Armstrong, Charles Alfred Swinburne and Robert Chignell, in the *Edinburgh Review or Critical Journal*, no.406, Oct. 1903, pp.354–5.

8 This was Mark Twain's reaction to Turner's *Slave Ship* in 1878: see *A Tramp Abroad* (1880) quoted in John McCoubrey, 'Turner's *Slave Ship*: Abolition, Ruskin, and Reception', *Word & Image*, vol.14, no.4, Oct.–Dec. 1998, p.350.

9 *The Prince of Orange, William II, Embarked from Holland and Landed at Torbay, November 4th 1688, after a Stormy Passage* (1832; B&J 343); *Bridge of Sighs, Ducal Palace and Custom-House, Venice: Canaletti Painting* (1833; B&J 349); *The Golden Bough* (1834; no.14); *The Dogano, San Giorgio, Citella, from the Steps of the Europa* (1842; no.99); see Hamlyn 1993.

10 See under note 2 above.

11 National Gallery Archives: Wornum Diary, 12 Dec. 1856

12 See press coverage in the *Athenaeum*, 18 Dec. 1852, pp.1397–8, *Literary Gazette*, Dec. 1852, p.933, and the *Art Journal*, Feb. 1853, p.74 (quoted in Whittingham 1995, p.5. See also Egerton 1998, pp.266–81; and Michael Kitson, 'Turner and Claude' in Warrell 2003, pp.15–45, 176–84.

13 *Works*, XIII, pp.81–5; paraphrased in Warrell 1995, pp.21–2.

14 Seventy-five works were hung on 31 January, and another twenty-seven on 6 February; for a list of these works, see Warrell 1995, p.148.

15 Ruskin, *Notes on the Turner Gallery at Marlborough House 1856* (*Works*, XIII, pp.93–181; see especially the Appendix); see also Warrell 1995, p.24.

16 Ruskin, *Catalogue of the Turner Sketches in the National Gallery, Part I, 1857* (*Works*, XIII, pp.185–226); reprinted and with editorial commentaries in Warrell 1995.

17 See Warrell 1995, p.25, fig.12. In his diary for 20 June 1857, Wornum records that the cases were made by Messrs Snell & Co of Albermarle Street, costing £28.5s.0d. a piece, of which there were four, with twenty-five frames in each. These were constructed by Ruskin's frame-maker Foord, of Wardour Street, costing eighteen shillings each (see National Gallery Archives, Wornum Diary, 9 Oct. 1857).

18 Ruskin, *Catalogue of the Sketches and Drawings by J.M.W. Turner, R.A., Exhibited in Marlborough House in the Year 1857–8. Accompanied with Illustrative Notes*, 1857 (*Works*, XIII, pp.231–316). Wornum's diary entry for 24 October 1857 listing the watercolours then on display at Marlborough House refers to '230 sketches in 109 frames, not including the *Liber Studiorum* series' (National Gallery Archives, Wornum Diary).

19 See B&J 285, 460, 439; de Pesquidoux's comments are discussed in Gage 1987, pp.8–9; see also no.4.

20 See *Catalogue of the Art Treasures of the United Kindgom Collected at Manchester in 1857*. The oil paintings listed were mostly hung in Saloon E, with others divided between Vestibule 3 and the Clock Gallery. The works on paper were shown as the main attraction in Room 2 of the Gallery of Drawings in Water-Colours (nos.296–380).

21 *Literary Gazette*, 26 Nov. 1859, p.528.

22 Wornum records the advice Ruskin proffered on this, but seems to have refrained from acting upon it, noting, 'This would no doubt be wise, but can scarcely yet be ventured on – Turner would be a great gainer in reputation by the suppression of some 12 or 20 of them' (National Gallery Archives: Wornum Diary, 31 Jan. 1859).

23 Issued as the bound volume *Turner's Gallery* (1875); see also the rival publication by Cosmo Monkhouse.

24 *Works*, XV, pp.5–228.

25 *Report from the Select Committee of the House of Lords Appointed to Consider and Report in what Manner the Conditions Annexed by the Will of the Late Mr Turner, R.A., to the Bequest of his Pictures to the Trustees of the National Gallery Can Best Be Carried Out...* 1861 (page references given are to the typescript in the Tate Prints and Drawings Room), p.21.

26 Ibid., pp.45–7.

27 Thornbury 1862, II, pp.88, 168 (Turner's friends George Jones and H.A.J. Munro of Novar challenged these allegations in their annotations to a copy of the book, now in the Tate Prints and Drawings Room); for a discussion of the impact of Thornbury's book on Ruskin, see Ian Warrell, 'Exploring the "Dark Side", Ruskin and the Problem of Turner's Erotica; with a Checklist of Erotic Sketches in the Turner Bequest', *British Art Journal*, vol.4, no.1, Spring 2003, pp.5–46.

28 *Works*, XIII, p.554, n.1, letter dated 2 Dec. 1861.

29 *Works*, VII. See, for example, pp.374–388, 441.

30 *Annual Report of the Director of the National Gallery to the Lords of the Treasury for the Year 1870*, p.3.

31 *Annual Report of the Director of the National Gallery to the Lords Commissioners of Her Majesty's Treasury, for the Year 1879*, p.3. Sadly the visitors' book mentioned in the report has not survived in the National Gallery archives.

32 Ruskin, *Catalogue of Sketches by Turner Lent by the Trustees of the National Gallery to the Ruskin Drawing School, Oxford*, 1878 (*Works*, XIII, pp.560–8). For Ruskin's revised order of the drawings on display at the National Gallery, see *Works*, XIII, pp.607–46, and the concordance of number in *Works*, XXXVIII, pp.385–90.

33 *Annual Report of the Director of the National Gallery to the Treasury, for the Year 1890*, p.6.

34 See Cook 1905 and Finberg 1909.

35 *Daily Telegraph*, 5 Feb. 1906, which quotes Sizeranne on Turner as follows, 'He stands alone, as little to be imitated in his own country as elsewhere, belonging no more to one region of the globe than a comet belongs to one region of the sky'; for further reactions to the 'new' paintings, see *Art Journal*, March 1906.

36 See Gage 1987, p.15.

2 FROM REALISM TO THE 'IMPRESSION'
John House
(pp.109–111)

1 Letter from Whistler to Fantin-Latour, ?Sept. 1867 (LC PWC 1/33/25, GUW 08045).

2 See the transcript of the Whistler–Ruskin trial in Merrill 1992, especially pp.145–6, 154.

3 ART, MUSIC, AND AN AESTHETICS OF PLACE IN WHISTLER'S NOCTURNE PAINTINGS
John Siewert
(pp.141–147)

1 From 'Mr. Whistler's "Ten O'Clock"', Whistler 1967, p.15.

2 Chesneau 1873, pp.214–17. One of the few published notices of Whistler's Paris exhibition, this article records titles (p.216), making it possible to identify, in some cases tentatively, the works Whistler listed.

3 For Chesneau's review, see Berson 1996, I, p.18. This connection between Whistler and Monet via Chesneau's commentary was noted previously in Joel Isaacson, *Claude Monet: Observation and Reflection*, Oxford 1978, p.204.

4 Duranty 1946, p.34: 'suprenants portraits et des variations d'une infinie délicatesse sur des teintes crépusculaires, diffuses, vaporeuses, qui ne sont ni le jour ni la nuit.'

5 Colvin 1874, p.673.

6 For a fuller discussion of the role memory played in the making of the Nocturnes, see entry for no.48.

7 Significantly, Whistler framed his concern to combine 'nature' and 'decoration' with reference to Turner. According to one account, in 1867 Whistler expressed an opinion against Turner for 'not meeting either the simply natural or the decorative requirements of landscape-art, which he [Whistler] regards as the only alternative'. See Rossetti 1903, pp.233–4.

8 Pennell 1908, I, p.145.

9 On the facture of Whistler's oil paintings, what the artist referred to as his 'sauce', and its possible debt to the English watercolour tradition, see Dorment and MacDonald 1994, p.24; and, with particular reference to the Nocturnes, p.121.

10 Letter to F.R. Leyland, [Nov. 1872], LC PWC 6B/21/3, GUW 08794.

11 Wilde 1877, p.124.

12 See Merrill 1992 for a complete reconstruction of the lost trial transcript and an indispensable recounting of the legal and art-historical issues at stake.

13 For a recent discussion of Cremorne Gardens see Nead 2000, pp.109–46. On Cremorne and Whistler see Curry 1984, pp.71–87. In addition to *The Falling Rocket*, the pictures related to Cremorne include: *Cremorne, No.1* (Fogg Art Museum, Harvard University, Cambridge, Mass.; YMSM 163), *Cremorne Gardens, No.2* (Metropolitan Museum of Art, New York; YMSM 164), *Nocturne: Cremorne Gardens, No.3* (Freer Gallery of Art, Washington, DC; YMSM 165), *Nocturne in Black and Gold: The Gardens* (Metropolitan Museum of Art, New York; YMSM 166) and *Nocturne: Black and Gold – The Fire Wheel* (Tate, London; YMSM 169).

14 The sale of Turner's painting was through Thomas Agnew and Sons, who had been handling Whistler's 'Thames Set' etchings from the time of their publication in 1871.

15 *New York Herald* [?Oct. 1883], Whistler PC 3:37.

16 [London] *Standard*, 1 May 1882, Whistler PC 4:101.

17 'The Grosvenor Gallery,' *Birmingham Gazette*, 1 May 1882, Whistler PC4:97; and *Guardian*, 10 May 1882, Whistler PC 4:115.

18 *Literary World*, 2 June 1882, Whistler PC 4:105. Albert Smith (1816–60) was an English associate of P.T. Barnum; see Altick 1978, pp.473–6.

19 *Liverpool Mercury*, 3 July 1884, Whistler PC 7:13.

20 One critic described the Saint Mark's Nocturne as 'a libel on that exquisitely beautiful basilica', a characterisation perhaps intentionally ironic in the aftermath of the *Whistler v. Ruskin* litigation (*Daily Chronicle*, n.d., Whistler PC 3:57).

21 On the tower, which no longer stands, see Bennett 1956, pp.25–6.

22 Geffroy 1892, I, pp.270–1: 'C'est la Nuit qui passe sur l'eau, qui englobe la ville, qui absorbe l'air, c'est elle qui domine ce paysage, qui lui donne cette couleur inclassée que l'on voit les yeux fermés, qui en fait l'apparence visible de l'Ombre, le portrait prodigieux de l'Obscurité.'

23 Moore 1893, pp.22–3.

24 Duret 1904, p.58: 'Il est arrivé là, à une limite qu'on ne saurait dépasser, il a atteint cette extrême région oú la peinture devenue vague, en faisant un pas de plus, tomberait dans l'indéterminisme absolu et ne pourrait plus rien dire aux yeux.'

25 Huysmans 1889, pp.67–8: 'sites d'atmosphère et d'eau s'étendaient à l'infini . . . transportaient sur des véhicules magiques dans des temps irrévolus, dans des limbes. C'était loin de la vie moderne, loin de tout, aux extrêmes confins de la peinture qui semblait s'évaporer en d'invisibles fumées de couleurs, sur ces légères toiles.'

4 MALLARMÉ, WHISTLER AND MONET
Luce Abélès
(pp.163–168)

1 Letter from Mallarmé to Paul Verlaine, entitled 'Autobiography', 16 Nov. 1885, in *OC*, I, p.662: 'Ayant appris l'anglais simplement pour mieux lire Poe'. In 1860 Mallarmé had become interested in the work of Edgar Allan Poe, as attested in a youthful notebook entitled 'Glanes 1', where he copied the poetry of Baudelaire and translated Poe's poems (*OC*, II, pp.790–804). This marks the beginning of his association with the American writer celebrated in the monumental 1874 edition of *The Raven*, illustrated with lithographs by Manet (published by Richard Lesclide in Paris) and, in 1888, by the appearance of *Poems of Edgar Poe* (published by Edmond Deman in Brussels) – a bringing together of a choice of titles already published in reviews.

2 A single such handbook appeared, *Petite philologie à l'usage des Classes et du Monde. Les Mots anglais par M. Mallarmé professeur au Lycée Fontanes* (Leroy frères successeurs, Truchy, Paris, n.d. [1877]); various

3 projects in manuscript form regarding the teaching of English exist but were not published (see *OC*, II, pp.790–804).

3 *Portsmouth* (watercolour, 1824; Tate, London; TB CCVIII S); *St Michael's Mount, Cornwall* (oil on canvas, 1834, Victoria and Albert Museum, London; B&J 358). The reproductions, annotated by Mallarmé, were sold at Drout's, Paris, 19 December 1977.

4 At Mallarmé's request, at the end of 1875, the poet Algernon Swinburne agreed to collaborate on a new review, *La République des Lettres*, which took over from *Parnasse contemporain*, by now obsolete. At this time Mallarmé was editing a gossip column for the London journal *The Athenaeum*. Later, on Whistler's recommendation, he would write a similar series of French columns for the *National Observer* (1892–3); the following year he delivered his important lecture (in French), *La Musique et les Lettres*, at Oxford and Cambridge.

5 See note 28.

6 Letter from Mallarmé to Monet (June 1888), Mallarmé 1965–85, III, p.212: 'Monet a du génie.' Cited by Gustave Geffroy in Geffroy 1924, II, p.186.

7 'Quelques médaillons et portraits en pied: Whistler, Manet', in *Divagations*, 1897 (*OC*, II, pp.531–2).

8 On the friendship between Whistler and Mallarmé see MacDonald 1973 and Barbier 1964. On Mallarmé and his artist friends see Nectoux 1998.

9 On the relationship between Manet and Whistler see Spencer 1987, pp.47–64.

10 On this work, see Druick and Hoog 1983, pp.165–78.

11 Baudelaire's article was 'Peintres et aquafortistes', *Le Boulevard*, 14 Sept. 1862.

12 'Quelques médaillons et portraits en pied: Whistler, Manet', in *Divagations*, 1897 (*OC*, II, pp.531–2): 'railleur à Tortoni, élégant', 'guerroyant, exultant, précieux, mondain.'

13 On the role played by Mallarmé in the purchase by the state of *Portrait of the Painter's Mother: Arrangement in Grey and Black, No.1* in 1891, see Barbier 1964, pp.98–141.

14 *Mr Whistler's 'Ten O'Clock'*, monograph of twenty-eight pages published at the expense of the author by Chatto & Windus in 1885, edition of twenty-five copies.

15 'The man can be a democrat, the artist must double as an aristocrat' ('L'homme peut être démocrate, l'artiste se dédouble et doit rester aristocrate') declared Mallarmé in his article 'Hérésies artistiques. L'art pour tous', *L'Artiste*, 15 Sept. 1862 (*OC*, II, pp.257–60). It should be noted that Mallarmé saw no point in picking up on this youthful pronouncement afterwards.

16 In 1887 Mallarmé began systematically to assemble these scattered texts in volumes. Henceforth they followed one another at regular intervals, the same text reappearing in succeeding versions.

17 'A publisher has been found' ('L'éditeur est trouvé'), Mallarmé wrote to Whistler on 18 March 1888, 'it is Dujardin, the director of the *Revue indépendante*' ('c'est Dujardin, le directeur de la Revue indépendante') (Barbier 1964, p.9). The previous year Dujardin had published a luxury edition of just forty-seven copies of photolithographs of the original manuscript of Mallarmé's *Poésies* and an updated version of *L'Après-midi d'un faune*.

18 On Whistler's recommendation (sought by Mallarmé), the *National Observer* would commission a series of articles in French, to appear in March 1892 and July 1893.

19 James M.N. Whistler, 'Le "ten o'clock", conference, traduite par Stéphane Mallarmé', *La Revue Indépendante*, May 1888. The pamphlet appeared simultaneously in London, published by Chatto & Windus, and in Paris, at the librairie de la Revue indépendante (edition of 250 copies).

20 Letter from Whistler to the editor Heinemann, 23 June 1892, cited in Barbier 1964, p.167: 'Il faut que la plaquette soit un Bijou – de présentation comme de format'.

21 On the ups and downs of this project between February 1892 and April 1893 see Barbier 1964, pp.154–208.

22 Mallarmé 1893.

23 Mallarmé commented in a letter to Whistler, 5 Nov. 1892 (GUL MS Whistler M191, GUW 03857): 'This portrait is a marvel, the only thing that might ever have been considered to have been influenced by me, which makes me smile' ('Ce portrait est un marveille, la seule chose qui ait jamias été faite d'apres moi et je m'y souris.').

24 Duret 1904, p.124: 'L'image n'existe que comme un souffle, elle est venue du plus rapide coup de crayon. C'est une improvisation et on n'improvise pas le rendu aussi frappant d'un être humain, il faut l'avoir profondément pénétré pour le donner avec cette intensité de vie et de caractère'.

25 Organised by the Symbolist review, *Les Essais d'Art Libre*, at the Le Barc de Boutteville Gallery from July to September 1893, the purpose of this exhibition was to promote writers and artists of the Symbolist movement, largely unknown to the general public at the time. It led to a first collected edition, *Portraits du prochain siècle, 'Poètes et prosateurs'*, published by Edmond Girard in 1894, which was to be followed by a second devoted to painters and musicians. In the first volume, which featured his own portrait by Charles Morice, Mallarmé produced a cameo of Edgar Allan Poe evoking the personage of Whistler. The portraits of Whistler and Manet were intended for the second volume, which was never published, as confirmed in an invoice of Girard to Mallarmé for 15 Feb. 1895 (Mallarmé 1965–85, VII, p.14).

26 De Régnier 2002, p.371: 'Dimanche chez Whistler. Mallarmé, en maniant des eaux-fortes du maître . . . me disait : "Il me semble toucher là des papiers-monnaies d'un féérique pays imaginaire. On a le sentiment que cela est infiniment précieux et pour-rait servir à l'échange d'êtres un peu surnaturels." Et, devant une petite danseuse légère et psychéenne: "Je sens que l'aspect d'art grec qui s'en dégage n'est point par imitation mais par l'apparence de mêmes qualités de nouveau, par elles-mêmes".' Régnier's *Cahiers* contain numerous character portraits of Mallarmé, of whom Régnier was a disciple, and of Whistler, to whose house he went with Mallarmé.

27 If Mallarmé indicated an awareness of Redon's engravings, which he frequently mentions in his letters to the artist, it is worth noting that he remained silent on the artist's paintings.

28 'Le jury de peinture pour 1874 et M. Manet', *La Renaissance Artistique et Littéraire*, 12 April 1874, and 'The Impressionists and Edouard Manet', *Art Monthly Review*, 30 Sept. 1876. These two articles were not collected during Mallarmé's lifetime. The French version of the second has disappeared. The translation used here is by Philippe Verdier, *Gazette des Beaux-Arts*, Nov. 1975, pp.148–56.

29 This painting (*Le Linge*), rejected by the Salon of 1876 and exhibited by Manet in his studio, is the origin of Mallarmé's article.

30 'La Musique et les Lettres', a lecture given at Oxford and Cambridge in March 1894: 'La Nature a lieu, on n'y ajoutera pas; que des cités, des voies ferrées et plusieurs inventions formant notre matériel.' Text published in *La Revue Blanche*, April 1894, then in a volume by Perrin et Cie, 1895 (*OC*, II, p.67).

31 'Grands faits divers: Bucolique', in *Divagations*, 1897 (*OC*, II, p.256): 'se percevoir, simple, infiniment sur la terre'.

32 On the Monet series see House 1986a, esp. last chapter, and Tucker 1989.

33 Letter from Mallarmé to Gustave Geffroy, 7 Oct. 1890, on the subject of the *Grain Stacks* (Wildenstein 1974–91, III, letter 1076): '"l'instantanéité", surtout l'enveloppe, la même lumière répandue partout'.

34 See House 1986a, pp.222–4, and John House, 'Monet: The Last Impressionist?', in Tucker 1998, pp.3–13.

35 Mallarmé 1962–85, IV, p.119: 'Vous m'avez ébloui récemment avec ces *Meules*, Monet, tant! que je me surprends à regarder les champs à travers le souvenir de votre peinture; ou plutôt ils s'imposent à moi tels'. The date of the letter given by Gustave Geffroy (9 July 1890) is surely erroneous since in July Monet had not yet begun to paint the *Grain Stacks* series that he would not complete until the end of the summer.

36 Letter to Claude Monet, 21 July 1890 (Mallarmé 1962–85, IV, pp.123–4): 'On ne dérange pas un homme en train d'une joie pareille à celle que me cause la contemplation de votre tableau, cher Monet. Je me noie dans cet éblouissement et estime ma santé spirituelle du fait que je le vois plus ou moins, selon mes heures. Je me suis peu couché la première nuit, le regardant.'

37 In 1888 Mallarmé had planned to put together selected works in prose (poems and articles) in a collection entitled 'Le Tiroir de laque'. John Lewis Brown was given the job of designing the cover and his Impressionist friends – Degas, Berthe Morisot, Renoir and Monet – were asked to illustrate various poems. In the end, all the artists approached declined their services, except for Renoir. The book appeared in 1891 under the simple title *Pages*, published by Deman in Brussels, with a frontispiece by Renoir.

38 'La Gloire', in *Pages*, 1891 (*OC*, I, pp.433–4): 'cent affiches s'assimilant l'or incompris des jours, trahison de la lettre', 'une approche de forêt en son temps d'apothéose', 'lent et repris du mouvement ordinaire, se réduisît à ses proportions d'une chimère puérile emportant du monde quelque part, le train qui m'avait là déposé seul.'

39 'Offices : Plaisir sacré', in *Divagations*, 1897 (*OC*, II, p.235): 'magnificence déserte de l'automne'.

40 'Crayonné au théâtre: Hamlet' in *Divagations*, 1897 (*OC*, II, p.235): 'la Nature prépare son Théâtre, sublime et pur'.

41 An expression used by Mallarmé in his article 'Le jury de peinture pour 1874 et M. Manet': 'cet art fait d'onguents et de couleurs'.

42 Letter to Mallarmé, 12 Oct. 1889 (Mallarmé 1965–85, III, p.363): 'Je suis honteux vraiment de ma conduite et je mérite tous vos reproches, il n'y a cependant pas mauvaise volonté de ma part comme vous pourriez le penser, la vérité vraie c'est que je me sens incapable de vous faire rien qui vaille, il y a peut-être excès d'amour propre mais vraiment dès que je veux faire la moindre chose avec des crayons, cela est absurde et de nul intérêt, par conséquent indigne d'accompagner vos poèmes exquis (*La Gloire* m'a ravi et j'ai peur de n'avoir pas le talent nécessaire pour vous faire quelque chose de bien) ne croyez pas à une vulgaire défaite. C'est hélas la pure vérité excusez-moi donc et surtout d'avoir mis ce temps à vous l'avouer.'

43 *Rose et gris – Geneviève Mallarmé* 1897 (private collection; YMSM 485). The portrait was executed in Mallarmé's home at Valvins, 20 October 1897 (Barbier 1964, pp.263–6).

44 For a list of Whistler's works given to Mallarmé see Nectoux 1998, pp.217–18.

45 Nevertheless, the following allusion can be seen in a letter of Mallarmé to his wife and daughter (20 Nov. 1896, Mallarmé 1965–85, VIII, p.296): 'Everything lifts, even me; last night a Whistlerian nocturnal fog, on the forest and on the barges: quite fantastic, but less fantastic than to feel you close to me somewhere else.' ('Tout se lève, moi aussi ; hier soir une brume d'un nocturne de Whistler, sur la forêt et les chalands : très fantastique, mais moins fantastique que de vous sentir autrepart qu'où je suis.') .

5 THE RETURN OF WHISTLER AND MONET TO THE THAMES
Sylvie Patin
(pp.179–183)

1 Letter to Henri Cazalis, London, 24 July 1863 (Mallarmé 1959, I, p.92): 'Je hais Londres quand il n'y a pas de brouillards ; dans ses brumes, c'est une ville incomparable.'

2 Letter to Théodore Duret, 13 Aug. 1887 (Wildenstein 1974–91, III, letter 794): 'Saviez-vous que je suis allé à Londres voir Whistler et que j'ai passé là une douzaine de jours émerveillé de Londres et aussi de Whistler qui est un grand artiste: il a été on ne peut plus charmant pour moi du reste, et m'a invité à exposer à son exposition.'

3 Letters to Whistler, 28 April 1889 and 18 May 1896 (Wildenstein 1974–91, III, letters 967 and 1349): 'affection et admiration'.

4 The 'Ten O'Clock' lecture given by Whistler in London on 20 February 1885 and translated into French by Mallarmé in 1888. In December 1891, Monet announced to Whistler his next trip to London, whereas, a few days later, on 9 December, Pissarro notified his son Lucien: 'Monet est à Londres

. . . il est très probable qu'il va y travailler . . . on attend avec impatience la série de Londres' (Bailly-Herzberg 1980–91, III, letter 726). They were made to wait until the next century since this stay of 1891 was taken up largely with meetings with Whistler and the young Chelsea artists more than with painting.

5 In 1918, Monet would declare: 'J'avais toujours eu l'idée, depuis ma soixantaine, de me livrer . . . à une façon de synthèse où je résumerais dans une toile, parfois deux, mes impressions et mes sensations d'autrefois' (Thiébaut-Sisson 1927, p.48).

6 Monet did not pass up the opportunity to point out to Durand-Ruel his 'intention, si l'hiver n'est pas très beau, j'entends sec ou neigeux, de retourner à Londres pour y travailler' (25 Dec. 1891, Wildenstein 1974–91, III, letter 1126).

7 It consisted of a visit to the young Michel Monet, the second son of the artist, about twenty years of age.

8 Letter to Durand-Ruel, 17 Oct. 1899 (Wildenstein 1974–91, III, letter 1473).

9 Letter to Duret, 17 Oct. 1887 (Wildenstein 1974–91, III, letter 797): 'Je compte venir à Londres . . . je voudrais même essayer d'y peindre quelques effets de brouillard sur la Tamise.' See also his letter to Duret, 9 Dec. 1880 (Wildenstein 1974–91, I, letter 203). The expressed wish was not realised until some ten years later, even though in July 1888 Monet found himself on his way to London, hosted this time by the American painter John Singer Sargent; in November 1898 he took a brief trip to London to satisfy himself on the health of his son Michel.

10 Letter to Alice Monet, 4 March 1900 (Wildenstein 1974–91, IV, letter 1523): 'ma Tamise'.

11 When he returned to London in February 1900 he was not given room 641, which he had occupied the previous autumn (temporarily reserved for wounded officers returning from the Boer War), but was offered the corresponding room on the floor below, 'from which the view is less precipitous' ('où la vue est moins plongeante'), he lamented to Alice (10 Feb., Wildenstein 1974–91, IV, letter 1503). His letter of the following day (letter 1504) seems to show him reconciled to this change: 'I am well installed on the fifth floor and I have the same two rooms that we had on the sixth: room 541 has been stripped of furniture and I sleep in 542, because with all my materials, I would never be able to turn round' ('Je suis bien installé au 5ᵉ et j'ai les deux chambres que nous avions au 6ᵉ: on a démeublé le 541 et je couche au 542, car, avec tout mon matériel, je n'aurais jamais pu me retourner.')

12 Although Monet was in London during the winter, his letters addressed to his wife reveal how little the effect of snow entered into his experiments at the time.

13 Letter to Alice Monet, 6 Feb. 1901 (Wildenstein 1974–91, IV, letter 1597): 'le joli ballon rouge.'

14 Letter to Alice Monet, 9 March 1900 (Wildenstein 1974–91, IV, letter 1527): 'une énorme boule de feu.'

15 Letter to Alice Monet, 14 Feb. 1901 (Wildenstein 1974–91, IV, letter 1604): 'A partir de 10 heures, le soleil s'est montré, un peu voilé par moments, mais des effets de brillants sur l'eau admirables: aussi m'en suis-je payé ferme.'

16 Letter to Alice Monet, 3 Feb. 1901 (Wildenstein 1974–91, IV, letter 1593): 'le soleil s'est levé aveuglant . . . La Tamise n'était que de l'or. Dieu que c'était beau, si bien que je me suis mis à l'œuvre avec frénésie suivant le soleil et ses miroitements sur l'eau . . . Grâce aux fumées, la brume est venue.'

17 Notably 'un brouillard des plus épais à ne rien voir par moments' (12 Feb. 1900; Wildenstein 1974–91, IV, letter 1505), 'un brouillard superbe' (24 Feb. 1900; letter 1517), 'délicieux' (17 March 1900; letter 1531), 'terrible' (12 Feb. and 19 March 1900; letters 1505 and 1533), 'une brume exquise' (17 Feb. 1900; letter 1509), 'cette brume merveilleuse' (11 Feb. 1901; letter 1601).

18 Letter to Alice Monet, 26 Feb. 1900 (Wildenstein 1974–91, IV, letter 1519): 'au petit jour, il y a eu un brouillard extraordinaire, tout à fait jaune; j'en ai fait une impression pas mal, je crois.' See also the letter from Mallarmé to H. Cazalis, London, 30 Nov. 1862 (Mallarmé 1959, I, p.59): 'here is the fog again . . . it is so beautiful, so grey, so yellow') ('Revoici le brouillard . . . il est si beau, si gris, si jaune.')

19 Letter to Alice Monet, 19 Feb. 1901 (Wildenstein 1974–91, IV, letter 1608a): 'quand je suis parti pour Chelsea, à chaque pas je voyais de belles choses justement à cause de ce grand brouillard.'

20 Letter to Alice Monet, 3 Feb. 1901 (Wildenstein 1974–91, IV, letter 1593): 'une promenade le long de la Tamise, à Chelsea. Quel bel endroit et les belles choses . . . vues!'

21 Letter to Alice Monet, 14 Feb. 1901 (Wildenstein 1974–91, IV, letter 1604): 'c'est dur d'avoir de belles choses à peindre et d'avoir subitement devant soi une couche d'obscurité d'une couleur innommable . . . Hélas! le brouillard persiste, de brun foncé il devient vert olive, mais toujours aussi sombre et impénétrable.'

22 Letters to Alice Monet, 26 Jan., 3 Feb., 10 March 1901 (Wildenstein 1974–91, IV, letters 1588, 1593, 1616): 'Comme toujours le dimanche, pas l'ombre de brume, même c'était d'une netteté épouvantable'; 'Quelle journée triste que ce sacré dimanche anglais, la nature s'en ressent, tout est comme mort, pas de train, pas de fumée ni de bateaux, rien qui excite un peu la verve.' The smoky fog is Huysmans's image of the city as it intruded on the thoughts of des Esseintes (Huysmans 1959) and the paintings by Monet devoted to the Gare St Lazare, with clouds of smoke filling the space below the rafters: one can picture the passion that consumed the artist to study the smoky atmosphere of the Thames.

23 Letters to Alice Monet, 17 Feb. 1900 and 22 Feb. 1901 (Wildenstein 1974–91, IV, letters 1509 and 1608c): 'que de mal, car pas un jour n'est pareil', 'toute la journée a été variable, prenant une toile, puis une autre pour les reprendre un instant après. Enfin, c'était à devenir fou ne sachant plus trop ce que je faisais.'

24 Letter to Bl. Hoschedé-Monet, 4 March 1900 (Wildenstein 1974–91, IV, letter 1522): 'je trouve Londres chaque jour plus beau à peindre.'

25 Letters to Alice Monet, 25 and 28 March 1900 (Wildenstein 1974–91, IV, letters 1539, 1543): 'progressant chaque jour dans la compréhension de ce climat si particulier', 'ce que j'ai vu de beaux effets depuis près de deux mois que, sans cesse, je regarde cette Tamise, c'est à n'y pas croire.'

26 Letters to Alice Monet, 30 March 1900 and 3 Feb. 1901 (Wildenstein 1974–91, IV, letters 1545, 1593): 'ce pays si changeant, mais, à cause de cela, si admirable', 'Il fait un temps des plus variables, mais c'est splendide . . . Je ne puis te dire cette journée fantastique. Que de choses merveilleuses, mais ne durant pas cinq minutes, c'est à devenir fou. Non, il n'y a pas de pays plus extraordinaire pour un peintre.'

27 Letter to Alice Monet, 1 March 1900 (Wildenstein 1974–91, IV, letter 1521): 'il me faut te quitter, l'effet n'attend pas.'

28 Letter to Alice Monet, 3 Feb. 1901 (Wildenstein 1974–91, IV, letter 1593): 'j'ai aussi de grandes jouissances. Je vois des choses uniques, merveilleuses et je tripote de la peinture . . . Mais revoilà la lumière naturelle, je m'arrête.'

29 Letter to Alice Monet, 25 March 1900 (Wildenstein 1974–91, IV, letter 1539): 'toiles pas assez londoniennes.'

30 Mauclair 1927, p.44: 'se rapprochent des Nocturnes de Whistler, elles contiennent une musicalité de la nuance qui se transposerait aisément de l'œil à l'ouïe, et enfin elles se relient aux derniers vœux de ce glorieux Turner que Monet, le Turner français, est venu honorer, et non braver, jusque dans sa vieille Cité. Toute cette série, symphonie, ou suite d'orchestre, sur la Tamise, est profondément pénétrée du caractère londonien.'

31 Geffroy 1924, pp.310–11: 'Son effort se rattache à celui de Turner, mais combien il est différent, dégagé de toute attache classique, et d'ailleurs, d'une personnalité si tranchée, si complète, que jamais, dans la suite des temps, quand même toute signature aurait disparu, on ne pourrait prendre un de ces "Monet" pour un "Turner". Les toiles de Monet sont d'une lumière plus unifiée, d'une coloration plus soutenue dans la clarté . . . S'il me fallait établir une analogie, je la verrais plutôt avec Whistler: bien que celui-ci ait peint, surtout des nocturnes, des nuits de velours bleu pointillées d'or, mais ce n'est pas de cette ressemblance-là qu'il s'agit. Claude Monet, comme Whistler, a peint des harmonies, et comme lui, aurait pu donner pour titres à ses tableaux des dominantes de couleurs et de nuances. En réalité, Claude Monet est surtout lui-même, un des plus subtils et des plus puissants peintres qui aient existé, mais il est aussi un grand poète.'

32 Letter from Monet to Durand-Ruel, Giverny, 10 April 1901 (Wildenstein 1974–91, IV, letter 1549): 'Commencements.'

33 Letter to Alice Monet, 28 March 1900 (Wildenstein 1974–91, IV, letter 1543): 'il ne faut pas s'attendre à voir rien de terminé ; ce ne sont que des essais, des recherches, des préparations et, en somme, des recherches folles et inutiles.'

34 Letter to Alice Monet, 10 March 1901 (Wildenstein 1974–91, IV, letter 1616): 'ce n'est pas un pays où l'on peut terminer sur place : les effets ne se retrouvent jamais et il m'aurait fallu ne faire que des pochades, de vraies impressions.'

35 De Trévise 1927, p.126: 'Où cela devint surtout terrible, ce fut sur la Tamise : quelle succession d'aspects! Au Savoy Hôtel ou à l'hôpital Saint-Thomas, d'où je regardais mes points de vue, j'avais jusqu'à cent toiles en train, – pour un même sujet. À force de chercher, parmi ces ébauches, fiévreusement, j'en choisissais une qui ne différait pas trop de ce que je voyais ; malgré tout, je la modifiais complètement. Mon travail fini, je m'apercevais, en remuant mes toiles, que j'avais justement négligé celle qui m'aurait le mieux convenu et que j'avais sous la main.'

36 Letter to Durand-Ruel, 23 March 1903 (Wildenstein 1974–91, IV, letter 1690): 'Non, je ne suis pas à Londres si ce n'est par la pensée, travaillant ferme à mes toiles qui me donnent beaucoup de mal . . . Je ne peux pas vous envoyer une seule toile de Londres, parce que, pour le travail que je fais, il m'est indispensable de les avoir toutes sous les yeux, et qu'à vrai dire pas une seule n'est définitivement terminée. Je les mène toutes ensemble ou du moins un certain nombre.'

37 See the letter from Monet to Durand-Ruel, 12 Feb. 1905 (Wildenstein 1974–91, IV, letter 1764): 'Je . . . connais . . . Mr. Harrison, que Sargent avait chargé de me faire faire une petite photo du Parlement dont je n'ai jamais pu me servir . . . que mes Cathédrales, mes Londres et autres toiles soient faites d'après nature ou non, cela ne regarde personne et ça n'a aucune importance. Je connais tant de peintres qui peignent d'après nature et ne font que des choses horribles . . . Le résultat est tout'; and on 26 October 1905 he made this precise and significant observation to the dealer (Wildenstein 1974–91, IV, letter 1787): 'C'est un Pont de Waterloo qui me reste à vous livrer, il m'est utile de l'avoir pour en faire un autre avec fumée, comme vous me l'avez demandé.'

38 Letter to Durand-Ruel, 2 March 1904 (Wildenstein 1974–91, IV, letter 1712): 'Voilà près de quatre années que je travaille à ces Vues de Londres . . . Je ne suis pas de votre avis et suis loin de regretter de ne pas vous avoir livré quelques toiles, car la vue de la série complète aura une bien plus grande importance.' On the design for the invitation card that he sent to the dealer on 28 April (Wildenstein 1974–91, IV, letter 1723), the title chosen to announce the event (reproduced on p.9 of the catalogue), 'Série de Vues de la Tamise à Londres de 1900 à 1904', is significant. He did not disguise his having worked on the paintings at the Giverny studio (the flyleaf for the catalogue mentions only 'Views of the Thames at London'). As always with Monet, the dating of the works is difficult, as he added dates and signatures to works after the event, when they came to be sold or exhibited. The almost identical handling of these works permitted him to exploit to the full his habit of creating a 'series' with only the use of light varying from one to another.

39 Certain of his works are characterised in the exhibition catalogue of 1904 as: 'temps gris; temps couvert; effet de soleil dans la brume; soleil voilé; trouée de soleil dans le brouillard; soleil couchant'.

40 Mirbeau 1904, repeated in Humanity, 8 May 1904 and Mirbeau 1993, pp.352–6: 'Il [Monet] a vu Londres, il a exprimé Londres, dans son essence propre, dans son caractère, dans sa lumière . . . Plus encore que le ciel normand, le brouillard de Londres est changeant, insaisissable, compliqué. Tout ce qui s'y mêle de lueurs sourdes ou vives, de reflets aériens, de presque invisibles influences, transforme, déforme jusqu'au fantastique, les objets, les reculant ou les rapprochant selon des lois cosmiques inflexibles.'

Note also this extract: 'Des fumées et du brouillard; des formes, des masses architecturales . . . toute une ville sourde et grondante, dans le brouillard, brouillard elle-même ; . . . le drame multiple, infiniment changeant et nuancé, sombre ou féerique . . . des reflets sur les eaux de la Tamise ; du cauchemar, du rêve, du mystère, de l'incendie'.

41 'l'âme fuligineuse'. Émile Verhaeren, who had already published an article with the evocative title 'L'impressionniste Turner' in *L'Art Moderne* (20 Sept. 1885), returned in 1901 to: 'on annonce, pour la saison prochaine, toute une série d'œuvres où le Londres des docks, des ponts, des gares et de la Tamise sera exprimé. Un précurseur de cet envois vient d'arriver chez Bernheim: *Paysage de ville fuligineuse*. Il étonne et conquiert. Il annonce des merveilles' (Verhaeren 1901, pp.544–7 reprinted in Verhaeren, 1997, p.795).

42 Letter to Gustave Geffroy, 4 June 1904 (Wildenstein 1974–91, IV, letter 1732): 'la presse me comble cette fois avec exagération d'éloges.'

43 Vauxcelles 1904: 'descendant de Turner'; at the end of the article the author refers to twenty-seven paintings 'flamboyante comme un Turner'.

44 Kahn 1904, p.84: 'S'il est vrai que Turner aima juxta-poser certains Turner à certains Claude Lorrain, on concevrait qu'on plaçât certains Monet à côté de certains Turner. Ce serait comparer deux aboutissements, rapprocher deux dates de l'Impressionnisme, ou plutôt – car les appellations d'école sont décevantes . . . ce serait rapprocher deux dates d'une histoire de la sensibilité visuelle'; on p.88 the author uses the words 'harmonies' for 'steam' and 'symphony', which are more in the style of Whistler.

45 Geffroy 1924, p.235: 'l'une des vues du pont de Charing Cross, par un ressouvenir peut-être de la fameuse inscription qui devait fournir un drapeau au groupe des exposants de 1874, portait en sous-titre: *Fumées dans le brouillard; impression*'. The painting (today in the Musée Marmottan, Paris; W 1535) appears as no.4 in the 1904 exhibition catalogue.

46 Gimpel 1963, p.88, on 28 Nov. 1918: 'Dans le temps j'ai beaucoup aimé Turner, aujourd'hui je l'aime beaucoup moins . . . Il n'a pas assez dessiné la couleur et il en a trop mis; je l'ai bien étudié . . . j'aime Londres, beaucoup plus que la campagne anglaise; oui, j'adore Londres ... Puis, dans Londres, par-dessus tout ce que j'aime, c'est la brume.' Cf. also p.156, on 1 Feb. 1920: 'J'ai passé trois hivers à Londres . . . J'aime tant Londres! mais je n'aime Londres que l'hiver. En été, c'est bien avec ses parcs, mais ça ne vaut pas l'hiver avec le brouillard car, sans le brouillard, Londres ne serait pas une belle ville. C'est ce brouil-lard qui lui donne son ampleur magnifique. Ses blocs réguliers et massifs deviennent grandioses dans ce manteau mystérieux'.

47 Blanche 1928, p.32: 'un couvert joliment mis, comme chez Whistler'.

6 THE LAST ACT: TURNER, WHISTLER AND MONET IN VENICE
Sylvie Patin
(pp.203–207)

1 Letter to Alice Monet, 3 Feb. 1901 (Wildenstein 1974–91, IV, letter 1593): 'Que de choses merveilleuses . . . il n'y a pas de pays plus extraordinaire pour un peintre.'

2 Mirbeau 1912 and the preface to the catalogue for the exhibition *Claude Monet: 'Venise'*, galerie Bernheim-Jeune, Paris 1912; Mirbeau 1993, pp.514–17: 'Venise . . . Non . . . je n'irai pas à Venise.'

3 Geffroy 1924, p.317: 'il est allé à Londres, où son art avait une étape depuis longtemps assurée, et notre mémoire garde les prodigieux portraits de l'atmo-sphère mêlée de brouillards, de fumées et de rayons lointains . . . Puis, il est allé à Venise, et son art exprime d'une façon nouvelle ce qui nous avait été montré avec un faste si admirable, une précision si jolie et si pittoresque par les peintres mêmes de Venise, depuis Carpaccio jusqu'à Canaletto et Guardi.'

4 See Bowness and Callen 1973, pp.25–6: Alan Bowness emphasises that Turner's *Sun of Venice* was hung at the National Gallery; his example could very well have been the origin of Monet's own decision.

5 Letter to Lucien Pissarro, 20 Feb. 1883 (quoted in Bailly-Herzberg 1980–91, I, letter 119): 'Tu es allé à la National Gallery . . . tu as vu les Turner? Tu ne m'en dis rien, cela ne t'a pas fait impression . . . À Kensington, la *Vue de la place Saint-Marc à Venise*, etc.' The South Kensington Museum, which housed some of Turner's works, is today the Victoria and Albert Museum.

6 Escholier 1956, p.41: 'Il me semblait que Turner devait être le passage entre la tradition et l'impres-sionnisme . . . J'ai trouvé, en effet, une grande parenté de construction par la couleur dans les aquarelles de Turner et les tableaux de Claude Monet.'

7 In his work devoted to Whistler, Duret paid special attention to his views of Venice: Duret 1904, pp.79–92.

8 Letter to Marcus B. Huish, n.d. [Jan. 1880], GUL MS Whistler LB 3/8, GUW 02992. See Lochnan 1984, p.184.

9 Letter to Lucien Pissarro, 28 Feb. 1883 (quoted in Bailly-Herzberg 1980–91, I, letter 120): 'Que je regrette de ne pas voir l'exposition de Whistler, tant au point de vue des fines pointes sèches qu'au point de vue de la mise en scène, qui, chez Whistler, est d'une grande importance; il y met même un peu trop de *puffisme* selon moi . . . Whistler fait surtout de la pointe sèche, et, quelquefois c'est de l'eau-forte ordinaire, mais la souplesse que tu constates, le moelleux, le flou qui te charme est une espèce d'estompage fait par l'imprimeur, qui est Whistler lui-même; aucun imprimeur de profession ne pourrait le remplacer, car c'est tout un art, un complément de ce qui a été fait au trait. Ce que nous autres nous voulions faire, c'était la souplesse avant l'impression.'

10 Letter from Monet to [?], 5 April 1914 (Wildenstein 1974–91, IV, letter 2113): 'ne dessinant jamais qu'avec le pinceau et la couleur.' See Françoise Fossier, 'L'œuvre', in Fossier 1987, p.14.

11 Letter to Durand-Ruel, 19 Oct. 1908 (Wildenstein 1974–91, IV, letter 1861): 'Je suis dans l'admiration de Venise, mais je n'y puis malheureusement pas faire un bien long séjour, par conséquent travailler sérieusement. J'y fais quelques toiles à tout hasard, pour en conserver le souvenir, mais je compte bien y faire une bonne saison l'an prochain.'

12 Letter to Clemenceau, 25 Oct. 1908 (Wildenstein 1974–91, IV, letter 1863): 'Je suis ici depuis un mois dans le ravissement, c'est merveilleux et j'essaye de peindre Venise.'

13 Letter to Georges Bernheim-Jeune, 25 Oct. 1908 (Wildenstein 1974–91, IV, letter 1863a): 'bien que je sois enthousiasmé de Venise et que j'y aie commencé quelques toiles, je crains bien de ne pouvoir apporter que des commencements qui seront uniquement des souvenirs pour moi.'

14 Letter to Durand-Ruel, 4 Nov. 1908 (Wildenstein 1974–91, IV, letter 1864): 'je ne sais pas du tout ce que je pourrai rapporter, quelques essais ou pochades.'

15 See Piguet 1986. This excellent study gives a useful insight into the connection established between the painter and the location, through the journal and letters of Alice Monet.

16 Alphant 1993, p.638: 'Coin ruskinien.' Chap.XXXIII, 'La Gondole atelier', analyses the relationship of the painter with the Venetian landscape.

17 Mirbeau 1912 and preface to the catalogue for the exhibition *Claude Monet: 'Venise'*, galerie Bernheim-Jeune, Paris 1912 (Mirbeau 1993, pp.514–17): 'un voile rose est posé sur Venise'.

18 Mauclair 1927, p.45.

19 Ibid., pp.45–6: 'toiles . . . radieuses et captivantes', 'tonalités somptueuses et exquises'.

20 Letter to Clemenceau, 6 Dec. 1908 (Wildenstein 1974–91, IV, letter 1868): 'Toujours plus dans l'enchantement de Venise, mais qu'il va me falloir abandonner, hélas!'

21 Letter to Mrs Daniel Sargent Curtis, 7 Dec. 1908 (Wildenstein 1974–91, IV, letter 1870): 'sans que vous vous en doutiez, c'est bien à vous que je dois d'y être venu. Va a été un régal d'artiste, une vraie joie pour moi.'

22 Letter to Gustave Geffroy, 7 Dec. 1908 (Wildenstein 1974–91, IV, letter 1869): 'mon enthousiasme pour Venise . . . n'a fait que croître et, le moment de quitter cette lumière unique approchant, je m'en attriste. C'est si beau! . . . Je m'en console à la pensée d'y revenir l'an prochain, car je n'ai pu faire que des essais, des commencements. Mais quel malheur de n'être pas venu ici quand j'étais plus jeune, quand j'avais toutes les audaces!'

23 Letter to Paul Durand-Ruel, 10 Oct. 1911 (Wildenstein 1974–91, IV, letter 1982): 'Je commence seulement à me ressaisir . . . Je vais donc essayer tout d'abord de terminer quelques toiles de Venise.'

24 Letter to G. Hoschedé-Salerou, 19 Nov. 1911 (Wildenstein 1974–91, IV, letter 1986): 'un peu, mais non sans peine', 'à mes *Venise*'.

25 Letter to B. Hoschedé-Monet, 4 Dec. 1911 (Wildenstein 1974–91, IV, letter 1989): 'souvenir des si heureux jours passés avec ma chère Alice.'

26 Photograph reproduced in Wildenstein 1974–91, IV, p.87.

27 Letters to J. Bernheim-Jeune, 1 Feb. 1912 (Wildenstein 1974–91, IV, letter 1995a); to Paul Durand-Ruel, 15 April 1911 (letter 2002); to Gustave Geffroy, 2 May 1911 (letter 2007).

28 Mirbeau 1912 and preface to catalogue for the exhibition *Claude Monet: 'Venise'*, galerie Bernheim-Jeune, Paris 1912 (Mirbeau 1993, pp.514–17): 'Claude Monet est maître de la lumière insaisissable.'

29 Guillaume Apollinaire, *L'Intransigeant*, 31 May 1912.

30 Letter to Monet, 31 May 1912, quoted in Geffroy 1924, pp.248–9: 'Mon cher Maître . . . j'ai éprouvé devant vos *Venise*, devant l'admirable interprétation de ces motifs que je connais si bien, une émotion aussi complète, aussi forte, que celle que j'ai ressentie, vers 1879 . . . devant vos *Gares*, vos *Rues pavoisées*, vos *Arbres en fleurs*, et qui a décidé de ma carrière . . . Et ces *Venise*, plus forts encore, où tout concorde à l'expression de votre volonté, où aucun détail ne vient à l'encontre de l'émotion, où vous avez atteint à ce génial sacrifice, que nous recommande toujours Delacroix, je les admire comme la plus haute manifestation de votre art'.

31 Nicolas Ivanoff, 'Venise dans la peinture française', *Archives de l'Art français*, vol.25, 1978, p.399: 'à relever une coïncidence: lorsque Proust rédigeait l'épisode vénitien de la *Recherche*, avait lieu chez Bernheim l'exposition des "Venise" de Claude Monet'; see also Nicolas Ivanoff, 'Proust et Venise', *L'Œil*, nos.217–18, Aug.–Sept. 1973.

32 Proust 1973–7, III (*La Fugitive*), p.629: 'le palais ducal qui considérait la mer avec la pensée que lui avait confiée son architecte et qu'il gardait fidèlement dans la muette attente des doges disparus', 'tandis que la gondole . . . remontait le Grand Canal, nous regardions la file des palais entre lesquels nous passions refléter la lumière et l'heure sur leurs flancs rosés, et changer avec elles.' And see ibid., pp.646–7: 'Je regardais l'admirable ciel incarnat et violet sur lequel se détachent ces hautes cheminées incrustées, dont la forme évasée et le rouge épanouissement de tulipes fait penser à tant de Venises de Whistler'; see also ibid., p.770 (*Le temps retrouvé*): 'Sans doute des jeunes gens avaient surgi qui aimaient aussi la peinture, mais une autre peinture, et qui n'avaient pas, comme Swann, comme M. Verdurin, reçu des leçons de goût de Whistler, des leçons de vérité de Monet, leur permettant de juger Elstir avec justice.'

33 Paul Claudel, *Conversations dans le Loir-et-Cher* ['Dimanche', 31 July 1927], 1934, in *Œuvres en prose*, Gallimard, Bibliothèque de la Pléiade, Paris 1965, pp.716–17: 'C'est l'œuvre de sa vieillesse, un petit peu comparable à celle de Turner, quand leur œil trop dilaté, échappant à la forme, ne voyait plus que la lumière.'

34 Mirbeau 1912 and preface to catalogue for the exhibition *Claude Monet: 'Venise'*, galerie Bernheim-Jeune, Paris 1912 (Mirbeau 1993, pp.514–17): 'Un dernier acte . . . n'a pas d'autre décor que Venise'.

Chronology

Edited by John House

JOSEPH MALLORD WILLIAM **Turner** (1775–1851)	JAMES McNEILL **Whistler** (1834–1903)	CLAUDE **Monet** (1840–1926)	**Other events**
1775 23 April(?): born near Covent Garden, London.			
1790 First exhibits at the Royal Academy in London (a watercolour).			
1796 First oil painting exhibited at the Royal Academy.			
1799 Elected Associate Member of the Royal Academy.			
1802 Elected full Royal Academician; travels on the Continent for the first time, visits the Louvre in Paris.			
1804 Begins to exhibit some of his pictures at his own gallery in Queen Anne Street, next to his home at 64 Harley Street.			
1807 First part of his *Liber Studiorum* published.			
1815			British victory at Battle of Waterloo leads to final fall of Napoleon Bonaparte, who is exiled to St Helena.
1817			Completion of Waterloo Bridge.
1819 First tour of Italy, with a brief stay in Venice.			
1821			Death of Napoleon Bonaparte on St Helena.
1822–3 Paints the Battle of Trafalgar for George IV.			
1830 Publication of edition of Samuel Rogers's *Italy*.			
1832			First cholera epidemic in London.
1833 Second visit to Venice.			
1833–5 Publication of volumes of *Turner's Annual Tour*, with engravings of his views of the Loire and Seine.			
1834	11 July: born in Lowell, Massachusetts.		16 October: the old Houses of Parliament in London burn down.
1837 Re-publication of all Turner's engravings of French rivers as *The Rivers of France*, with texts in both English and French.			Queen Victoria accedes to the throne on the death of William IV.
1838 Presented with a gold snuffbox by King Louis-Philippe of France in exchange for a set of *Turner's Picturesque Views in England and Wales* (1825–38).			
1840 By June the young John Ruskin is acquainted with Turner; later in the year Turner makes his final trip to Venice.		14 November: born in Paris.	Publication of Charles Eastlake's translation of Goethe's *Theory of Colours*.
1841–4 Annual visits to Switzerland.			1842: Birth of Stéphane Mallarmé, 18 March.
1843 Publication of first volume of Ruskin's *Modern Painters*, largely a defence of Turner.	Moves to St Petersburg where his father supervises the building of the railway, its bridges and viaducts, between St Petersburg and Moscow.		
1844 Exhibits *Rain, Steam and Speed* (fig.18) at the Royal Academy.	Francis Seymour Haden (Whistler's future brother-in-law) studies medicine in Paris, tours Italy and Switzerland.		
1845 First Turner painting enters an American collection: Col. Lenox purchases *Staffa, Fingal's Cave* (B&J 347) on advice of C.R. Leslie. Turner makes his last trips to France during the early autumn.		c.1845 Moves with his family to Le Havre, on the Channel coast.	
1846 October: moves to 6 Davis Place, Cremorne New Road, Chelsea (from 1862,			

Year				
1846 (continued)	Cremorne Road; later Cheyne Walk), where he lives incognito as Admiral Booth.			
1847	Robert Vernon's gift to the National Gallery of recent pictures by contemporary artists includes the first of Turner's oils to enter the national collection (nos.14, 99).	Whistler's half-sister Deborah marries Haden.		House of Lords opens, in new Houses of Parliament.
1848		1848–9: Whistler moves to London; stays with Deborah and Haden.		February: Revolution in France, over-throws monarchy of Louis Philippe, establishment of Second Republic; December: Louis Napoleon, nephew of Napoleon Bonaparte, elected President of French Republic.
1849		Decides to become an artist, visits the Vernon Gallery, attends C.R. Leslie's lectures on art, has his portrait painted by William Boxall. Death of Whistler's father; the family return to the United States.		Cholera epidemic in London.
1850	Exhibits his last works, a group of four Claudian paintings, at the Royal Academy.			
1851	March: Ruskin publishes the first volume of *The Stones of Venice*, presenting a copy to Turner (vols.II and III appear in 1853); August: Ruskin publishes *Pre-Raphaelitism*, essentially a eulogy of the work of Turner and Millais; 19 December: Turner dies at his Chelsea home; buried in St Paul's Cathedral, close to other prominent Royal Academicians.	Enters West Point Military Academy.		Great Exhibition in the Crystal Palace in Hyde Park, London; December: Louis Napoleon stages *coup d'état*, seizes power in France.
1852	9 December: *Dido Building Carthage* (fig.15) and *Sun Rising through Vapour* (no.2) put on display at the National Gallery, alongside paintings by Claude Lorrain, as required in Turner's will.	1852–3: Whistler's mother, Anna, visits the Hadens in London, hears the terms of the Turner Bequest, sees Turners at the Gallery for Amateurs and at the home of Mr Stokes.		House of Commons opens, in new Houses of Parliament; December: Louis Napoleon declared Emperor, as Napoleon III.
1853				Baron Haussmann becomes Prefect of the Seine, with brief to implement Napoleon III's plans for driving broad boulevards through Paris.
1854		Whistler discharged from West Point; works in the Drawing and Engraving divisions of US Coast and Geodetic Survey; makes copy in watercolour after chromolithograph after Turner (nos.24–5).		Paris building programme begins; outbreak of cholera in London; Crystal Palace opens in Sydenham, South London, after removal from Hyde Park.
1855		Turns 21 and comes into small inheritance from his father; decides to go to Paris to study art; autumn: after a month in London with the Hadens, moves to Paris.		Metropolitan Board of Works set up in London to deal with streets and sewers; Sir Charles Eastlake becomes first director of the National Gallery; first *Exposition Universelle* in Paris.
1856	Ruskin publishes *Modern Painters*, III (January) and IV (April); March: decree of the Court of Chancery resolves the legal dispute over Turner's will: all the paintings and watercolours in his gallery considered to be by his hand become national property.	Enters the studio of the Swiss academic painter Charles Gleyre.	c.1856/7 Meets Eugène Boudin, who introduces him to outdoor landscape painting.	
1856–7	Between November 1856 and June 1857 a temporary Turner gallery is created at Marlborough House, ultimately containing 102 oil paintings and about the same number of watercolours.			
1857	Manchester *Art Treasures* exhibition includes 24 oil paintings and 83 water-colours by Turner (all finished works); these are discussed in books by the French writers Charles Blanc and Théophile Thoré.	September: visits Manchester *Art Treasures* exhibition.		Manchester *Art Treasures* exhibition; Charles Baudelaire publishes *Les Fleurs du mal*.

1857–8	Ruskin is permitted to select watercolours and sketches from the Turner Bequest for public display at Marlborough House; 400 are prepared in frames, some displayed and others stored in cases.			
1858	1858/9: Publication in series of Théophile Thoré's biography of Turner, *Histoire des peintres de toutes les écoles* (reprinted in collected volume 1862).	Autumn: meets Henri Fantin-Latour and Alphonse Legros in Paris; the three form the Société des Trois; meets Gustave Courbet.		The summer of the 'Great Stink' on the Thames in London; Act for purification of the Thames; Big Ben raised in clocktower of Houses of Parliament.
1859	December: National Gallery, British School galleries open at the South Kensington Museum; pictures in the Vernon and Turner Bequests transferred from Marlborough House (including the watercolours selected by Ruskin). 1859–61: *The Turner Gallery* published by the *Art Journal* (texts supplied by R.N. Wornum).	*At the Piano* (YMSM 24) rejected by the jury of the Paris Salon; is exhibited in the studio of François Bonvin; summer: moves to London after seeing the Paris Salon; begins working on etchings of the Thames (nos.27–30); Fantin-Latour visits Whistler and sees work of Turner for the first time.	May: visits Paris, sees Salon exhibition.	Joseph Bazalgette's main drainage scheme begun in London.
1860	April: Ruskin's father attempts to generate a consortium to buy one of Turner's views of Venice for the Louvre (B&J 362); June: Ruskin publishes *Modern Painters*, V; October: Turner's *Dido Building Carthage* (fig.15) removed from the National Gallery for a month to be relined.	Working in London; *At the Piano* exhibited at the Royal Academy of Arts; December: paints *The Thames in Ice* (fig.44), his first canvas of the Thames in foggy conditions.	Brief spell studying at Académie Suisse in Paris, possibly where first meets Pissarro; frequents Brasserie des Martyrs, where he sees but does not meet Gustave Courbet.	Victoria Tower completed at Houses of Parliament.
1861	March: Ruskin presents a group of Turner watercolours to the University Museum, Oxford; July: report of the Select Committee of the House of Lords on the future of the Turner Bequest; October: first gallery specifically devoted to Turner opens at the National Gallery in the West Room, made up of 94 oils and six watercolours; at the South Kensington Museum, two rooms remain devoted to Turner's studies (194 frames); December: publication of Walter Thornbury's sensational two-volume *Life* of Turner.	Working in Paris and Brittany, autumn and winter; probably meets Edouard Manet at this date.	1861–2: Military service with Chasseurs d'Afrique in Algeria.	Bazalgette's high-level sewer north of the Thames completed.
1862	Haden promotes Turner's *Liber Studiorum* to Paris-based artists. 1862–3: Haden adds Turnerian sunset to Legros's *The Angelus*.	January: Thames etchings exhibited at Martinet's gallery in Paris, praised in a review by Charles Baudelaire; summer: in London; *Symphony in White, No. 1: The White Girl* (YMSM 38) rejected by Royal Academy; meets Dante Gabriel Rossetti and Algernon Charles Swinburne, and becomes a regular visitor at their home, Tudor House, on Cremorne Road.	1862–4: Enrols in the studio of Charles Gleyre, studies there sporadically; among his fellow students are Frédéric Bazille, Auguste Renoir and Alfred Sisley.	Thames Embankment Bill passed. Completion of new Westminster Bridge, replacing bridge of 1738–50; International Exhibition at South Kensington; September: Mallarmé publishes an article, 'Hérésies Artistiques: L'Art pour tous' in *L'Artiste*; 8 November: Mallarmé moves to London and lives with Maria Gerhard while studying English.
1863		March: moves into 7 Lindsey Row, Chelsea, overlooking the Thames, between Tudor House and Turner's last home, 6 David Place, Cremorne Road; paints views of this reach of the Thames (nos.32–3); spring: *The White Girl* rejected at the Salon, exhibited in Salon des Refusés.		10 August: Mallarmé marries Maria in London; November–December: publication of Baudelaire's *The Painter of Modern Life*.
1864		Spring: *Wapping* (no.26) exhibited at Royal Academy; Fantin-Latour's *Homage to Delacroix* at the Salon, includes Whistler; paints first view whose sole subject is the Thames in fog, *Chelsea in Ice* (no.34).		Charing Cross Railway Bridge completed, replacing Isambard Kingdom Brunel's Hungerford Suspension Bridge of 1845; beginning of construction of Victoria Embankment.
1865		Meets Albert Moore; August: Swinburne invites Ruskin to visit Whistler's studio but the visit does not take place; Charles Daubigny dines with Whistler in London; autumn: works with Courbet at Trouville on the Normandy coast.	Spring: two Channel coast scenes accepted at the Salon. c.1865 By this date he is acquainted with Courbet and Daubigny.	Bazalgette's London sewer system opens.

1866		January–September: paints in Valparaiso, Chile.	Meets Edouard Manet; spring: exhibits a portrait and a forest scene at the Salon; autumn: meets Courbet on the Channel coast.	Final outbreak of cholera in East End of London; Sir William Boxall becomes Director of the National Gallery; Swinburne's *Poems and Ballads* published.
1867		February: moves to 2 Lindsey Row, Chelsea; by this date Whistler has met Frederick R. Leyland through Rossetti, and has proposed that Moore replace Legros, with whom Whistler has quarrelled, in the Société des Trois; 23 April: quarrels with Haden and severs contact with him; spring: exhibits at Royal Academy, the Salon (including no.33, fig.44) and Paris *Exposition Universelle* (including nos.26, 32); 29 May: Whistler criticises Turner at William Michael Rossetti's dinner table; Whistler writes to Fantin-Latour rejecting realism and the influence of Courbet, saying that there are more 'beautiful' things to paint.	Spring: rejected at the Salon; Fantin-Latour writes to Edwin Edwards of his admiration for Monet. 1867–8: Winter: painting atmospheric snow scenes at Bougival, to the west of Paris (no.35).	May: *Exposition Universelle* opens in Paris; 31 August: death of Baudelaire in Paris.
1868		1868–70: Works at classicising figure subjects.	Spring: one coast scene accepted at the Salon, one rejected.	Haussmann's collector sewers completed in Paris.
1869	January: further Turner watercolours available to students, on application, in a room on the lower floor of the National Gallery; April: display of Turner oils at National Gallery reopened, in an expanded sequence of three rooms; first three loan collections selected for regional museums.		Spring: rejected at the Salon.	Albert Embankment opened, on south side of Thames from Westminster to Vauxhall Bridge; move of Royal Academy of Arts from the National Gallery to new premises in Burlington House.
1870		Spring: exhibits *The Balcony* (fig.50) at Royal Academy.	Spring: rejected at the Salon; Fantin-Latour's *A Studio in the Batignolles* at the Salon, includes Monet; 28 June: marries Camille Doncieux, the mother of his son Jean (born 1867); autumn: takes refuge in London from the Franco-Prussian War; Daubigny introduces him to the dealer Paul Durand-Ruel. 1870–1: Winter: paints views of the Thames and the London parks; visits the National Gallery and studies the Turners there; exhibits with Society of French Artists, organised by Durand-Ruel; meets Edwin Edwards.	January: Haussmann dismissed as Prefect of the Seine, after financial irregularities; July: Victoria Embankment opened, on north side of Thames from Westminster to Blackfriars; July: outbreak of Franco-Prussian War; September: fall of Napoleon III; Third Republic proclaimed.
1871		Walter and Henry Greaves row Whistler on the Thames; begins to paint a sequence of night scenes on the Thames, first called 'moonlights' (nos.43–7); spring: publishes *Sixteen Etchings of Scenes on the Thames* (the 'Thames Set'); autumn: exhibits first Thames night scenes at the Dudley Gallery in London.	January: meets Camille Pissarro, who is also taking refuge in London; spring: exhibits in the International Exhibition at the South Kensington Museum; rejected at the Royal Academy; December: moves to Argenteuil, on the Seine north-west of Paris; his interior decoration with Japanese fans is similar to Whistler's decor at Chelsea. 1871–3: Monet's works appear in several exhibitions of Society of French Artists in London; Whistler's work appears with his in the fifth, sixth and seventh exhibitions, in late 1872, summer 1873 and late 1873.	January: fall of Paris after four-month seige; St Thomas's Hospital, Lambeth, completed; International Exhibition at South Kensington Museum, London.
1872	Publication of Hippolyte Taine's *Notes sur l'Angleterre*, with discussion of Turner; all works from Turner Bequest recalled from South Kensington Museum to National Gallery.	1872–5: Exhibits with the Society of French Artists in London, organised by the Paris dealer Paul Durand-Ruel; his work appears with Monet's in the fifth, sixth and seventh exhibitions, in late 1872, summer 1873 and late 1873. 1872: Whistler welcomes Leyland's suggestion that he should title his 'moon-lights' as 'nocturnes'; November: first uses title Nocturne to describe his night scenes at exhibition at the Dudley Gallery.	Paints *Impression, Sunrise* (no.39).	

1873		Ruskin, in a lecture, criticises a painting by Whistler shown at the fifth (winter) exhibition of the Society of French Artists in 1872 (probably YMSM 98); January: Whistler exhibits at Durand-Ruel's Gallery in Paris, including night scenes of the Thames; declines invitation from Edgar Degas to exhibit in the first exhibition of the Société anonyme (the First Impressionist Exhibition).		April: Mallarmé meets Manet; Marshall MacMahon becomes President of France, institutes 'moral order' regime.
1874	March and April: paintings by or attributed to Turner sold at auction in Paris, apparently the first Turners to be publicly displayed there; April: etching by Félix Bracquemond after *Rain, Steam and Speed* (fig.22) included in First Impressionist Exhibition.	June: solo show in the Flemish Gallery, Pall Mall, London.	April–May: exhibits in the first exhibition of the Société anonyme, including *Impression, Sunrise*, whose title leads to the group being named the 'Impressionists'; probably meets Mallarmé around this date.	April–May: first exhibition of the Société anonyme des artistes peintres, sculpteurs, graveurs etc. in Paris (the First Impressionist Exhibition); May: Chelsea Embankment opened, from Chelsea Bridge to Battersea Bridge.
1875	Summer: Berthe Morisot admires Turners in National Gallery, comments on Whistler's debt to Turner.	November: exhibits *Nocturne in Black and Gold: The Falling Rocket* (no.50) at the Dudley Gallery.		Bazalgette's main drainage and sewer system in London completed.
1876	Building work at the National Gallery, under way since 1872; Turner water-colours, formerly at the South Kensington Museum, installed in sixty cabinets in lower rooms.	1876–7: Winter: paints the Peacock Room in the house of his patron, Frederick Leyland	March–April: exhibits in second Impressionist group exhibition.	
1877	Publication of second, revised edition of Thornbury's *Life* of Turner.	May: exhibits at newly formed Grosvenor Gallery, including *Nocturne in Black and Gold: The Falling Rocket* (no.50); Ruskin's review, in *Fors Clavigera*, leads him to sue for libel.	April–May: exhibits in third Impressionist group exhibition.	Cremorne Gardens, on the Thames in Chelsea, close; May: Grosvenor Gallery opens in London.
1878	300 works on walls in display of Turner watercolours, drawn from the cabinets, in lower rooms at National Gallery; March: exhibition of Turner watercolours from Ruskin's collection at Fine Art Society in London; July: Ruskin selects group of watercolours from the Turner Bequest for display at the University Museum, Oxford.	25–6 November: wins libel case against Ruskin, but is awarded only one farthing damages, without costs.	January: moves back to Paris from Argenteuil; late summer: moves with the family of his bankrupt patron Ernest Hoschedé to Vétheuil, a remote village on the Seine north-west of Paris; Hoschedé spends most of his time in Paris, leaving his wife Alice and their children at Vétheuil.	May: *Exposition Universelle* opens in Paris.
1879		Sale of his property; he is declared bankrupt; September: travels to Venice, commissioned by the Fine Art Society in London to make a set of etchings, returning in November 1880.	April–May: exhibits in fourth Impressionist group exhibition; 5 September: death of Camille Monet; Alice and the Hoschedé children continue to live at Vétheuil.	January: after elections, Jules Grévy replaces MacMahon as President of France, institutes expansionist 'opportunist' republic.
1880		December: exhibits Venice etchings at Fine Art Society.	Spring: submits to the Salon, where one painting accepted, one rejected; does not exhibit with the Impressionists; December: writes to Théodore Duret of his wish to visit London and paint the Thames, but does not make the trip.	F.A. Rollo Russell publishes *London Fogs*; Emile Raspail publishes *Des Odeurs de Paris*, voicing concern about pollution of the air and the river Seine in the Paris region.
1881		January: exhibits Venice pastels at Fine Art Society; April: visits Renoir at Chatou, to the west of Paris.		
1882	Publication of Ernest Chesneau's *La Peinture anglaise*, with extended discussion of Turner. 1882/3: A group of French artists, including Monet, writes to Sir Coutts Lindsay seeking an exhibition of their work at the Grosvenor Gallery and acknowledging Turner as a precursor.		March–April: exhibits in seventh Impressionist group exhibition; July: four of his paintings included in an Impressionist exhibition organised by Durand-Ruel in King Street, St James's, London.	
1883	Summer: Camille Pissarro urges his son Lucien, who is in London, to study Turner's oils and watercolours.	February: exhibition of etchings, mostly of Venice, at Fine Art Society; spring: portrait of Whistler's mother (YMSM 101) wins third class medal at Paris Salon; exhibits at Galerie Georges Petit in Paris.	March: solo show at Durand-Ruel's Gallery in Paris; April: Monet settles at Giverny, on a tributary of the Seine near Vernon, north-west of Paris, with Alice Hoschedé and her children; April–July: seven of his paintings exhibited in Impressionist show at Dowdeswells'	April 30: death of Manet.

Year				
1883 (continued)			Gallery in London, organised by Durand-Ruel.	
1884	Display of Turner oils at National Gallery moved to Room 1; 40 oils sent to English regional galleries.	May: solo exhibition, 'Notes'–'Harmonies'–'Nocturnes', at Dowdeswells' Gallery in London; November: elected member of Society of British Artists in London.		Ruskin delivers his 'The Storm Cloud of the Nineteenth Century' lectures.
1885		20 February: first delivery of his 'Ten O'Clock' lecture, in London.	1885–6: Exhibits at Georges Petit's Exposition Internationale in Paris.	
1886		April: *Twenty-Six Etchings of Venice* issued by Dowdeswells'; May: solo exhibition at Dowdeswells'; June: elected President of Society of British Artists.		6 October: death of the architect E.W. Godwin, whose widow Whistler marries in 1888.
1887	Turner oils in two rooms on main floor of National Gallery; February/March: paintings by Turner exhibited in Paris in exhibition for benefit of flood victims, probably including no.22.	May: exhibits with Monet and others at Georges Petit's Exposition Internationale in Paris; late May: invites Monet, who is visiting London, to exhibit with the Royal Society of British Artists; July: Society of British Artists receives a Royal Charter; November: four paintings by Monet included in exhibition of Royal Society of British Artists	Late May: visits London for first time since 1871, where spends time with Whistler; on return, writes that he is 'amazed by London and also by Whistler'; May–June: exhibits with Whistler and others at Georges Petit's Exposition Internationale in Paris; early autumn: writes to Whistler accepting invitation to exhibit with the Royal Society of British Artists in London; writes to Duret saying that he plans to paint 'fog effects on the Thames'; November: four paintings by Monet included in exhibition of Royal Society of British Artists; he visits London for the opening of the show.	
1888		Early January: introduced by Monet to the poet Stéphane Mallarmé; May: Mallarmé's translation of the 'Ten O'Clock' lecture published in *Revue Indépendante* and as a separate pamphlet; May–June: Whistler exhibits with Boudin, Caillebotte, Morisot, Pissarro, Renoir and Sisley at Durand-Ruel's gallery in Paris; Monet does not participate; 4 June: resigns as President of Royal Society of British Artists; 11 August: marries Beatrice Godwin, widow of the architect E.W. Godwin.	Early January: introduces Whistler to the poet Stéphane Mallarmé; 27 May: meets Whistler in Paris; May–June: does not participate in group exhibition at Durand-Ruel's gallery, in which Whistler exhibits; 5 June: thanks Mallarmé for sending him a dedicated copy of his translation of Whistler's 'Ten O'Clock' lecture; July: visits London briefly, stays with John Singer Sargent but does not see Whistler; an English journalist writes of his 'enthusiastic admiration' for Turner's later works.	
1889	Publication of first monograph in French on Turner, by P.G. Hamerton.	28 April: banquet for Whistler in Paris celebrating award of medal at Munich and the Cross of St Michael of Bavaria; autumn: made a Chevalier de la Légion d'Honneur.	April: solo show at Goupil Gallery, London; 28 April: writes to Whistler, regretting he cannot attend the Whistler banquet in Paris; June–September: major Monet/Rodin exhibition at Georges Petit's gallery in Paris.	Savoy Hotel opens in London; May: Exposition Universelle opens in Paris.
1890	Late works by Turner accessible in collection of Camille Groult in Paris; article on Turner by Robert de la Sizeranne published in *La Grande Revue*.	June: publishes his collected writings under the title *The Gentle Art of Making Enemies*.		Bazalgette's new Battersea Bridge completed, replacing old wooden bridge of 1771–2.
1891		Sends Monet two lithographs through the intermediary of Mallarmé; November: the French State buys *Portrait of the Painter's Mother* (YMSM 101) for the Musée du Luxembourg following lobbying by Mallarmé and others; 19 December: welcomes Monet, in London for the exhibition of the New English Art Club, at a dinner at the Chelsea Arts Club held to celebrate the purchase of *Portrait of the Painter's Mother*, where he introduces him to young British artists.	19 March: death of Ernest Hoschedé; April: Monet thanks Whistler for the gift of two lithographs, sent through the intermediary of Mallarmé; May: mounts his first series exhibition, of *Grain Stacks* at Durand-Ruel's gallery in Paris; November–December: exhibits with New English Art Club, London; December: visits London, dines with Whistler at the Chelsea Arts Club.	
1892		January: made Officier de la Légion d'Honneur; March: major retrospective exhibition at Goupil Gallery, London; April, moves his base from London to Paris.	16 July: marries Alice Hoschedé; September: Monet speaks to Theodore Robinson of his admiration for Turner's watercolours and *Rain, Steam and Speed*.	
1893			April: exhibits with New English Art Club, London.	

1894	June: exhibition including Turner organised by dealer Sedelmeyer in Paris, includes no.22, lent by Camille Groult; Sedelmeyer tries unsuccessfully to persuade the Louvre to buy a Turner (*Ancient Italy – Ovid Banished from Rome*; B&J 375).			
1895	Chapter on Turner published in Gabriel Mourey's *Passé le détroit*.		May: solo exhibition at Durand-Ruel's gallery, including *Rouen Cathedral* series.	
1896		January–March: stays with his wife in the Savoy Hotel, London, during her final illness; executes lithographs of the views from his window; 10 May: death of Beatrice Whistler; 17 May: Mallarmé writes letter of condolence to Whistler; 18 May: Monet writes letter of condolence to Whistler; Whistler takes group to the National Gallery to disparage Turner's *Dido Building Carthage* (fig.15).	18 May: writes letter of condolence to Whistler upon the death of his wife.	
1898	March: Paul Signac studies the Turners in the National Gallery.	April: elected President of International Society of Sculptors, Painters and Gravers; May: first exhibition of International Society of Sculptors, Painters and Gravers in London. 1898–1903: Alternating periods living in Paris and London.	May: exhibits in first exhibition of International Society of Sculptors, Painters and Gravers; June: solo exhibition at Georges Petit's gallery in Paris, including series of *Mornings on the Seine* (see nos.60–2); November: brief visit to London, where his son Michel is ill.	9 September: death of Mallarmé.
1899	April–July: large loan exhibition of paintings and watercolours by Turner at the Guildhall Art Gallery, London.	Autumn: probably not in London during Monet's first Thames painting campaign.	September–October: in London, staying at Savoy Hotel and painting views of the Thames from his window, of Charing Cross Bridge, with the Houses of Parliament, and Waterloo Bridge (see nos.70–7).	
1900		Visits London during Monet's second Thames painting campaign.	February–April: in London, painting views from Savoy Hotel and of the Houses of Parliament seen from St Thomas's Hospital.	January: death of Ruskin; *Exposition Universelle*, Paris.
1901		In Corsica during Monet's third Thames painting campaign.	January–April: in London, painting views from Savoy Hotel and St Thomas's Hospital, as well as a few night-time sketches of Leicester Square. 1901–4: During the winters, works on his London series in his studio at Giverny.	22 January: death of Queen Victoria.
1902	E.T. Cook publishes *Ruskin on Pictures*, vol.I: *Turner at the National Gallery and in Mr Ruskin's Collection*.			
1903		17 July: Whistler dies in London.		
1904			May–June: exhibition of *London* series at Durand-Ruel's gallery in Paris; December: visits London to plan an exhibition of his *London* series; the show does not materialise; this is his final visit to London.	
1905	E.T. Cook publishes *Hidden Treasures at the National Gallery*, a selection of previously unpublished sketches by Turner.	Major Whistler retrospectives at International Society of Sculptors, Painters and Gravers in London and Ecole des Beaux-Arts in Paris.	January–February: major Impressionist retrospective at Grafton Galleries in London, organised by Durand-Ruel, includes 55 works by Monet.	
1906	Unfinished paintings in the Turner Bequest are catalogued and displayed at the Tate Gallery (National Gallery for British Art).			
1908	A.J. Finberg completes first inventory of the Turner Bequest.	E.R. and J. Pennell publish *The Life of James McNeill Whistler*.	October–December: painting in Venice.	
1909				
1911			19 May: death of Alice Hoschedé.	
1912			May–June: exhibition of Venice series at Bernheim-Jeune gallery in Paris, after reworking the paintings at Giverny.	
1926			5 December: Monet dies at Giverny.	

Bibliography
Edited by Jessica Morden

LIST OF ABBREVIATIONS

AAA Archives of American Art, Washington, DC

B&J Butlin, Martin and Evelyn Joll. *The Paintings of J.M.W. Turner*. rev. ed. New Haven: Yale University Press, 1984

GUW *The Correspondence of James McNeill Whistler, 1855–1903*, ed. Margaret F. MacDonald, Patricia de Montfort and Nigel Thorp; including *The Correspondence of Anna McNeill Whistler, 1855–1880*, ed. Georgia Toutziari. On-line Centenary edition, Centre for Whistler Studies, University of Glasgow, 2003 www.whistler.arts.gla.ac.uk/correspondence

GUL Glasgow University Library

K Kennedy, Edward G. *The Etched Work of Whistler*. 5 vols. New York: The Grolier Club of the City of New York, 1910 (reprinted in 3 vols., New York: Da Capo Press, 1974)

LC PWC Library of Congress, Pennell–Whistler Collection

M MacDonald, Margaret F. *James McNeill Whistler: Drawings, Pastels, and Watercolours: A Catalogue Raisonné*. New Haven: Yale University Press for the Paul Mellon Centre for Studies in British Art, 1995

OC Mallarmé, Stéphane. *Œuvres complètes*, ed. Bertrand Marchal. 2 vols. Paris: Gallimard, Bibliothèque de la Pléiade, 1998 and 2003

R Rawlinson, W.G. *The Engraved Work of J.M.W. Turner RA*. 2 vols. London: Macmillan, 1908, 1913

S Spink, Nesta, Harriet K. Stratis, Martha Tedeschi et al. *The Lithographs of James McNeill Whistler: A Catalogue Raisonné*. 2 vols. Chicago: Art Institute of Chicago in association with the Arie and Ida Crown Memorial; New York: Hudson Hills Press, 1998

TB Finberg, A.J. *A Complete Inventory of the Drawings of the Turner Bequest: with which are included the Twenty-three Drawings Bequeathed by Mr Henry Vaughan*. 2 vols. London: National Gallery, 1909

W [Monet] Wildenstein, Daniel. *Claude Monet Biographie et Catalogue Raisonné*. 5 vols. Lausanne: La Bibliothèque des Arts, 1974–1991 (reprinted in 4 vols., Cologne: Benedict Taschen Verlag, 1996; this edition does not include Monet's correspondence)

W [Turner] Wilton, Andrew. *J.M.W. Turner: His Art and Life*. New York: Rizzoli, 1979

Whistler PC Whistler Press-cutting Books, Glasgow University Library

Works Cook, E.T. and A. Wedderburn, eds. *The Works of John Ruskin*. 39 vols. London: G. Allen; New York: Longmans, Green & Co., 1903–12

YMSM Young, Andrew McLaren, Margaret MacDonald, Robin Spencer and Hamish Miles. *The Paintings of James McNeill Whistler*. New Haven: Yale University Press for the Paul Mellon Centre for Studies in British Art, 1980

ABRAMS 1962
Abrams, M.H. et al., eds. *The Norton Anthology of English Literature*. 2 vols. New York: W.W. Norton, 1962

ALPHANT 1993
Alphant, M. *Claude Monet, une vie dans le paysage*. Paris: Hazan, 1993

ALTICK 1978
Altick, Richard. *The Shows of London*. Cambridge, Mass.: Belknap Press, 1978

D'ANNUNZIO 1900
D'Annunzio, G. *The Flame of Life*. trans. K. Vivaria. London, 1900

ARMSTRONG 1912
Armstrong, Thomas. *Thomas Armstrong, C.B.: A Memoir, 1832–1911*. ed. L.M. Lamont. London: Martin Secker, 1912

ASHBY AND ANDERSON 1981
Ashby, Eric and Mary Anderson. *The Politics of Clean Air*. Oxford: Clarendon Press, 1981

BACHER 1908
Bacher, Otto H. *With Whistler in Venice*. New York: Century, 1908

BAILLY-HERZBERG 1980–91
Bailly-Herzberg, Janine, ed. *Correspondance de Camille Pissarro*. 5 vols. Paris: Presses Universitaires de France and Valhermeil, 1980–91

BARBIER 1964
Barbier, Carl Paul, ed. *Mallarmé–Whistler Correspondance*. Paris: Nizet, 1964

BARBIER 1968–79
Barbier, Carl Paul, ed. *Documents Stéphane Mallarmé*. 7 vols. Paris: Nizet, 1968–79

BAUDELAIRE 1964
Baudelaire, Charles. *The Painter of Modern Life, and other Essays*. ed. and trans. Jonathan Mayne. Oxford: Phaidon Press, 1964

BAUDELAIRE 1965
Baudelaire, Charles. *Art in Paris 1854–62: Salons and other Exhibitions Reviewed by Charles Baudelaire*. ed. and trans. Jonathan Mayne. Oxford: Phaidon Press, 1964

BAUDELAIRE 1975–6
Baudelaire, Charles. *Œuvres complètes / Baudelaire*. ed. Claude Pichois. 2 vols. Paris: Gallimard, 1975–6

BAUDELAIRE 1995
Baudelaire, Charles. *Selected Poems*. With a plain prose translation, introduction and notes by Carol Clark. London: Penguin, 1995

BEADLE 1995
Beadle, William. *Jack the Ripper: Anatomy of a Myth*. Dagenham: Wat Tyler Books, 1995

BECKETT 1967
Beckett, R.B. *John Constable's Correspondence*, XIV. Ipswich: Suffolk Records Society Publications, 1967

BELL 1880
Bell, Lynn. 'Art, Mr. Whistler's Venice.' *Spectator*, 11 Dec. 1880, p.1587

BENNETT 1956
Bennett, Richard. *Battersea Works, 1856–1956*. London: The Morgan Crucible Company, 1956

BERNHARDT 1906
Bernhardt, F. de. *Londres et la vie à Londres*. Paris: J. Dumoulin, 1906

BERNSTEIN 1975
Bernstein, Henry T. 'The Mysterious Disappearance of Edwardian London Fog,' *London Journal*, vol.1, no.2, Nov. 1975, pp.189–206

BERSON 1996
Berson, Ruth, ed. *The New Painting: Impressionism 1874–1886, Documentation*. 2 vols. San Francisco: Fine Arts Museums of San Francisco and Seattle: University of Washington Press, 1996

BERTIN D'ANTILLY 1783
Bertin d'Antilly, Louis Auguste. *L'Anglais à Paris; comédie en un acte et en prose. Representée, pour la première fois, à Paris, sur le Théâtre des Variétés Amusantes, le 12 mars 1783, par M. D' . . . y, l'aîné*. Paris: Cailleau, 1783

BIJVANCK 1892
Bijvanck, Willem Gertrud Cornelis. *En Hollandais à Paris en 1891: Sensations de literature et d'art*. Paris: Perrin et cie, 1892

BLANC 1857
Blanc, Charles. *Les Trésors de l'art à Manchester*. Paris: Pagnerre, 1857

BLANC 1876
Blanc, Charles. *Les Artistes de mon temps*. Paris: Firmin-Didot et Cie, 1876

BLANCHE 1928
Blanche, J.-É. *Propos de peintre, De Gauguin à La Revue Nègre*. 3rd series. 3rd ed. Paris: Emile-Paul, 1928

BLOOM 1973
Bloom, Harold. *The Anxiety of Influence: A Theory of Poetry*. Oxford and New York: Oxford University Press, 1973

BLOUËT 1883
Blouët, Paul. *John Bull et son ile: moeurs anglaises contemporaines*. Paris: Calmann Lévy, 1883

BOWNESS AND CALLEN 1973
Bowness, Alan (intro.) and Anthea Callen. *The Impressionists in London*. exh. cat. London: Hayward Gallery, 1973

BRADLEY 1978
Bradley, John Lewis. *Ruskin's Letter from Venice, 1851–1852*. 2nd ed. New Haven and London: Yale University Press, 1978

BRIMBLECOMBE 1987
Brimblecombe, Peter. *The Big Smoke: A History of Air Pollution in London since Medieval Times*. London: Methuen, 1987

BROOKE 1991
Brooke, John Hedley. *Science and Religion: Some Historical Perspectives*. Cambridge: Cambridge University Press, 1991

BURNE-JONES 1904
Burne-Jones, Georgiana. *Memorials of Edward Burne-Jones*. 2 vols. London: Macmillan, 1904

BUTLIN AND JOLL 1984
Butlin, Martin and Evelyn Joll. *The Paintings of J.M.W. Turner*. rev. ed. New Haven: Yale University Press, 1984

BYNUM 1991
Bynum, W.F., ed. 'Parish Pump to Private Pipes: London's Water Supply in the Nineteenth Century', *Living and Dying in London*. London: Wellcome Institute for the History of Medicine, 1991

CAIZZI 1965
Caizzi, Bruno. *Storia dell'industrial italiana*. Turin: UTET, 1965

CALLOW 1908
Callow, William. *An Autobiography*. ed. H.M. Callow. London: Black, 1908

CASTERAS 1987
Casteras, Susan P. *Images of Victorian Womanhood in English Art*. Rutherford: Farleigh Dickinson University Press, 1987

CASTERAS AND DENNEY 1996
Casteras, Susan P. and Colleen Denney. *The Grosvenor Gallery: A Palace of Art in Victorian England*. London: Yale University Press, 1996

CHADWICK 1842
Chadwick, Edwin. *Report on the Sanitary Condition of the Labouring Population of Great Britain* [1842]. ed. M.W. Flinn. Edinburgh: Edinburgh University Press, 1965

CHESNEAU 1864
Chesneau, Ernest. *L'Art et les artistes modernes en France et en Angleterre*. Paris: Didier, 1864

CHESNEAU 1873
Chesneau, Ernest. 'Les Japonisme dans les arts'. *Musée Universel*, vol.2, 1873, pp.214–17

CHESNEAU 1874
Chesneau, Ernest. 'Soleil levant sur la Tamise', 'A côté du Salon, II', *Paris-Journal*, 7 May 1874, repr. Berson 1996, I, p.18

CHESNEAU 1882
Chesneau, Ernest. *La Peinture anglaise*. Paris: A. Quantin, 1882

CHESNEAU 1888
Chesneau, Ernest. 'The English School in Peril, a Letter from Paris', *Magazine of Art*, 1888, pp.25–8

CHEVRILLON 1901
Chevrillon, André. *Études anglaises*. Paris: Hachette, 1901

CIPOLLA 1992
Cipolla, Carlo M. *Miasmas and Disease: Public Health and the Environment in the Pre-industrial Age*. trans. Elizabeth Potter. New Haven: Yale University Press, 1992

CLARK 1984
Clark, T.J. *The Painting of Modern Life: Paris in the Art of Manet and his Followers*. Princeton: Princeton University Press, 1984

CLARKE AND THOMSON 2003
Clarke, Michael and Richard Thomson. *Monet: The Seine and the Sea*, exh.cat. National Galleries of Scotland 2003

COLVIN 1874
Colvin, Sidney. 'Exhibition of Mr. Whistler's Pictures', *Academy*, 13 June 1874, p.673

COLVIN 1877
Colvin, Sidney. 'The Grosvenor Gallery', *Fortnightly Review*, no.27, June 1877, pp.831–2.

COOK 1902
Cook, E.T., ed. *Ruskin on Pictures: A Collection of Criticisms by John Ruskin not heretofore Re-printed and now Re-edited and Re-arranged. I, Turner at the National Gallery and in Mr Ruskin's Collection*, London: George Allen, 1902

COOK 1905
Cook, E.T. *Hidden Treasures at the National Gallery*, London: Pall Mall Press, 1905

COOK 1911
Cook, E.T. *The Life of John Ruskin, 1860–1900*. London: George Allen and Co., 1911

COOK AND WEDDERBURN 1903–12
Cook, E.T. and A. Wedderburn, eds. *The Works of John Ruskin*. Library ed. 39 vols. London: G. Allen; New York: Longmans, Green, and Co., 1903–12

COOLIDGE 1994
Coolidge, John. *Gustave Doré's London: A Study of the City in the Age of Confidence, 1848–1873*. Dublin, NH: Willam L. Bauhan, 1994

COOPER 1954
Cooper, Douglas. *The Courtauld Collection*. London: University of London, The Athlone Press, 1954

CORBIN 1982
Corbin, Alain. *Le Miasme et la jonquille: l'odorat et l'imaginaire social, XVIIIe–XIXe siècles*. Paris: Aubier Montaigne, 1982

CURRY 1984
Curry, David Park. *James McNeill Whistler at the Freer Gallery of Art*. Washington, DC: Freer Gallery of Art; New York: Norton, 1984

DENÈGE 1906
Denège, Blanche. *Trois mois à Londres (impressions d'une artiste)*. Paris: Félix Juven, 1906

DEWHURST 1903
Dewhurst, Wynford. 'Impressionist Painting: Its Genesis and Development, Second Article', *Studio*, no.29, July 1903

DEWHURST 1904
Dewhurst, Wynford. *Impressionist Painting: Its Genesis and Development*. London: Charles Scribner's Sons and George Newnes, 1904

DIETERLE 1995
Dieterle, Bernard. *Die versunkene Stadt: Sechs Kapitel zum literarischen Venedig-Mythos*. Frankfurt am Main: Peter Lang, 1995

DORÉ AND JERROLD 1978
Doré, Gustave and Blanchard Jerrold. *London: A Pilgrimage* [1872]. New York: Arno Press, 1978

DORMENT AND MACDONALD 1994
Dorment, Richard and Margaret F. MacDonald, eds. *James McNeill Whistler*. exh. cat. London: Tate Gallery, 1994

DRUICK AND HOOG 1983
Druick, Douglas and Michel Hoog. *Fantin Latour*. exh. cat. Ottawa: National Gallery of Canada, 1983

DUBOSQ DE PESQUIDOUX 1858
Dubosq de Pesquidoux, Léonce. 'William Turner', *L'École anglaise 1672–1851*. Paris, 1858 (repr. in *L'Artiste*, Sept. 1871, pp.358–91)

DUPRET 1989
Dupret, Marcel-Etienne. 'Turner's *Little Liber*', *Turner Studies*, vol.9, no.1, Summer 1989, pp.32–47

DURANTY 1946
Duranty, Edmond. *La nouvelle peinture* [1876], repr. Paris: Librairie Floury, 1946

DURET 1904
Duret, Théodore. *Histoire de James Mc N. Whistler et de son œuvre*. Paris: Librairie Floury, 1904

DURET 1917
Duret, Théodore. *Whistler*. trans. Frank Rutter. London: Grant Richards 1917

EGERTON 1995
Egerton, Judy. *Turner: The Fighting Temeraire*. exh. cat. London: National Gallery, 1995

EGERTON 1998
Egerton, Judy. *National Gallery Catalogues: The British School*. London: National Gallery, 1998

ESCHOLIER 1956
Escholier, R. *Matisse, ce vivant*. Paris: Fayard, 1956

EVANS 1992
Evans, Mark. *Impressions of Venice from Turner to Monet*. exh. cat. Cardiff: National Museum of Wales; London: Lund Humphries, 1992

EVELYN 1969
Evelyn, John. *Fumifugium: Or the Inconvenience of the Aer and Smoake of London Dissipated, repr. The Smoake of London, Two Prophecies*. ed. James P. Lodge, Jr. New York: Maxwell Reprint Co., 1969

FEAVER 2002
Feaver, William. *Constable: le choix de Lucian Freud*. exh cat. Paris: Grand Palais, 2002

FELS 1927
Fels, Marthe de. *La Vie de Claude Monet*. Paris: Librairie Gallimard, 1927

FINBERG 1909
Finberg, A.J. *A Complete Inventory of the Drawings of the Turner Bequest: with which Are Included the Twenty-Three Drawings Bequeathed by Mr Henry Vaughan. Arranged Chronologically*. 2 vols. London: Darling & Son, 1909

FINBERG 1961
Finberg, A.J. *The Life of J.M.W. Turner, R.A.* revised ed. Oxford: Clarendon Press, 1961

FINE 1987
Fine, Ruth, ed. *James McNeill Whistler: A Re-examination*. Studies in the History of Art, vol.19. Washington: National Gallery of Art, 1987

FITCH 1982
Fitch, Raymond E. *The Poison Sky: Myth and Apocalypse in Ruskin*. Athens, Ohio: Ohio University Press, 1982

FITZGERALD 1975
Fitzgerald, P. *Edward Burne-Jones*. London: Hamish Hamilton, 1975

FLEMING 1978
Fleming, Gordon. *The Young Whistler, 1834–1866*. London: George Allen & Unwin, 1978

FLICK 1980
Flick, Carlos. 'The Movement for Smoke Abatement in 19th-Century Britain', *Technology and Culture*, vol.21, no.1, Jan. 1980, pp.29–50

FLINT 1984
Flint, Kate, ed. *Impressionists in England: The Critical Reception*. London: Routledge & Kegan Paul, 1984

FORRESTER 1996
Forrester, Gillian. *Turner's 'Drawing Book': The Liber Studiorum*. exh. cat. London: Tate Gallery, 1996

FOSSIER 1987
Fossier, Françoise. *Whistler graveur*, exh. cat. Paris: Musée d'Orsay, 1987

FRANCE 1883
France, Hector. *Les Va-nu-pieds de Londres*. Paris: G. Charpentier, 1883

FREESE 2003
Freese, Barbara. *Coal: A Human History*. Cambridge, MA: Perseus, 2003

FREND 1819
Frend, W. 'Is it Impossible to Free the Atmosphere of London in a Very Considerable Degree, from the Smoke and Deleterious Vapours with which it is Hourly Impregnated?' [1819], *The Pamphleteer*, vol.15, no.29, pp.61–5

GAGE 1972
Gage, John. *Turner: Rain, Steam and Speed*. London: Allen Lane, 1972

GAGE 1983
Gage, John. *Colour in Turner: Poetry and Truth*. New York: Frederick A. Praeger, [1969] 1983.

GAGE 1983a
Gage, John. 'Le Roi de la lumière: Turner et le public français de Napoléon à la seconde guerre mondiale', *J.W.M. Turner*. exh. cat. Paris: Grand Palais, 1983

GAGE 1987
Gage, John. *J.M.W. Turner: 'A Wonderful Range of Mind'*. New Haven and London: Yale University Press, 1987

GAGE, JOLL AND WILTON 1983
Gage, John, Evelyn Joll, Andrew Wilton et al. *J.W.M. Turner*. exh. cat. Paris: Grand Palais, 1983

GALASSI 1996
Galassi, Susan Grace. *Mortlake Terrace: Turner's Companion Pieces Reunited*. exh. cat. New York: Frick Collection, 1996

GEFFROY 1892
Geffroy, Gustave. *La Vie artistique, première série*. Paris: H. Floury, 1892

GEFFROY 1894
Geffroy, Gustave. *La Vie artistique, troisième série: Histoire de l'impressionnisme*. Paris: H. Floury, [1892] 1894

GEFFROY 1924
Geffroy, Gustave. *Claude Monet, sa vie, son temps, son œuvre*. Paris: G. Crès et cie, [1922] 1924

GERBOD 1995
Gerbod, Paul. *Les Voyageurs français à la decouverte des îles britanniques, du XVIIIème siècle à nos jours*. Paris: L'Harmattan, 1995

GIBSON 1995
Gibson, Robert. *Best of Enemies: Anglo-French Relations Since the Norman Conquest*. London: Sinclair-Stevenson, 1995

GIMPEL 1927
Gimpel, René. 'At Giverny with Claude Monet', *Art in America*, vol.XV, no.IV, June 1927, p.168–175

GIMPEL 1963
Gimpel, R. *Journal d'un collectionneur, marchand de tableaux*. Paris: Calman-Lévy, 1963

GIMPEL 1966
Gimpel, René, *Diary of an Art Dealer*. trans. John Rosenberg. New York: Farrar, Straus and Giroux 1966

GLICK 1980
Glick, Thomas F. 'Science, Technology, and the Urban Environment: The Great Stink of 1858', *Historical Ecology: Essays on Environment and Social Change*. ed. Lester J. Bilsky. Port Washington: Kennikat, 1980, pp.122–39

GOLDWATER 1979
Goldwater, Robert. *Symbolism*. New York: Harper & Row, 1979

GONCOURT 1979
de Goncourt, Edmond and Jules [1867]. *Manette Salomon*. Paris: Gallimard, 1979

GOUBERT 1989
Goubert, Jean-Pierre. *The Conquest of Water: The Advent of Health in the Industrial Age*. intro. Emanuel Le Roy LaDurie. trans. Andrew Wilson. Princeton: Princeton University Press, 1989

GREEN 1965
Green, F.C. *A Comparative View of French and British Civilization, 1850–1870*. London: J.M. Dent, 1965

GRIEVE 2000
Grieve, Alastair. *Whistler's Venice*. New Haven and London: Yale University Press for the Paul Mellon Centre for Studies in British Art, 2000

GSELL 1892
Gsell, Paul. 'La Tradition artistique française, I: L'Impressionnisme', *Revue bleue*, 26 March 1892, p.404

GUILLEMOT 1898
Guillemot, Maurice. 'Claude Monet', *Revue illustré*, 15 March 1898 [n.p.]

HACKNEY 1994
Hackney, Stephen. 'Colour and Tone in Whistler's "Nocturnes" and "Harmonies", 1871–2', *Burlington Magazine*, vol.136, Oct. 1994, p.697

HALLIDAY 1999
Halliday, Stephen. *The Great Stink of London: Sir Joseph Bazalgette and the Cleansing of the Victorian Capital*. Stroud: Sutton, 1999

HAMERTON 1868
Hamerton, Philip Gilbert. *Etching and Etchers*. London: Macmillan, 1868

HAMERTON 1889
Hamerton, Philip Gilbert. *Turner*. Paris: Librairie de L'Art, 1889

HAMLIN 1985
Hamlin, Christopher. 'Providence and Putrefaction: Victorian Sanitarians and the Natural Theology of Health and Disease', *Victorian Studies*, vol.28, no.3, Spring 1985, pp.381–411

HAMLIN 1998
Hamlin, Christopher. *Public Health and Social Justice in the Age of Chadwick: Britain, 1800–1854*. Cambridge: Cambridge University Press, 1998

HAMLYN 1993
Hamlyn, Robin. *Robert Vernon's Gift: British Art for the Nation 1847*. exh. cat. London: Tate Gallery, 1993

HARDY 1991
Hardy, Anne. 'Parish Pump to Private Pipes: London's Water Supply in the Nineteenth Century', in *Living and Dying in London*, eds. W.F. Bynum and Roy Porter. *Medical History*, supplement no.11, 1991, pp.76–93

HARDY 1993
Hardy, Anne. *The Epidemic Streets: Infectious Disease and the Rise of Preventive Medicine, 1856–1900*. Oxford: Clarendon Press, 1993

HARRINGTON 1911
Harrington, H. Nazeby. 'The Watercolours of Seymour Haden', *Print Collectors' Quarterly*, vol.1, no.4, 1911, p.406

HASSAN 1998
Hassan, John. *A History of Water in Modern England and Wales*. Manchester: Manchester University Press, 1998

HAUSSMANN 2000
Haussmann, Georges Eugène, Baron. *Mémoires: Édition intégrale*. ed. Françoise Choay *et al*. Paris: Seuil, 2000

HERBERT 1994
Herbert, Robert L. *Monet on the Normandy Coast: Tourism and Painting, 1867–1886*. New Haven: Yale University Press, 1994

HEWISON, WARRELL AND WILDMAN 2000
Hewison, Robert, Ian Warrell and Stephen Wildman. *Ruskin, Turner and the Pre-Raphaelites*. exh. cat. London: Tate Gallery, 2000

HONOUR AND FLEMING 1991
Honour, Hugh, and John Fleming. *The Venetian Hours of Henry James, Whistler and Sargent*. London: Walker Books, 1991

HOUSE 1978
House, John. 'New Material on Monet and Pissarro in London in 1871–2', *Burlington Magazine*, vol.120, Oct. 1978, pp.636–9

HOUSE 1980
House, John. 'The Impressionist Vision of London', *Victorian Artists and the City*. ed. Ira Bruce Nadel and F.S. Schwarzbach. New York: Pergamon, 1980, pp.78–90

HOUSE 1986
House, John. 'Camille Pissarro's Idea of Unity', *Studies on Camille Pissarro*. ed. Christopher Lloyd. London and New York: Routledge, 1986, pp.15–34

HOUSE 1986a
House, John. *Monet: Nature into Art*. London and New Haven: Yale University Press, 1986

HOUSE 2004
House, John. *Impressionism: Making, Marketing, Meaning*. New Haven and London: Yale University Press, 2004

HUYSMANS 1889
Huysmans, Joris-Karl. 'Wisthler.' [*sic*], *Certains*. Paris: Tresse & Stock, 1889

HUYSMANS 1959
Huysmans, Joris Karl. *Against Nature (À rebours)* [1884]. trans. Robert Baldick. Harmondsworth: Penguin, 1959

ISAACSON 1965
Isaacson, Joël. 'Manet's Views of the Thames', *Herron Museum of Art (Indianapolis) Bulletin*, Annual Report, Oct. 1965, pp.44–51

JACQUEMET 1979
Jacquemet, Gérard. 'Urbanisme parisien: La Bataille du tout-à-l'égout à la fin du XIXe siècle,' *Revue d'histoire moderne et contemporaine*, no.26, 1979, pp.505–48

JAMES 1992
James, Henry. *Italian Hours* [1909]. ed. John Auchard. University Park: Pennsylvania State University Press, 1992

JARDINE 1853
Jardine, Sir William, ed. *The Natural History and Antiquities of Selborne* [1788]. London: Nathaniel Cooke, 1853.

JEFFERIES 1975
Jefferies, Richard. *After London; or, Wild England* [1885]. New York: Arno Press, 1975

JOLL, BUTLIN AND HERRMANN 2001
Joll, Evelyn, Martin Butlin and Luke Herrmann. *The Oxford Companion to J.M.W. Turner*. Oxford: Oxford University Press, 2001

JUPILLES, n.d. [c.1886]
Jupilles, Fernand de. *La Moderne Babylone (Londres et les anglais)*. Paris: Librairie illustré, n.d. [c.1886]

KAHN 1904
Kahn, G. 'L'Exposition Claude Monet.' *Gazette des Beaux-Arts*, no.32, 1 July 1904, pp.87–8

KENNEDY 1910
Kennedy, Edward G. *The Etched Work of Whistler*. New York: The Grolier Club of the City of New York, 1910

KINGSLEY 1854
Kingsley, Charles. 'Who Causes Pestilence? Four Sermons (1849)', *Miscellanies*. London: Richard Griffin, 1854

KNIGHT 1986
Knight, David M. *The Age of Science: The Scientific World-View in the Nineteenth Century*. Oxford: Basil Blackwell, 1986

KOECHLIN 1927
Koechlin, Raymond. 'Claude Monet', *Art et decoration*, vol.51, Feb. 1927

LECOMTE 1892
Lecomte, Georges. *L'Art impressionniste d'après la collection privée de M. Durand-Ruel*. Paris: Typographie Chamerot et Renouard, 1892

LEES 1973
Lees, Lynn. 'Metropolitan Types: London and Paris Compared', *The Victorian City: Images and Realities*. ed. H. J. Dyos and Michael Wolff. 2 vols. London: Routledge & Kegan Paul, 1973, I, pp.413–28

LESLIE 1843, 1845
Leslie, C.R. *Memoirs of the Life of John Constable* [1843, 1845]. London: Phaidon Press, 1951

LESLIE 1848
Leslie, C.R. 'Professor Leslie's Lectures on Painting, Lecture 1', *The Athenaeum*, 19 Feb. 1848

LESLIE 1855
Leslie, C.R. *A Handbook for Young Painters*. London: John Murray, 1855

LEVITINE 1967
Levitine, George. '*Vernet Tied to a Mast in a Storm*: The Evolution of an Episode of Art Historical Romantic Folklore', *Art Bulletin*, vol.XLIX, no.2, June 1967, pp.93–101

LEWIS 1976
Lewis, Paula Gilbert. *The Aesthetics of Stéphane Mallarmé*. London: Associated University Press, 1976

LEWISON 1963
Lewison, Florence. 'Theodore Robinson and Claude Monet', *Apollo*, vol.78, no.19, Sept. 1963, p.211

LIGHTMAN 1997
Lightman, Bernard, ed. *Victorian Science in Context*. Chicago: University of Chicago Press, 1997

LOCHNAN 1984
Lochnan, Katharine. *The Etchings of James McNeill Whistler*. London: Yale University Press, 1984

LOCHNAN 1986
Lochnan, Katharine. *Whistler and his Circle: Etchings and Lithographs from the Collection of the Art Gallery of Ontario*. exh. cat. Toronto: Art Gallery of Ontario, 1986

LOCHNAN 1988
Lochnan, Katharine. *Whistler's Etchings and the Sources of his Etching Style, 1855–60*. New York and London: Garland Publishing, 1988

LOCHNAN 1999
Lochnan, Katharine. 'The Medium and the Message: Popular Prints and the Work of James Tissot', *Seductive Surfaces: The Art of Tissot*, Studies in British Art, VI. London and New Haven: Yale University Press for the Paul Mellon Centre for Studies in British Art and the Yale Center for British Art, 1999, pp.1–22

LOCHNAN, SCHOENHERR AND SILVER 1993
Lochnan, Katharine, Douglas Schoenherr and Carole Silver, eds. *The Earthly Paradise: Arts and Crafts by William Morris and His Circle from Canadian Collections*. exh. cat. Toronto: Art Gallery of Ontario and Key Porter Books, 1993

LUCKIN 1986
Luckin, Bill. *Pollution and Control: A Social History of the Thames in the Nineteenth Century*. Bristol: Adam Hilger, 1986

LUCKIN 1997
Luckin, Bill. 'Town, Country and Metropolis: The Formation of an Air Pollution Problem in London, 1800–1870', *Viertel-Jahrscrift für Sozial-und-Wirtschafts-geschichte*, no.135: *Energie und Stadt in Europa, von der vorindustriellen 'Holznot' bis zur Ölkrise der 1970er Jahre*. ed. Dieter Schott. Stuttgart: Franz Steiner, 1997

LUDOVICI 1926
Ludovici, Albert. *An Artist's Life in London and Paris, 1870–1925*. New York: Minton, Balch, 1926

McCONKEY 1995
McConkey, Kenneth. *Impressionism in Britain*. New Haven: Yale University Press, 1995

MACDONALD 1973
MacDonald, Margaret F. *Whistler and Mallarmé*. exh. cat. Glasgow: Hunterian Museum, University of Glasgow, 1973

MACDONALD 1984
MacDonald, Margaret F. *Whistler's Pastels*. exh. cat. Glasgow: Hunterian Art Gallery, University of Glasgow, 1984

MACDONALD 1995
MacDonald, Margaret F. *James McNeill Whistler: Drawings, Pastels, and Watercolours: A Catalogue Raisonné*. New Haven: Yale University Press for the Paul Mellon Centre for Studies in British Art, 1995

MACDONALD 2001
MacDonald, Margaret F. *Palaces in the Night: Whistler in Venice*. Berkeley: University of California Press, 2001

MALLARMÉ 1893
Mallarmé, Stéphane. *Vers et prose: Morceaux choisis, avec un portrait par James M.N. Whistler*. Paris: Librairie académique Didier, Perrin et Cie, 1893

MALLARMÉ 1959
Mallarmé, Stéphane. *Correspondance I, 1862–1871*. ed. H. Mondor and Jean-Pierre Richard. Paris: Gallimard, 1959

MALLARMÉ 1965–85
Mallarmé, Stéphane. *Correspondance II–XI, 1872–1898*. ed. H. Mondor and Lloyd James Austin. Paris: Gallimard, 1965–85

MALLARMÉ 1998, 2003
Mallarmé, Stéphane. *Œuvres complètes*. ed. Bertrand Marchal. 2 vols. Paris: Gallimard, Bibliothèque de la Pléiade, 1998 and 2003

DE MARÉ 1862
De Maré, Eric. *The London Doré Saw: A Victorian Evocation*. London: Allan Lane, The Penguin Press, 1973

MALOT 1862
Malot, Hector. *La Vie moderne en Angleterre*. Paris: Michel Lévy, 1862

MANTZ 1866
Mantz, Paul. 'Turner,' *Nouvelle biographie générale*, no.45. Paris: Firmin Didot 1866

MARX 1887
Marx, Roland. *Jack l'eventreur et les fantasmes victoriens*. Brussels: Editions Complexe, 1987

MAUCLAIR 1905
Mauclair, Camille. *De Watteau à Whistler*. Paris: E. Fasquelle, 1905

MAUCLAIR 1927
Mauclair, Camille. *Claude Monet*. Paris: Rieder, [1924] 1927

MÉNARD 1872
Ménard, René. 'Institution de South Kensington, III', *Gazette des Beaux-arts*, vol.31, Oct. 1872, p.283

MENPES 1904
Menpes, Mortimer. *Whistler as I Knew Him*. London: Black, 1904

MERRILL 1992
Merrill, Linda. *A Pot of Paint: Aesthetics on Trial in Whistler v. Ruskin*. Washington, DC: Smithsonian Institution, 1992

MERRILL 1998
Merrill, Linda. *The Peacock Room: A Cultural Biography*. New Haven and London: Yale University Press in collaboration with the Freer Gallery of Art, 1998

MILLAN 1994
Millan, Gordon. *A Throw of the Dice: The Life of Stéphane Mallarmé*. New York: Farrar Straus Giroux, 1994

MIRBEAU 1904
Mirbeau, Octave. Preface to *Claude Monet, Vues de la Tamise à Londres (1902–1904)*. exh. cat. Paris: Galeries Durand-Ruel, 1904. Repr. in *L'Humanité*, 8 May 1904, and Mirbeau 1993

MIRBEAU 1912
Mirbeau, Octave. 'Les "Venise" de Claude Monet', *L'Art moderne*, 2 June 1912

MIRBEAU 1993
Mirbeau, Octave. *Combats esthétiques*, ed. Pierre Michel and Jean-François Nivet, 2 vols., Paris: Séguier, 1993

MOORE 1888
Moore, George. *Confessions of a Young Man*. London: Swan Sonnenschein, 1888

MOORE 1893
Moore, George. *Modern Painting*. London: Walter Scott, 1893

MOORE 1914
Moore, George. *Vale*. London: William Heinemann, 1914

MOREAU-NÉLATON 1925
Moreau-Nélaton, Etienne. *Daubigny raconté par lui-même*. Paris: Henri Laurens, 1925

MOTYKA 1990
Motyka, Gereon. *Venedig im Spiegel viktorianischer Reiseliteratur: Eine Quellensammlung*. Frankfurt am Main: Peter Lang, 1990

MOUREY 1895
Mourey, Gabriel. *Passé le détroit: La vie et l'art à Londres*. Paris: Paul Ollendorff, 1895

MUNDAY 1996
Munday, John. *Edward William Cooke, RA, FRS, FSA, FLS, FZS, FGS, 1811–1880, A Man of his Time*. Woodbridge, Suffolk: The Antique Collectors Club, 1996

MUTHER 1896
Muther, Richard. *The History of Modern Painting*. 3 vols. New York: Macmillan; London: Henry and Co., 1895–6

NADEL AND SCHWARZBACH 1980
Nadel, Ira Bruce, and F.S. Schwarzbach, eds. *Victorian Artists and the City*. New York: Pergamon, 1980

NEAD 1988
Nead, Lynda. *Myths of Sexuality: Representations of Women in Victorian Britain*. Oxford: Basil Blackwell, 1988

NEAD 2000
Nead, Lynda. *Victorian Babylon: People, Streets and Images in Nineteenth-Century London*. New Haven and London: Yale University Press, 2000

NECTOUX 1998
Nectoux, Jean-Michel. *Mallarmé, un clair regard dans les ténèbres*. Paris: Adam Biro, 1998

O'RELL 1883
O'Rell, Max. *John Bull et son île: moeurs anglaises contemporaines*. Paris: Calmann Lévy, 1883

PALMER 1960
Palmer, R.E., ed. *French Travellers in England, 1600–1900*. London: Hutchinson Educational, 1960

PARIS 1904
Claude Monet: Vues de la Tamise à Londres (1902–1904). exh. cat. Paris: Galeries Durand-Ruel, 1904

PARRIS 1994
Parris, Leslie, ed. *The Pre-Raphaelites*. exh. cat. London: Tate Gallery, [1984] 1994

PARTRIDGE 1961
Partridge, Eric. *Dictionary of Slang and Unconventional English*. 2 vols. London: Routledge & Kegan Paul Ltd, 1961

PENNELL 1908
Pennell, Joseph and Elizabeth Robins Pennell. *The Life of James McNeill Whistler*. 2 vols. Philadelphia: Lippincott; London: Heinemann, 1908

PENNELL 1921
Pennell, Joseph and Elizabeth Robins Pennell. *The Whistler Journal*. Philadelphia: Lippincott, 1921

PENNELL 1930
Pennell, Joseph and Elizabeth Robins Pennell. *Whistler the Friend*. Philadelphia: J.B. Lippincott Company, 1930

PERUZZA, RANDOLFI, ROMANELLI ET AL. 1980
Peruzza, Paolo, Nicola Randolfi, Giandomenico Romanelli et al. *Venezia, cittá industriale gli insediamenti produttivi del 19° secolo*. Venice: Marsilio, 1980

PIERRET 1902
Pierret, Emile. 'Turner et Westminster Bridge: souvenir de Londres', in *Voluptés d'artiste: Paris-Londres-Madrid*. Paris: Alphonse Lemerre, 1902, pp.239–55

PIGGOTT 1993
Piggott, Jan. *Turner's Vignettes*, exh. cat. London: Tate Gallery, 1993

PIGUET 1986
Piguet, P. *Monet et Venise*. Paris: Editions Herscher, 1986

PINKNEY 1958
Pinkney, David H. *Napoleon III and the Rebuilding of Paris*. Princeton: Princeton University Press, 1958

PLANT 2002
Plant, Margaret. *Venice: Fragile City 1797–1997*. New Haven: Yale University Press, 2002

POLLOCK 1992
Pollock, Griselda. *Avant-Garde Gambits 1888–1893: Gender and the Colour of Art History*. London and New York: Thames and Hudson, 1992

PROUST 1973–7
Proust, Marcel. *À la recherche du temps perdu*, ed. P. Clarac and A. Ferré. 3 vols. Paris: Bibliothèque Pléiade Gallimard, 1973–7

PYNE 1994
Pyne, Kathleen. 'Whistler and the Politics of the Urban Picturesque', *American Art*, vol.9, nos.3–4, Summer–Fall 1994, pp.61–77

RASHDALL 1888
Rashdall, E.M. 'Claude Monet', *The Artist*, 2 July 1888, p.196 (repr. Kate Flint, ed. *Impressionists in England: The Critical Reception*. London: Routledge, 1984)

RASPAIL 1880
Raspail, Emile R. *Les Odeurs de Paris*. 2nd ed. Paris, 1880

RAWLINSON 1908, 1913
Rawlinson, W.G. *The Engraved Work of J.M.W. Turner RA*. 2 vols. London: Macmillan, 1908–1913

RECLUS 1860
Reclus, Elisée. *Guide de voyageur à Londres et aux environs*. Paris: Hachette, 1860

REED 1993
Reed, Nicholas. *Camille Pissarro at Crystal Palace*. 2nd ed. London: Lilburne Press, 1993

DE RÉGNIER 1931
de Régnier, Henri. 'Nos Rencontres', *Mercure de France*, 1931, pp.209–10

DE RÉGNIER 2002
de Régnier, Henri. *Les Cahiers inédits, 1887–1936*. ed. David J. Niederauer and François Broche. Paris: Pygmalion/Gérard Watelet, 2002

REID 1977
Reid, Martin. 'Camille Pissarro: Three Paintings of London of 1871. What do they represent?', *Burlington Magazine*, vol.CXIX, no.889, April 1977, pp.251–7

REID 1991
Reid, Donald. *Paris Sewers and Sewermen: Realities and Representations*. Cambridge, MA: Harvard University Press, 1991

REWALD 1943
Rewald, John. *Camille Pissarro: Letters to his Son Lucien*. London and New York: Pantheon, 1943

REYNOLDS 1842
Reynolds, Sir Joshua. *The Discourses of Sir Joshua Reynolds: Illustrated by Explanatory Notes and Plates, by J. Burnet*. London: Carpenter, 1842

REYNOLDS 1981
Reynolds, Sir Joshua. *Discourses on Art* [1788]. ed. Robert Wark. New Haven: Yale University Press, 1981

RIBNER 2000
Ribner, Jonathan. 'The Thames and Sin in the Age of the Great Stink: Some Artistic and Literary Responses to a Victorian Environmental Crisis', *British Art Journal*, vol.1, no.2, Spring 2000, pp.38–46

RODNER 1997
Rodner, William S. *J.W.M. Turner: Romantic Painter of the Industrial Revolution*. Berkeley: University of California Press, 1997

ROE 1928
Roe, F.C., ed. *French Travellers in Britain, 1800–1926: Impressions and Reflections*. London: Thomas Nelson, 1928

ROOD 1879
Rood, Ogden. *Modern Chromatics*. London: C. Kegan Paul & Co., 1879

ROSSETTI 1892
Rossetti, D.G. 'A Collector's Correspondence', *Art Journal*, Aug. 1892, p.251

ROSSETTI 1903
Rossetti, William Michael. *Rossetti Papers, 1826–1870*. New York: Scribner's, 1903

ROUART 1950
Rouart, Denis. *Correspondance de Berthe Morisot*. Paris: Quatre Chemins - Editart, 1950

ROWELL, WARRELL AND BROWN 2002
Rowell, Christopher, Ian Warrell and David Blayney Brown. *Turner at Petworth*. exh. cat. Petworth House, Sussex. London: Tate Publishing 2002

RUSKIN: SEE COOK AND WEDDERBURN 1903–12

RUTTER 1927
Rutter, Frank. *Since I was Twenty-Five*. London: Constable and Co., 1927

ST JOHN 1854
St John, Bayle. *Purple Tints of Paris: Character and Manners in the New Empire*. 2 vols. London: Chapman and Hall, 1854

SCHNEIDERMAN 1973
Schneiderman, Richard. *Sir Francis Seymour Haden: A Reassessment of his Etchings and Watercolours*. M.A. thesis, University of Cincinnati, 1973

SEIBERLING 1988
Seiberling, Grace. *Monet in London*. exh. cat. Atlanta: High Museum of Art; Seattle: University of Washington Press, 1988

SEITZ 1960
Seitz, W.C. *Claude Monet*, New York: H.N. Abrams, 1960

SEZNEC 1964
Seznec, Jean. *John Martin en France*. London: Faber & Faber, 1964

SHANES 1994
Shanes, Eric. *Impressionist London*. New York: Abbeville Press, 1994

SICKERT 1908
Sickert, Bernhard. *Whistler*. London: Duckworth; New York: Dutton, 1908

SICKERT 1947
Sickert, Walter. 'The New Life of Whistler', *A Free House!*, London: Macmillan, 1947, pp.6–20

SIEWERT 1994
Siewert, John. *Whistler's Nocturnes and the Aesthetic Subject*. Ph.D. dissertation, University of Michigan, 1994

SILVESTRE 1926
Silvestre, Théophile. *Documents nouveaux sur Eugène Delacroix* [1864], repr. *Les Artistes français*. Paris: Les Editions G. Crès et Cie., 1926

SIMMONDS 1879
Simmonds, Henry S. *All About Battersea*. London: Ashfield Printers, Battersea, 1879

SMITH 1961
Smith, Raymond. *Sea-coal for London: History of the Coal Factors in the London Market*. London: Longmans, 1961

SPATE 1992
Spate, Virgina. *The Colour of Time: Claude Monet: Life and Work*. London: Thames and Hudson, 1992

SPENCER 1987
Spencer, Robin. 'Whistler, Manet and the Tradition of the Avant-Garde', *Studies in the History of Art*, vol.19: Centre for Advances Studies in the Visual Arts, Symposium Papers VI (National Gallery, Washington), 1987, pp.47–64

SPENCER 1987a
Spencer, Robin. 'Whistler's First One-Man Exhibition Reconstructed', *The Documented Image: Visions in Art History*, ed. Gabriel Weisberg, Laurinda S. Dixon and Antje Bultman Lemke. Syracuse, NY: Syracuse University Press, 1987, pp.27–49

SPENCER 1987b
'The Aesthetics of Change: London as Seen by James McNeill Whistler', *The Image of London: Views by Travellers and Emigrés*. ed. Michael Warner. exh. cat. London: Barbican Art Gallery, 1987, p.69

SPENCER 1989
Spencer, Robin. *Whistler: A Retrospective*. New York: Wings Books, 1989

SPINK, STRATIS, TEDESCHI 1998
Spink, Nesta R., Harriet K. Stratis, Martha Tedeschi et al. *The Lithographs of James McNeill Whistler: A Catalogue Raisonné*. 2 vols. Chicago: Art Institute of Chicago in association with the Arie and Ida Crown Memorial; New York: Hudson Hills Press, 1998

STAINTON 1985
Stainton, Lindsay. *Turner's Venice*. New York: George Braziller, 1985

STEVENS 2001
Stevens, MaryAnne. 'Monet e Londra: le esperienze del luogo', *Monet: I luoghi della pittura*. exh. cat. Treviso: Casa dei Carraresi, 2001, pp.137–60

STIRLING 1909
Stirling, A.M.W. 'Roddam Spencer-Stanhope, Pre-Raphaelite', *The Nineteenth Century and After*, vol.66, no.390, Aug. 1909, pp.307–25

STIRLING 1916
Stirling, A.M.W. 'A Painter of Dreams: The Life of Roddam Spencer Stanhope, Pre-Raphaelite', *A Painter of Dreams and other Biographical Studies*. London: John Lane, 1916, pp.287–345

STOLBERG 1996
Stolberg, Michael. *Wolken über der Serenissima: Eine kleine Geschichte der Luftverschmutzung in Venedig.* Venice: Centro Tedesco di Studi Veneziani; Sigmaringen, Jan Thorbecke, 1996

STUCKEY 1986
Stuckey, Charles F., ed. *Monet: A Retrospective.* exh. cat. New York: Park Lane, 1986

SWINBURNE 1904
Swinburne, Algernon Charles. *The Poems of Algernon Charles Swinburne.* 6 vols. London: Chatto and Windus, 1904

TAINE 1872
Taine, Hippolyte. *Notes on England,* trans. W. Fraser Rae. London: Chapman and Hall, 1872

TEXIER 1851
Texier, Edmond. *Lettres sur l'Angleterre (souvenirs de l'Exposition universelle).* Paris: Garnier, 1851

THIÉBAUT-SISSON 1927
Thiébaut-Sisson, F. 'Un nouveau musée parisien. Les Nymphéas de Claude Monet à l'Orangerie des Tuileries', *Revue de l'Art Ancien et Moderne,* no.52, June–Dec. 1927, pp.6–25

THORÉ 1857
Bürger, W. [Théophile Thoré]. *Trésors d'art en Angleterre.* Brussels and Ostende: Vve J. Renouard, 1857

THORÉ 1859
Bürger, W. [Thoré, Théophile]. 'Turner,' W. Bürger, *Histoire des peintres de toutes les écoles: École anglaise.* Paris: Vve J. Renouard, 1859

THORÉ 1870
Thoré, Théophile. *Salons de W. Bürger 1861 à 1868.* Paris: Hurst and Blackett, 1870

THORNBURY 1862
Thornbury, Walter. *The Life of J.M.W. Turner, R.A., Founded on Letters and Papers Furnished by his Friends and Fellow Academicians.* 2 vols. London: Hurst and Blackett, 1862

THORP 1994
Nigel Thorp, ed. *Whistler on Art: Selected Letters and Writings, 1849–1903, of James McNeill Whistler.* Manchester: Fyfield; Glasgow: Centre for Whistler Studies, Glasgow University Library, 1994

DE TRÉVISE 1927
de Trévise, Duc. 'Le Pélerinage de Giverny', *La Revue de l'Art ancien et moderne,* Jan.–Feb. 1927, p.126

TUCKER 1982
Tucker, Paul Hayes. *Monet at Argenteuil.* New Haven and London: Yale University Press, 1982

TUCKER 1989
Tucker, Paul Hayes. *Monet in the Nineties.* exh. cat. Boston: Museum of Fine Arts, 1989

TUCKER 1995
Tucker, Paul Hayes. *Claude Monet, Life and Art.* London: Yale University Press, 1995

TUCKER 1998
Tucker, Paul Hayes, ed. *Monet in the 20th Century.* exh. cat. Boston: Museum of Fine Arts, 1998

UPSTONE 1993

Upstone, Robert. *Turner: The Final Years: Watercolours 1840–1851.* exh. cat. London: Tate Gallery, 1993

VAUXCELLES 1904
Vauxcelles, Louis. 'Notes d'art. Une exposition de Claude Monet', *Gil Blas,* 11 May 1904

VAUXCELLES 1905
Vauxcelles, Louis. 'Un après-midi chez Claude Monet', *L'Art et les artistes,* vol.2, no.9, Dec. 1905, pp.85–90

VERHAEREN 1997
Verhaeren, É. 'Art moderne', *Mercure de France,* Feb. 1901, pp.544–7. Repr. É. Verhaeren, *Écrits sur l'art,* ed. P. Aron, II. Brussels: Labor, Archives du futur, 1997

VIARDOT 1860
Viardot, Louis. *Les Musées d'Angleterre, de Belgique, de Hollande et de Russie.* 3rd ed. Paris: L. Hachette, 1860

WAAGEN 1857
Waagen, G.-F. 'Exposition des Trésors d'Art à Manchester', *Revue Universelle des Arts.* Paris, 1857, pp.255–6

WARNER ET AL. 1987
Warner, Malcolm, et al. *The Image of London: Views by Travellers and Emigrés 1550–1920.* exh. cat. London: Barbican Art Gallery, 1987

WARNER ET AL. 1996
Warner, Malcolm, et al. *The Victorians: British Painting, 1837–1901.* exh. cat. Washington, DC: National Gallery of Art, 1996

WARRELL 1995
Warrell, Ian. *Through Switzerland with Turner: Ruskin's First Selection from the Turner Bequest.* exh. cat. London: Tate Gallery, 1995

WARRELL 1999
Warrell, Ian. *Turner on the Seine.* London: Tate Gallery 1999

WARRELL 1999a
Warrell, Ian. 'Turner's Late Swiss Watercolours – and Oils', *Exploring Late Turner.* ed. Leslie Parris. exh. cat. New York: Salander-O'Reilly Galleries, 1999

WARRELL 2003
Ian Warrell, *Turner et le Lorrain.* exh. cat. Nancy: Musée des Beaux Arts, 2003

WAY 1912
Way, T.R. *Memories of James McNeill Whistler, the Artist.* London and New York: John Lane, 1912

WAY 1913
Way, T.R. 'Whistler's Lithographs', *Print-Collector's Quarterly,* vol.3, Oct. 1913, p.286

WEY 1856
Wey, Francis. *Les Anglais chez eux.* Paris: Michael Lévy, 1856

WHEELER 1995
Wheeler, Michael, ed. *Ruskin and Environment: The Storm-Cloud of the Nineteenth Century.* Manchester: Manchester University Press, 1995

WHISTLER 1967
Whistler, James McNeill. *The Gentle Art of Making Enemies* [1890]. intro. Alfred Werner. New York: Dover, 1967

WHITE 1853
White, Rev. Gilbert. *The Natural History and Antiquities of Selborne* [1788]. ed. Sir William Jardine. London: Nathaniel

Cooke, 1853

WHITTINGHAM 1995
Whittingham, Selby. *Turner Exhibited 1856–61: Companion to Ruskin's Guide to the Clore Gallery,* London: J.M.W. Turner, R.A. Publications, 1995

WILDE 1877
Wilde, Oscar. 'The Grosvenor Gallery.' *Dublin University Magazine,* no.90, July 1877, p.124

WILDENSTEIN 1974–91
Wildenstein, Daniel. *Claude Monet: Biographie et catalogue raisonné.* 5 vols. Lausanne: La Bibliothèque des Arts, 1974–91

WILLIAMS 1987
Williams, Susan A. *The Rich Man and the Deseased Poor in Early Victorian Literature.* Highlands, NJ: Humanities Press, 1987

WILSON 1955
Wilson, Francesca M., ed. *Strange Island: Britain through Foreign Eyes.* London: Longmans, Green, 1955

WILTON 1979
Wilton, Andrew. *J.M.W. Turner: His Art and Life.* New York: Rizzoli, 1979

WILTON 1981
Wilton, Andrew. *Turner and the Sublime.* exh. cat. London: British Museum, 1981

WILTON AND BARRINGER 2002
Wilton, Andrew, and Tim Barringer. *American Sublime: Landscape Painting in the United States, 1820–1880.* exh. cat. London: Tate Britain, 2002

WILTON AND TURNER 1990
Wilton, Andrew, and Rosalind Turner. *Painting and Poetry: Turner's 'Verse Book' and his work of 1804–1812.* exh. cat. London: Tate Gallery, 1990

WOHL 1983
Wohl, Anthony S. *Endangered Lives: Public Health in Victorian Britain.* Cambridge, MA: Harvard University Press, 1983

WOOD 1982
Wood, Leslie B. *The Restoration of the Tidal Thames.* Bristol: Adam Hilger, 1982

WORNUM 1860
Wornum, Ralph Nicholson. *Descriptive and Historical Catalogue of the Pictures in the National Gallery,* ??23rd ed. Paris: [publisher?], 1860

WORNUM 1871
Wornum, Ralph Nicholson. *Descriptive and Historical Catalogue of the Pictures in the National Gallery,* ??23rd ed. London: [publisher?], 1871

WORNUM 1875
Wornum, Ralph Nicholson. *The Turner Gallery. A Series of Sixty Engravings from the Principal Works of J.M.W. Turner, with a memoir and illustrative text.* London: Chatto and Windus, 1875 (repr. from articles in the *Art Journal,* 1st pub. 1860s)

YOUNG, MACDONALD, SPENCER AND MILES 1980
Young, Andrew McLaren, Margaret MacDonald, Robin Spencer and Hamish Miles. *The Paintings of James McNeill Whistler.* New Haven: Yale University Press for the Paul Mellon Centre for Studies in British Art, 1980

ZANIELLO 1981
Zaniello, T.A. 'The Spectacular English Sunsets of the 1880s', *Annals of the New York Academy of Sciences,* vol.360, 20 April 1981, p.258

Lenders

Photo Credits

Index

Supporting Tate

Tate relies on a large number of supporters – individuals, foundations, companies and public sector sources – to enable it to deliver its programme of activities, both on and off its gallery sites. This support is essential in order to acquire works of art for the Collection, run education, outreach and exhibition programmes, care for the Collection in storage and enable art to be displayed, both digitally and physically, inside and outside Tate. Your donation will make a real difference and enable others to enjoy Tate and its Collections both now and in the future. There are a variety of ways in which you can help support the Tate and also benefit as a UK or US taxpayer. Please contact us at:

The Development Office
Tate
Millbank
London SW1P 4RG
Tel: 020 7887 3937
Fax: 020 7887 8738

Tate American Fund
1285 Avenue of the Americas
(35th fl)
New York
NY 10019
Tel: 001 212 713 8497
Fax: 001 212 713 8655

DONATIONS

Donations, of whatever size, from individuals, companies and trusts are welcome, either to support particular areas of interest, or to contribute to general running costs.

GIFTS OF SHARES

Since April 2000, we can accept gifts of quoted share and securities. These are not subject to capital gains tax. For higher rate taxpayers, a gift of shares saves income tax as well as capital gains tax. For further information please contact the Campaigns Section of the Development Office.

TATE ANNUAL FUND

A donation to the Annual Fund at Tate benefits a variety of projects throughout the organisation, from the development of new conservation techniques to education programmes for people of all ages.

GIFT AID

Through Gift Aid, you can provide significant additional revenue to Tate. Gift Aid applies to gifts of any size, whether regular or one-off, since we can claim back the tax on your charitable donation. Higher rate taxpayers are also able to claim additional personal tax relief. Contact us for further information and a Gift-Aid Declaration.

LEGACIES

A legacy to Tate may take the form of a residual share of an estate, a specific cash sum or item of property such as a work of art. Legacies to Tate are free of Inheritance Tax.

OFFERS IN LIEU OF TAX

Inheritance Tax can be satisfied by transferring to the Government a work of art of outstanding importance. In this case the rate of tax is reduced, and it can be made a condition of the offer that the work of art is allocated to Tate. Please contact us for details.

TATE AMERICAN FUND AND TATE AMERICAN PATRONS

The American Fund for the Tate Gallery was formed in 1986 to facilitate gifts of works of art, donations and bequests to Tate from United States residents. United States taxpayers who wish to support Tate on an annual basis can join the American Patrons of the Tate Gallery and enjoy membership benefits and events in the United States and United Kingdom (single membership $1000 and double $1500). Both organisations receive full tax exempt status from the IRS. Please contact the Tate American Fund for further details.

MEMBERSHIP PROGRAMMES

Tate Members enjoy unlimited free admission throughout the year to all exhibitions at Tate Britain, Tate Liverpool, Tate Modern and Tate St Ives, as well as a number of other benefits such as exclusive use of our Members' Rooms and a free annual subscription to Tate Magazine.

Whilst enjoying the exclusive privileges of membership, you are also helping secure Tate's position at the very heart of British and modern art. Your support actively contributes to new purchases of important art, ensuring that the Tate's Collection continues to be relevant and comprehensive, as well as funding projects in London, Liverpool and St Ives that increase access and understanding for everyone.

PATRONS

Tate Patrons are people who share a strong enthusiasm for art and are committed to giving significant financial support to Tate on an annual basis. The Patrons support the Tate Collection, helping Tate acquire works from across its broad collecting remit: historic British art, modern international art and contemporary art. Tate welcomes Patrons into the heart of its activities. The scheme provides a forum for Patrons to share their interest in art and to exchange knowledge and information in an enjoyable environment.

CORPORATE MEMBERSHIP

Corporate Membership at Tate Modern, Tate Liverpool and Tate Britain, and support for the Business Circle at Tate St Ives, offer companies opportunities for corporate entertaining and the chance for a wide variety of employee benefits. These include special private views, special access to paying exhibitions, out-of-hours visits and tours, invitations to VIP events and talks at members' offices.

CORPORATE INVESTMENT

Tate has developed a range of imaginative partnerships with the corporate sector, ranging from international interpretation and exhibition programmes to local outreach and staff development programmes. We are particularly known for high-profile business to business marketing initiatives and employee benefit packages. Please contact the Corporate Fundraising team for further details.

CHARITY DETAILS

The Tate Gallery is an exempt charity; the Museums & Galleries Act 1992 added the Tate Gallery to the list of exempt charities defined in the 1960 Charities Act. The Friends of the Tate Gallery is a registered charity (number 313021). Tate Foundation is a registered charity (number 1085314).

All information current as at February 2004